MIRACLES OF THE SPIRIT

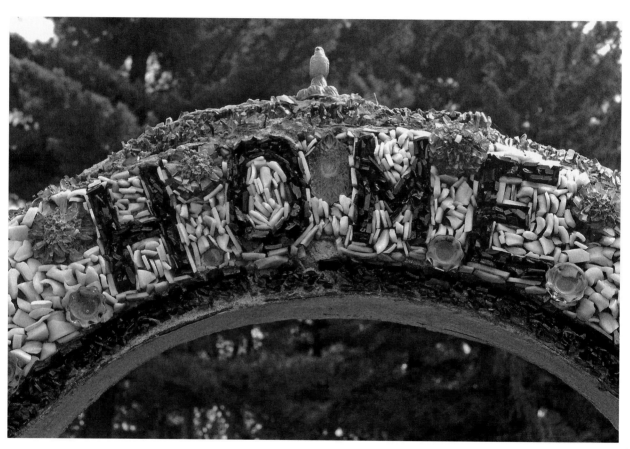

Paul and Matilda
Wegner Grotto (detail)

MIRACLES OF THE SPIRIT

FOLK, ART, AND STORIES FROM WISCONSIN

DON KRUG AND ANN PARKER

FOREWORD BY ROGER CARDINAL

UNIVERSITY PRESS OF MISSISSIPPI / *JACKSON*

www.upress.state.ms.us

Designed by Todd Lape

The University Press of Mississippi is a member of
the Association of American University Presses.

Illustrations courtesy of Don Krug and Ann Parker
unless otherwise noted

First edition 2005
∞
Library of Congress Cataloging-in-Publication Data
Krug, Don.
 Miracles of the spirit : folk, art, and stories from
Wisconsin / Don Krug and Ann Parker.— 1st ed.
 p. cm.
 Includes bibliographical references and index.
 ISBN 1-57806-753-7 (cloth : alk. paper) 1. Outsider
art—Wisconsin. 2. Folk artists—Wisconsin—Inter-
views. I. Parker, Ann. II. Title.
 N6530.W6K78 2005
 700'.92'2775—dc22 2005003949

British Library Cataloging-in-Publication Data
available

CONTENTS

ACKNOWLEDGMENTS

We will value for a lifetime our journey, which was full of visual wonders and roadside rewards, and the assistance we received and relationships we established along the way will always be cherished. Few individuals know about the many side-trips we encountered like our partners Willie Spoden and Mary Underwood. It was their gentle, patient, and lasting encouragement that help bring this publication to fruition. Our sincere gratitude goes to Roger Cardinal for writing an insightful foreword. And, it is our extreme pleasure to recognize the many people who contributed to the making of this story of Wisconsin's folk and their art.

ARTISTS AND THEIR FAMILIES

Hope Atkinson, Prophet William Blackmon, Guy Church, Jack Dillhunt, Anton Flatoff, Tom Every, Lester Fry, Pauli Hefti, Wally Keller, Norbert Kox, Les Morrison, Ellis Nelson, John Ree, Lori Reich, Rudy Rotter, Simon Sparrow, Bruce Squires, Johnny Sroka, Loretta Sylke, Carter Todd, John Tio, Bob Watt, Mona Webb, Della Wells, Mike White, and Clyde Wynia

EDITING AND PUBLICATION

Craig W. Gill (editor in chief), Anne Stascavage (editor), Shane Gong (production coordinator), and Todd Lape (designer) at the University Press of Mississippi

TYPING, TRANSCRIPTION, AND ADMINISTRATION

Melanie Buffington, Hsiao-ping Chen, Cynthia Chwelos, Kate Compton, Sara Jenkins, Chien-hua Kuo, Penny Metzke, and Cathleen Cummings (Huntington Archive, Ohio State University)

PHOTOGRAPHIC REPRODUCTION RIGHTS AND PERMISSIONS

Mortimer Cushman, Eric Erikson, Jakob Furnald, Sarah Hall and Robert Teske (Cedarburg Art Center), Amelia James, Mark Klassen, Michael Kienitz, Lewis Koch, Ralph Knasinski, Los Angeles County Museum of Art, Jim Mankoph, Milwaukee Art Museum, Vincent Monod, Gladys Nilsson,

Claude Nutt, James Nutt, David Oswald and the Rhinelander Chamber of Commerce, Doris Rinker, Rayna Rokicki (John Michael Kohler Art Center), Deb Brehmer, Riana de Raad, Michael Rosenfeld Gallery, Trudi Mullen, Susan Soucheray, B. J. Tworek, Marcia Weber, Erik Weisenberger, Jim Wildeman, and Zane Williams

SUPPORTIVE INDIVIDUALS

John Bambic, Bill and Donna Borzyskowski, Russell Bowman, Dan Erbstoesser, Steve Erbstoesser, TC Farley, Janet Gilmore, Jerome Hausman, Jeffrey R. Hayes, Dean Jensen, Cavalliere Ketchum, Ruth Kohler, James Leary, Richard Marsh, Cookie Martin-Smith, Kent Mueller, Ronald Neperud, Mary Nohl, Paul Phelps, Anton Rajer, Seymour Rosen, David Smith, Lester Schwartz, and Patricia Stuhr

FOREWORD
BY ROGER CARDINAL

It's been quite a while since anonymity was the norm for the folk artist. In earlier times, when the working lives of rural populations were still regulated by the seasonal cycle and social behavior was governed by traditional beliefs and values, the making of artworks tended to reflect the ethos of communal solidarity. Art was oriented toward group satisfaction; it was inseparable from the collective sense of what should be tolerated, treasured, or admired. So long as there was unanimity about its vision of the world and its place therein, the community would take pride in its social and religious customs, often affirming its identity in shared ways of speaking and dressing. In such a context, individual creative talent was rarely cause for celebration, and artmaking tended to conform to a single standard.

It is indeed astonishing that, despite remaining faithful to an inherited stock of fixed patterns and motifs, the peasant arts of preindustrial Europe should have given rise to such a rich and diverse output in so many different media: music, dance, storytelling, cooking, and architecture, as well as the making of handmade, portable artifacts of every imaginable kind: pottery, kitchen utensils, furniture, garments, quilts, farming and dairy equipment, weathervanes, toys, and so forth. It has been argued that embellishment in the form of decorative devices or abstract patterns was the first sign of a progression whereby a basic proficiency in the shaping of the functional artifact modulated into what we would nowadays judge to be true artistic expression. It was in fact comparatively late in the day that ornamentation, typically based on permutations of stylized configurations (such as floral motifs), began to be overtaken by more realistic designs composed of recognizable figures and settings. It might be said that our modern sense of what art is "all about" began to assert itself here, with the emergence of scenes and narratives, rendered in visual form: painting and carving emerge as privileged media, or at least as the modes of expression least hampered by the principle of utility. (Albeit folk imagemakers never seem to have had any trouble in reconciling the aesthetic with the functional, inasmuch as their best pictorial designs can be found on perfectly serviceable tools, furniture and other objects of everyday use). Once the representational trend

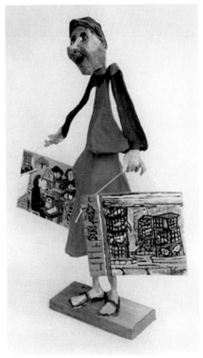

Hope Atkinson shopping in New York, papier-mâché

had assumed a momentum, the contents of peasant art fell into two broad categories: on the one hand, the evocation of exceptional scenes derived from biblical lore or from other religious or visionary sources; and on the other hand, more familiar scenes based on the observation of daily life on the farm, or of seasonal festivities.

In late eighteenth- and early nineteenth-century Europe, and beginning above all in England, agriculture underwent a dramatic conversion from a painstaking, manual approach to managing crops and livestock to an accelerated, mechanical approach propelled by the invention of factory-made tools and engines. The advance of industrialization, with its grim cotton-mills and mushrooming cities, sucked up rural workers and transformed them into an urban proletariat which swiftly lost touch with the rhythms and rituals of the peasant lifestyle. Despite many remarkable pockets of resistance—especially in territories remote from the metropolitan centers, such as the Alps, or in countries slow to embrace industry, such as Romania—the honored values of the countryside tended to be abandoned or irrevocably corrupted, so that an immense heritage of folkways fell into abeyance. From the Romantic period on, a small number of enlightened individuals—nourished on the culture of the elite yet appreciative of the culture of the people—recognized the situation and strove to arrest this dispersal of riches through such activities as folksong collecting and the preservation of rural artifacts. The more recent phenomena of the folk museum, the folk-music revival and serious folklore studies constitute the latterday traces of a long and emotionally colored campaign to lay hold of a disappearing past.

It was at the beginning of the twentieth century that Naïve Art, as it was subsequently labeled, arose as a curious product of individual idealism pursued more or less against the grain of history, within the framework of an alienating urban culture, if not a faltering rural one. As a city-based fantasist, the Frenchman Henri Rousseau stands out as the first master of Naïve Art: his artistic vision flourished under the influence of models drawn from high culture, but was shaped by a technique improvised on the spot, with no recourse to academic training. Other individuals, typically of working-class origin, were inclined to produce heartfelt representations of simple scenes, bathed in an idealizing light. Only occasionally did Naïve Art take a collective form, as happened in the 1930s with the rural community of Hlebine in Yugoslavia (now Croatia), where a forum of village painters drew

strength from solidarity in quite sophisticated renderings of peasant life within the local landscape. Their work is strongly imbued with nostalgia, an ingredient typical of that mode of half-documentary, half-invented picture-making which has been dubbed Memory Painting.

A fascinating chapter in the wider history of Folk Art starts up in the mid-nineteenth century with the large-scale emigration to North America of rural populations from central and eastern Europe. Many of these traveled in groups bound by fervent religious beliefs (they were frequently victims of religious discrimination in their former homelands); all arrived with considerable cultural baggage and were eager to regenerate their lifestyles upon fresh soil, in a location extolled as a promised land, though often experienced as a dangerous wilderness. The priorities of survival cemented the pioneer mentality, and cherished tradition was paramount in imposing order upon novel experience. The settlers clung to their ancient myths and customs, made stable through the enduring styles of their crafts and arts; these constituted vital markers of sociality in an otherwise ill-marked and confusing world.

The present book engages with this complex history by honing in upon a specific location within the North American territories, namely the state of Wisconsin, which has the merit of being one of the most fertile, if not the most typical, arenas of development as regards the phenomenon of self-taught artmaking. In narrowing their focus upon a select number of self-taught individuals in this particular region at the beginning of the twenty-first century, the authors contrive to throw into relief some of the critical issues that not only continue to affect folk art but actually define it as a fertile, and sometimes controversial, division within the arts at large.

Wisconsin, as the authors tell us, is a geographically diverse territory: thanks to accidents of geological formation, parts of the terrain are flat and extremely hilly; there is a marked profusion of rivers and lakes, while the long eastern shoreline of Lake Michigan and the western boundary of the upper Mississippi make of the state a kind of self-contained peninsula. Wisconsin boasts an exceptional number of archaic earthworks, the remains of cultural activity on the part of the original Native American peoples, some of which still survive in isolated pockets. A formidable regional history dates from the time of first contacts and unfolds as an agitated tale of early exploration, skirmishes between natives and Europeans, fur-trading, bitter wars, florid immigration, political turbulence, and the eventual establishment of

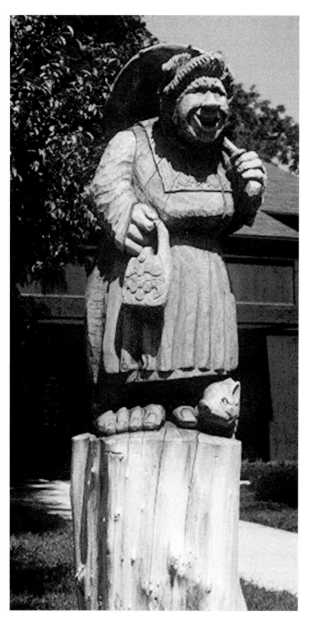

Troll with parasol, Michael Feeney, Mount Horeb, Wisconsin. Mount Horeb is a community with a strong Norwegian Heritage.

modern government. In the latter half of the nineteenth century, Wisconsin saw the establishment of rural settlements differentiated by distinct languages and codes of behavior, as anxious sects and immigrant groups flooded in from such countries as Germany, Sweden, Ireland, Poland, and Russia. These populations enjoyed a respite from the impact of European industrialization, and their rural folkways were able to maintain a changeless coherence through much of the late nineteenth century: the management of crops and dairy cows was the perennial preoccupation of life on the farm. And while industrialization and urbanization dragged the Badger state into the twentieth century with a vengeance, as witness the great manufacturing centers and ports of Milwaukee, Superior, and Green Bay, it continues to sustain an important agricultural economy whose forceful modern methods seem not entirely to have broken the link with the past. The authors assure us that there are dozens of annual festivals which keep faith with ancient folkways; and, finally, all sorts of robust manifestations of folk art—that is, the vernacular expressions of common people.

Nevertheless, there is no denying that technological modernization has drastically restructured the cultural life of communities throughout North America, and this has inevitably altered the context within which folk art flourishes today. Above all, the telephone, the television set, and the news magazine have for many years been disrupting the closed circuits of rural communication, negating the relevance of traditional vernacular iconography. Homesteads no longer adhere to old styles of furnishing and decoration, and the average person is inclined to dress in accordance with national norms and fashions, rather than regional ones. If there is still a decorated handmade wooden spoon to be found in a Wisconsin household, it is almost certain that it is being treated as an heirloom and not an object of daily use.

Given the evolution of social and political expectations in the populace through the nineteenth and twentieth centuries, notions of individual iden-

tity and individual rights have today become normative, so that no contemporary autodidact artist would be likely to acquiesce if asked to relinquish the right to be seen as author of his or her work. Indeed, in marked contrast to the old folk tradition of conformity and anonymity, the primacy of the individual sensibility seems to have become the new marker of authenticity. Whereas early twentieth-century inventories might list dozens of artifacts without reference to any maker, the unknown artist is now all but extinct. A recently published survey of American self-taught art by Florence and Julius Laffal includes the capsule biographies of no less than 1,319 named creators. (Ironically, they don't acknowledge the so-called Philadelphia Wireman, whose exuberant constructions deserve our full attention even though their author's identity remains a mystery.) It is clear that names and biographies have become inseparable from the study of the field.

One can only praise Don Krug and Ann Parker for having made the decision to document the self-taught art of contemporary Wisconsin not only by compiling illustrations of outstanding artworks, but above all by directly contacting a number of living individuals, no less than twenty-six in all. Each has been tracked down to his or her workplace, which is invariably synonymous with his or her home. Each is thereby established for us as an expressive subject who can articulate his or her sense of vocation within the context of an intimate environment. Past experience and its imprint on personality, along with physical presence and the immediacy of locale, these are all valuable components in what amounts to an endeavor to establish the fullest illuminating context. An admirable straightforwardness is central to the researchers' methodology. Admittedly, the fact that a tape-recorder sits on the table might be thought a corruptive intrusion of technology into spheres of concern which frequently engage with delicate psychological and spiritual matters. At least one artist makes it clear that the revelation of deep truth is incompatible with the indiscreet gadgetry of our age. Nevertheless, Krug and Parker, it would seem, have mastered the art of asking the right sorts of questions and eliciting frank and uninhibited replies. No doubt the sharing of a coffee in the studio or a meal in the kitchen are gestures of hospitality which nourish reciprocal respect and trust. In turn, we as readers are privileged to listen in on the homespun informalities which (after gentle editing) have emerged from the interview sessions.

Some artists are keen to foreground their self-taught status, proudly stating their credentials as autodidacts who have had no benefit of classroom

Hope Atkinson at the Outsider Art Fair in New York. In contemporary societies, anonimity is seldom the norm for folks artistically unschooled.

study or pedagogic expertise. Be it noted, however, that the authors have not slavishly rejected from their purview any artist who may have benefited from a good education and a steady job: they rightly avoid the stereotype of the hamfisted grassroots genius or holy fool. Moreover, the articulacy of many of the interviewees points instead to a canny understanding of the deeper implications of a commitment to artmaking, an understanding which even trained professionals might envy. Many of these independent

spirits speak of the intrinsic benefits of creativity; those with troubled private histories hint at a therapeutic dimension. Some speak in awe of the secret power they derive from their vocation. Others insist that their paramount motive is to enlighten other people: religious and, increasingly, political messages are not untypical of such art, registering a concern to communicate and persuade, rather than to retreat from dialogue. All the same, one may be struck by the recurrent emphasis on selfhood, as if artmaking were integral to the discovery and nourishment of the sense of a person's uniqueness. Yet it should be noted that this sense is not at odds with the sense of community, for the speakers repeatedly invoke the goodwill and support of other people, as if to demonstrate that, in recent times, the inspired autodidact fulfils a special function within the community, just like the priest or the blacksmith of old. In this context, the rejection of anonymity does not signify a triumphal egotism but rather a strengthening of self-confidence and personal worth. I suggest that the differing voices of these exemplary speakers tend to assert the mutuality of the singular sensibility and the plural culture: indeed, the artwork itself can be located at the symbolic heart of a network of interdependent forces, with the awareness of a shared environment as its grounding. In this perspective, and in a way which reveals the essential face of the creative endeavor, the private realm within which the artist gives shape to his or her creative vision is seen to be both protected by and subsumed within the greater whole.

I daresay there will come a point when contemporary self-taught art will be judged so distant from the traditional folk art evoked above that a fresh term will be needed, marking the historical shift by a new conceptualization. The authors review the diverse terminological coinages that have intensified (but also befuddled) critical discussion over the past few decades. But, quite sensibly, they decline to adopt any one term as a permanent rallying cry: for what they intend is to foster our appreciation of the freely beating heart of this sort of nonconformist artmaking, not to trap it within a definitional straightjacket. If, as William Blake declared, "Exuberance is Beauty," then true art must always resist bureaucratic stipulation.

While it is fascinating for us to ponder the significance of personal trauma and emotional upheaval in several of the narratives, advanced by the artists themselves as likely catalysts of their creativity, Krug and Parker avoid reducing the shaping impulse to a simple reaction to psychological or sociological pressures. Discussions of untutored art and kindred modes of self-

expression have occasionally fostered a paradigm which depreciates the art-making as an activity of compensation, an escapist reflex, the turgid out-pourings of tortured souls, and so forth. Undeniably, a number of extravagant artworks do catch our attention because they are accompanied by exceedingly troubled lifestories: in such cases, there may be grounds for a legitimate enquiry into the impact of biography upon art. However, a facile correspondence between creativity and physical, mental or emotional distress can never be the whole story. There are more important things to be discussed, and most especially the shapes and textures of the expressive artifact itself—its composition, its formal properties, its overt narrative content, its tonality, its darker connotations and potential symbolic radiance.

Given these critical options, it is striking that the artists themselves frequently draw attention to the *materiality* of the shaping process. Jack Dillhunt takes pride in his idiosyncratic technique, namely the use of a ballpoint pen on polyester bed-sheets, as does Norbert Kox in his application of multilayered glazes. Lori Reich paints with a toothpick and sprinkles glitter on her paintings. John Tio is a compulsive manipulator of aluminum pulltabs and paper clips. Wally Keller welds together obsolete machine parts. (I can't help but notice a harmony here, for Keller was raised on a dairy farm, and the mission of his old age is to conjure active expressions from the inert dross of the agricultural past.) It's noticeable that a good many Wisconsin artists exploit a stock of accumulated elements, collecting discarded scraps on the street or rusted machinery from agricultural dumps. Their art consists in making fresh ensembles out of these residues, whether in the form of assemblages, installations, shrines, and roadside displays, or of full-blown environments of architectural or landscapelike proportions. It's characteristic of all these exponents of *bricolage* that they have a detailed tale to tell about how they started off their work, how they pursue the quest for junk materials, how they approach the tasks of glueing, welding, or finishing. Perhaps this is the most innovative approach to be found in contemporary vernacular art, one in which worthless materials are redeemed through the alchemy of the creative mind. Although there may be a lingering reminiscence of the farming ethos—"thou shalt let nothing go to waste!"—the ambition seems to go beyond simple recycling. Here is art-making as symbolic sublimation, an obstinate progression from the down-to-earth to the sublime.

"Discrimination is shaped by the sensation of diversity" is a fertile observation made by the French traveler Victor Segalen; it occurs in an essay in which he recommends the intelligent absorption and appraisal of things that are exotic, disparate and even baffling. As viewers of the contemporary modes of self-taught art—so much more idiosyncratic and adventurous than the folk art of earlier times—we thrill to the spectacle of artistic expressions which challenge our imagination and stretch the bounds of our visual tolerance. The versatility and dynamism of these Wisconsin artmakers are astonishing. Set against the background of their individual lives, their works take on a density of meaning that subsumes considerations of artistic subtlety and eloquence within a wider span of social and indeed political awareness. There is nothing here that is not marked by a lively personality. Equally there seems no trace of affectation, no cool egocentricity. These are artists whose messages reach beyond the limits of a set of hackneyed motifs, beyond the limits of a culturally self-sufficient elite: their messages are touched by something we all share as inhabitants of the same planet. To appreciate the singularity of these works—and likewise the singularity of their makers—is to be attuned to the profound resonances which authentic art transmits. Coming close to these diverse expressions, savoring the quirkiness of their idioms, while honoring their no less palpable mutuality of intent, is to engage in an exhilarating experience of contact. In these privileged circumstances, meaning arises as a reciprocal construct, dependent on both the fluency of the artist and the empathy of the viewer, and guaranteed by the overarching framework of a common humanity.

—ROGER CARDINAL
Chartham Hatch, March 2005

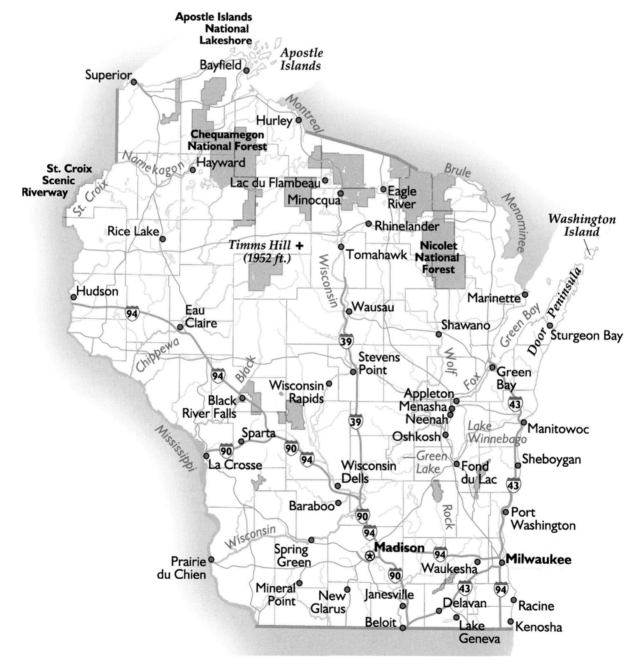

Graphic courtesy of Amelia James

INTRODUCTION

No matter where one lives in Wisconsin, it is not far to the nearest artistic wonderment. For over a hundred years, Wisconsin folk have built grottoes, yard environments, and enticing private spaces in numbers and variety that rival any other state. Driving up north one happens by Fred Smith's Concrete Park or Herman Rusch's Prairie Moon Museum. Heading out to pick up fresh cheese curds? A giant scrap metal "space module" beckons from an abandoned schoolyard. A bathtub angel or a herd of dinosaurs guard a private bridge. A woman fishing in her front yard reeling in a giant fish or an old three-story brewery covered in mosaic tiles and painted nudes causes the brakes to be applied. Whether one is driving to work, traveling to a family picnic, or making a quick run to the local convenience store, the chances are high that a grassroots art experience is on the route. The wealth of these encounters in Wisconsin is varied and dazzling. Best of

We stood before miracles of the spirit of art that emerge dawn-like from depths far beyond thought and consideration. . . . I absorbed these impressions into myself with an emotion of greatest joy . . . and now these things refuse to leave me alone any longer.

—ALFRED KUBIN

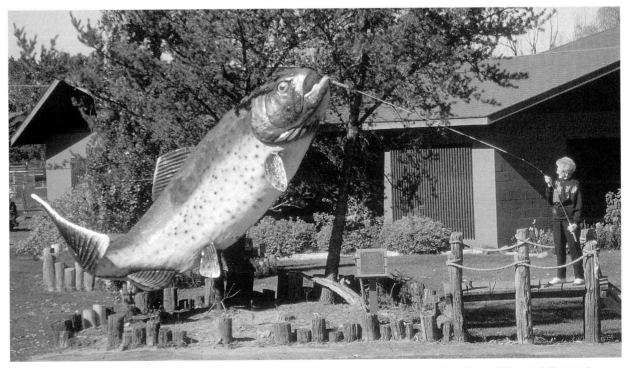

A Wisconsin roadside reward. Photograph courtesy of Trudi Mullen.

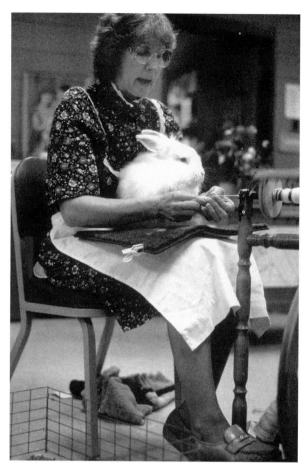

Bea Zuelke demonstrates to a grade school art class how to spin yarn from combed rabbit hair.

all, the Badger State is home to a living, breathing group of artists, who in the pages that follow articulate their need to create things outside the mainstream of university and museum art worlds.

From 1991 to 1999, we canvassed the state of Wisconsin talking with a variety of folk typically called outsider or self-taught artists. We embraced an inclusive and fluid set of everyday aesthetics that acknowledges the extraordinary values of many different groups of people. From our perspective, all people can be considered folk, and they are culturally productive in their everyday lives no matter where they live.

In this book, we present twenty-six artists from Wisconsin by relaying their stories in their own words rather than speaking at great length in our voices about them. The narratives provide the reader with a way to better understand how and why these artistically unschooled folks make things special in their home environments. Our description and interpretation of folk, art, and stories encompass the visual cultural practices (music performance, storytelling, cooking, sewing, and art making) people use to make things. Visual culture includes tangible or physical objects and intangible human conditions such as certain types of ideas, behaviors, beliefs, assumptions, and dispositions. In sharing our conversations with these artists, we hope to demonstrate the vast range of visual culture of people outside the mainstream of the many different art worlds.

As we traveled the state, we were tempted to include the art of Wisconsin's rich ethnic traditions. Many people choose to participate in familial, occupational, religious and/or community-based ways of making things based on skills, ideas, and styles that are handed down from generation to generation. From the late 1700s, waves of immigrants flowed into Wisconsin. French, Dutch, Germans, Norwegians, Danes, Swedes, Finns, Swiss, Poles, and Italians joined the many indigenous groups already in the state. In the early twentieth century and later, Wisconsin residents were joined by Ukrainians, Russians, Mexicans, Puerto Ricans, African Americans, and H'mong.

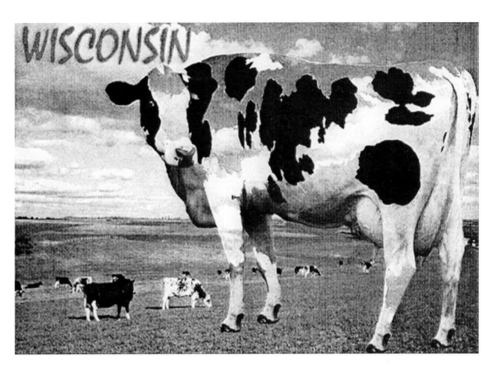

Wisconsin: In America's Dairyland Cows Are Sky High, courtesy of Argonaut (photograph by Michael Kienitz)

Each of these major groups brought with them traditional community-based arts that have become treasured pastime rituals and family heirlooms. African American quilts and walking canes, Swiss lace, Latvian patterned mittens, Ukrainian pysanky eggs, Ho-Chunk (Winnebago) reed baskets and beadwork, Slovenian wood carvings and sturgeon decoys, Polish intricate papercuts (Wycinanki), Finnish "Bucksaw in a Bottle" and rag rugs, Italian bobbin lace, Scandinavian kubbestol (log chairs), Norwegian fiddles and rosemaling, and German concertinas are only a fraction of the traditional folk aesthetic bounty evident on Wisconsin's cultural terrain.

However, the majority of people in this book produced things based on ideas and visions that were not passed down through family generations or rooted in their cultural or ethnic heritage. These people create with a variety of materials in sometimes unusual and idiosyncratic ways. For example, Mona Webb used her whole house as a surface on which to create her art, from huge encrusted concrete figures built into walls to painted and collaged murals that covered nearly every interior and exterior surface. These artists choose to work in manners that are often ephemeral and less consciously constructed than an academically schooled artist.

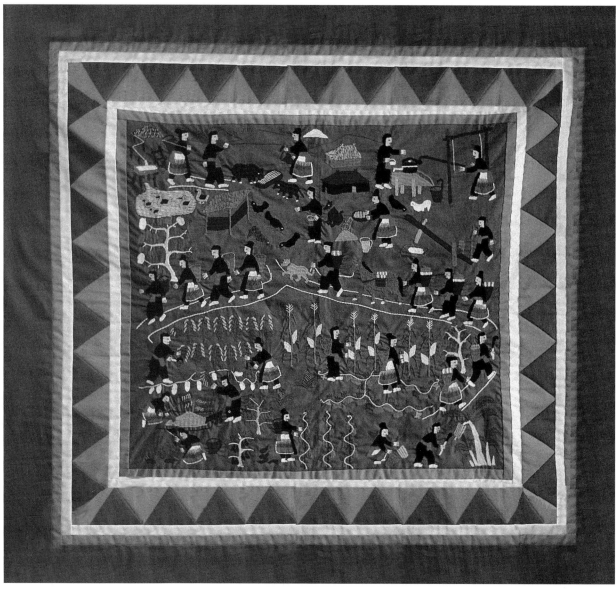

H'mong storycloth

Differences between traditional community aesthetics and idiosyncratic artistic practices sometimes endeared these people to their communities and some became local celebrities. However, occasionally an artist's vision of individuality, spirituality, fantasy, and reality along with an obsession with expressing it generated misunderstandings and alienation. In some cases, an artist was virtually unknown in his or her immediate locale, but well known

Rosemaling, by Vi Thode, Stoughton, Wisconsin
(original in color). Cedarburg, Wis.: Cedarburg
Cultural Center, 1997 (photo by Lewis Koch)

in academic art circles in neighboring cities. For instance, over the years, Dr. Evermor has had guests visiting his sculpture park from all over the United States and Europe, yet until recently local teachers rarely scheduled field trips for students to see his site.

Some of the people we spoke to did not consider themselves artists. Others believed they were artists because visitors called them such. A few people pursued art in a formal way using traditional motifs and techniques. Most of the folks produced work easily distinguishable from art coming out of university art programs. Some of the people that came to our attention were aware of outsider and mainstream art through museums or books. Several of the artists accepted the folk, self-taught, outsider, naïve, and visionary labels and some did not. One greeted us at the door with "Hi, I'm a self-taught artist working in the style of outsider Lonnie Holley." This young artist openly appropriated the work of other artists in order to enter the growing contemporary folk art market. The derivative nature of his work excluded him from this book. On the other hand, Loretta Sylke candidly voiced her dislike for the term "outsider," saying, "People call my work 'primitive.' 'Prim-

Loretta's Granddaughter, date unknown, by Loretta Sylke, oil paint, 14" x 18"

itive' doesn't bother me as much as 'outsider.' I don't especially care for 'outsider!'" While very few absolutely considered themselves artists, many of the people we talked with didn't care what they or their work was called as long as they could keep making it.

The artists we interviewed all started making things on their own. None were academically educated in art when they started making things, but several had higher education degrees in other subjects. Some of the people had had art classes in elementary school or high school but chose to pursue other careers, usually for financial reasons. A few started creating things without course work and at some point went back to art school to learn more about art-making. Norbert Kox, a painter from New Franken, was told in high school that he had no artistic ability and should drop an art course he enjoyed very much. Ellis Nelson, an electrician, gunsmith, and machine and metal worker from Muscoda, found academic subjects difficult in school. His elementary teachers failed to identify his exceptional manual skills and his ability to creatively pose and solve mechanical problems. Some of the artists started making art as small children and continued doing so throughout their working careers. For example, Simon Sparrow supported himself with other jobs for much of his life, and only in the late 1980s and '90s, at the end of his life, was he able to support himself by making art full time.

Many of the people we talked with made things with no particular concern for selling them. The value of their work derived from the satisfaction of "doing."

Some of the profiled artists lived in relative isolation, while others were actively involved in their urban, rural, or suburban communities. A few of the artists used traditional materials, while others created with recycled and found objects. For example, Della Wells uses high quality paper and pastels to create some of her colorful and dramatic drawings. John Tio, over a period of years, decorated the surfaces of his small mobile home with over

"Melancholy Dreamers," by Della Wells,
30" x 22", pastel, 1997

a million pull-tabs from aluminum pop cans, along with Christmas tree lights and colored paper clips.

When this book was begun, we came upon the work of three living environment builders who had been artistically schooled: Mary Nohl, Lester Schwartz, and Riana deRaad. The playfulness, scale, and lack of inhibition in their sites make them wonderful roadside rewards along Wisconsin's scenic highways. Their work represents a recent part of the long and distinguished history of idiosyncratic environments built in the state. Many of the creators of these historic sites are now deceased. We had initially assumed that we would include any and all of these many outstanding environments and grottoes, but we soon realized that we would need consistent guidelines

within this genre, too. We questioned how we would present the work of artists who had died before our research began and debated whether stories provided by families and friends would satisfy our concept of narratives.

In the end, we decided to include only living artists/makers who were not artistically schooled when they began their art odysseys. Their stories and art embraced a world richly textured and colored with personal and social cultural values and meanings. Our conversations with them were especially helpful for understanding their visual cultural practices in relationship to their sense of place in the world.

The narratives are loosely organized geographically into eastern, central, western, and northern regions of the state. Of course, our transcriptions of the artists' stories, what we included and what we excluded, have been colored by our own philosophical positions concerning issues of contemporary folk, self-taught, and outsider art. We agree with Krieger (1991) that "when we discuss others, we are always talking about ourselves. Our images of 'them' are images of 'us.' Our theories of how 'they' act and what 'they' are like, are, first of all, theories about ourselves: who we are, how we act, and what we are like. This [critical] self-reflective nature of our statements, we can never avoid" (p. 5). In this sense, the stories are not by any means an unbiased representation of the makers' oral life narratives. These interviews encompass our own interests in knowing more about how the artists' interests, values, satisfaction, and practices were all interwoven to form the fabric of their life and art. Idiosyncratic makers of art are too often misrepresented as if their practices arise out of some inherent, spontaneous, or accidental creativity (Manley, 1989). This is evident in Alfred Kubin's observation that miracles of the spirit of art seem to "emerge dawn-like from depths far beyond thought and consideration." The life stories of these twenty-six artists challenge these assumptions.

MIRACLES OF THE SPIRIT

EASTERN WISCONSIN

Eastern Region

Wisconsin's "East Coast" runs from Kenosha to Gills Rock, taking in the major cities of Racine, Milwaukee, Port Washington, Sheboygan, and Manitowoc with detours bayside to Green Bay and Sturgeon Bay. The east is separated from the rest of the state by a strip of low rolling hills, bogs, and marshes known as the Kettle Moraine, formed during the last years of the ice age, when two glacial lobes moving south met and formed a ridge of rocky debris that stretches from just west of Sheboygan south to the area around Whitewater Lake in the southeastern corner of the state. Land on either side of the Kettle Moraine is primarily flat and cut by numerous creeks and lakes, as well as the Rock and Milwaukee Rivers.

There is huge diversity in this strip of land in almost every way. The southeast is the most industrial part of the state and has attracted immigrants from almost every part of the globe over the past two hundred years. People continue to settle and pursue jobs there to this day giving the area larger African American, Latino/Latina American, Mexican American, and Asian American populations than are found elsewhere in the state. Cultural groups in the past tended to settle in neighborhoods and retain clear ethnic identities in Milwaukee, Racine, and Kenosha as they did to the south in Chicago. For visitors, this phenomenon affords excellent opportunities to explore microcosms of ethnicity by visiting neighborhoods and participating in "ethnic fests" throughout the year. Milwaukee hosts celebrations for Cinco de Mayo (May), Asian Moon Festival (June), Bavarian Volkfest (June), Polish Fest (June), Annunciation Greek Festival (July), Bastille Day (July), Festa Italiana (July), African World Festival (August), Irish Fest (August), Mexican Fiesta (August), Serbian Days (August), Bavarian Oktoberfest (September), and Indian Summer (September), among scores of other festivals.

The kettle moraines were formed when the Wisconsin glacier retreated over 15,000 years ago.

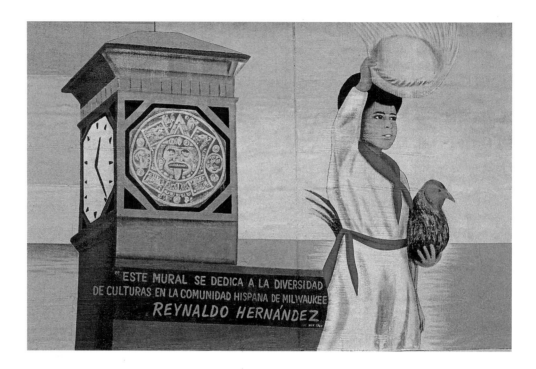

Latina/o Community Murals on Milwaukee's south side, 1989, by Reynàldo Hernandez

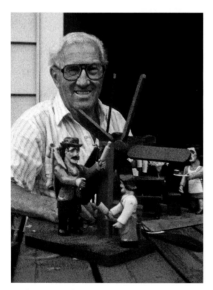

John Bambic, with one of his whirligigs, at his home in Milwaukee, 1996

The enduring strength of these ethnic groups produces wonderful traditional folk art in the eastern region. John (Ivan) Bambic (b. Slovenia, 1922) has lived on the southwest side of Milwaukee in a Slovenian community since 1950. In his spare time he fashions hand-carved wooden whirligigs depicting scenes from his childhood. John is also active in Slovenian community life and was instrumental in establishing a summer camp in Racine County for families from his neighborhood.

The south side of Milwaukee has large Serbian, Polish, and Latino communities. Here visitors can admire outdoor community murals, stop for a traditional Serbian meal, and dance the polka. The Walker's Point Center for the Arts on National Avenue is a community-based art venue in this southside neighborhood sympathetic to a broad range of artistic endeavors. Created by the Greater Milwaukee Foundation, the center offers local exhibitions, performances, and educational programs in a multicultural environment.

The St. Francis Seminary on the south side is home to the Lourdes Grotto (1894) created by Father Paul M. Dobberstein. Recent surveys of American art have occasionally mentioned some of Wisconsin's exceptional constructed environments and grottos. Wisconsin has a century-old tradi-

tion of secular and sacred outdoor sculpture sites beginning with the well-known work of Father Dobberstein. Born in 1872 in Germany, Father Dobberstein came to study at the St. Francis Seminary in Milwaukee. During a bout with pneumonia, he promised to build a shrine to the Virgin Mary, if she would help him recover from his illness. His resulting return to health inspired him to build Our Lady of Lourdes Grotto, dedicated in 1894, on the St. Francis Seminary grounds. Dobberstein went on to build two more grottos in Wisconsin: the Grotto of the Holy Family in St. Joseph and the now demolished St. Rose Grotto of the Blessed Virgin in LaCrosse. Father Dobberstein also built concrete grottos in Iowa, with increasingly exotic types of crystals, rocks, and pebbles.

Three Brothers, a Milwaukee eastern European tavern and restaurant

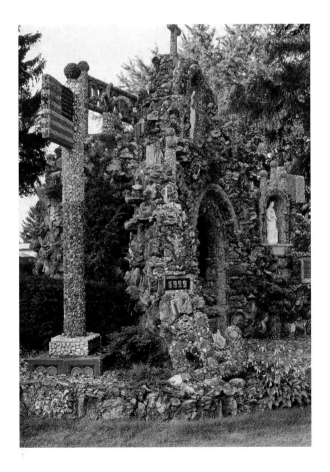

Detail from the Grotto of the Holy Family at St. Joseph, built by Father Paul Dobberstein and Frank Donsky

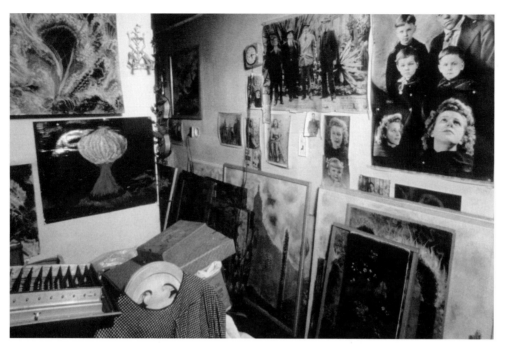

Interior of Von Bruenchenheim's house. From the Permanent Collection of the John Michael Kohler Arts Center.

His work seems to have inspired countless other grotto and secular sculpture makers in the state.

Eugene Von Bruenchenhein, poet, polka lover, and visionary artist extraordinaire, lived for over forty years in a house, now demolished, on South 94th Place. Von Bruenchenhein was a West Allis resident who spent most of his artistic life in relative seclusion. A baker during the day, his considerable passion for creating things made him a most prolific artist. His small home was alive with hundreds of paintings, thousands of photographs (mostly of his wife Marie), chicken bone towers, ceramic crowns and vessels, musical instruments, and poetry books stacked everywhere. Von Bruenchenhein painted his walls and furniture and created huge concrete heads outside of his home. After his death, Dan Nycz, a West Allis police officer, told the Milwaukee Art Museum about his art. The John Michael Kohler Arts Center (JMKAC) in Sheboygan undertook the restoration and preservation of Von Bruenchenhein's entire body of work. JMKAC acquired what is, still today, the most important archive of Von Bruenchenhein's work. The remainder of the Von Bruenchenhein estate was purchased by a business group from Chicago, spearheaded by art dealer Carl Hammer of the Carl Hammer Gallery, who worked with other dealers in the sale of additional works of art.

Downtown Milwaukee has an active arts scene that encompasses the art of professional, folk, and self-taught artists with some regularity. Milwaukee Art Museum is home to the Michael and Julie Hall Collection of Folk Art and the Richard and Erna Flagg Collection of Haitian Art. The Haggerty Museum at Marquette University showed the Diane and John Balsley Collection of Folk Art in 1992 and the Signs of Inspiration exhibit by Prophet William Blackmon in 1999. The University of Wisconsin–Milwaukee Art History Gallery has exhibited Mona Webb's artwork and has supported many conceptions of art in the past. Milwaukee has two galleries that actively promote the work of artistically unschooled artists, the Dean Jensen Gallery and KM Art Gallery. Downtown Milwaukee is also the site of the Anthony Petullo Study Center and Milwaukee Public Museum which houses an excellent collection of Native American materials.

Northeast Milwaukee is home to artists Mike "Ringo" White and Bob Watt, who live in a neighborhood of free thinkers and philosophers. When interviewed, Prophet Blackmon lived in Milwaukee's urban inner city where he ran a ministry that collected and dispersed clothing and offered spiritual community. Della Wells, whose colorful paintings tell tales of contemporary social issues and cultural events, resides on Milwaukee's west side.

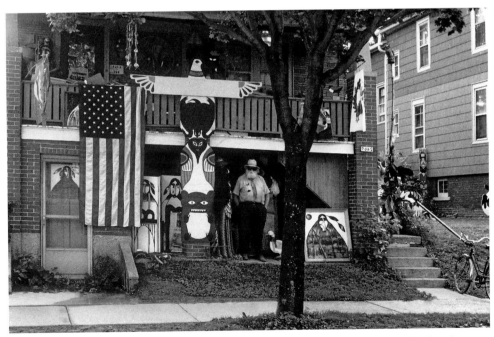

Poet, photographer, artist, and philosopher Bob Watt, on his porch, Milwaukee, 1996. Bob recently ran for mayor of the city.

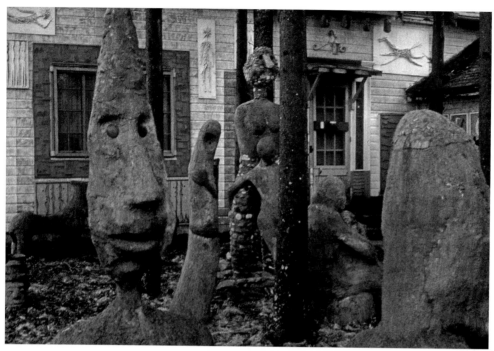

Mary Nohl's yard environment in north Milwaukee (photo by Deb Brehmer)

On the far north side, Mary Nohl (d. 2001), a retired art professor, built a yard environment on the banks of Lake Michigan. Starting in the late 1960s, Nohl assembled an amazing three-plus-acre yard scene populated with sculpted dinosaurs and creatures overlooking Lake Michigan. Her education at the School of Art Institute of Chicago and her art teaching career put her outside of our conceptual paradigm, but the intensity and magnitude of her creations connected her to other environment builders profiled. Some of Mary Nohl's work is on permanent display at the John Michael Kohler Arts Center.

West of Milwaukee near Rome, John Tio, self-named "Pop Top King," spent years creating a wondrous world around his small trailer in a summer campground. His mobile home, decorated with more than a million pull-tabs, was nothing short of glimmering, and it garnered media attention and visitors for many years in the 1980s and 1990s.

North of Milwaukee the towns get smaller and their relationships to Lake Michigan often become more intertwined. Several towns directly north of the city have Native American effigy mounds. Holy Hill, at 289 feet is one of the highest points in southern Wisconsin and is the site of three earth mounds. A log church occupied the site by 1863, and in the 1880s a brick church was started. The view from the current Romanesque church is one

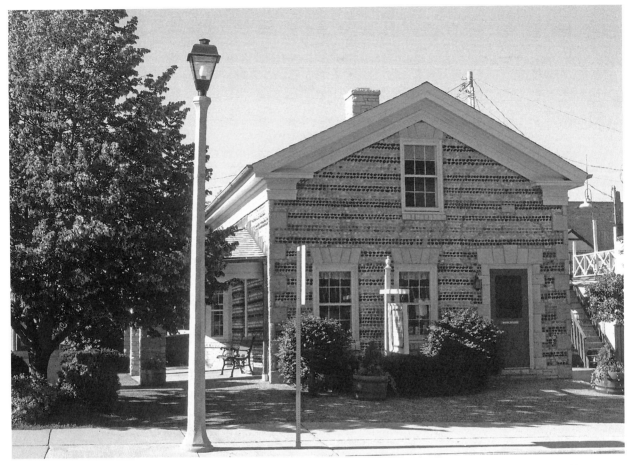

Ed Dodge's Pebble House, Port Washington

of the most beautiful in Wisconsin and is a wonderful spot for a picnic. Just to the northwest at West Bend is Lizard Mound Park.

Each summer Port Washington hosts the largest outdoor, one-day fish fry in the country. The city was once the home of the Kewpie Doll, but the factory that produced millions of the china collectibles burned down years ago. The headquarters for the chamber of commerce is located in a multicolored house, built by Ed Dodge in 1848 out of Lake Michigan pebbles, black basalt, pink and gray granite, flint, and quartzite. The structure, listed on the National Register of Historic Places, once served as a gatehouse for the Port Washington Power Plant until it was moved to its present location.

Just north of Port Washington along Lake Michigan lies Sheboygan, named for a Chippewa word meaning "passage or waterway between the lakes." Sheboygan is home to the John Michael Kohler Arts Center, a strong

advocate for self-taught, visionary, folk, and ethnic arts in the state. The JMKAC has hosted many exhibitions of traditional and idiosyncratic art and decorative objects over the years as well as work of academically schooled artists. The Kohler Foundation actively participates in the preservation and restoration of environmental art sites in Wisconsin, among them, Nick Engelbert's Grandview, The Painted Forest by Ernest Hupeden, Fred Smith's Concrete Park, and Herman Rusch's Prairie Moon Museum. The JMKAC owns the entire oeuvre of cartoonist Norm Pettingill and woodcarver Levi Fisher Ames, as well as many pieces by Eugene Von Bruenchenhein, Mary Nohl, Frank Oebser, Clarence Powell, Rudy Rotter, and Albert Zahn.

On the lakeshore of Sheboygan's near south side, Dan Erbstoesser lived and worked in a residence that family members have preserved since his death. After retiring from the police force as a detective, Erbstoesser started a concrete relief mural, approximately six by twenty feet, which doubles as a fence. Five mural panels depict three themes from the artist's literary favorites. The piece also includes a replica of Grant Wood's *American Gothic*. Over the years, he also created several smaller concrete busts and oil paintings of the nearby Wisconsin lakeshore.

Sheboygan is one of the few places in the world where effigy burial grounds have been found. Located in the Black River area of Sheboygan, eighteen mounds exist in the shape of animals and geometric forms. Nomadic Native Americans built these earthworks between 500 and 1000 A.C.E. An open mound exhibit contains artifacts and replica skeletal material and can be accessed from a boardwalk trail through a wetlands area containing various plant species found only in Wisconsin.

Down the road from the effigy burial grounds is the home of Sheboyganite James Tellen (1880–1957). Tellen created more than thirty outdoor sculptures, including large lifelike concrete animals and human figures that are an animated presence in the densely wooded landscape. The Kohler Foundation purchased the site for purposes of restoration and conservation in the early 1990s and plans to use the site for seminars, classes, and research. Tellen also constructed a log cabin, a small "Brat Fryer," and a pub house on his property along the Black River. Other sites of interest in the Sheboygan area include a restored 1876 Heritage Schoolhouse, Elwood H. May Environmental Park, and Kohler Andrae State Park. The Old Plank Road Trail, a seventeen-mile stretch for walkers and bicyclists along State Highway 23

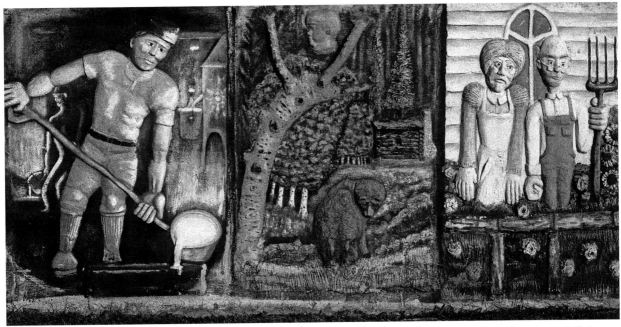

Wall section, Dan Erbstoesser's environment, Sheboygan

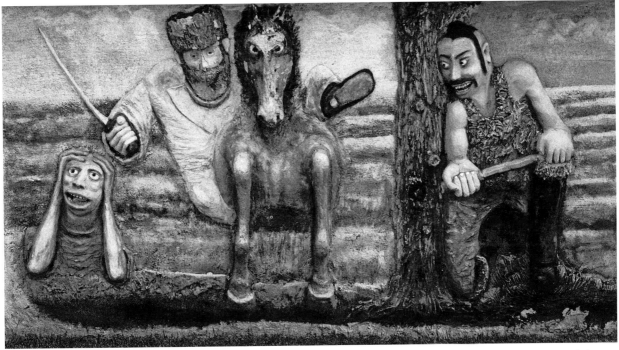

Wall section, Dan Erbstoesser's environment, Sheboygan

Driftwood fence by C. Neumeyer, Clarks Mill

Green Bay Packers yard display, Fox Lake

from the Lake Michigan shore to Greenbush, connects with the Ice Age National Trail in the Kettle Moraine State Forest.

Manitowoc is a picturesque city on Lake Michigan with a history of ship-building and commercial fishing. This city is home to two very different museums, the Manitowoc Maritime Museum and the wildly inventive Manitowoc Sculpture Museum, at one time operated by Dr. Rudy Rotter.

Dr. Rotter, a retired dentist, made over 15,000 pieces of art from the early 1940s until his death in 2001. The works collected in the museum show his artistic progress using a variety of materials such as imported wood and stone carvings in the 1960s, to sculptural collages utilizing foundry forms and carved bowling balls in the 1980s. Rotter's last collages and drawings incorporated a riotous palette of materials such as mink fur scraps, leather, reflective metal scraps from a nearby trophy factory, carpet tubes, and whatever recyclable tidbits neighbors and friends brought him to use. Recurring themes of love between family members, fantasy, religion, and politics informed Dr. Rotter's astounding creative outpourings.

Photographers Julie Lindemann and John Shimon live around the corner from the Sculpture Museum and were close friends with Rudy Rotter. The two have been collaborating for years in documenting pocket communities in Wisconsin's northeast. Their photographs chronicle some of the "folk" not often portrayed in Wisconsin literature, such as Midwestern rebels and the people of St. Nazianz, a tiny German community. Just to the west of Manitowoc is Pinecrest Historic Village, a collection of buildings from the late

1800s to the early 1900s, which were moved to and assembled at the site. On County Highway JJ at Clark's Mills, the Neumeyers have built a rather spectacular fence around their home with driftwood. Further north, lie Green Bay, the first permanent European settlement in Wisconsin (founded in the late 1600s), and Red Banks, considered a sacred spot of origin to the Ho-Chunk (Winnebago) peoples. Because the Fox River heads south to the Wisconsin and Mississippi Rivers, thus connecting the Great Lakes and the Mississippi, the area was of considerable economic value as a transportation link between the eastern and western parts of the early United States. As railroads replaced waterways, Green Bay continued to be a commercial hub serving the logging industry of northern Wisconsin, as well as providing services for the farm communities in all directions and the fishing and shipbuilding industries of the Great Lakes. Today the area has a sizeable Native American population that includes Ho-Chunk, Potawatomi, and Ojibwa, as well as descendants of European immigrants from Germany, Sweden, Poland, Ireland, and Denmark.

Many current day Green Bay residents would most likely consider the Green Bay Packers football players the most important population in town. Green Bay is the smallest city in the United States to be home to a NFL team. The people and the city of Green Bay have owned the team since 1935, and Packer hysteria escalates every autumn. All over Wisconsin, proud football fans express their loyalty with homegrown yard environments and creative costuming worn throughout the football season.

The Green Bay area is also home to Norbert Kox, Jack Dillhunt, and Lori Reich. Norbert Kox has used the isolation and quiet of the area in recent years to develop his vision of the decay of contemporary morality and to prophesy and portray apocalyptic "nightmares" with his stunning painting skills. Jack Dillhunt uses a very laborious and time-consuming drawing style, with ballpoint pens on bed sheets, to escape from the pressures of contemporary life into a dreamy world of floating biomorphic shapes informed by music. Lori Reich uses painting and drawing as an act of healing for herself and as a means to provoke political and satirical discussion with her viewers.

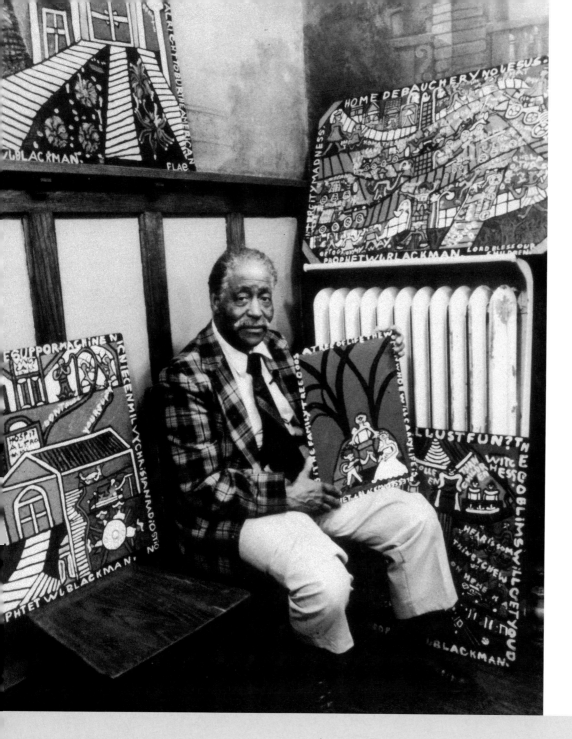

Prophet Blackmon,
at the home of his
former art dealers,
Kent and Linda Mueller,
Milwaukee, 1996

PROPHET WILLIAM BLACKMON

Sometimes you can paint a picture to a person.
It doesn't have to be with a brush, maybe just by
talking. If you can tell it so that the person can
see it, they actually see this in their mind, it'll be
like a little painting in their mind. That's what this
art is for, getting a message to people.

—PROPHET WILLIAM BLACKMON

PROPHET WILLIAM BLACKMON has spent most of his life giving of himself. For many years, he ran his Revival Mission Church in Milwaukee's inner city, where he collected and redistributed clothes, as well as the limited money that came his way. Prophet has served the spirit his whole life, at first as a "traveling man of God," then through his work with the poor in his community, and now for the last few years through the messages he incorporates into the painted signs that have attracted art connoisseurs to him. In 1999 the Haggerty Museum of Art (Marquette University) mounted a major exhibition, Signs of Inspiration: The Art of Prophet William J. Blackmon, and published a monograph of the same name. Prophet was forced to move out of the Revival in the early 2000s. He has been selling paintings in front of North Street Library and finding shelter with one of his former parishioners. In 2004 the Rahr-West Museum (Manitowoc) presented an exhibition of his work.

THE HAT OF A PROPHET

I'm in the street ministries and I'm grateful to God. If I wasn't the man of God that I claim to be, I would have been dead a long time ago. I found out one thing. If you really are honest with God, he'll take care of the situation. So the main thing is to love one another, and trust in the Lord. Because we're all living in His mercy.

I was a hitchhiking man of God for over forty years. I traveled Michigan, Indiana, Illinois, and Wisconsin. Most times, I didn't have enough money to buy a hamburger, but I got to where I was going. I would get there sometime around dusk, then I'd just go into a neighborhood, start ringing doorbells, and praying for the sick. God was doing some healing and people felt better. The people I visited would be getting ready to eat supper. They said, "Well preacher are you hungry?" and I said, "Well I could eat something." So then after I got through eating, they asked, "Where are you staying?" I said, "Well I don't know." They'd say, "Well, we'll make up a bed on the floor." That's been my theological seminary. I have learned how to be grateful.

While I was hitchhiking on the highway for God, I knew some people that looked down on me. In fact, if I came to their home, they wouldn't even open the door. They knew I didn't have a place to stay, but they didn't want to hear any preaching. So they'd make like they were not even home. I try to tell people to do the right thing, try to treat people right regardless of what

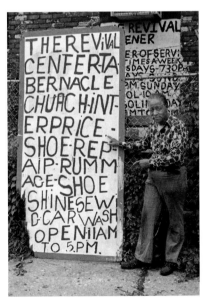

Prophet Blackmon, at his Revival Center and Tabernacle Church with an early example of his painted signs, 1996

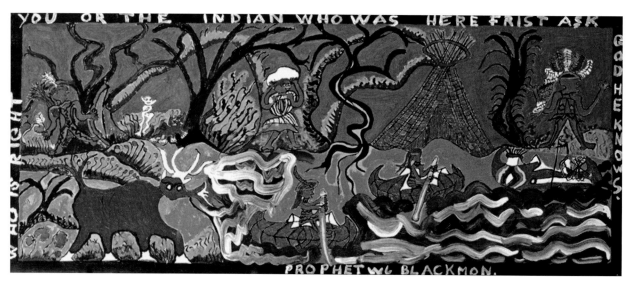

Who Is Right, You or the Indian . . . , 1990,
enamel, 48¹/₂" x 20"

others do. I believe it'll work out in the long run. It'll work out. Like I said,
only God has preserved my life. I have to give Him the credit.

I have walked Milwaukee over, door by door. I've done extensive mission
work here. Now, when people first met me in the art world, they saw I had
the hat of a prophet. Well, that sounds like something magical, to draw peo-
ple maybe to some little art. So that's what they looked at. They thought
maybe I was just carrying a handle in order to get known or be able to sell
some art. But see, as time went on, I believe people are starting to under-
stand that I am a preacher—a prophet of God.

For example, years ago, I had shows of my work at the Metropolitan Art
Gallery [Milwaukee, Wisconsin, currently closed]. At the openings, the
gallery served strong drinks, which I never agreed with. But God gave me
the idea not to resist it and to do some work with the people that came. So
while people were at the gallery, me and two or three of my Revival Center
sisters would talk about Jesus. We had a service in the corner of the gallery
and God would reveal problems, troubles, and so forth. I've learned how to
take and use situations to His advantage. Therefore, I was able to get along
with the people I worked with.

THE GIFT

I came to the Revival Center about twelve years ago [1986], in the winter-
time. Before, I lived at 300 West Juneau. I rented a shoe repair store from Mr.

Eisenberg. He was one of the world's greatest attorneys. He owned three buildings called Sidney HIH in Milwaukee. At my shoe repair shop, a sister said, "Prophet, God's going to make an artist out of you."

Well, all week long I'd be there and sometime I'd close up with only twenty or thirty dollars. I was feeding folks on the street. I had hot plates plugged in and the city inspector said, "You can't do that." But when he left, I'd plug them back in again—it was cold.

One particular Saturday, while I was talking to someone, I heard somebody else say, "Oh, how nice." We looked around and a woman said, "What's that one cost down there?" All winter long I was making signs, hanging them up on the building, misspelled words and all. Remember, I was closing up with only twenty or thirty dollars, and I was staying in the building, which I wasn't supposed to. Mr. Eisenberg didn't know about it. I owed him back rent and I couldn't afford to pay for another place. I would just fix myself a little place to stay there. We said, "What's that?" She was a white lady and she said, "Oh, your signs." We almost said it in unison—"Signs?" I said, "Yes, my landlord, Mr. Eisenberg, would come on Saturday with helpers to take 'em all down." Mr. Eisenberg said, "You're making my place look bad!"

There was one sign leaning against the wall and one big old lanky wooden sign in the corner. She said, "Would you sell that?" I was shocked. I thought it would be a small miracle if it sold for five or ten dollars. I said, "Well." She said, "I tell you what you do. Fix it up a little better than that, I'll be here next Saturday for it." I said, "All right."

A strange thing happened. God took over and I began to make little people on the signs. Before, I was never able to even put a torso on anything. I stood back and looked, it look—well—it was different. As Mr. Eisenberg said, "Primitive, real primitive!"

Well, Saturday arrived and the woman entered my shop. She came in and said, "Oh, I like that." She was on one knee, and she had her checkbook in her hand. I said, "Well, I guess a couple dollars is gonna cover it." I thought she was going to write a check for probably ten dollars. She looked back and said, "Will a hundred dollars do?" I almost fell out of my chair.

I owed Mr. Eisenberg back rent, so I didn't want him to know I had a check for a hundred dollars, but I couldn't help myself. When he came in, I said, "Shalom," which means peace. I always owed him money, so I wanted him to have peace. He said, "Shalom." I said, "I want to show you something." I handed him the check. He goes, "A hundred dollars!" He knew how poor I

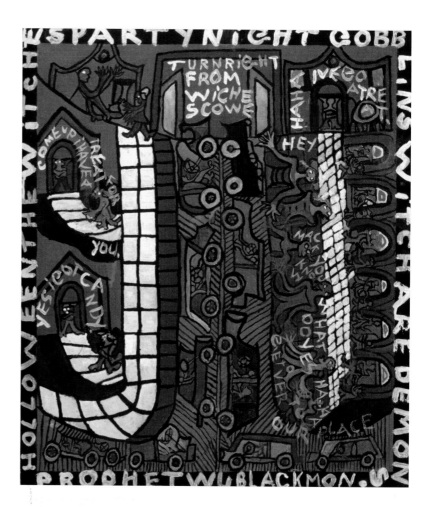

Top: *Holloween the Witches Party Night*, 1996, acrylic and enamel on wood, 26⁵/₈" x 23¹/₂"

Bottom: *Chicago Take Eye Ninty Four*, 1997, acrylic and enamel on wood trunk, 33³/₄" x 17" x 15¹/₂"

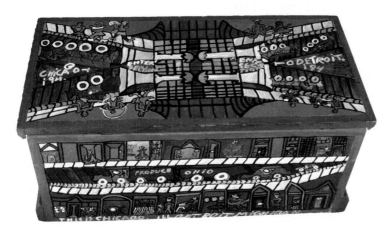

was and said, "Where'd you get this?" I said, "You know that sign that you had the fellows take down, a lady just gave me a hundred dollars for it." "She did? Her husband's gonna break both of her arms and her legs!" he said. She was the business agent for the Conservatory of Music in Milwaukee.

Well, Mr. Eisenberg passed and his wife didn't want to deal with the buildings. I had to move out and put all my stuff in storage. At the time, I had about eight pieces of artwork. I knew if they went in storage I'd never see them again. So this is how I happened to be here. There is no other place in Milwaukee for me. Believe me, I knocked on doors. I did mission work. I don't charge people money. I don't drive a Cadillac. I have *the gift*. I don't put a price on it.

A SOLDIER OF THE CROSS

When Mrs. Eisenberg said we couldn't stay at the shoe shop anymore, I moved my stuff into storage. Finally the storage people told me, "Look if you don't come in here with five hundred dollars, we are gonna take your stuff over. We are gonna take everything." Guess what? One of my poor members was living in a shack. Her basement flooded and the city gave her a few dollars. She handed the money right to me so I could have this place. They let me move in without paying the first month's rent with an option to buy.

When I moved in here, it was so cold. It was wintertime, and I had to burn wood and coal. All my new things got full of smoke. Anyway, about three or four days later the man living next door stopped with my mail. He said, "I got your mail." "Brother what are you doing with my mail . . . what is your name?" I said. "My name is Blackmon," he said. I told him my name was Blackmon, too. It was a sign of God. Out of all the places in Milwaukee, it had to be someone with the same name. So I knew that it was God's will. God put me here.

At the Revival Center, every Saturday's share day. We all share expenses. If they bring some shoes in to be repaired they get a portion of that money. If we wash cars, they get a portion of the money. At the Revival Center, I teach two things, working and sharing. People learn how to work together. These are things of importance.

It's hard to stay alive in the inner city of Milwaukee. Hate is in the air and it's all colors. I'm in the midst of all that. All the moral principles that we

used to know under a democratic process are being pushed aside. We're asleep. People don't even realize what's happening. The constitution guarantees freedom of speech, but it doesn't mean cursing and swearing. To me, cursing and swearing are not speech. We're in trouble. This is why the Lord said, "Try to be a peacemaker." So be it. I'm a soldier of the cross.

PAINTING AND PREACHING

I try to convey a message through my art of right over wrong. The inspiration for most of my work is taken from the Bible. The Bible is a book of mystery. I've done paintings about John the Baptist—baptizing. In this day and age, when there are so many terrible things going on and some good things, it's hard for the good things to get in the limelight. The evil things are taking the limelight. See a lot of people don't understand that. So, you have good and bad, bad and good, good and bad. And it's everywhere. So, I believe paintings are beautiful because they tell stories about the mix-ups in the city. . . . It's not only everywhere, it's all colors. It's not one color. You know, when you cut open an orange, you find it has partitions, but it's one orange. Now, I tell people it is not a question of it being either white or black. We should not separate people. We have to overcome that.

When I was coming up, we were very poor. Still, I always had a mind to write poetry. I could look at a picture on the wall and I could write poetry all afternoon just by looking at one picture and that was a part of me. Now, this painting over here says inner city madness. Now you know what we have in the inner city, unfortunately, it's everywhere, but it seems like it's bunched up in the inner city a little more. We have home debauchery. By that I mean that nothing is really going on *right* in the home.

I want to tell you a parable. . . . I said to some of our young folks, "You are the future." With the way that dope is flowing, some of our young folks don't have the capacity to know how to resist and there is not enough older people who understand the situations of young people. Older people become afraid of young people, so they hide behind doors, lock their doors, and talk about how bad young people are. Then this situation with the young people gets worse. They crowd the streets, leaving their houses, leaving home, becoming gang members, and so forth. Why? Because the adult population is hiding and running from the younger generation. See, if I'm always talking about how bad the young folks are, I'm not going to

have a mind to go out there because I'm scared.

Sometimes you can paint a picture to a person. It doesn't have to be with a brush, maybe just by talking. If you can tell it so that the person can see it, they actually see this in their mind, it'll be like a little painting in their mind and they could see it. That's what this art is for, getting a message to people.

For example, in Missouri, a man's daughter was on a life support system. A local Christian radio station aired the story. The church told the father that it was all right to unplug the machine so his daughter would not have to suffer anymore. The doctors wanted to do it. When I heard about it, that was inspiration for me to do a painting. I did it and it's called Missouri because that's where this was, in Missouri. They went ahead and unplugged the life support system. I thought, "How can they pull out a plug on a human being?"

I understand that there are circum-

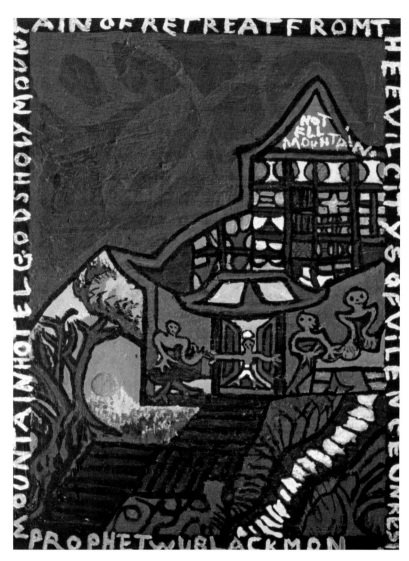

Mountain Hotel, 1994, acrylic and enamel on wood, 24$\frac{1}{4}$" x 17$\frac{7}{8}$"

stances beyond one's control. If a person's life isn't safe, do they have a right to make a decision to end their life? Doctors take an oath to preserve life. I tell people, we can disagree. I'm not God and they're not God. I meet other Christians. I meet other believers: Baptists, Methodists, Catholics, and so forth and we all have our own beliefs. Still, there should be a basic need to work together. We are all human. We're supposed to respect one another, find God in one another . . . this is God's gift. If God heals anybody through me or he reveals, that's God's gift—that's not me. I'm just flesh and blood like everybody else. I tell people, "Thank God, thank Jesus. Don't thank me."

A lot of people don't think that I mean what I say when I say my job is to help stop riots and revolutions. The only way you do that is to try to keep them from happening. I wanna start a campaign of shaking hands. They say when people get their hand on you, they really got you. So, seemingly God has given me balance through my art. I know there's no way I could have enough sense to do this. I don't take any credit for this at all.

A LITTLE TEACHING IN IT

I think we should face societal issues on morality and principle. A lot of times, I didn't have a place to stay when I was preaching. But I never got up with a sad face. I'd go ahead. It just comes natural. I would laugh and no person knew about my situation according to how I was acting, because that's the way a pastor's supposed to be, really. To smile when you got awful pains in your body. . . . I guess the big boss just fixed me up. It's strange how that happens. God gives me the inspiration. I know that's true because of some of the things that happen. For instance, this is a small piece of art, but it's sort of unique. It's a marriage. I am stressing the importance of the family tree. They're getting married. This is a family tree that is supposed to grow from their marriage. The words on the painting say, "This is the family tree. God's a tree of life."

I always have a lot to say. There is a lot to talk about nowadays. Problems exist. How are we going to cope with them? Everyone has something. Wanting to do something with what you have, this was my problem when I was coming up in Michigan. A lot of people have great works but don't meet the right contacts and get to the right people. I've never forgotten the owners of the Metropolitan Gallery in Milwaukee. They gave me an opportunity. See, it doesn't make any difference what you have if you don't have an opportunity to tell your story. They didn't have to give me money. They listened. Sometimes, I didn't want to listen. But sometimes that's the only way we can help people under certain circumstances. For some people, it's a talent to be able to listen. When we do that, we gain wisdom and knowledge. My work is about teaching. Most of all—my art has a little teaching in it.

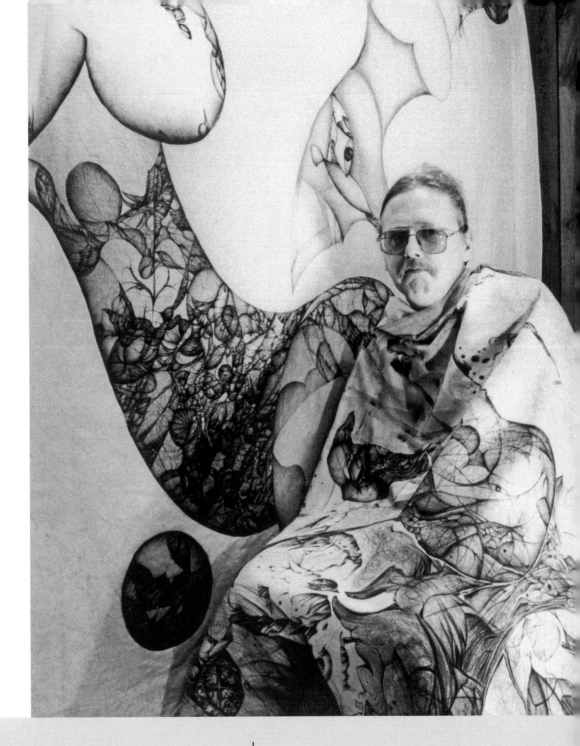

Jack Dillhunt, in his
living room, 1997

To get one of these finished is quite
a thrill. Sometimes I think it's gonna take forever!
Some of these drawings tell stories, but most of
them do not.

—JACK DILLHUNT

JACK
DILLHUNT

JACK DILLHUNT sometimes calls himself "the Sheetman," a reference to his chosen drawing surface since childhood. Jack was recommended to us by Norbert Kox, another artist profiled in this book. It was easy to understand Norbert's appreciation of Jack's fascinating meticulous approach to drawing. A youthful-looking, gentle man, Jack creates a welcome escape from his everyday life through music and the act of drawing.

THE SHEETMAN

I'm from Green Bay, Wisconsin. When I was in grade school, art worked out really well because teachers let me do whatever I wanted, pretty much. I was the designated "talented student" for some reason. My sister drew really well and people probably just figured, "Hey he's one of that family. They do real good art work, so let him do it." It was a Catholic school with nuns and everything, but they were less strict than the high school. I didn't do so well in high school. I followed the rules and everything, but I figured I didn't need to learn what they had to teach me because I knew what I needed to know. I didn't know *anything*, but I thought I didn't need to know anything more. I could have used some of what they were teaching. I didn't want to take tests. I thought, "What do I need that test for?" I don't think they liked giving me a really bad grade.

Detail, ballpoint pen drawing

Art was recognized in our family as being valid and good and commendable. I have eleven brothers and sisters. There's four younger than me. We had a home that supported our interest in music. My dad played piano, but not professionally. There was a lot of music in the household. We did a lot of vocal music. It was a really nice household to grow up in. I imagine in some households art is not appreciated. But my parents were really appreciative of all kinds of art. That helped.

I don't remember any of my family except my sister doing any visual art. My mom did embroidery. She had a job and ran the household. That was a full-time job. I don't know how she did it! My father was an accountant. I don't remember him ever talking about doing art. My aunt is an artist. She

does textile painting and is a really good painter. I used to see her paintings at grandpa's house when I was growing up.

When I was fifteen or maybe sixteen, I couldn't find a piece of paper big enough to draw on so I got a bed sheet and started drawing. My mom never complained. She had twelve kids so she couldn't keep track of everything. She was just happy that I was keeping busy. I couldn't find the size of paper I wanted and large pieces of paper would crumble up and then you'd have problems. That was how I got started with sheets.

I get my sheets pretty much wherever they're on sale or at closeouts. I need sheets with polyester, 'cause otherwise they wrinkle too much while I'm working on them. I have to wash them, sometimes two or three times, before I get all of the preprocessed chemicals out that they are treated with. The ballpoint pens start clogging if I don't wash it all out.

The medium is pretty permanent. I really believe the work will outlive me. I think the main enemy to my drawings is actually sunlight. The ballpoint pen will just fade right out and I'll have a nice, perfectly clean sheet. I think anybody who buys one of these pieces would need to keep it away from sunlight. Of course, anybody who has enough money to buy my work would be able to afford to put it in a place without the sun reaching it.

I guess I found out that I actually have a flair for these ballpoint pens— I can do 'em well. I can't get this kind of effect with painting. I know there are people who can, but I can't. I did oil paints for a while and it's all about chemicals. A lot of people are saying that poison can come through your skin with the paint. Oil paint is a really nice medium, but it has a lot of problems. Ballpoint pens don't have many problems to them. I can pull a sheet up wherever I want. It's cheap and I like the size, too. There are things about this that are just not convenient, but I just like sheets. I like the fabric. Have you ever tried to move a six-foot oil painting?

I keep looking around for the best pens. They had this one brand that was really, really good at an office supply store near here and then they stopped stocking them. When I find ones I like, I buy up some pens, but I don't want to buy them too far in the future or they'll dry up.

OLD HABITS

When I was young, I went through my drinking and drug stage. I went through some years where I talked a lot more than I did art. There was a

Detail from *Let Them Go*, 1994, ballpoint and ink, 12" x 18"

rumor that I actually did do some art at that time. I don't remember. When I was a kid, oh yeah, there were gaps. I don't know—I might even have gone a few years, from time to time, without making any art. I've been more prolific during the last few years.

I've been sober for over fifteen years. Some people will go to meetings for the rest of their lives. I just decided a couple years ago that I can go to these for the rest of my life, but it's really not my issue anymore. It is an issue if I decide to go back to old habits. Then it's an issue. But I don't feel the need to go to the meetings for the rest of my life. I have no urge to get back into that world again at all. It would be more of a decision. When you're fighting urges to get into these things, then it's not just a decision. You're drawn to it in a chemical way. I talked a lot about it. I am actually doing a lot of art, now.

Through the years I've told people that from time to time, "It's a good thing I've got this drawing to do here." Everybody has pressures. Work is high pressure. Marriage is high pressure. I need an escape. Making art helps. I can't escape by going to the bar and having a few drinks. I can't do that, so I have to have a natural means of escape and my natural means doesn't hurt anybody. In my early days of recovery, I would paint or draw, or whatever, most of the day. Then I would do the same thing the next day and it didn't get me in any trouble.

I used to draw all night long. A few years ago, I would draw twelve hours at a time. Now I'm trying to stop after ten or eleven at night. I'm trying not to draw too late. It's best to draw on my days off rather than after work. Then on my day off I don't get a lot done, and it's like I stayed up till five drawing. I miss the times when I could just draw as much as I wanted.

I have an easy job, housekeeping I guess is what they call it. I don't "take that home with me." It's really nice. I could get paid more money with a job I "took home with me," but I'd always be on the job. Then I wouldn't get any artwork done. My job works out well with what I'm trying to achieve with my artwork. I think of cleaning as my job and art as my career.

UNTITLED OR UNDESIGNATED

My work is not supposed to mean anything specifically unless it's got a title that really implies meaning. I name most of my drawings "untitled" or "undesignated." I don't want the viewer to go, "Oh, this is a game, and I'm supposed to figure it out." When it's "undesignated," you can do what you want with it. Sometimes I think people look at stuff like that and are worried they can't figure it out. A lot of contemporary art is like that. I don't want to tell the viewer exactly what to think. Not a lot of thought really goes into the work—I gotta tell you that. People have this overwhelming capacity to read things into stuff. They can do that to their heart's content. I think what is important is the idea of escape. I don't really have a philosophy. My goal is to come up with an image where someone could look at it and escape into the image and get their mind off their nine-to-five world or whatever it is that their life is about and just kind of take a break. That's the idea. That's the goal.

I lose track of time when I work. I try not to think too much. I try to concentrate on the music and not the art, and focus in on the image. Sometimes the work looks a lot better when I'm drawing them than when they're done. Some of them really do look better when they're done. I just do the image. I'm listening to the music and I'm trying not to think too much at all. That's when I achieve my best drawings. When I'm thinking too much, it ruins the drawing for me.

I think these drawings are kind of like rock music. A lot of rock music has to be played loud to get the effect. If I play rock music real quiet, it wouldn't be Jimi Hendrix or something. I play all kinds of music while I work. I like Neil Young a lot, with that guitar going. I've been playing some classical music, from time to time. I can't have that on all the time; it just doesn't motivate me to get going faster. I like the Beatles, Eric Clapton, and the Moody Blues. I try to listen to some current stuff. I just can't follow music today because it seems like it's all fragmented. It's hard to know who's doing what.

I think these need to be really large to really get a full effect. I'm trying for an escape value, you know. Maybe somebody can escape into a nice little drawing, but it's not easy. If the drawing is as tall as you are, it's easier. There's not really any deep, deep hidden meanings or anything in my artwork. It's escape art, kind of. It's kind of like some people read to escape.

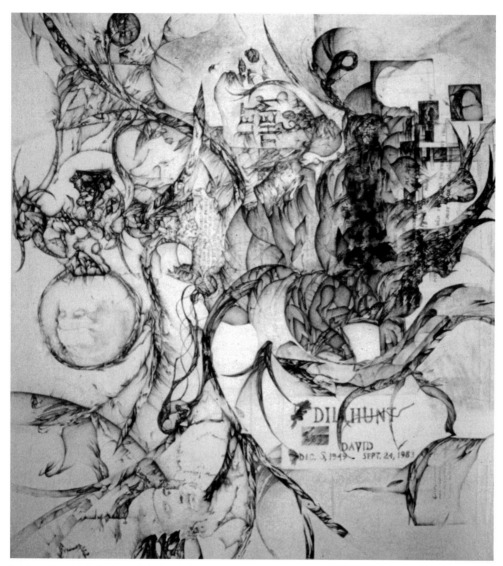

Let Them Go, 1994, ballpoint and ink, 7' x 8$\frac{1}{2}$'

I'm trying to rely on the subconscious. I want accidents to happen. Consciously, I don't know where it is going. There might be an imbalance and I take the imbalance and then balance it again. There's a give and take. In the final stage, I need to be aware of the whole thing or it's just not gonna work. So I take it to the library and fine tune the whole piece. I can't do that without seeing it all at one time.

I work on the sheets, flat on the kitchen table. Sometimes I take them to the library to use a bigger table. For background stuff, I go and use the

library table, because if I tried that on the kitchen table it won't look right. The library has never complained about me taking up a whole table. Once, a librarian just stopped by and said, "Hey, you've improved!" That was really nice.

I get a really big kick when the work is done. They take so damn long! To get one of these finished is quite a thrill. Sometimes I think it's gonna take forever! Some of these drawings tell stories, but most of them do not. What I want to achieve, but I haven't yet been able to come up with it, is a feeling that the image is totally unreal. However, I am in this world; therefore I am gonna produce things that are from this world. One reason I like black and white so much is because it has an unreal look to it. If my art were in color, it might look a lot more real.

ESCAPE VALUE

Drawing is extremely important to me. It's drawing for the escape value and I feel I need the escape value. I think that's really why I do it. I'm to the point where I do accept the fact that I have some talent in art. In my mind that means I should at least try to pursue getting it out there. I've never been one of these people that are after money, money, money. But I think it would be a good idea for me to try to achieve something, make something come of it, and produce more work. I want to produce more work. I have a lot of really good ideas for big work that would look really neat. I want to get those going. I could also do studies for smaller ones. I can't spend all my time on these big drawings. I'd get next to nothing done. It is real important for me to get my work out there.

My shapes change a lot. An image can change quite a bit from one stage to the next. It can get broken up. They just happen. Something of this size usually starts with a really small part, maybe a scratch or a mark. I come up with a little area and kind of keep blowing that up. I might, some days, come up with a really nice pattern and blow it up or I might not really have a sketch for it. Some of them start with sketches, but not in all pieces. There is no real general rule. Oftentimes I will have a sketch. But it's not required. I enjoy the drawing process. I try not to think about anything when I'm drawing. In between, when I'm not drawing, I can look and say, "This could use a little of this, this could get a little darker here, that could be balanced." But when I'm drawing I'm not thinking. I put music on, put the headphones

on, and just go with it. I try to achieve a state of mind where I'm really not being critical at all. My escape is drawing the drawing.

How do I see "quality"? Well, does it achieve the goal? The goal is to produce escape value, through the image. Does it produce something like that, or is it just a bunch of ink splattered on a sheet? Some work does better than others. I've heard Billy Joel on TV. He said in an interview that his songs are like kids, some turn out to be lawyers, and some have their problems get in the way. Some of these are gonna be good and some are gonna be less good, you know. There could be some that I don't like that other people do like and I can accept that. For me, quality work has an escape value and some originality—that's important. I think that's the main thing. I think that my art might be something to offer an escape value, an aesthetic break for a viewer. I think there is something of value here.

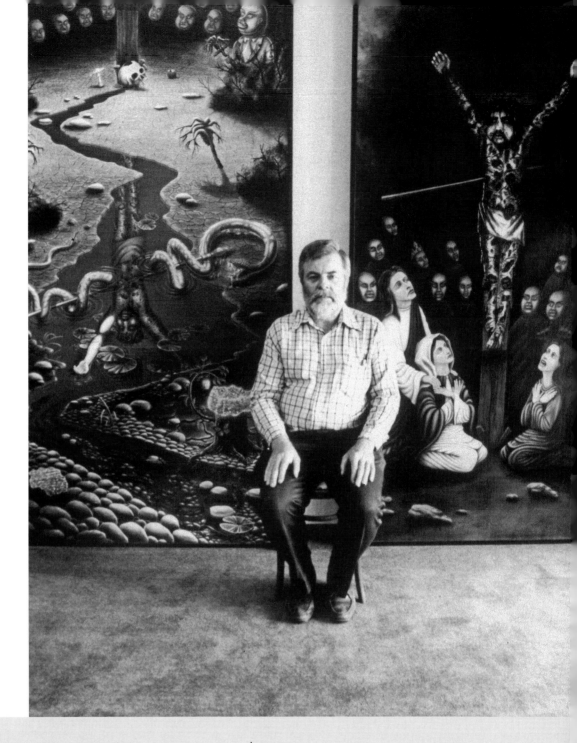

Norbert Kox, at a gallery
show of his work, 1996

I feel that I'm led by the Holy Spirit. It's hard
to always keep ourselves yielded to the Holy
Spirit and to the moving of God, but I try as
well as I can.

—NORBERT KOX

NORBERT KOX

When **NORBERT KOX** began to exhibit his paintings in the 1980s, viewers sometimes mistook his imagery for blasphemy. Sometimes compared to the works of fifteenth-century Dutch painter Hieronymus Bosch, Norbert's paintings are more accurately apocalyptic visual parables that offer a path away from debauchery, hypocrisy, and evil. Norbert has perfected his painting skills, especially a multilayered glazing technique that lends depth and luminosity to his work. Recently he has begun to experiment with computer images. He is an indefatigable scholar of the world's religions, and his canvases and images are meant to encourage the study of the scriptures.

A TURNING POINT IN MY LIFE

I was born in Green Bay, Wisconsin. My mother was from Marinette [Wisconsin], my dad was from Green Bay. I have four brothers and one sister. My mom did craft stuff for quite a few years. My father was a carpenter and took care of boilers and stuff like that. I don't think my art came out of my family history.

As a child I always enjoyed drawing. In high school, my sophomore year, I signed up for art, but the instructor asked me to drop the course. I said, "No, I really like this and I want to do it." She said, "You don't have any artistic talent, and you don't belong in here!" So I dropped the class, and I took a shop class instead. But I didn't let it discourage me. I really enjoyed the drawing and sketching, so I just kept on drawing on my own. A short time later, I dropped out of high school and joined the service.

When I quit high school, I just felt such an emptiness. I needed something to fill up my life. There was something missing. From about the time I was eighteen to thirty years old, I was really wild. I was riding with motorcycle outlaws and just really going crazy, alcohol and drugs and stuff. Things got pretty wild in my life, and I got to the point where I just thought there was no hope left for me.

But when I was a child, I was taught to pray every night before I went to bed. Even in my worst hours, somehow I'd always say those prayers. I'd just say, "God I know that there's really not much hope for me. I belong in Hell. That's the only place for me, I'm afraid, and I don't want to go to Hell, so save me somehow." Eventually, I guess what happened, God turned my heart around, and I had some spiritual experiences that showed me that there was more than

just this physical world that we see. I started to have spiritual experiences. This was a turning point in my life.

DÉJA VU

One of the earliest things that happened was I started having what someone might call a "déja vu" experience. Something would happen and all of a sudden I thought, "Well, wait a minute! This seems like this happened before!" It got to the point where at times it would be so intense. At one point, I recall that I even knew what people were going to say before they said it. For example, one night I was sitting at home and a strange feeling came over me. I thought, a friend I hadn't seen in a couple of years was going to knock on the door. All of a sudden, I hear this knocking on the door! I went to open the door, and there was my friend looking through the window, smiling and waving. I almost fell down.

Norbert painting in his studio, New Franken, 1998

These experiences influenced me to find out what was taking place. The first thing I did was get a book about the mind. I started to read that alcohol was very destructive on brain cells. I had been told this, time after time, but it didn't seem to faze me. I tried to stop drinking. But I would make it about two weeks, and then either something would happen that would get me upset and I'd go back to drinking again, or I would get overconfident and I'd think I had it made. Then I'd stop just for one beer, and I'd end up closing the taverns down.

Up until that time all of my paintings had been surrealistic. Sometimes I'd lay in bed at night, and before I'd fall asleep, I could dream while I was awake. I'd just shut the lights off and I'd start to see things. Then I would stop when I saw something I wanted, and I'd flip the light on and I'd take my little sketch pad and make a quick sketch. That was basically what I guess you'd call true surrealism because it came out of the subconscious mind. I did surrealistic paintings until about 1975. The type of work that I do now, I don't think you could really call true surrealism, because the things I do now are really planned out. They're things that I'm interpreting symboli-

cally from the scriptures. I'm sure there is still a certain amount of the sub-conscious that takes place.

These spiritual experiences turned my life around. I really started to get into prayer and meditation. Still I was a little bit afraid to share some of the experiences with someone else. I thought they would think I was crazy. I didn't realize that other people had these experiences, too. One night, I went and talked to my dad. I told him, "I have to tell you about some of the stuff that's happening to me. You're probably going to think I'm nuts!" I explained, and he said, "No, I've had some similar experiences." On another occasion we were sitting face to face, and for just a split second, it was like I didn't see him anymore. Instead, I saw a crucifixion. It looked real. I had never seen anything like that before. All I had ever seen pictured was a crucifixion with hardly any blood; a couple nails in the hands and feet and the little hole in the side with maybe a trickle or two of blood. When I saw *this*, my hair stood on end. I had goose bumps and tears ran down my eyes. I started a painting in 1975 about this experience. I worked on the painting for about a year. I showed it to some people that came around, but I never publicly exhibited it. It was twelve years later that the finishing touches were put on this painting.

GERMINATING IDEAS

With most of my paintings, I have an idea that starts to germinate. Then I'll work around a certain theme. Once in a while I'll do something that's really spontaneous. I don't know what it's going to be. But then I get to a certain point and say, "Well, what am I trying to say here?" Somewhere along the line it will become clear. However, it might be a year later before I figure it out.

At first, when studying and researching, I was like a semi-hermit. I moved about seven and a half miles north of Suring [Wisconsin]. My folks had a little cabin and I had a small house that I built on the back of a truck. I drove the truck up there and parked behind their cabin. I was all by myself studying, praying, and meditating. Every two weeks or so, I drove back to Green Bay for a few days, and then I'd go back up to the cabin. This went on for almost ten years.

When I started to have spiritual experiences, I was Catholic. That's how I was brought up, but I didn't go to church. After a short period of time, I felt like there was something more that I wanted to find out. I attended church and started reading Catholic literature about saints and cate-

chisms. These are things I had failed to learn when I was a child because I skipped my catechism classes. I learned a lot and it brought me a lot closer to God. When I decided to go up and live up in the woods, I didn't have quite as much contact with the Catholic Church. It wasn't as convenient. I still wasn't into the Bible.

In 1977, one of my friends built a large cross and put a sign on it against abortion, and he dragged the cross from Green Bay all the way to Washington, D.C. Somewhere on his journey, he ran into some people who showed him a few things in the Bible and he got all excited. When he came back, he said, "You've gotta get into it, this is great stuff!" At one point prior to this he had been desperate, because he was on alcohol and drugs, too. So he came to me wanting to know what I had found that was so great. I got him into prayer and meditation. He started really feeling the presence of God.

Later on, I started writing things down, and I was showing somebody my notes and how I was putting together my studies. They told me there were concordances I could get. That got me interested in Biblical languages and studying things a lot more deeply, deciphering them. I think of my paintings as teaching tools. I think people look at them and read them like books. At one point, I actually started calling them apocalyptic visual parables. Apocalyptic means "revelation." Visual parables are symbols that reveal things from the scriptures. These Biblical studies were mostly on my own. However, every time I saw some kind of correspondence course advertised in a magazine I'd send for it. But for the most part, I did the studying on my own, with friends or other people interested in studying together.

At one time, I thought that the King James was the most reliable version, but I don't count on that anymore because there are a lot of mistranslations in there when you go back into the original languages. Still, I stick with the King James now because all of the study guides that you can get are keyed out to the King James. I do have some interlinear Bibles that actually show Hebrew and Greek in the Bible with English under it. An interlinear Bible allows me to find a word from the *Strong's Concordance* and double check it. I can make sure I have the right word. I can go into lexicons if I want to look up each individual word. *Strong's Concordance* is a large Bible reference. It's set up like a dictionary and has Hebrew and Greek lexicons. It has every word in the Bible. I can look up one word or a portion of a sentence and find the scripture verse I am looking for, and it'll give me a number that is keyed to the lexicons in the back of the book. I can find the exact Hebrew

Kundalini Arises in the Ugliness of Sin: The Garden Is Lost, But There Is Hope in Yesu Christ, 1988–1990, oil/acrylic, 96" x 48"

word if it's from the Old Testament, or Greek if it is from the New Testament. I can really get into deciphering it.

Much of my studying has taken place at the Brown County Public Library and St. Norbert's Library because these are pretty good theological libraries. My work is well researched in terms of symbolism. It is important to me that the paintings are set up so that they can be viewed on many different levels. In some paintings, there's no narrative in the painting itself. On other paintings like *The Last Days: Shades of Regression, The Rape of Liberty,*

The Final Dance [1988–1990], there are little scripture verses written that explain what's happening. All through the painting you'll see scripture verses that get even deeper into another level of interpretation.

In some of my more recent paintings, besides having the scripture references I actually have scriptures written out. Some of them have text that is paraphrased from scriptural sayings. In some of my paintings, there is a lot of text. It's in the painting in such a way that it's almost hidden, you wouldn't really see the text until you start to look closer.

RELIGIOUS REPRESENTATIONS

On the painting, *Kundalini Arises in the Ugliness of Sin: The Garden Is Lost, But There Is Hope in Yesu Christ*, I wrote:

Man surrendered dominion of this world to Satan when he failed to tread the serpent down and thus came under the bondage of Satan. Satan can and does appear as an angel of light. He is Lucifer, the bearer of the light. Through the false image of Mary he pretends to be a savior of mankind proposing the same lies told to Adam and Eve. Lucifer is the Latin word for Venus. Venus is Isis, the virgin mother goddess or the great earth mother. To the Aztecs, Venus was Quetzalcoatl, the feathered serpent. The new-agers call this deity by the Hindu name, Kundalini. Kundalini is the hermaphrodite fusion of Shakti-Shiva, the destroyer synonymous with Satan. It is referred to as the fiery serpent which sleeps at the base of the spine whose arousal can cause insanity and death. The children of Israel were plagued by the fiery serpents with the sting of death as they wandered in the wilderness.

The Statue of Liberty on the minaret symbolizes the United States as mystery Babylon from the books of Revelation and Isaiah. On the right the smoke arises from the bottomless pit bringing darkness, false prophets and demons to torment and deceive mankind.

This painting overviews the beginning of creation with Adam and Eve to the end of the book of Revelation when the smoke rises from the bottomless pit. On the right are demons described in the book of Revelation. They had the faces of men, hair of women, wings of locust, and tails of scorpions. These demons wore crowns upon their heads and metal breastplates. Adam and Eve are holding onto the earth. The earth is symbolized as forbidden fruit. Before the fall, man had no need of a redeemer because mankind was innocent. When Adam and Eve ate of the forbidden fruit (the symbol of the

bite out of the earth), they needed to be redeemed. Within the bite is a little picture of the crucifixion of Yesu Christ. His blood drips down onto Eve's head, which symbolizes the blood of Christ is for the forgiveness of sins and redemption. Her Medusa-like hair has turned into snakes and worms, symbolic of the fall, of the degeneration. Eve's hands are bound with the serpent, and as described in the Kundalini, the fiery serpent is coming right up out of her spine. She is in bondage. The serpent looks over the situation and foams at the mouth. In the reflection of the snake's eyes is Venus. Venus in the Latin Lexicon refers to Lucifer. The serpent symbolizes Lucifer having an image of Venus in it.

When Adam and Eve sinned after the fall, there was a curse placed upon them, that the ground was going to bring forth thorns and thistles. In the painting, this thorn bush grows right through Adam's skin. It shows he's in torment. The apple core is another symbol of the fall. Down in the lower portion of the picture, coming out of all of this death, is a skull under the dung pile. A rose blooms from all of this filth. The yellow rose stands for hope and resurrection. The seed has to fall into the ground, be buried, before the plant comes to life. The nearby little butterfly sitting on the rose holds out hope of eternal life.

Like some of my other paintings, there's a lot of death and destruction, a lot of stuff going on here that seems evil. What I am doing is portraying evil, showing and exposing what the evil is, but also showing little glimpses of good, a little glimpse of hope. I usually try to do that in my paintings, but I can't do it in all of them because some of them portray a subject that is so hopeless that I can't depict a ray of hope into it.

The thing that I'm trying to do by portraying these negative examples is to point out the things to watch out for—the things that I think are wrong. This procession, leading up the side, shows various types of Pagan worshipers. They're carrying a little image of the Queen of Heaven that is in the book of Jeremiah, in chapter 44. It says that the Queen of Heaven isn't really Mary as so many people have been led to believe. It warns people not to pray to the Queen of Heaven or offer sacrifice to her. What they were talking about and what people were worshiping was Astarte; the equivalent of "the great earth mother."

The procession starts to climb the minaret that represents the tower of Babel. The Babylon tower was actually a step pyramid, but I used a minaret because I wanted to have a snakelike look to it. In some old paintings, artists

The Last Days: Shades of Regression, The Rape of Liberty, The Final Dance, 1988–1990, oil/acrylic, 45½" x 73½"

used a snake symbol for the tower of Babel. At the top of the tower, it turns into scales with the snake going up under the dress of the Statue of Liberty and comes out of the arm holding up the book.

On the tower, I wrote how, through the English language, the name of the savior has changed. It was originally Yesu, not Jesus; And Jehovah is a mistranslation and counterfeit replacing Yahweh. Text on the tower of Babel tells of a time when people wanted to build the tower and make a name unto themselves (Genesis, chapter 11). I compare it to *e pluribus unum*. It's "one out of many," the motto that is on U.S. coins and money. At the time of the tower of Babel, people were supposed to spread out across the face of the earth, multiply, and regenerate the earth after the flood. Instead, they all came together in one place with one language. When God came down and confounded their languages, they spread about over the face of the earth and became many from the one. They went out to many nations and became many nationalities. The immigration and regathering in the United States brings "one out of many" again. Everybody comes back together with

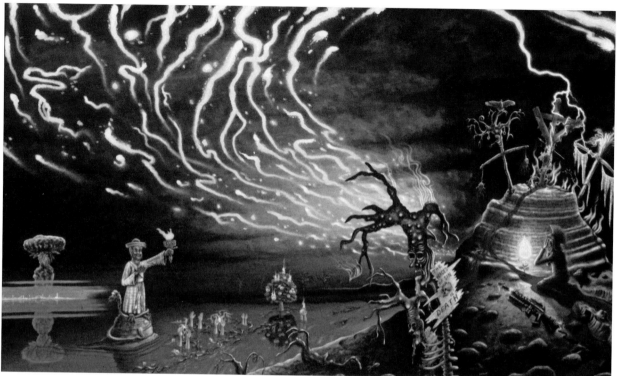

Apocalypse of the End Times: Manasseh and the Forgotten World, 1990–1991, oil/acrylic, 48" x 80"

one language and one speech saying, "Let us build a tower, the tower of Babel here."

When I started out, I had some ideas for this image. It first started with Eve holding up the fruit; then there was a development period where I went through probably a dozen different sketches. I read that Kundalini is supposed to be a fiery serpent and in the Bible that a fiery serpent in the wilderness came upon the children of Israel as a type of plague. The children of Israel were bitten by these fiery serpents. In some of my research, I also found that Quetzalcoatl was a fiery "feathered" serpent of the Aztecs.

The serpent comes out of the earth and goes up in the shroud. It looks like a shroud of Mary, but what I'm showing is that it's not really Mary. This is Satan using a "good" image to try to deceive people. This was one thing that has been misunderstood by some people. There was an elderly woman who gave me a little static. She saw me painting little flames coming out of the top of this image and said, "Boy are you lucky that you painted those flames. If you'd have put one of those little roundheaded demons in there I was going to cold cock ya!" I think she was serious, too. She'd come in and she'd say,

"What kind of blasphemy you got for us today?" But the thing is that the image is not blasphemy—at all. I'm trying to point out a scriptural truth.

For example, 2 Corinthians, chapter 11 talks about Satan appearing as an "angel of light." The King James Bible says that he's transformed into an angel of light. When you look it up in original Greek, the verse means disguised. I interpret the verse to say that there are false Apostles who have gone forth disguised as Apostles of Christ. Therefore, Satan can be disguised as an angel of light, so don't marvel that his ministers might be disguised as ministers of justice. Things are not always as they appear. Sometimes spiritual representations, especially in religion, appear to be innocent and good, even though there's some type of deception taking place.

One thing that I found through my studies is that Satan will be allowed to appear as the false Messiah in modern day Christian religion. I can't see any other way that it could happen. The scriptures say that if possible, he will deceive even the very elect. The very elect were the people of God. How is he going to deceive the very elect? I believe it has to be through some form of Christianity for that to happen. This is Satan's goal. In Isaiah, Satan declared that he would ascend above the heights of the clouds and be like the most high. He said, "I will sit also upon the mount of the congregation." So if he's going to be sitting upon the mount of the congregation, that means he's going to be infiltrating into the church. In 2 Thessalonians, chapter 2, it says that he himself will be seated in the temple, showing himself that he is God, and so it goes all through the scriptures. There's one verse after another that shows Satan's true goal is to deceive God's people and to set himself up as both God and savior. There are many different ways that he attempts to do this.

In a different example, on the United States flag it says, "Don't Tread on Me." There were about a half a dozen different flags designed between 1775 and 1776 that had this text and a picture of a rattlesnake. In Luke 10:19, Malachi 4:3, Genesis 3:15, and Romans 16:20, these scripture verses tell God's people to crush the head and tread down the serpent. So this is a Satanic statement right from the start! Whether the people that made the statement knew or whether they were just being used and it was fulfilling prophecy— I don't know.

There were other things during that period of time that show that the United States wasn't really founded on Christian principles. All the forefathers were Freemasons and Rosicrucians. All symbols around the founding of the country were occult and not Christian principles. There's a quotation

that I ran across in a reputable magazine by George Washington. It said he assured Muslims that they should feel no threat in any way from the United States because it's in no way founded on Christian principles. That led me deeper in my studies to investigate this idea more thoroughly.

When I started this painting, Eve was standing, but the flames weren't coming out of her. The flames were all around her, and she was just standing in the flames, holding up this great big apple. Originally, I thought the snake should be wrapped around or sitting on top of the apple. This representation just gradually developed into this picture. In many of my paintings you'll see the Biblical images and things from the occult. I am trying to expose the occult and to reveal Biblical truths. Some scholars see these ideas as a literal thing. I'm not saying it can't be, however—I'm not certain. I see it as a spiritual thing. For example these spiritual representations of locust depict false prophets and false preachers. There's one place in the scripture where it talks about that "The ancient and honorable, he is the head; and the false prophet, he is the tail; that false prophet that preaches lies." Their stings are in their tails. If you look closer you can see them in the shadows.

It's kind of hard to say for certain where my work is going. I just keep going along. I feel like I'm being led. So far lots of the paintings show false teachings, misconceptions, and stuff like that. They expose those things and reveal them. A lot of my work uses negative examples to try and point out the wrong and show the way to the truth. A lot of it's done through this negative stuff. I think in the future, I might turn from this destruction-type thing to more of the resurrection-type paintings, and the paradise-type thing. I've got a feeling that it'll go in that direction. It hasn't yet, but there have been times when I've really pondered on it. I haven't felt completely led in that direction yet, but I do have some ideas for some paintings in that direction.

DEMAND A SECOND LOOK

Now, I usually have about four or five pieces going at a time. When I start getting close to finishing one up and I get excited about it, I will drop everything else and finish it. Then I'll jump to another one. I kind of jump back and forth. I've discovered that I can write on the canvas with a graphite pencil. I seal the writing with matte medium. By sealing the words, I can paint over it with oil paint and it won't smear, it won't erase. I'm able to do a lot of fine detailing. Originally I was sitting there with a little tiny number one

or a zero brush and painting all those little scales one at a time. Now they're detailed ahead of time and they're just showing back through the glaze.

In 1975, I went to UW–Green Bay for one semester and met a guy from the advanced studio. I was working and he asked me if I'd ever tried glazing. He said I'd get a lot more depth in my paintings with glazes. So I started to experiment on my own. Now, I do the underpainting of most of the background with acrylic. I start out opaque and then I do glazing over the top. I've developed my own glazing medium by using linseed oil, Grumbacher clear gel, and liquin. I mix those three together and it gives me the consistency that I want. It works out perfect. It dries quickly enough, but if I've got something that I really want to work on fast, I'll use a little Japan dryer.

People become interested in my work because they see beyond the symbolism, beyond the formal elements and technique, and read the scripture passages. I know that it's working. Many times gallery curators have told me that people will come in, sometimes with a pencil and a pad of paper. They'll start going around and writing down the scripture verses from the paintings. Sometimes the people will come in and they'll view the paintings and then they'll come back, maybe a day or two later, with a Bible, and they'll actually stand in the gallery, looking through their Bible.

It's important for me to have people see the work. It is helpful, it's real encouraging, and it keeps me going. In Kenosha [Wisconsin], I probably had about twenty pieces or so in a show. I went down about a week after the show had opened to give a slide presentation and talk. While I was down there, one of the professors came up to me. I believe he was a psychology professor. It got me pretty excited because he said that whenever they have a show in the gallery, after it's been up a couple of weeks, he would ask his students how many saw the show and usually two or three hands might go up in the whole class. For mine, every hand went up. After my show was open for two days or so, students came up to him and talked about what they had gotten out of the show. He said the neat thing was that it didn't seem to matter who they were, Buddhist, Christian, Jewish, Muslim, or atheist. Everybody got something out of it. That was encouraging to hear. People at all these different walks of life could get something out of these paintings. I feel that no matter what I say to anybody, no matter what anybody else says, the main point is that people have to get into the scriptures themselves. They have to read, study, and see for themselves what they say. My paintings demand a second look.

LORI
REICH

My therapist said to me one time, "I want you to embrace your fears and paint them." I said, "I've never had somebody tell me to paint something," so I did and that was what I painted.

—LORI REICH

LORI REICH has used her artmaking as a healing process and a vehicle for social change. Gravely injured during an airplane crash in 1979, Lori struggled back to physical and emotional health with the help of her caring family and friends, doctors, and the therapeutic art activities that she began to explore. Lori's sometimes negative experiences with the mental health and political establishments at that time led eventually to the development of her current body of work including the "Newts" and "Newtopia."

Although artistically unschooled, Lori credits her friendship with Norbert Kox as a positive influence on the development of her painting.

OUT OF CONTROL

I had a troubled first marriage and was left with two children and no money. I sought welfare for two children and myself until I could get on my feet by working as a hair stylist. My children and I were homeless for two days as I sought help in getting an apartment and car so I could work. My employer at that time helped by cosigning for me. My parents and friends helped care for the children until we were reestablished without any child support from my ex-husband. When I married again, Dean adopted the children and we became a family.

In 1979, my mother passed away and Dean took a job in Green Bay, Wisconsin. We were living in Wheeling, Illinois, and had to sell our hair-styling business and home. There was a Christmas pageant and my husband wanted me to come up for it. We were in the process of selling our house so we could move to Green Bay. My husband worked for a big company that had airplanes coming and going from Chicago. They said that they could pick me up and bring me to the party. They picked me up in Wheeling, Illinois, on December 21, 1979. It was unseasonably warm and there was frost. The pilot was a hundred feet lower than he thought he was. As we were coming in, approaching some trees, right outside the Green Bay airport, we hit the trees and crashed. It took them over an hour to find us. I was found between a mother and a son who were killed. She and I had switched seats before the airplane took off.

I was thrown out from the airplane. When they found me, I was still in my seat. A lot of the internal injuries came from being strapped in the chair. The pilots were both killed. I was in the most critical condition of the survivors. I was in critical condition for about two weeks and my insides liter-

Previous page: Lori Reich, in her studio, Green Bay, 1996

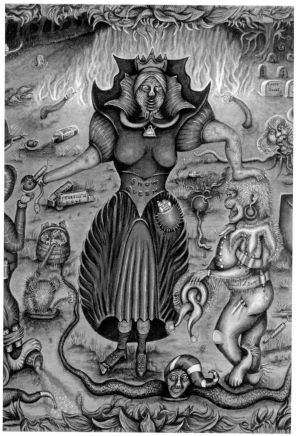

Detail of *Snow Queen and the 7 Deadly Sirs*,
1997, acrylic, 2½' x 8'

ally had to be put back together again. The physical recovery was not so bad to deal with, but I started to have these weird sensations all the time. After four weeks in the hospital, I went home to Wheeling. I knew I felt different, but because of the amount of trauma I incurred, I didn't discuss it with anyone at first. After selling our home in Illinois and moving to Green Bay in March 1980, I went out of control.

I was scared all the time. It took quite a while to realize that I suffered from posttraumatic stress disorder and anxiety. The space that I could feel comfortable in started getting smaller and smaller and smaller. After my family would leave for the day, I'd take the clock and go in a closet and that's where they'd find me. I knew it was the aftereffects of the accident. I realized that I needed help and I started to seek it.

My first years in Green Bay were filled with panic attacks, depression. I hid in the closet, a space I felt secure in, but it seemed to be shrinking. After many outbursts and unusual behavior, I went for help. I was diagnosed with posttraumatic stress disorder (PTSD) and

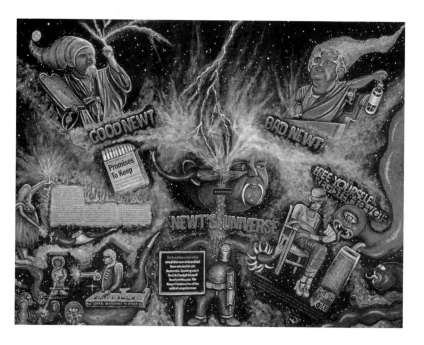

Newt's Universe, 1996,
mixed media, 24" x 30"

Defixiones, 1996 , acrylic, 24" x 30"

agoraphobia. I owe the most to my husband, daughter, and son. I cherish their support. They lived through hard times while growing up with my ranting and outbursts. Soon I started to attend a support group.

During this time, I learned how to advocate for issues and found people with the same interests. I was extremely vocal at the local level. I became the first mental health consumer appointed to the Brown County Community Programs Board. We reviewed contracts for county mental health, developmentally disabled, and alcohol and other drug abuse programs and gave recommendations. As an advocate, there were many issues. The more I delved into them, the more there seemed to be. One of the most rewarding was working with a small group of Vietnam veterans. We worked at trying to get the VA to listen to the problems they have had with the lack of services.

A PROCESS OF HEALING

My interest in painting started in 1991 and my interest in advocacy waned. I needed taking care of myself. The best part of being self-taught is in the adventure of learning the process. I go to the studio almost every day. With the music blaring, I'm totally involved in painting and loving every minute

of it. Norb Kox and I paint together at least one day a week. Norb helps me by not helping me. If I ask him a question about painting, he usually says, "It needs more work" or "I don't know." His greatest gift is allowing me the satisfaction of knowing, when the time comes to finish the work, that the journey was truly mine. The journey of painting is my joy.

In my early abstractions, I wanted to use color to represent how I was feeling and what I wanted to say. I went from working abstract to painting figures. Now, I try to have my artwork portray social statements in strong colors and unsettling imagery. This comes from experiences with those who know the meaning of poverty, stigmatization, and societal neglect. If there is a mission to my artwork, it is to bring to the public a message of the hate, pain, struggle, hypocrisy, and evil that surrounds our lives. Through self-discovery, I hope that one day I will choose love over hate, education over ignorance, acceptance over intolerance, and freedom over oppression.

My first art things were playing with play-doh and making little people. Some clay I broke up with a toothpick. I found that it was really enjoyable. It was a type of therapy. I still have horrendous anxiety that keeps me pretty well cooped up in the house. The clay helps me to remember times when I really had fun. I have strong memories of childhood and playing in the sandbox and with paints. I'd always try to sneak into the paint line.

I enrolled in some painting classes at the university. But as I look back, I guess I was really lucky that they just didn't pan out. I really didn't know what they were talking about, and I didn't want to do what they said. I decided to go to the library and look at books to figure out what I'm doing. I also found out a lot of my information from the art supply store.

I liked making texture. One of my first paintings was painted with a toothpick and a toothbrush. Then I added glitter and stuff. I just had fun. I kept building and building. I didn't even know that there was stuff on the market that you could buy to build paint up. I made lines and stuff with toothpicks. Later, I reapplied paint and scratched it with a toothpick. That's how I just built the surfaces up. Some of the surfaces were built up with a toothbrush. I'd take a toothbrush, put paint on it, push it on the painting and pull it off. I couldn't understand why the paint would disappear. Then I'd take paint and I'd turn the painting upside down hoping gravity would pull the paint and drag it out. I had no idea what glitter would do either. It was shiny. I didn't know how else to do it. I was into the physicalness of what I was doing. I played with the color.

I liked the process and I didn't think of anything else. There was no time. Everything else evaporated, except what was happening here. I felt great afterwards, there was an afterwards feeling. It felt so wonderful. It was just this natural high and I just went, "Wow! I really like doing this!" I do it and just play. I turned it into play. I didn't do it for any other reason except to have fun, to have that wonderful feeling. This was a process of healing for me. I'm not even sure how long each painting took to do. I don't remember.

CYCLE OF FEAR

One of the first art history things I looked at was a book about Monet. I loved the colors. My son took me to a museum that had Monet paintings. It had very white colors with lines. It was a bridge. It looked very abstract. There was all this color! I really liked all that color. I thought that was really neat. My son told me that Monet was going blind when he painted it, so I picked up a book and read about it.

At first I didn't know anything about additives; all I knew about was paint. I just kept trying to make the paint into a three-dimensional texture. I put paint on toothbrushes and toothpicks to try to pull the paint out. I experimented with paint textures. I thought it was fun!

I finally went to the art supply store. I was telling them about building up my paint, and the paint person said, "Oh there's stuff you can put in paint, there's all these things that you can use." My next painting had five different textures. I even left a mosquito in one of my paintings. It had flown into the wet paint. I figured it was a good way of showing you could texture work with anything.

I began to use resin and fiber in my paint. I applied it with a palette knife and little drips with a toothpick. When I'd show these in art shows, little kids would want to come up and pull them off. I never used a brush until later on. A friend told me about an older technique of glazing. He asked if he could see my work and I showed him some. That's how they ended up at Instinct Gallery in Milwaukee [now closed].

Later, I started doing things that had to do with the cosmos. The first universe paintings were abstractions. But then, I did more glazing. I was trying to get the feeling that the universe is still coming altogether; that there was universal stuff going on. All of a sudden something hits a planet, fire starts, then water and then life.

I seem to work on these series for a long time. I get into something and I go the whole way with it, until I feel like I've used it up. It seems like all of a sudden I went from totally abstract into the figural stuff, but I had figural stuff in my work all the time. All the way through just about, but it was really abstracted. One of my first noticeable figures was a universal soldier that watches over everything.

A TELLING TALE

I've had a lot of migraine headaches over the years. The headaches leave me feeling raw. I can't stand bright light. I can't even stand bright colors. I wrote a poem about migraines:

> *I sometimes wonder about the pain,*
> *is it really going to make me insane?*
> *The pain goes on inward and outward, pulse in vein.*
> *The pain goes on forward and backward, body and mind.*
> *I sometimes wonder about the pain,*
> *is it really going to make me insane.*
> *I pray. I say, "No more can I stand it all."*
> *I say no more can I stand it at all.*
> *I visit my pain, it must have meaning.*
> *I sit awaiting that which must be profound.*
> *Will it always be like this, the pain in and out?*
> *Will it always be like this, the torture of body and soul?*
> *Will it always be like this, this pain in my psyche, my body, my brain?*
> *Will it always be like this?*

When I did my first realistic painting with glazing and imagery, boy did I surprise my family! I decided that I wanted to do something about my accident. The painting was called *Cycle of Fear*. It showed what I went through. It started out with the airplane. There was a shadow of fear. The airplane goes into the trees and it rips off all the branches. This represents foolish fears. The airplane turns into the monster and it engulfs my hands. What goes into my mouth and what's coming out of the mouth is all these horrid, terrible things that create my distress. All this horrible stuff was blind fear. It goes down into

the hand and the hand is still monstrous. It's reaching out to nature. Nature's portrayed with long nails. I have a fear of being in storms, ice, fog, and things like that. This was my way of showing that I was fearful of natural . . . not nature, but of natural things that are stormy. This was a very personal piece.

I was just getting to the point where I wanted to free myself a little bit from what I was feeling. I had been voicing my emotion with abstract work. I began to want to paint something with emotion and tell the story. This was the first introduction of the monster. From this painting, I decided that a lot of who I am has to do with social issues. I feared doing this kind of painting, so I was starting to break the cycle just by doing the painting. I think it opened the door because the new paintings said to me, "Oh well, you can do other stuff now and you can tell stories." That was in '95 and it was a big transformation.

As I reopened this door, I felt, "I don't have to be afraid of doing this anymore!" I could do these images the way I wanted to do them. They didn't have to look like people or like certain things. They could just be what I wanted them to be. It was awesome when I realized this. The social statement became very, very important to me. I was very upset with the ideology going on. I believe that there's a lot of injustice, our rights are being taken away. That scares me! I wanted to portray that and that's what my work is about. Talk radio was coming out with crazy stuff at that time, telling you to love your neighbor and yet they're for the death penalty. My art said, "Thou shalt not kill." I try to show the hypocrisy in things.

THE EYE OF NEWT

I looked at ads. I watched TV. The monster lets me represent things I see. On one level, it's just a funny monster, but there is the other serious level. Newt Gingrich was not a fun person. He was not a favorite of mine. We would joke and I'd say, "Well, this is my Newt." These paintings are my personal slam at Newt Gingrich. People who saw my work would make puns. "Ah, the eye of Newt." So I'd paint an eye of Newt. That started my Newt series.

I introduced gargoyles to my work with the Newts. Gargoyles from myth are supposed to be protectors. They're supposed to protect who they're up against. They're actually uglier than the evil spirits. I've got them coming in to clean up Newtville. Evil begets evil, violence begets violence. Even though

we have these gargoyles coming in, they're protecting through violence. We keep violence and negativity going. Even though they're supposed to be cleaning things up, they're not. In a lot of my paintings I have a mouse, mouse holes, things like that. Evil things are everywhere. Gargoyles are supposed to be the good guys. I got some information on gargoyles off the Internet. It told about whom they were supposed to come and protect.

I work on political campaigns and stuff and do that type of thing. It just helps me keep current on things that are going on. I'm very upset that not many people vote. This is a big thing with me. Everybody complains about the government, and not even 10 percent of the population are voting. This is very scary to me. A small amount of people are making all the decisions. It seems to me it's getting worse. That's very scary. These are things I want to paint about.

My therapist said to me one time, "I want you to embrace your fears and paint them." I said, "I've never had somebody tell me to paint something," so I did and that was what I painted. Although my work rarely portrays hope, I am optimistic about our greater spiritual nature. Through meditation, prayer, and philosophical quest, I look forward to broadening my artistic messages.

Rudy Rotter, in his
Manitowoc Museum
of Sculpture, 1995

You'll see a whole series of interrelationships.
This shows that all humanity is interwoven and
interrelated. And how each one is holding some-
one being held, being supported, loving, and
being loved. This is the dream.

—RUDY ROTTER (1913–2001)

RUDY ROTTER

"Happy" was a fitting way for **DR. RUDY ROTTER** to sign his prodigious artistic output from the last fifty years. Our several lengthy visits at the Rudy Rotter Museum of Sculpture in Manitowoc were filled with outpourings of passion, enthusiasm, creative thought, and kindness. Rudy's life's work was to portray the value of family, and he created more than fifteen thousand pieces of work housed in his multilevel warehouse on Buffalo Street. As he talked about family, ideas, and inventive ways to explore new materials (i.e., mink fur scraps, leather, scrap trophy metal) his enthusiasm was infectious. His work is in the collection of the John Michael Kohler Art Center and the American Visionary Art Museum in Baltimore.

THIS IS THE DREAM

Both my parents were business people. They ran a number of stores. In fact, I think part of my artistic effort comes by way of making bouquets and wedding corsages at a real early age. We were a whole family working together during the Depression, and each one had to chip in, you know. My parents were immigrants from the Ukraine. There were eleven kids. My father came over first in 1905 and worked until he got enough money, because I had three brothers and a sister living in Europe. Then he went back in 1907 and brought the family to Milwaukee.

I was born and raised in Milwaukee. I went to UW–Madison and I got my degree in zoology. I was a zoologist at the Milwaukee Public Museum. Owen Gromme was my boss. He was a young man, and I found out I'd have to wait until he died before I could move up the ladder. So I decided to go back to school and I took up dentistry.

I lived on Mitchell Street. It's an old south-side neighborhood. Later, my parents changed the grocery store into a floral shop. Then they bought half a block of this auto repair business right on Mitchell Street and created a number of stores there. So we made bouquets and ran next door and fixed flat tires. Oh yeah, I worked hard, worked from morning until night.

So I think that ties in with my being a worker today. Because I'm a plodder, see? And the way I learned all this stuff being self-taught, and it's only by doing one thing after another after another that something starts to form. Hey, this looks interesting. Then I follow it. You'll see, as you look around, you'll see all these variations, changes, and studies.

Rudy Rotter's museum and studio, Manitowoc

One of many rooms packed with sculptures and
2D art in Rudy's museum

I used to spend a lot of time with my children. I was with them all the time, until they got to be young teenagers, and then all of a sudden they said, "Gee Dad, I'm pretty busy, my friends are waiting for me." At first, I was hurt, and then I said, "Hey, buddy, that's it." So I started making. I had always kind of had it in my mind. I said, "Hey, now that the kids are grown up and I have more time . . ." So one day I had a little bit of clay and this is what happened. It was fun. So I started doing a little bit more.

We had a big family, but loving. My mother would give me a kiss good-night. My father would greet me with a kiss in the morning. It is burned right into my mind. And I think all this love and everything comes by way of my experience and my feelings from my parents. As you go, you'll see a thousand pieces of families, mother, father, and child, it's endless. Like this piece here shows a father—wrapped around a little child. That's one of my early projects. You'll see a whole series of interrelationships. This whole series is on love and family strength. This shows that all humanity is inter-woven and interrelated. And how each one is holding someone being held, being supported, loving, and being loved. This is the dream. I have had a man come in and say, "Almost looks like you're preaching." In a way, I am.

THE SHRINE ROOM

I made this room into a shrine. My sister, who is a trained artist, sixty years ago made sculptures of my mother and father. She graduated from Wisconsin. She sent them to me. I had done this table, and I was looking for a place to put the sculpture. So I put them on here, and then the idea of the shrine came to me. I stepped back and said, "My god, that looks like a shrine." I'm really happy with it. See, with all my work, I'm not satisfied. I'm happy and delighted with what I can do. I'm not satisfied. I'm always looking for some more and something better. I think from the shrine, it would be apropos to go into the Old Testament room that's here.

OLD TESTAMENT ROOM

All of these, with the exception of the two latest pieces, are scenes from the Old Testament. *Rebecca at the Well* depicts King Solomon on his throne and the weight of the decision. You can see both mothers claiming the same child. And he had to make the decision. I carved a head of Moses in granite.

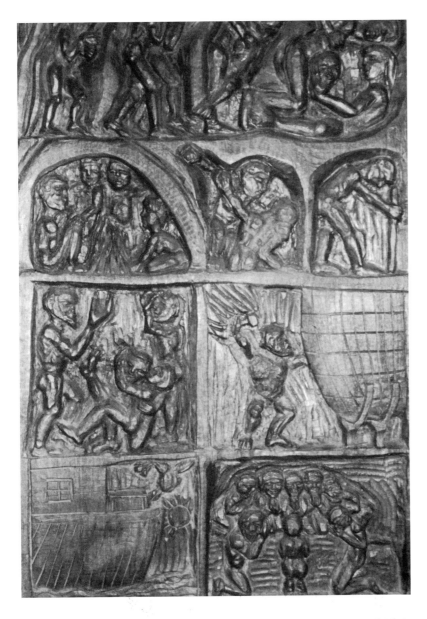

The Creation, c. 1975, side one, mahogany,
3' x 5' x 6'

I broke about fifteen chisels. Here is a carving of Jacob and Esau which is carved out of steatite or soapstone. This is Moses holding back the waters of the sea. The wooden pieces are carved from mahogany, Dorse mahogany, and teakwood. This depicts Adam and Eve in the Garden of Eden. This was also carved out of a block of mahogany. All of these carvings I just made up from the Old Testament. In the Testament laws it says, "Do not carve graven images." So there aren't many carvings in the Jewish religion. But I feel that

these are not graven images to pray to, but these are educational things. They are depictions of a historical event.

For example, in this large carving, the story goes, in the beginning, God created night and day, and then he created the waters and the fishes, then he created the animals. From the dust, he created Adam. From Adam's sleep he created Eve from Adam's rib. Then he created the Garden of Eden. Here is the serpent, and this is Adam looking on in horror because Eve has taken a bite out of the apple. Then it goes over on the other side.

This is the angel with the flaming sword chasing Adam and Eve out of the Garden of Eden. This is Adam and Eve in conjugal love. This is Adam helping Eve to deliver Cain. This is Adam and Eve and Cain and Abel, the first family. Cain murders Abel. He's sent out to wander the earth as his punishment. Then starts the story of Noah. He pleads with the people to mend their ways and they scoff at him. Then he receives the message from God to build the ark. The floods come and the floods go. And here is the dove with the olive branch, and the sun is shining.

This is Noah and his family all thanking the Lord for their deliverance. Down below is the story of the Tower of Babel, and all the people falling off the sides. And on both sides are all the different peoples of the earth and the symbol of wheat or bread. This is Gabriel blowing his horn. This depicts Sodom and Gomorrah as she turns around and was turned into a pillar of salt. This scene shows Isaac blessing Jacob. This is the angel hovering over Samuel as he died, to lift him up to heaven. So in reading some of these things I learned according to history that this was the first murder. So this is humanity looking on in horror. These are some of the things that I added on to the original theme.

I made these large mahogany panels in the early 1970s, while I was still strong. Making the panel has an interesting story to it. I was chiseling on the figures and this large block was sliding off the ledge, and I didn't know it. In my enthusiasm, I gave one good punch, and the whole thing came down and landed on my foot and broke my foot. Everybody thought it was a tragedy, but I didn't think so. I was practicing dentistry and it was wintertime. My physician said, "You got to take a couple of weeks off." It took me about six months to complete this block. This is the only piece that I've ever gone back and forth between some smaller pieces. I had so much to do. Otherwise, I always finish a piece before I start the next.

HAPPY ACCIDENTS

For the first five and a half or six years I used a hammer and chisel to carve
all these stones. The granite I got from an old company here in town that
made tombstones. They were going out of business. I bought a whole bunch
of them. I bought a big chest full of stone chisels. And so I started working
at it. I could take a piece of stone or wood, but especially stone, and start
carving it. Then I could feel the way it gives or the way it doesn't. How it
carves. How it doesn't carve. Where it will fracture, where it will not frac-
ture. How much polish and grinding and so forth that is required. It was
only by the experience of it that I learned to do this. Many times, I was
working on a piece and something broke. And I started to recarve it. I call
them happy accidents. Sometimes the new ideas are more interesting than
what my original idea was. Only by keeping my mind open and continuing
to investigate continually—that's where all these things have come about.

The female figure well has been used by artists since time immemorial
for flow and movement and abstract shape. I think besides being a man, and
being, how should I put it, normally erotic, that the beauty of eroticism is
normal. It's natural. So I love the figure. You can see a lot of female figures
here. The male figure is magnificent but the female figure has a flow and a
line and cohesiveness in design. Sometimes I want to abstract this and peo-
ple say, "How can you do that when you're doing figurative work?" I said,
"It's shaping. Every figure is made up of a series of abstract shapes, forms,
lines, designs." Whether it's a round bowling ball or whether it's a figure or
a series of figures. It's all the same.

ALL DIFFERENT INGREDIENTS

The new work, all this weird stuff, I think comes by way of the fact I'm quite
arthritic since the early 1990s. I have to sleep in a chair. I can't sleep in a bed.
And I don't sleep as soundly, so while I'm awake certain ideas and things
start to form. I can't wait to get up and start on it. So I try these different
ideas. Some don't work out. Some of them are fair, but all of them lead me
to something that's great.

For example, after all these years of working in wood and stone, which
have nice colors but don't have the reflectiveness and the spark of this stuff,

I came upon trophy metal by accident. One day a guy from the trophy factory said, "Hey, Rotter, I got a box of this shiny stuff. I don't know what to do with it, but I think you can. Here, take it." So I did, and I started working. There is a company in Manitowoc that makes all different awards and trophies. It's a trophy company. There are things that they can't use. So I was able to get a hold of them just by accident. I give him some pieces of sculpture and I get this stuff, marvelous supplies, too! It's reflective metal and I've gone nuts with it the last couple of years. I started out by just using the big pieces themselves. I cut it into smaller pieces and started nailing onto boards of wood, so it looked like stained glass. I also had people just recently bring me leather cutouts from stampings. So I've been using that.

So in my workshop, I've got loads of stuff lying around all over. It's like a cook who has all different ingredients. Reaching out for one, reaching, reaching, and all different ingredients to put something together. Sometimes I also go out to the junkyards. There are beautiful stamping pieces that are left after the pieces are stamped out, which then have the beautiful shapes and designs. From that, I went into abstractions because of all of these designs. I see things in the junkyard and say, "Oh, that looks interesting." I'll look around and see what looks to me like interesting things. Some I'll use. Some I won't use.

Over here is a gasket from a junkyard. This mahogany model was from the shipyard. This was a mold for a ship part. This is a keel that I used. These are parts from old electric motors. This is from bathroom fixtures. This is a pattern from the foundry.

I also have friends here in town who own the Wisconsin foundries. That's where I get all the industrial pattern forms. They're wonderful people. I drive them crazy, when I bring something to be done.

They say, "You're going to screw up our entire production." I say, "Ah, just throw some metal in there." So they've been real nice. Done a lot of casting. It is an industrial foundry. But I've made a number of bronze castings and aluminum castings at their foundry. I have a lot of contacts with people in town from being a dentist.

A SENSE OF FAITH

As a dentist, I made dentures. But that was different. I did some jewelry work, but that was just like making gold inlays, just like dentistry. It didn't appeal

to me. I did drawings in the beginning; it didn't appeal to me, because it wasn't physical enough. I was looking for some real physical release. Like I said, I started with a little bit of clay. I said, "Hey, this is pretty neat." Then I started a little bit more, little bit more, and a little bit more. Then I started studying anatomy. I got some books from the library and started another piece, and then the next piece and the next piece, and so we're now up to almost fifteen thousand pieces. And I'm still looking forward to coming every day. I go in my studio and I start chopping away at something. Then something else starts to form. It's only by doing it and keeping my mind open while I am doing it, and looking for new things that I learned to do this.

I am fairly active in our community. I have gotten to know a number of people, both from my practice and people who come into the museum. I'm kind of a schmoozer. I even enjoy working when people come in. My general impression of everybody who are not artists is that there are a great many people who have no real interest in art, see. The artist has to ward against becoming insulted or hurt, because . . . I would say, "I'm the nut on this stuff." I have got a friend, my buddy from the foundry that gives me all this stuff, he hasn't been in in the last six months. It's not that he doesn't like me or anything, he's just not interested in art. Many, many people like what I make. I remember reading years ago an article, which has kept me going for all these years. The main point was that the only thing an artist has going for him or her is the faith in him/herself, that what he/she is doing is good, what he/she is doing is right. And that he/she should not let anything divert him/her from his search. And so I've had that all my forty-plus years.

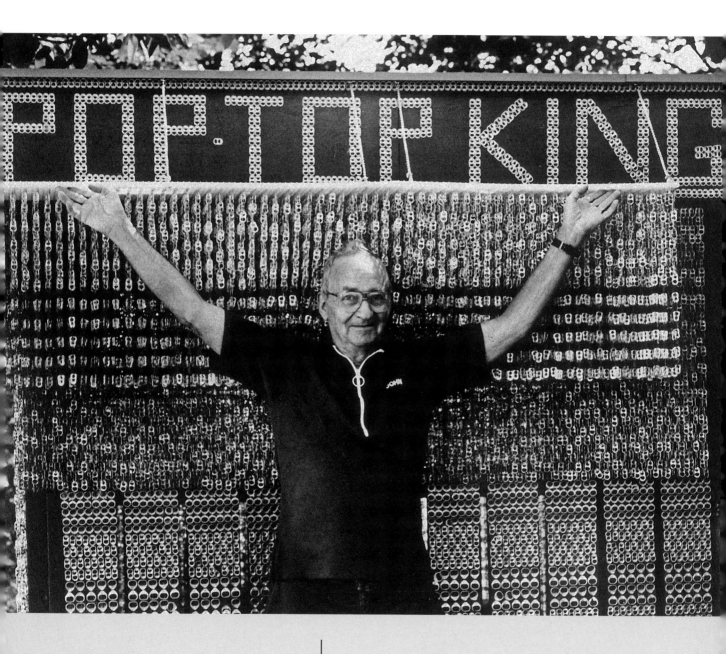

JOHN
TIO

I just love numbers and every chain I put on is fifteen to twenty more. I'm just tryin' to get a million . . . and I enjoy doin' it. This is my hobby. I'm the "Pop Top King."

—JOHN TIO

JOHN TIO'S pull-tab environment developed from his lifelong interest in large number projects. John started recycling aluminum pull-tabs one night because he had "time on his hands." At first, John strung the tabs together into chains with no particular project in mind, but he soon decided to decorate a shed next to his holiday camper in a campground in the tiny village of Rome. At its high point, John's "Pop Top King" display contained over fourteen miles of chains and more than one million pull-tabs. Over the years, John received a fair amount of positive recognition. The site was dismantled and put into storage in 1997, but John has not ruled out reassembly.

FROM ROME TO ROME

My parents grew up in Taylor County, Wisconsin. A place called Gilman. My wife's family was from up there, too. My father was a tavern keeper. The bar was the Village Tavern. I was John, Jr., although people called my father Jack. When I got out of the service in '45, I went from Rome, Italy, to Rome, Wisconsin. It's changed names four or five times since then. My father also had a bar in Helenville that he wanted me to take over, but I was raising four kids. I wasn't gonna raise four kids in a tavern because we would have had to live right there. He also had the Oasis Bar in Waukesha in 1947, and the Trickle Inn in Waukesha, which has since been torn down.

I was in Milwaukee during the Depression 1939, and my family came to Milwaukee to live with me 'cause my father was looking for work. My mother was a knitter and a seamstress. She knitted afghans for all the kids and grandkids.

When I got married, I was working as a typist at an engine company in Waukesha. My wife, Marge, and I both worked there. Then I bought a tavern in Milwaukee and ran that for a couple of years. Later, I went to RTE South Cooper Systems. Cooper bought RTE [Rural Transformer Electric]. They're third behind General Electric and Westinghouse in building transformers, which you see on the power poles. When I quit there I had been foreman and supervisor for over ten years. I was only fifty-eight when I retired, so I got a part-time job taking care of a building in Waukesha, a commercial rental building. I do cleaning, maintenance, plumbing, some electric, and painting.

Previous page: John Tio, the "Pop Top King," at his campground yard environment, in Rome, 1993

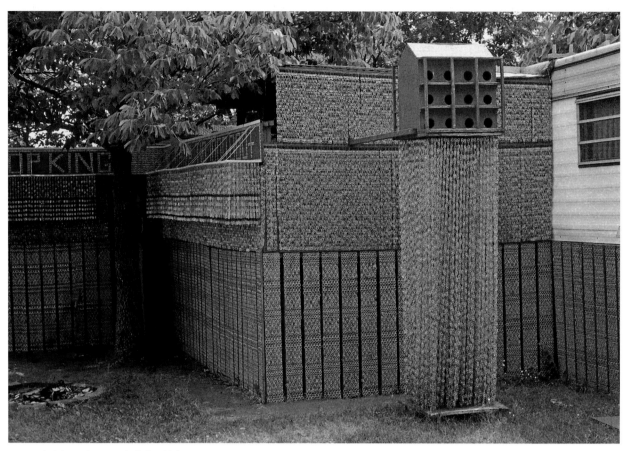

West end of the environment including bird-house with tab chain base. Some of these early chains were held together with colored paper clips until they proved to be too expensive.

TABS OFF FOR DAD

In the summer on my days off, I come out to the camper in Rome. I got started decorating my mobile home because I had a bunch of aluminum pull-tab rings that I'd been savin'. One day I decided to attach them to the door of the shed. That was probably about 1987. Somewhere in there, I had a friend who had a recycling outfit. I went down there and had him save tabs for me. He saved 'em for me. I said, "What do you want for 'em?" I thought I'd bring him a six pack or a twelve pack of beer. After awhile, when I didn't have enough, I'd go down there and sit on a barrel and pull 'em off his cans. Couple a thousand a day during the winter. I got them that way.

I also went down to Great Lakes Dragaway and got permission to take some of the rings from underneath the grandstand. I got a few thousand from there. I did that a couple of hours until my back got tired. Then I went

to Alpine Valley, an outdoor music theater. They gave me permission to go out in the field and pick some up.

The majority I got from a local grade school in Palmyra. The kids started saving 'em for learning how to count. They were going to sell them and buy something for the school. They said, "Let's save a million!" So I told the teacher that when she got ready to sell them to let me know, and I'd give them a nickel a pound above the going price. I bought 560,000 of them in the spring of 1989 or 1990.

The school knew what I was going to do with 'em. They're just interested in getting the money for whatever purpose they wanted. Palmyra wanted to buy something for their school. Well, I paid her something like forty cents a pound, so a couple hundred dollars for about a half million you know. It was a thousand to a pound and I got five hundred pounds. Five hundred pounds of pull-tabs. There's a few dollars in these trailer walls. I don't know what that means. . . . I just love it! The more I can make the better.

I spend a lot of time out here. I do it almost every day I'm out here. If I'm out here, there's always something to do. Except when I run out of tabs. My friend from Waukesha comes out on Sunday and he's savin' 'em for me, too. He brought a coffee can full of tabs. That was Sunday and they're all strung already. There were a couple thousand in that can I guess.

My kids are really amazing! They're trying to get my middle son to save tabs, "tabs off for dad," you know. My other son, he brought me a can full of 'em one time for my birthday. And, of course, my daughter saves them. I'll go over to her house and she'll have a garbage can full of cans. She saves a lot of 'em for me. My nephew in Michigan, now he's saving 'em too. And a tavern keeper near here who has had a tavern for thirty-seven years is also saving 'em for me. I got my nephew and a tavern keeper over in Flint, Michigan, saving 'em for me. They were over here during the summer. He said, "I'll save 'em for you." My nephew and his wife and all the kids, they drink soda and beer like crazy. I talk to them every day and they have a ton of 'em for me. My daughter-in-law gets them from the place she works. People bringing them in to her.

BY THE NUMBERS—I JUST LOVE IT!

I work on preparing the tabs during the winter at home, cutting 'em, stringing 'em and when I come out here in spring, I hang 'em. I strung most of

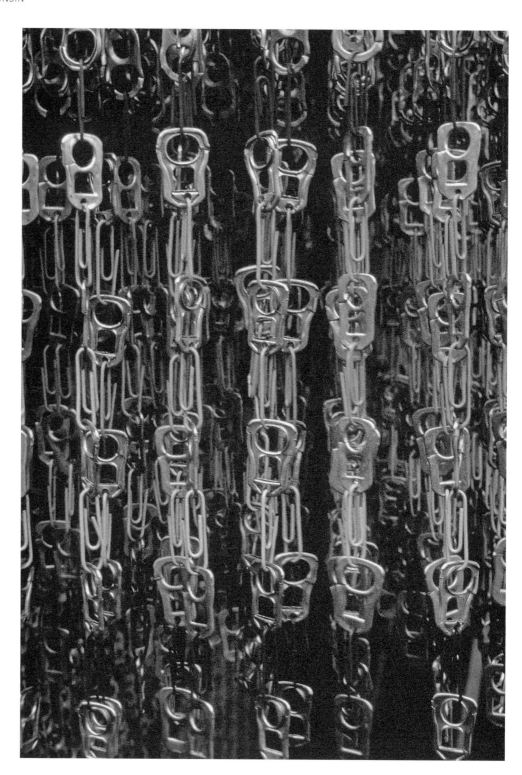

Detail of paper clips
and tabs

John Tio kept detailed ledgers to keep track of numbers of pull tabs used in various areas of his environment

them at home in sections during the winter. I strung maybe twenty-five in a section. I didn't know what length I needed, so I just put twenty-five on a string. Later, I sat in the trailer and did it every night or during the day if it's raining. I still am doing it almost every day. During the week I get up at 8:30 in the morning and string a bunch of them together. I need to know the length. Then, I come out here and start stringing 'em.

I thought I'd have enough with the half million I received from Palmyra, but I needed more. I have barrels and boxes of them. In fact, I had about twenty-four thousand in a box that I thought I'd never get rid of them. All of a sudden, they were gone! One year a school over in Johnson Creek saved tabs and I went over to see them a couple of times. I offered the school the same deal as the Palmyra school when they got through collecting them. But a teacher wrote me and said they only had about half a million so it'll be a few more years before they reach a million. I sent the school a bunch of pictures that I had taken. I thought it would have been a good field trip for the kids. It's a grade school. The teacher invited me to come over to show the kids what I do, but I didn't do that.

I always liked numbers. I always liked big numbers of anything, you know. Saving marbles or saving golf balls, I think that it's kind of fascinating. I also collect golf balls. I got four or five hundred balls—good ones. I find 'em in the back of the building where I work. I found about 250 already this summer. My daughter works at a high school, and they wanted some practice balls for their golf team. Her high school bought a whole bunch.

The paper clips and hooks I get from the K-Mart and Target stores all over Milwaukee. I pick up as many boxes of paper clips as they have in stock. There are quite a few paper clips. For example, the inside patio has 22,680 hooks and 26,568 tabs. The birdhouse is made with 648 hooks. I record all the numbers, and I listed them by different areas of the trailer, you know. There is about 120,000 over the fence. On the fire pit area are four different sections of about 75,000. The south shed wall has 20,000 tabs and the north side wall has 5,700; 31,000 more tabs are on the inside deck and over the deck are hangin' 25,000 additional ones. I also have the ceiling divided in sections. Section one has 45,000 and section two has 53,000. In total there are one million plus tabs.

I had a lotta room to put them up. It just keeps me on the go. The shed was the first thing I did. I had an awning out there. I had a screened-in area and it didn't look all that great so I tore that down and covered this end of the patio. Then I did the area above the fence. At first, I wasn't ambitious enough or didn't think it would work to cut 'em and drill 'em. I thought it would be too much work. So I bought paper clips that won't rust. I put together a tab, a paper clip, a tab, and a paper clip. So I didn't need a hole or didn't need to cut the tab to put them together. Then I got more ambitious and went to cutting and drillin' each tab to attach them together. I can drill about six hundred an hour. I took the whole birdhouse down; actually, I took everything down and redid them. When I started building the fence, I sort of built it knowing I was going to go around this whole area. I had so many paper clips I wanted to keep track of 'em. But they ran into so much money that I stopped. I didn't want to know!

The patterns I just figured out how I wanted them to look. Then I decided how many had to go on one section, you know. I went from there with the patterns. I basically started one section and saw how that looked and then made other sections. The pattern doesn't stay the same all the way around. There's a lot of oddball tabs and rings around over some of the sides. These are tabs that haven't been around for years. I made the wooden

fence to put them on. I bought the boards, painted them red, and nailed the tabs in place. It worked out really nice.

In one space I put the chains so close together, I didn't have enough space to turn. In looking this over, it didn't look good. The winds blew and they were too close together. So I took all them off, every other one. I think it looks better. I just kept track of what I take off in the area and reuse them. Since I did this patio with tabs, it's cooler in here for some reason. The heat doesn't get through the silver wall as much, I don't think. Somebody asked me about lightning. I think it might serve as a lightning rod. A friend came over for a cup of coffee a couple weeks ago. We were sitting in the kitchen and a bolt of lightning hit. Scared the hell outta me. I'm still alive to tell the tale, so it must've worked okay.

MY PLACE

I have been doing this for quite awhile. In fact, I've got a book about tabs that my daughter gave me on different clothing and stuff that you could make outta these rings by stringing 'em together. My work has been on WTMJ in Milwaukee. A fellow somewhere in the state said he had a spool a mile long of tabs, but he got on TV with 'em and he didn't have a mile. I probably have seven or eight miles; I wonder what they think of that?

Some of my neighbors are very nice, you know. I used to do a lot of pounding. For example, on the shed I made a pattern. I took pieces and put them on my work bench in the patio and worked on the boards. I pounded the tabs onto the boards. It was a little irritating to the neighbors, all that tap-tapping. People a couple of trailers down complained, so I tried to do it when they weren't around. I even did some of it in my daughter's basement over the winter. I can understand that it might get on their nerves. Some people complained to the manager last year. I wasn't even pounding last year, so I don't know what that was all about. I don't do any pounding now. But mostly they're all nice about it.

I don't think there'd be too many people that would copy this project to be truthful with you. I don't think kids would want to do it and not too many grownups. It's like the button man [Dalton Stevens] said, he works with his hands and has all these buttons and he loves it. The more buttons, or with me it's the more tabs, the better. I heard about a man in Houston

[John Milkovisch] who built a whole house out of beer cans. He's got the cans hangin'. I saw him on TV a while back. This was two or three years ago. He has a beer can house. They claim he drank all the different kinds of beer. He has 'em fastened like I did on the shed. I put a hole through and nail 'em with aluminum nails to the shed. He had the house covered with 'em and he also built a fence. He had 'em stacked on the fence and then he died. The news asked his widow what she was gonna do with it? She says, "I'm gonna recycle."

That's what my wife has told me more than once, you know. She's just as soon I'd get rid of the trailer, then I'd be home more. She told me, "If anything happens to you, Johnny," she said, "I'll recycle those suckers." Would ya care to make a guess on how many tabs it takes for a pound of recycling? One thousand per pound. That's why my friend said, "Go ahead and pull the tabs off those. If you get a couple thousand, you will have a couple of pounds. At least I'm doing something with them rather than them going into a landfill or having them get just dropped off and kicked around. I've had lots of fun working on it. I enjoy it. I even sit here and marvel at it sometimes, you know.

Is it art? I suppose if I wanted to use the term in a loose way. I don't know. I suppose it's a little artistic. Some people say I am outta my mind or I have to have the patience of a saint. I heard this a couple of times. This is what people say that come to see it for the first time. A lot of people drive by, stop, and come to talk. They're a little reluctant to come in. That's why I have a welcome sign up here. If I'm here, they come on in. That's the best part of it.

If I'm still around, I might do even more. Why not, if I've got someplace to put 'em? I thought about doing an entrance like the golden McDonald arches. I thought about that. It's a good idea. I thought about what I could put out there to be an entrance area. For example, a lady down here she's been coming to the park for about three years. She had a barrel of cans down at her place. So I dumped the barrel out and was pulling the tabs off and her three kids came over and asked if they could help me. I said, "You sure can or I'll be here all night." They brought their mother over to see my place. She had never seen it before. She also had a bunch of cans, so a little while later she brought me more tabs. Another time, a couple of neighbor girls came up from the lower road of the campground with more tabs. Another lady down below had a lot of company. Every time somebody new comes out she brings him or her here and shows 'em my place.

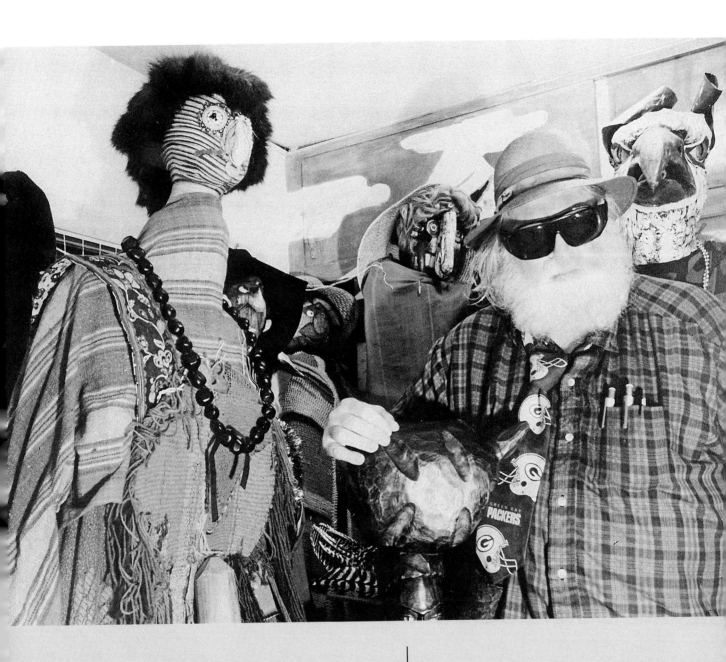

I have to somehow accidentally break through to
new areas a little bit. I don't know why I'm doing
it. Maybe I'm driven to do it or something.
Maybe it's what I like to do.

—BOB WATT

BOB
WATT

BOB WATT is an agent provocateur. For more than thirty years he has advocated the ridiculous and the outrageous with relish and enthusiasm from his art-filled home on Milwaukee's east side. Bob has published numerous small volumes of poetry and often goes to poetry readings at local venues. After his house and hundreds of artworks burned to the ground in 1993, he proceeded to do it "all over again." Bob says his art openly appropriates the work of Picasso, Van Gogh, and Gauguin. He read somewhere that Picasso produced more than 1,800 works over the course of his lifetime. So he has his goal set on topping this number. Bob somehow makes the things he touches uniquely his own.

PAINTING FAIRLY STEADY

I grew up in Maple Grove in Manitowoc County. My sister's an artist, and she wanted me to do a kind of abstract painting for her. I did one and the rest just kind of happened by accident. I guess that was maybe about 1970 or the late 1960s. So I painted for a while, then I quit for about four or five years. Lately, I've been painting fairly steady for about the last ten years.

Hundreds of paintings and totems fill every room of Bob Watt's house. A fire in 1993 destroyed hundreds more.

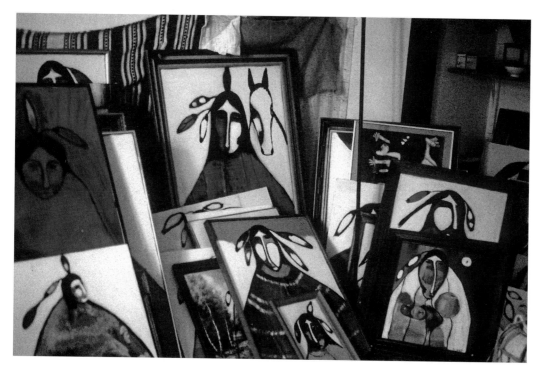

I went the last two years of high school in Manitowoc and afterwards joined the army for a couple of years. I was in Tokyo. When I came back from Japan, it was a real shock. People had been so nice to me over there. I stopped in Hawaii on the way back and I thought, "This is America, I kinda forgot what it was like." Tokyo streets were just packed. I could hardly walk a block. All these young girls came up to me and said, "Can I be your girlfriend?" My god, it was just like heaven there, you know what I mean? I wanted to sign up for more army time, but I was talked into coming back to school in Madison, which I liked an awful lot.

I took economics at the University of Wisconsin–Madison. I never looked for a job in that field for some reason. I just liked the advisor in the economics department. That's the only reason I guess I really took economics. After that I was in pest control for a while in Milwaukee. I was in the pest control business for thirty years, right here in Milwaukee from about 1950 to about 1980.

AVANT-GARDE THINGS

I never wrote any poetry until 1975. Then I used to write a little bit just for avant-garde things. Years ago, I was not interested in any art or poetry or anything. I was just a "wild Indian." That is how I would describe myself. There was a poet who used to live upstairs from me. When I had a place on the west side, we had a big house. He just lived in the attic. He was from Romania and he could speak four or five languages and he used to want to go to poetry readings.

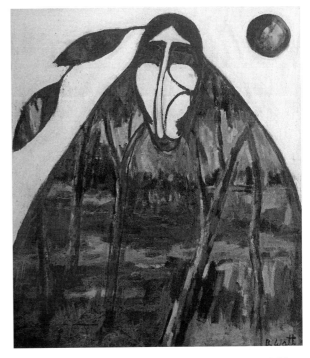

Bob frequently paints on canvases recycled from garage sales and garbage heaps. He usually incorporates existing visual materials into his paintings. Untitled, mid 1990s, 12" x 16".

One of the local disc jockeys at the time was in charge of it. This Romanian would say, "If I write a poem and introduce you, would you read it?" I said, "Well, all right!" I'd go over there with him. He'd always want me to write, but the first couple poems, he wrote and I read them. So I started doing that and then I started writing on my own and it was just pure accident. It's just that this guy needed a ride over to the poetry readings. Now, I have seven books published. I'm very fortunate I did a lot of poetry readings.

I'm the most published poet in the history of Wisconsin, as far as I know! But most of the time, I think poetry is generally boring.

I write about so many things. This one's called, "Signs on All Houses:"

Every house must have a lighted sign on the outside with the goals of the house on the sign. Be it commercial, artistic, religious, psychological, everybody failing with all these secretive goals in their head. Our present goals are so secretive, few can help us. Could more people freak out, yelling their most secret goals to the crowds that would gather to watch someone who had just freaked out? Don't be afraid to throw yourself on the mercy of the crowd.

Let me find another short one of some kind here. This is called "How to Rip-off a Dope Dealer."

Everybody's talking about being ripped off by dope fiends. I'm square, and I've ripped off a dope dealer for a FM radio for a month. He was arrested in a dope raid and assumed an artist had ripped off his place. He didn't expect an artist would leave anything after their raid. I reversed the usual procedure of being ripped off by dope dealers. Dope dealers are real jugglers of musical equipment on a small scale. They are not big businessmen, as the papers would like to pretend. Dope dealers can be ripped off by straight society.

That kind of gives you an idea that most of my poems are actual attempts at jokes. John Riley Publishing put out my books. He lives in Milwaukee and has a place up in Door County, near Ellison Bay.

PICASSO'S A WIMP

I had a house fire in 1993. Luckily, I wasn't there. It took the fire department fifteen minutes to get there even though they're only four blocks away. They got there in time to save the basement, as the saying goes. The water was high in the basement. They said it was the biggest house fire they ever had because I had nine hundred paintings, you see.

The water was cold as hell. The fire department wouldn't do anything to pump any of the water out. They said that they had no pumps. Well, I thought if you can pump all the water *in*, you should be able to pump it *out*.

A friend came to help but he practically froze to death because every time he'd dive in the water, it was about two and a half feet deep, it was completely dark. He had to keep opening the drain because all kinds of

stuff kept floating into it and blocking it. He did save some of the paintings, but everything else from the second and third floor went up in a big billow of smoke. Because of that I had a chance to start all over again.

I do things to please myself more or less. Anything I do, it's just pure luck, I would say. I know that's a very proper explanation of what is going on. I'd say my art is 99 percent luck and 1 percent planning. Nobody in his or her right mind would plan this! It doesn't make any sense. To go out and paint nine hundred paintings, and then to have them all burn, and then paint another five hundred, that doesn't make any real middle-class sense or involve planning.

For a while, I used to paint Egyptian paintings, but I haven't painted any of those lately. For a while, I made a lot of totems. I had 135 or 140 of them. I had some nice totems. Ringo White helped me make 'em. I don't have hardly any of 'em left. Most of them burned in the fire.

I like to make paintings, and I like to hear what people say about them. Everybody asks me how big my studio is, and I tell 'em, "It's two inches by a foot. Here's my

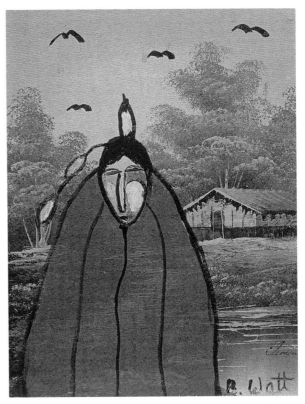

Found landscape with Bob Watt–style Native American, 26" x 30"

studio right here by my chair!" My other house was much bigger than this house. Sometimes I paint 'em right on the spot where I find 'em. That's all I can manage 'cause of all the rest of the junk in my house.

I like to sell my work. It's perfect! But it scares the bejesus out of regular people. They ask me how much and I tell them sixty dollars or eighty dollars. In America, almost all the money's spent on beer and cigs. When an artist tells someone eighty bucks for *art*, some folks almost have a heart attack. But once in a while someone will actually buy one for that much. Most people think the cost should be more like five or ten dollars. Art is not something people are used to seeing at the five-and-ten-cent store. They have no idea of what kind of prices they should pay.

I think Wisconsin art museums are doing a rather poor job of supporting Wisconsin artists. They won't buy any art from Wisconsin people. The artists that sell are from Michigan and everywhere else. Do people know Fritz Scholder and Georgia O'Keeffe are from Wisconsin? These are the leading people in the Southwest as far as selling art. I'm saying that that's Wisconsin

art. They went out there and they call it Southwest art when it should really be called Midwest art. Scholder had his first show in Madison, you know. They wouldn't even look at his work then hardly let alone buy any. They laughed at him.

I know about these artists because I read up on the ones I like. I like Indian art. I used to have hundreds of art books. A lot of them burned in the fire, so I don't have too many now. Other artists I like include John Nito, Malcolm Furlough, and Red Starr. I know a guy went out to the Southwest about twenty years ago and bought four Red Starr paintings for $250. Now his work sells for ten to twelve thousand bucks a painting.

I figure I paint about 350 or 400 works a year now, which I never did before. This house seems to have helped me in a way. I passed Gauguin and Van Gogh. They each did about 600 paintings. I have done hundreds more than that! Local citizens who'd thought of these artists as rather prolific should know that I have painted more than 500 paintings since the fire. Now, I call Picasso a wimp because he had 1,885 paintings when he died. Well, I've got that goal in mind, but I'm kinda stepping out a little ahead of myself by calling him a wimp before I actually have him outdone.

FEAR OF ART

I didn't always paint on top of other paintings at first. I foolishly or rather stupidly used to just paint on regular bare canvas. Or I would get other people's paintings and I would paint right over their work. That's the kind of thing that they teach in these art schools. I of course was somewhat influenced by that at first. Now, I'm ashamed of myself. But then I thought, "Why should I cover up the other person's work? He probably did it for a reason. Leave as much of it as I can." So, that's kind of what I try to do. I leave as much as I can.

Some people paint thinking that somebody would like to look at the painting. That's what I think. Maybe somebody might like to look at my work. Most people probably like one out of every hundred of my paintings.

I paint to drive away fear. I told a guy this and he said, "Well! They make me more fearful." So some of them make people more fearful and others drive some fear away. I'm basically trying to drive away fear of art.

There's a guy who claimed that the fear of art might only be in your head. I believe the fear of art could be a body reaction. When animals see some-

thing new, they jump back, and they run away a little bit. Then they come back and look at it a little more. If people are somewhat the same, when they see something new, it's kind of fearful and they can't accept it generally right away. The things I do are somewhat that way.

At first, critics reported how my poetry was "no good." Now that I've got lots of books, they say, "His poetry is good." These same critics changed their views because they got used to it. My poetry was a strange animal. I think painting is somewhat like that. I have to somehow accidentally break through to new areas a little bit. I don't know why I'm doing it. Maybe I'm driven to do it or something. Maybe it's what I like to do.

I think I'm breaking into new areas of art. There are a couple of Indian artists that paint quite a bit like me. There probably could be a hundred of them. I can't say. I'm all alone, but I'm working with the Indians and I think when you're an American you're supposed to "become an Indian." That's how the Indians became Indian. When they came here, they were Asians and they ended up being American Indians. So I think there's probably something here that causes me to become an Indian. I think with me, it was the area where I grew up. There were quite a few Indians who lived around me and I became part of it.

I just like Indian art. I can't explain it. It's sort of like—I like football. I've had a lot of influences. I feel that it just flows along with certain people and that maybe I have something to do with Indians—I'm working the best I can. I'm just in it for the fun of it. I never actually made any money on any of it, you know. Still, it's been said, I'm the scourge of Milwaukee. No matter where I go, I'm a very heavy threat.

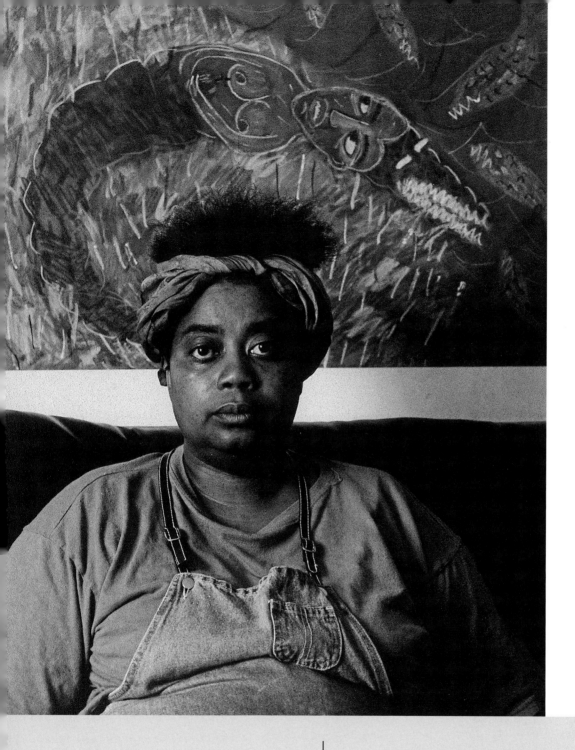

Della Wells, in front
of one of her Alligator
series drawings,
Milwaukee, 1996

DELLA WELLS

I think art should be pretty, but art also
should make a statement, too. It can be
controversial. . . . I like people to look, I mean
really look. . . . I want them to look and actually
see the people that I draw.

—DELLA WELLS

As a young woman, **DELLA WELLS** hoped to go to art school, but her dreams were temporarily derailed by the necessity of earning a living and supporting her young son. Today she is an articulate, well-informed, and well-read woman who has done considerable reading on African American artists, philosophers, and thinkers. Although she has earned her living in social work and mental health facilities, she is beginning to think of herself primarily as an artist. In 2004 she curated an exhibition called Sister Stories for the Walker's Point Center for the Arts.

DOING ART

My mother was from South Carolina, and my father was from Baltimore. I was born in 1951 and raised in Milwaukee. My parents married, and originally they were supposed to go to Chicago, but they came here instead. I used to look in my parents' old pictures. I like old pictures, history, and doing things in different times and places.

When I was a kid, I liked doing art. I always did like doing art, and I always did like to write. When I was a kid, I used to lay down and make a movie in my head. When I was a kid, I would color. For some reason, I didn't color within the lines, and my father used to get upset. Now I think I was saying something creative. Maybe I was saying that I don't want to be in the lines. When I got out of high school, initially what I wanted to be was a writer or fashion designer. Layton School of Art was where I was planning on going, but I got pregnant when I was seventeen. I was out of high school, and my father sent me to Mississippi. So I made a detour. For a while I didn't do art because I never saw art as being a practical thing to do. When I was in my later twenties and early thirties, I said I would do art when I got to sixty. I used to draw cartoons. I did a feminist strip called *Nine to Five with Miss Wells*. I was the central character. It took place in my office, and I guess it was my way of dealing with what I didn't like and what was happening in the office. I talked about a lot of political things like Newt Gingrich.

I do a lot of things about African, African American, and Haitian life and so forth in different time periods. I guess the reason I do that is because of my mother. She used to tell me all these stories about her growing up in the South. My mother was an orphan. Her mother died two months after she was born, and her father left her and her brothers. I think that's probably why she had problems. She was always talking about her childhood. She was

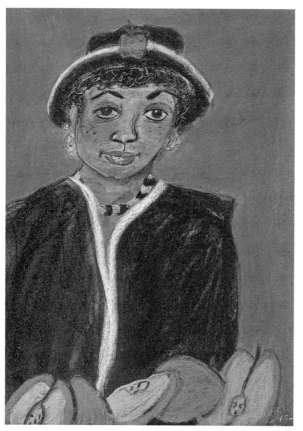

Della, 1997, pastel, 22¹/₄" x 30¹/₄"

raised by a woman who had a boarding school for rich black kids. She also took in children; my mother was one of those children.

I sometimes do contemporary women, and sometimes I do not do contemporary women. Sometimes I do pictures because I get pissed off at people. For example, at work, a kid was walking by and the kid spit at me. I know the kid really didn't know any better, that part didn't bother me. But it bothered me that a woman I work with didn't even acknowledge that I was being spit on. I thought that's really a heck of a thing to do to an African American woman, not to acknowledge it. So my roommate went and told her about it, and she said I'd have to get used to it. I said I don't have to get used to anything. So I did a picture. I made a picture of an African American woman grabbing hold of this white woman's hand and telling her she's not all that and this thing. I thought that was really important.

I have read bell hooks and Gloria Steinem. I think Frederick Douglass was a feminist—really. I took this course on political movements in the world. The teacher

Della's Death, 1997, pastel, 22¹/₄" x 30¹/₄"

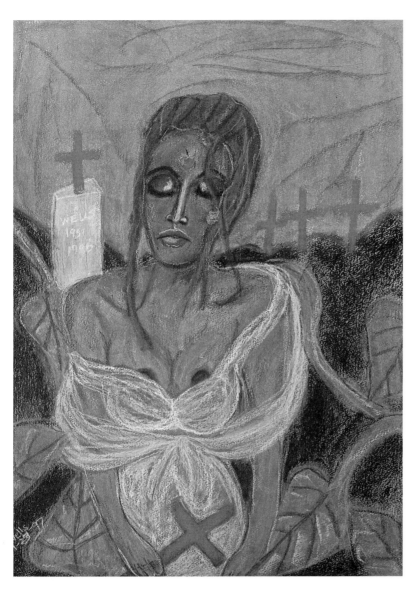

Mourning of Love, 1997, pastel, 30" x 22½"

made a point to have a section on African American women because he said a lot of black males had attacked African American women. He wanted to show that women were in the civil rights movement, constantly. I've learned especially that African American women were involved, like Ella Baker.

I keep thinking about how we can teach children about respect if we don't have respect for other people. I think that's very important. I think it's very important that we respect each other. Nobody has the right to be mistreated for any reason. We have children killing children. I saw in the news

that a twelve-year-old child killed this eighty-year-old grandmother. By not acknowledging everybody and saying that they are important, we throw away our elderly, we throw away our children. We're sending a message to children and young people that things are not important. I guess that's why I want people to look at my art.

A "FALLEN WOMAN"

I had drawings of a white Eve and a black Eve. One of the reasons I do Eves is because she has always been called a "fallen woman." We women kind of get the blame for everything that happened in the world. People really don't give any responsibility to Adam. There is, I think, a Jewish folktale where Adam had a first wife, and her name was Lil. The way I heard it was that he couldn't control Lil, and she was perceived as bossy. Probably if she had listened to him, she probably wouldn't have eaten the apple. But instead she listened to the serpent. So because he wanted somebody to be under him he married Eve. I do a lot with Eve for that reason. I don't think Eve was all that bad. It takes two to tango. They said she was weak, but I have to say Adam was the weaker of the two. It has nothing to do with strong religious convictions. It is more to do with strong political convictions rather than strong religious beliefs. I believe in God, but one of the reasons I deal with Eve is because of how religions portray women as dirty devils, and I don't think this is accurate. So I do African American versions of Eve.

MISCONCEPTIONS

One of the misconceptions about folk artists and "outsiders" is that they are supposed to be economically disenfranchised or illiterate. I went to the Folk Fest in Atlanta one year. I talked to someone from the Dean Jensen Gallery in Milwaukee. I asked him, "How do you get work in a gallery?" He said, "Well, first you gotta get discovered by the curator." I thought that was really crazy. I have to be discovered by a curator—like curators are out in the neighborhood. I just thought that was really ridiculous. The best way is to just do my art.

Evelyn Terry was really my initial mentor. I guess I should tell you how I got started. It was back in Milwaukee Technical College. I hated my job at Milwaukee County, and I said, "I can't do this, I just cannot do this any-

more." I know I have abilities to do more. I was really focusing on academics. My advisor said that I needed some humanities, so I took an art survey course. I liked art. I knew something about art. The artists that I had known about before were basically fine artists. I slept through a lot of courses but I did well.

I DO ART WHERE I CAN

A lot of people make art a lot more complicated than what it is. I had to do a paper on an artist, and I didn't want to do anybody like Rembrandt or Picasso. I wanted to do somebody local and I wanted to do an African American. I remembered Evelyn Terry. I had known her years ago when I was nineteen and she was at UWM in fine arts. There was a black art gallery called the Black Aesthetic, founded by an African American artist. A lot of the artists were young, just out of college. They founded this gallery.

I was planning to go to the art institute in Maryland or Pratt, but I got pregnant. Evelyn remembered that I used to do these weird drawings, years ago. I liked to draw baldheaded women with babies coming out. She says, "You should do them again," because I was planning to be a psychologist at the time. I said, "Yeah, right." She kept saying that I should do drawings. I told her artists don't make money from drawings. It is not a real profession. Three years later, I transferred to the University of Wisconsin–Milwaukee. I took an African religion course with Dr. Smith. It was very interesting. The course talked about Haitian religion, voodoo or voudun, and various other religions. It also focused on African-based religions where everything is interconnected, such as nature and man. It talked about respecting your ancestors and so forth.

Evelyn invited me to an art show. I felt moved because the show was basically a lot on Haitian religious work and Evelyn had pieces in the show. She had a lot of dolls. About three weeks later, I went to her studio, and she gave me some paper. I started drawing. She took the paper away and said, "You draw too good." I drew my first picture with these two women and snakes. I also do a lot of crocodiles. So I started drawing and I got the bug. A friend said if I got fifty pieces she would get me a show. So I started to make more work. I did a lot of work.

I do art where I can. Sometimes I go into my friend's studio. I used to do it at home. I'll do it on the bus stop. Sometimes I'll do it at the boys and girls

club. I do it when I can. When I was working third shift, I would do small things there. I do it when I can. I was really happy during this time and sold about three hundred dollars.

I LIKE PEOPLE TO LOOK

This show led to other exhibitions. A woman in the women's studies department was on the board of a 9–5 organization. Its women's resource department wanted to showcase women artists, so I had a show there. Later on some people contacted Evelyn at UW–Madison. They had a show called the Africans in America, and they were looking for some artwork. This year I was kind of proud to be in this show put on by the Milwaukee Inter-city Arts Council. They had a show on self-taught and folk art in Wisconsin. It was really a wonderful exhibit: Sherry Carolyn Holland, Reggie Kay, Prophet Blackmon, Simon Sparrow, and Reverend Josephus Farmer, who's now deceased. Most of their work is nationally known. Darrell Kolman's stuff revolved around the Yoruba African-based religion. I have studied African-based religion. I have a strong interest in southern folk art. So that's one of the reasons I do the art I do. Another woman artist named Rosemary Ullison was really phenomenal. I actually feel a kind of bond with Rosemary because her work is about women also and about her experiences. So it was a real nice show.

Occasionally, Evelyn and I and other artists get into discussions about what constitutes folk art and self-taught art. A lot of people have a notion that it's primitive, and there's a wide range. It's like fine art, really. There is a wide range that really can't be pigeonholed. That's one of the things so interesting about the show. These people said that some stuff was just too good.

I decided maybe about three or four years ago, when I wanted to be a psychologist, I really didn't see any use for African American studies. But from working in social service agencies and just finding answers to certain things, I began to realize it was very important that I understand other standards in people and not just African Americans. I don't care if you're talking about Russians, Vietnamese, Native American, women, the elderly, middle-aged people, or children, we need to understand certain things about culture and how it affects us. I myself do a lot of things about what it's like to be a woman in America. I'll deal with sexual issues and I deal with religion.

Usually I don't talk about my work because I always say it's therapeutic, but it's really a cop-out because I really don't want to talk about myself. I'd like to say it's therapeutic and leave it at that. I don't want to give people preconceived ideas of what this means. Some things have deep meanings, but some don't. If something's beautiful or if it's different or whatever, I don't think we should overanalyze it. When it comes to art, people have a tendency to overanalyze it. I really don't talk about my art a lot, because people get all these preconceived notions. I would love to hear Picasso, Rembrandt, or somebody say, "I did it because I spilled the paint!"

I was introduced to fine art before I even knew that there was such a thing as folk and self-taught art. As far as European-based artists, the ones that I like the most are Matisse, Picasso, and Van Gogh, because of his colors. As for African Americans, I like Romare Bearden, who was one of the first African American artists that I saw when I got educated. I think his work is phenomenal. Back in the seventies, Robert Wright, who has bought some of my work, bought a Bearden. I had read that you could probably pick up a Beardon for about four to six hundred dollars back then. You can't do that now! I also like Charles Lange, and Faith Ringgold is another one of my favorites.

I don't particularly like the term "black art." By reading books I have found out that the term "black art" is significant because African American artists, prior to maybe the late nineteenth century or early twentieth century, were not recognized for their contribution to the art world. Artists primarily painted European, white people. There were several reasons, including that African Americans didn't have the money to buy art. During the late nineteenth century, people like W. E. B. Du Bois were instrumental in forming the Harlem Renaissance. Alan Watt and Jacob Lawrence are my favorites. They were encouraged to paint folk styles and African American styles. That sparked my interest, too. When people overgeneralize using the term "black art," it kind of ticks me off. For example, one guy asked me, "Well you're doing black art. Is it like the art in Bill Cosby?" I said I thought it was my own style. Bill Cosby, he's an artist and lecturer, too, but art is so much broader than that.

I read a book about Palmer Hayden. A lot of African Americans hate his work because he drew African Americans with exaggerated lips and stuff. My friend Evelyn got a call from a large insurance company. They wanted

some art by African American people. They took my work and her work and the work of this other artist named Myron Tate. They said it was "too black." The features were too black, the tone was too black. They bought the work of a white artist of black people. Why would you contact African American artists if this is not what you wanted? It's not that I feel they should buy my work. I felt they had the right to buy what they wanted. Our work was about diversity. Maybe they wanted an older person, like Lena Horne or something like that. They say, "We want African American but we want things in a pattern." I just found that amazing! From now on I'm going to make the lips bigger, the noses bigger, the skin darker. Because I think it's a statement. I don't think an artist should succumb to popular beliefs. I'm also very fascinated with color and with brush strokes. I like the color to look like color. I suppose I could draw more realistically, but this is a decision that I made.

With the National Endowment for the Arts under attack, people like nice little-faced pictures. I think that a lot of the stuff that we think today is nice and safe a lot of people didn't think was nice and safe back years ago. I think art should be pretty, but art also should make a statement, too. It can be controversial. I think a lot of folk artists, they don't seem to be shutting out the message that they experience. I do a lot of expressive ideas. I like people to look, I mean really look. I don't want them to just look and say, "Oh that's nice!" I want them to look and actually see the people that I draw.

TEACHING KIDS ABOUT ART

I teach art during the summer at a boys and girls club. I didn't take it for the money, because they sure are not paying enough money. I think the creative spirit has to be nurtured. It takes lots of nurturing with kids. I say, "It's okay to do it this way," or "It's okay, don't feel that you can't do it, just try." I just find that interesting. In my other job, I work with emotionally disturbed children. Those kids are really good creatively. I say they have so much inside them that they have to get out. They do wonderful stuff. I like kids' art. I worked a lot in children's art. I love children's art. They're not tampered with. It's just wonderful!

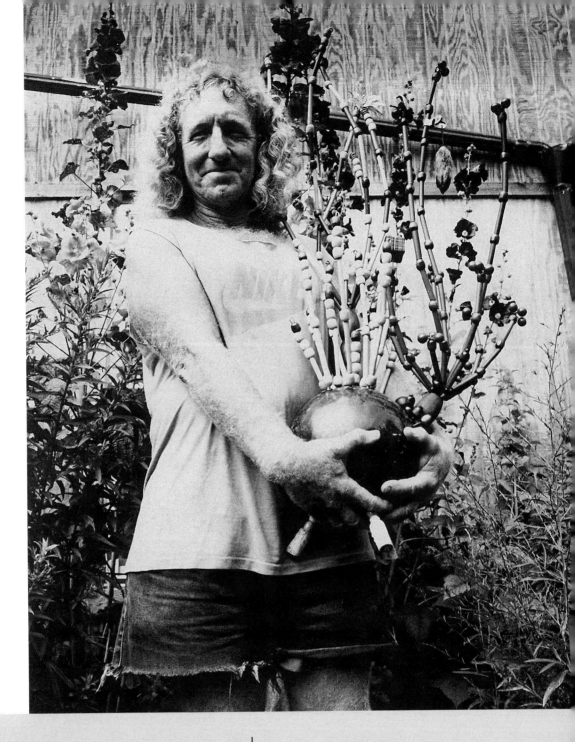

Mike "Ringo" White, in his backyard in Milwaukee, 1996. He is holding a sculpture made from a bowling ball, wooden beads, and wire.

A lot of people liked my work so I decided, "Well as long as people like 'em, maybe I should make 'em for other people to appreciate, too."

—MIKE WHITE

MIKE "RINGO" WHITE

Beach glass, plastic jug lids, driftwood, discarded bowling balls, and children's sleds are only a few of the discarded materials that find their way into the inventive constructions of Milwaukee artist **MIKE "RINGO" WHITE**. The ceilings of Ringo's home are reminiscent of wildly colorful stalactites, each a wire stacked with debris collected on bicycle trips to the Lake Michigan beach and along city streets. Ringo sees lots of potential in curbside refuse and garage sales. He enjoys being outdoors, and his bike rides to collect materials have become a favorite adventure in his daily life when weather permits.

GROWING UP

My dad was a machinist in Milwaukee. My ma worked in a restaurant and in a factory where they made things out of plastic, like signs, displays, and ads. My brother is into computers. One of my sisters is an artist. She's more into drawing, painting, and stuff like that. She is good with her hands and actually does carpenter work now. She can get up there and pound a nail in better than most of the guys I know. I've been to Florida quite a few times, but I basically grew up in Milwaukee and have lived here almost all my life.

When I was a kid, I would draw and paint mostly. I was always picking up rocks and stuff when I was younger. I had these big boxes full of rocks. I thought, "What am I gonna do with 'em?" One year my ma passed away, and I left 'em all over at the neighbors' to use for their rock garden. I took the best ones that I could carry. I plan on making them into artwork. I have always collected stuff, but I never really got into collecting the real junk on the street until I met my friend, Bob Watt. That is when I started picking up things off the street. I already knew where to look for stuff at the lakefront.

ROCKS AND STUFF

I used to just do paintings and sculptures and little things. Now, I go out and find stuff. My friend owns a big house and has all kinds of sculptures he had made out of stuff he got at rummage sales. He found a lot of it just going around "junking." I kind of copied some of his ideas. He got me into the idea of using anything I could find. He picks up cans of paint, wood, plastic, cloth, and other things. Sometimes he goes to these rummage sales and gets the same kind of things. He'd rather get it for free. He picks up wood, two by fours, and pieces of plywood and makes these Indian sculptures out

of them. I was helping him do those, and I thought, "Gee this is a neat idea. Instead of just walking around the streets doing nothing, I might as well pick up some stuff."

I believe if I am going to pick up something, I might as well make use of it so other people can appreciate it, too. Why just throw it away? I think about recycling. I see the plastic bags people use for groceries blowing around all over the place. I snatch them up and then I have something to carry the glass or bottle caps when I am riding my bike around. It's better than leaving them blow around the street.

Picking up stuff off the streets is one of my favorite things to do. I like riding my bicycle all over town and picking up whatever I can use for my artwork such as plastic bottle caps, blue glass bottles, or if I'm in the mood, I'll pick up wood and make off with it. I usually need wood for the back of a piece or for the frame. Most of the wood on some of these collages, I found on the street. People throw it away. I spend a little bit of every day picking up stuff and looking around. Hopefully I'll be able to keep doing this kind of thing when I'm seventy or eighty, if I make it that long.

I get ideas from the stuff I have on hand. I'll start with a piece of cardboard and put a frame around it. I find slats from snow fences and I'll pick 'em up. I'm not gonna break 'em myself. That's not right. But I find 'em broken or I find lathes from houses where they're doing work. I pick those up for frames. I found a wooden ball on the beach. I might put beads onto it with nails. I might use a piece of depression-ware glass. I might attach beads to a cork or use broken glass in there. I might take a piece of driftwood and hook beads into it. Here's the bottom of an old Coca-Cola bottle, says "Milwaukee" on it. I have pieces of driftwood, broken mirrors, plastic, bottle caps, and more. I use a lot of stuff. All of this stuff I picked up off the beach and the street. I even had a piece of the old Ambrosia Chocolate Company. Some of the tile broke off outside the building before they tore it down. I picked it up.

I remember stories of where I find some of the stuff, but mostly I can't remember where I get it. For example, here's a big giant fishing bobber, cigarette lighter, and plastic cap. Most of this came off the beach. I look for things that are clean and that I can change in some way. What I like to do in the summer is to go down to the lakefront and find colored glass and plastic bottle caps that have washed up on shore. Most of it's kind of rounded off so it's safe to handle. Every now and then if I find the right color glass,

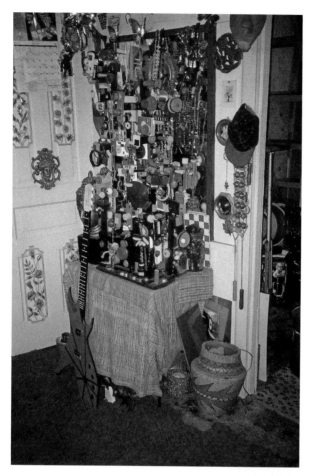

Found materials sculpture in the corner of Mike's living room. Much of the interior of his house is filled with collages and hanging sculptural installations.

I'll even pick it up when it's kind of sharp. Blue and red glass is really hard to find. There are certain areas where I know I'm going to find it. Usually I look for green, brown, white, and the clear glass that is rounded off. The beach is the main spot for glass. People also leave a lot of stuff on the beach. I'll pick it up and if it looks clean enough, I'll use it. I have really good luck finding great stuff, but I gotta look carefully. I walk around and look for things after it rains. Stuff's just buried in the ground. The rain washes the dirt away and I find things lying on top of the sand.

I find so much stuff on the beaches! Baby diapers, broken glass, condoms. It's not right. I could forgive people for dropping a bottle, but why break them? I find glass purposely smashed. The other day I was walking in the water at the beach and I stepped on something that was in the seaweed. I couldn't see it, but I knew right away it was a bottle. The top was gone and luckily I didn't put my weight on it or it might have broken. I like working with glass the best. It's sometimes dangerous. The glass is the prettiest. I also really like plastic and rocks.

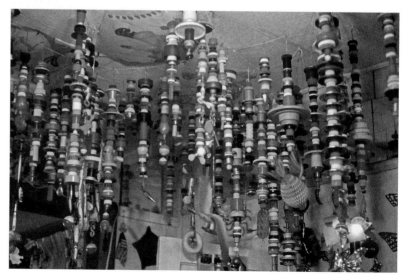

"Stalactites" made from discarded materials hang from the ceiling.

The plastic bottle caps I find on the lakefront, especially after the wind has kicked up the water, especially on the south side of Milwaukee. People toss them into the several rivers running through Milwaukee. You can find almost every color in plastic. I used to work in a plastic company where they made caps. I never thought I'd be using them for something like this. I had a whole bunch of these caps, and I didn't know what to do with them. I wound up giving the caps to the neighbor kids because they liked them. If I had known I was going to make artwork out of it, I would have hung onto them.

Collage, c. 1996, plastics and mixed media, 24" x 26"

I get pieces of foil from Christmas and Easter candies. I find PVC pipe that's green, especially after it is busted up and I find it in the lake with the edges rounded off. It comes up on the shore. I find green cement and the old red cement that they've put little white pebbles in years ago. Some stuff looks like a piece of sandstone from a build-ing. Some of the buildings around here got torn down and have red sandstone in 'em. I use pieces of marble from a building. I use natural rock, floor covering, linoleum, broken glass, broken chinaware, car window glass, and glass from a building that was torn down. I ride my bike and pick up this stuff. Sometimes I find fossils.

I also found celestite crystals. The city was digging a deep sewer tun-nel. They hit celestite. They dumped it as fill on McKinley Beach, and I went in there and picked it out. I've studied rocks but on my own mostly. I took a couple courses at school. Every now and then I'll find stuff like that around here. During the ice age, glaciers came down from Canada and brought rocks from Hudson's Bay. Every once in a while, I'll find Lake Superior agates.

I have to clean things a lot of times in real soapy water. I clean it, sort it, and put it in boxes and jars. I like to sort things, like these bingo chips. I found them at a rummage sale. When I find more, I just put them in the jar.

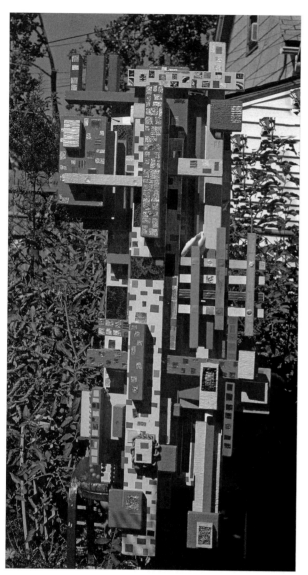

Collage sculpture, 1998, found wood, paint,
19" x 47" x 18"

Usually, I don't spend too much. Sometimes I get a third off or something at the Salvation Army because the lady knows me. When I go junk collecting, or if I get something I don't need, I take it over to the store and they give me a good price.

GETTING STARTED

When I first started making collages they were real simple. I started in 1985 or '86. Now I use more beads and things. I go to rummage sales when I need beads or I'll get a bag full of beads at the Salvation Army. They're pretty hard to find on the streets. I'm trying to use better quality materials so that they don't fall apart. I use white glue to secure the pieces and a clear acrylic glue to make them waterproof. If I don't think the white glue is gonna hold the way I want it to, then I take polyurethane and put it all over the top. It's like putting clear plastic over it.

Usually I just start putting a collage together. Once in a while I get an idea first. Most of them start out like as an accident. I don't want my collages to get too cluttered. Some of 'em I overdid. But you know what's neat? I can always take some pieces off of it and get it down to where it should be. Mostly I just make 'em for my own satisfaction. I know other people like 'em so I make them for other people, too. Now, when I'm working on my sculptures, I usually listen to TV or music, when nobody's around. If somebody's here, I'll talk to 'em. I just sit and work on it.

I call the things hanging from my ceiling "stalactites." I don't know what else to call 'em. I started making the stalactites a little bit here and there. I find lots of cigarette lighters. I take the top off and make sure there's no fluid left in them and then I put a screw in to tie on a string. I use the lighter for the bottom of the stalactite and stack up caps on top of the string. I drill holes through everything that goes on the string. I had all these canning lids in my attic, so I decided to make some strings out of those. An art dealer has sold them at a gallery.

One time, I found a bowling ball on the street. Somebody left it on the street, and I was afraid it was going to roll down the hill into North Avenue. You can dribble bowling balls! They don't have as much life as a basketball, but if you hit 'em hard enough they'll dribble. Bowling balls are real hard. I used a drill to put holes in it and then I inserted some strings of beads.

One particular time, I went searching in winter for scraps of wood at a beach down in Cudahy. It was 10 to 20 degrees outside. I was looking for stuff and poking around through the snow. It was a cold day. For some reason, I found a spot where it wasn't so icy. Sometimes that beach gets all covered up with ice. I picked up a bunch of wood. Some of the wood I found was lying around in a street. It's hard to remember. I pick up a lot of this stuff in the middle of winter. The winter's better 'cause the waves are big. The water goes down in the winter 'cause there's not so much rain and stuff going in there. The lake has a seasonal up and down. It gets lowest in February or so and highest in the summer. There's a regular rhythm to it. If you go down there in the winter, more of that stuff is exposed provided it isn't all frozen. Of course, if there are big piles of ice then I can't find anything. During the winter, I'll spend five or maybe six hours a day making my artwork.

I usually don't do much art in the summer 'cause on a nice warm day, if I don't have to work, I'd rather be down at the lakefront. But I'll do some work for maybe an hour or two a day during the summer. If we get a real rainy day I might spend a few hours working on it.

Back in 1987, some people liked what I was doing, so I started selling some and giving some away. In 1988 I had a little art show at the Wright Street Gallery [now closed]. I don't think anybody bought any of my work at that first show. It was set up for several different artists at once. A lot of people liked my work so I decided, "Well, as long as people like 'em, maybe I should make 'em for other people to appreciate, too." Pretty soon I had so many that it got to the point where I couldn't make anymore 'cause the house was full. I moved into this house in 1990. I had a lot of pieces, and I was selling them a little at a time and giving 'em away. So now I make stuff because I might sell them. It's better making art than working full time at something I don't want to be doing.

CENTRAL WISCONSIN

Central Region

Central Wisconsin encompasses Madison and the cities surrounding Lake Winnebago. Madison is home to both the state government and the University of Wisconsin. In 1996, the city was chosen the number one place to live in the United States by *Money Magazine* for reasons most Madisonians already knew: quality of life, beautiful physical setting, good available health care, a booming economy, and an excellent education system. Madison is situated on or near four lakes, and the city itself occupies an isthmus between two lakes: Mendota and Monona. Madison is a rapidly growing city in part because University of Wisconsin students tend to stick around forever and become part of the fabric of the community.

Madison, along with Sheboygan and Milwaukee to the east, is a repository for the arts in the state. The Wisconsin Arts Board, Madison Museum of Contemporary Art, Wisconsin Academy Gallery, Overture Center, Elvehjem Art Museum, Edgewood College, and Wisconsin State Historical Society all recognize traditional and idiosyncratic art and artists. The University of Wisconsin–Madison offers courses in folklore studies with other departments allowing research overlapping into their fields. The State Historical

Summer in Wisconsin, near Hollandale

95

Sid Boyum created a sculpture-filled garden around his east-side Madison home from the 1970s until his death in 1991. Arts advocates have placed many of his sculptures in park areas on Madison's east side.

"Cream city" brick, like that used in the Columbus City Hall, is common throughout small towns in central and especially eastern Wisconsin.

Society Museum in Madison has an extensive collection of prehistoric and historic artifacts and an excellent resource library.

Madison is also important because it draws more mixed populations and ideas than many other parts of the state. It is arguably the most progressive area of Wisconsin, both in politics and in embracing colorful and diverse ideas. Simon Sparrow was a street preacher in Madison for many years and was able to make both his art and proclamations with the support of the university community. Carter Todd did much of his drawing in local coffeehouses and enjoyed the admiration and companionship these public places allowed him. Mona Webb

and Sid Boyum thrived for years within the spiritual and intellectual freedom of Madison's east side, a community that encourages alternative and challenging ideas and practices. Occasional resident in the Madison area, Guy Church draws hauntingly powerful images of innocence and isolation.

In contrast to Madison, the rest of central Wisconsin is shaped by a more traditional reality. The southern half is primarily agricultural, and large farms have taken advantage of the landscape flattened by the glaciers of the last ice age. Some of the richest farmland in Wisconsin is just north of Madison in Arlington Prairie, now in danger from the urban sprawl creeping out of Madison. Germans, Danes, Norwegians, and other European immigrants heavily settled this part of the state. By the end of the nineteenth century, over 60 percent of the populations in many communities were of German descent, a statistic that explains the popularity of Wisconsin's trademark beers, bratwursts, polkas, and sauerkraut. Locals refer to a zeal for hard work as the "German work ethic," although other ethnic groups have been equally industrious.

Simon Sparrow preaches on Library Mall, University of Wisconsin, 1996. (photo courtesy of Erik Weisenberger)

Architecture in central and eastern Wisconsin is the oldest in the state because of early settlements and development along the rivers. Several historic sites showcase early state history. Portage is home to the Indian Agency House (1832) and the Surgeon's Quarters at the site of Fort Winnebago (1823). Other public historical sites in the central part of the state include Old Wade House (1850) in Greenbush, the first kindergarten (1856) and Octagon House (1854) in Watertown, Tallman House (1854) in Janesville, and Milton House (1844) in Milton. Visitors especially interested in architecture can explore Old World Wisconsin in Eagle, a collection of some fifty houses and farm buildings (1830–1880) that were reassembled at the site.

Modernization and urban sprawl has caused the loss of many historic buildings; on back roads and in small towns many beautiful old homes, commercial buildings, and farms still grace the landscape. Buildings made with "Cream City" brick (cream in color) are everywhere in this area and east to Milwaukee.

In Stoughton, rosemaling, a Norwegian style of traditional decorative painting, is available in local shops. Restaurants serve lutefisk (salt cod) and lefse (potato bread), and the town turns out to celebrate Norwegian Independence Day on May 17. The Signature Gallery in Stoughton occasionally shows the work of artistically unschooled artists from the area. Nearby Cooksville, whose population is primarily of Irish, Scots, and English descent, is a tiny,

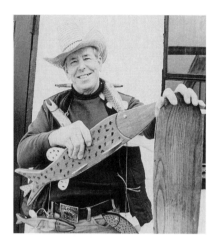

Jake Schroven, Stockbridge, carves fish decoys used in ice-fishing for sturgeon. Jake also sells his decorative fish to collectors, c. 1992.

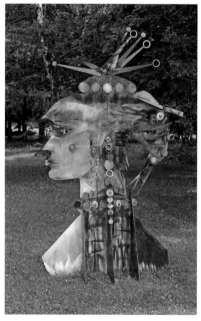

Lester Schwartz, Gloria Hills yard environment, date unknown, near Green Lake

well-preserved town with many buildings on the National and State Historic Register. One of Dr. Evermor's welding studios is in this area.

Near Lake Kegonsa, windmills made of old detergent bottles and discarded bicycle wheels are produced by the inventive imagination of Les Morrison.

Interesting Native American sites and museum collections abound in the south. Aztalan at Lake Mills was a community of perhaps five hundred around 1200 A.C.E. The site contains several mounds as well as a reconstructed pole and log enclosure. Fort Atkinson has an intaglio earthwork in the shape of a panther, as well as many raised mounds. The Hoard Museum in Fort Atkinson houses a collection of rare books on the Black Hawk wars and a sizeable collection of Native American artifacts from the area.

The northern half of central Wisconsin is dominated by Wisconsin's biggest inland lake, Lake Winnebago, and the cities that surround it: Fond du Lac, Oshkosh, Neenah, Menasha, and Appleton. These cities and other small towns surrounding the lake have beautiful parks and lake access that allow boating, fishing, and recreation. Lake Winnebago, home to many game fish, is especially known for its lake sturgeon. Sturgeon, which can easily grow to five feet long, are bottom feeders in the murky lake and fisher-people must lure them to the surface with curious-looking decoys. February sturgeon ice-fishing season finds hundreds of homemade ice shanties scattered over the frozen lake, some creatively designed and painted. A few taverns near the lake sell hand-carved wooden decoys, some with flamboyant color schemes and added textural adornments such as bottle caps and sequins. In recent years, many local fisher-people have begun to use commercial lures or curious plastic objects like toys or detergent bottles rather than the traditional wooden decoys, although several local carvers still produce well-crafted traditional art objects.

The western side of Lake Winnebago, the Fox River Valley, is highly industrial and manufactures lumber, paper products, heavy machinery, and foundry goods. The Paine Art Center, Oshkosh Public Museum, and the Experimental Aircraft Association (EAA) Air Adventure Museum are interesting stops on road trips in this area. Each July the EAA hosts an annual fly-in, a huge event for antique and modern airplane fanciers.

Just to the west of Lake Winnebago is the community of Green Lake, a beautiful small town that sports spectacular summer homes built by Chicago tycoons at the turn of the century. Green Lake is home to environment

builder Lester Schwartz and the Green Lake Music Festival. Lester Schwartz, like Mary Nohl (see eastern regional tour), was educated at the Art Institute of Chicago. He also studied at the Imperial Art School of Tokyo and American Academy of Rome. During his busy career, he knew Frank Lloyd Wright and Picasso and founded the Art Department at Ripon College. Schwartz's work has been exhibited nationally and internationally. In his late seventies, he concocted and built Gloria Hills, a landscaped sculpture park on 260 acres overlooking Green Lake. With the help of numerous assistants, he scavenged materials such as beer bottles, garbage cans, musical instruments, and convertible automobile bodies, and created huge structures for the park. Surfaces were brightly painted and adorned with found metal bits. Joyous metallic damsels cavorted on horseback in a circuslike environment.

North of Wisconsin Rapids and its Wisconsin State Cheese company is Rudolph township, one-time home to Father Philip Wagner. Wagner was born in Iowa in 1882 and as a young man traveled to Austria to prepare for the priesthood. Falling ill, he sought divine intervention at the Our Lady of Lourdes Grotto in France. Upon his recovery, he returned to the United States and in 1917

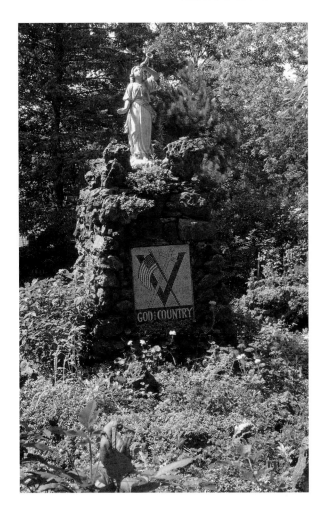

Top: Rudolph Grotto and Wonder Cave, 1928–1950s, landscaping and building by Father Philip Wagner and Edmund Rybicki
Bottom: Detail, Rudolph Grotto and Wonder Cave

Entrance to John and Doris Sroka's folk art business near Fremont, 1998. John's death in 1998 prompted longtime customers to buy up most of the couples remaining carvings. Doris and her daughter Marsha Parse hope to continue the family business with Marsha doing the chainsaw work.

was sent to Rudolph, where he started to build the Rudolph Grotto and Wonder Cave. His environment, more naturalistic than previous grottoes constructed around Wisconsin, grew to include shrines, numerous landscaped areas, and a cave that dripped water.

Nearby at Fremont, Doris's Folk Art once beckoned travelers into the Crystal Forest, an explosion of chainsawed wooden creatures that overflowed from the Sroka family house and workshop. The carved figures coincided with more than twenty children's books that the Srokas wrote when carver John was alive. Tony Flatoff's Fan Fair, a whimsical whirligig of wondrous scale, is found on the outskirts of Stevens Point.

Six miles from Green Lake, Ripon is home to a building now known as the Little White Schoolhouse, which claims to be the founding site of the Republican Party in 1854. Princeton, a tiny town just to the west, is home to a hugely popular flea market where collectors can browse for antiques and trash treasures. The painted childhood memories of Loretta Sylke were on display at her gallery near Princeton until her death in 1999.

The area to the south and west of Lake Winnebago has been the home of many folks who make interesting things. In 1977–1978, many of these artists were represented in Grass Roots Art: Wisconsin, a seminal exhibition hosted by the Madison Art Center, John Michael Kohler Arts Center, and Priebe Gallery, Oshkosh.

Next page: Guy Church's work table

The story is not printed in words; it's what I want
to think about it. That's kind of what I'm trying to
do. To get people curious, to make them think.

—GUY CHURCH

GUY CHURCH

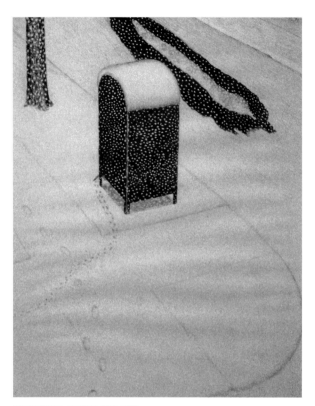

The Delivery, graphite, 25" x 19"

GUY CHURCH is a shy private man. He developed an avid group of collectors for his drawings in Madison, where he lived for many years. Guy had a much admired exhibition at the Wisconsin Academy of Letters and Sciences in 1994. Soon after, Guy left Madison and eventually moved to Memphis where we were able to interview him and photograph his work. It was Guy's wish that we not photograph *him*.

MY MOST FAVORITE THING?

I started drawing about '86. Some of my drawings I work on for three or four months, the bigger ones. I don't have very many color pencil drawings, mostly just charcoal. Sometimes I draw all the time, and then sometimes I get busy with something else and don't draw for a while. I like drawing a lot. I don't know if it is my most favorite thing. But drawing is a soothing kind of a thing for me. For the past several years, I have been developing myself as an artist. Being an artist is still a struggle for me.

I always admired great works of art and poems. I used to know some of the famous artists that everybody knows like Rousseau, Chardin, and Rembrandt. When I first looked at books in the library there were so many artists, I couldn't really pick one out. I liked people subjects best. That's what caught my eye. Somebody doing something that wasn't written on the page. I mostly studied paintings. I didn't really get into other things like sculpture too much. So I just decided to try to see what *I* could do.

BREATHING LIFE INTO THE WORK

I could never draw before I started working at it. I just pretty much picked up a pencil and drew. I do mostly charcoals and some colored pencil and sometimes I try some other things. I don't think my drawings have changed a whole lot since I started. I think I learned some new things. For example, you'll find the person in front is usually bigger in proportion. My first drawings were kind of crude. They kind of got better as I had more practice. Sometimes I stopped drawing for a while and then came back to it. I went

for weeks without drawing, but I think I missed out on something. I was kind of lost. I had to learn it all over again. I worked at it and felt pretty much that it was finished when I got a page colored. There's only so much I could do to it, if I overwork it, then it was ruined.

My drawing has developed since I first started, and I am aiming for the day when my drawings will match the vision I have in my head. Never having had any classes in art, what you see in my art is what I am offering to my art. It is my own contribution and this is how I wish it to be.

Most of the time I work on just one drawing until it's complete. I might work on a drawing about a week, maybe ten hours a day. In smaller pictures with less surface area, there is the same amount of detail and it can take a long time. I think that sometimes the kind of things they need are some empty spots. When the day is done, it gets dark and you don't know where it went.

I mostly just work on an idea I have for a subject that I want to put in the drawing and make it. The places that are depicted in the drawings I just make up. I know what a tree looks like. I know

One Horse Powered Dog, colored pencil, 22$^1/_2$" x 15"

The Side of the House, graphite, 14" x 8$^1/_2$"

Pile of Books, graphite, 16³/₄" x 13¹/₈"

what a house looks like. I use houses and with birds, squirrels, and chipmunks and all that. You know drawing is creative and forms our culture. It kind of defines or distinguishes American life from other countries. It's who we are. It's kind of important to me. I think that's kind of what I've always been trying to do. My art is about people. People may not always do such magnificent things, but in them is a very special wonder that is an artful thing. This is my vision and I hope that you can see it in my work.

I sometimes look through library books to get an idea of what I want and I draw from there. I didn't take classes. I drew in the public library. I sat up there and drew.

I was living in Madison then. I started with nobody in particular, just people subjects, somebody doing something interesting, somebody carrying something. But I almost never really looked at a reference or anything. I pretty much just tried to make it as best I could. Sometimes I just draw a picture from the beginning to the end. Sometimes I work out a special problem to develop an idea.

When I start, I have the idea that I want to put into the picture. I work on it and that's the way it turns out. I wouldn't say ideas are the most important things. There are all kinds of things that go into a drawing, the subjects, their positions, and the angles, and all that. They're all kind of important. My idea may not be that concrete. A lot of it depends on what I am thinking too. As long as there's something there that's for you. I have titles for most of my drawings. Sometimes I change them around a little bit after I finish the drawing to get the best name.

I have pictures that turn out that are satisfying. For example, the drawing *The Side of the House* is a typical subject of mine. The little girl is out in back of her house wandering around the corner. I tried to make the bushes and sky dark to get the idea across that the background is in darkness. The fair complexion of the young girl is set against the darkness as her hair is blowing by itself. I have the house lit up by the porch light. The idea I had is the girl is going around the side of the house.

I like the subject of people and who they are and what they do. I like the idea that people in pictures can breathe life into the work. There are all kinds of tricks that I can do with art to show how people live—who they are—and that kind of thing. Some parts of a drawing might not be satisfying. The position of a head, an angle I wasn't familiar with might come out kind of strange. Eyes kind of bugging out, a nose might be a little pointed. But if I try and correct all that, I have to change the whole picture around and that would mess it up. The ideas I have in mind for the subject and the story are not printed in words. They are what I want to think about it. That's kind of what I'm trying to do, to get people curious, to make them think. I try to suggest that there's something that's not printed on a paper. There's a story with the people. Whereas if I am just looking at trees, rocks, or something, I don't quite get that same idea of a story. I pretty much just try to invent a face that looks like the person in the story I have in my mind. I ask myself, "What is she thinking about?" Well that's kind of up to the viewer, I guess. She's not a real person. She's a picture. For example, in the drawing *The Pile of Books*, the girl is a bookworm. She's piling a big stack of books up on the table, and she's digging through them looking for something. This picture makes me wonder what she is thinking about. What is she looking for? It kind of adds extra meaning that's not on the page. I think this is my *Mona Lisa*.

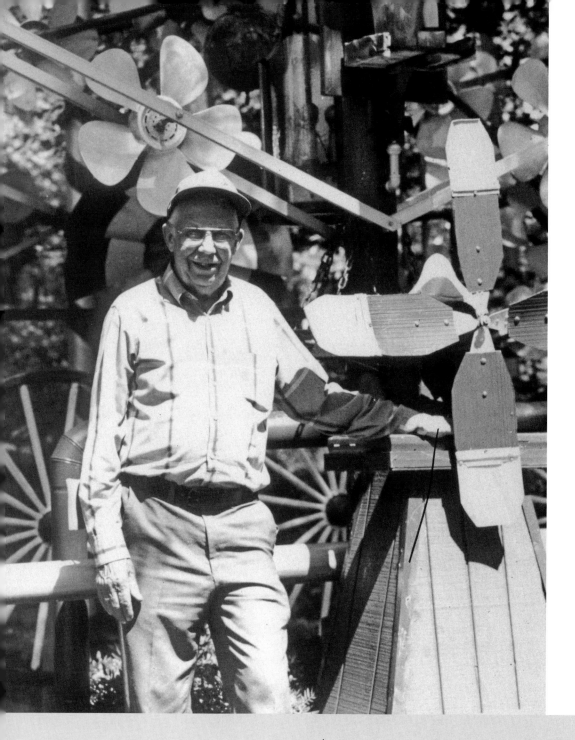

Anton "Tony" Flatoff, in front of his Fan Fair near Stevens Point, 1996

ANTON "TONY" FLATOFF

The big fan from the hotel kitchen, that one started this. It still works! When the wind blows from the south, it turns real nice.

—TONY FLATOFF

TONY FLATOFF belongs to a category of artists throughout the country who have made a public gift to their communities and to passersby.

Tony shares a thread common to other artists in this book who did skilled handiwork throughout their working careers and who felt a strong need to keep busy in retirement. Having lived through the Great Depression, he makes a point of recycling still usable materials and not letting things go to waste.

Tony, a World War II veteran, built his own house and enjoys sharing his roadside Fan Fair with admirers.

THE FAN MAN

My dad was born here in Wisconsin. My dad's dad came from Germany. I'm from Illinois. My mother's family was from Chicago; all of them were born in Illinois. I was born June 13, 1914. That's St. Anthony day on the calendar. My birthday's right on the Holy calendar. My first name was always on the calendar on my birthday. Years ago, people used to name kids from the Holy calendar.

I grew up here, about six miles away. I have five brothers, and there are eleven of us altogether. All my five sisters are still living. I have an older brother that was a good carpenter, built a lot of nice homes. My youngest brother built a house all by himself. My mom, well, she had all the children to bring up. My dad got sick when he was about fifty-three years old and was in bed for years.

When I first came here, this was sloppy land. I tracked muskrats. I was quite a trapper. They just came and dumped dirt for me on the pile and I had to haul it over and level it off. But I didn't mind.

I got started building Tony's Fan Fair when I worked for a hotel, almost forty-five years ago. They tore out the big fan from the kitchen, and I brought it home. I burned the grease off of it, painted it up, and thought, "I'm going to put it up, leave it upturned." It looked real nice. When I got the fan home, I put it up, and then I added four buggy wheels. I don't know why, it just came to me. The big fan in the middle that is red and silver and blue, that's where I started. But then I just kept on adding more and more

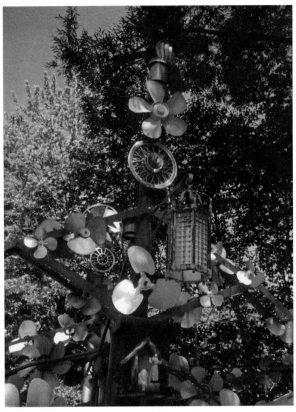

Fan Fair, a backyard sculpture park

Detail of Fan Fair

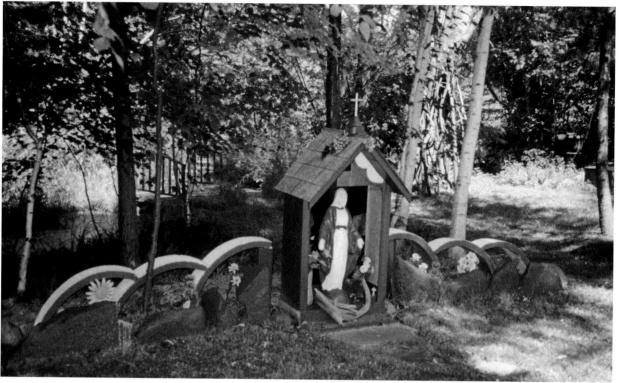

Yard shrine

and I added more. I got most of the parts from the hotel, like the bed railings. I used to bring them home, after they were replaced. Some of the parts came from the ironworks, too, but the big fan from the hotel kitchen, it started this and still works! When the wind blows from the south, it turns real nice. I keep it all up so it works.

A lot of people knew that I was saving fans, so they brought them over to me. I got a lot of fence from an electrician, guy from Stevens Point, here. He used to come and check on the hotel electricity. There was a Marshfield guy who had been collecting garbage for the city. When he saw a fan or something like that he always picked it up and saved it for me. There have been a lot of people that found out that I'm saving fans and they would bring them out to me.

SOME FANS

A lot of people stop by. I live so close to the highway, and a lot of people want to look at something like that. So I keep on making it bigger and

bigger, with more fence. Right from the beginning I thought about fans because they'd be outside moving, like windmills. I even put 'em on the house. On the house, I fixed them so they don't turn. Otherwise they'd be too noisy. For Christmas, I usually put a string of lights out here. From the highway, it looks real nice. If I wouldn't be living so close to the highway, I probably would never do it, but living so close to the highway . . . a lot of people stop in here. I even had the Minnesota Vikings football team stop here one year—not all of them, but some of them stopped. They had a movie camera, too, and took pictures of me. Then about a month or two later some other team members came. They wanted to show them that *they* were here, too. So they took a picture of me.

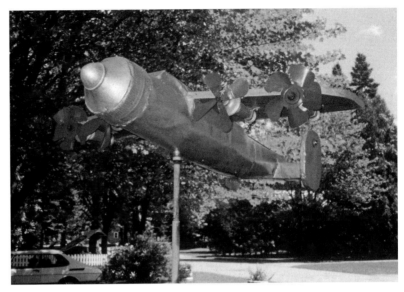

Tony Flatoff built this plane in 1946 after he returned from World War II.

JUST DOING IT

I worked for the hotel about forty-two years, steady. Then there was about three years I was part-time. I was a maintenance man. I took care of their heating system and everything, and I did a lot of painting. I painted the hotel outside, twice.

I built my own house. I started it all by myself, put the basement down. I had a pickup truck and I did all the lumber myself. I made my own blueprints, the way I wanted to do it, and I kept on doing it. After work, when I'd come home, I'd hammer, shovel, or something. I just kept on doing it.

When I got married, I had my own house. My mother wanted to live with my brother next door. That big plane, I made that right after the first year I came home from the army. In 1945 I came home and I made it in '46. I had it by the next-door house, but when I built this house, I moved it over here. I was in the infantry but I liked planes. I was in the Battle of the Bulge. I only got a couple of small wounds on my throat, but they bothered me for a long time.

TONY'S FAN FAIR

When I started building my Fan Fair, I just had the design in my mind. If I could build a house, I could build this. Most of it was out of big spur fans. There's a big fan on the side that comes from the First National Bank. Some come from small motors. In the back, some are from air conditioners. Some of them are house fans and car fans. The big one is from a big old Buick. A lot of the parts have been donated. I didn't *buy* nothing. Somebody would throw it out, and I made use out of it. I picked up a lot of gallon jugs. I look for the ones that are the right color. Then I don't have to paint them. I don't let nothing go to waste. I find things lying in a dump and I bring it home.

There are concrete cores here. They were for testing cement in the hotel lobby. Usually we'd throw them away. Those blue and white arch shapes, my brother made a whole bunch of them. He lived out where there was no cesspool. He made them to mark off his cesspool and made so many of them that I got quite a few of them. I use them around my garden.

It took thirty-five years to build this thing, but I kept adding things. The lights, they're hotel lights, all of them. Some came from the entrance into the hotel. The bigger ones were in the lobby, a whole bunch of them. The amber one, I think I got that from a rummage sale that they had up the street. The red, white, and blue are for patriotism. The more silver and the more red the better it looks. Red shows up pretty good and I think green would, red and silver—I like that. I did this all myself. I made all the cement real nice and strong. From the beginning I didn't think of it as a work of art, but now I kinda do, yeah!

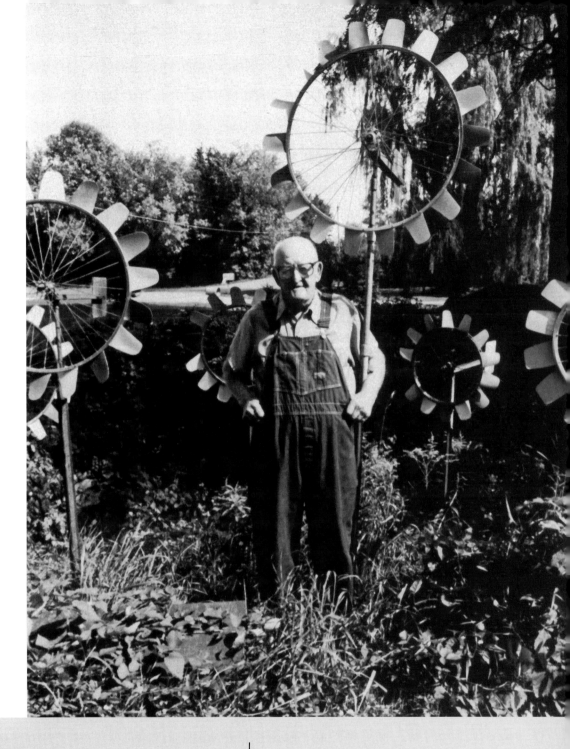

Les Morrison in his Wind
Wheel yard environment
near Stoughton, 1995

I've been making windmills for thirty years. I've
made maybe a hundred or more. I've got wind-
mills scattered all over Oh lord I got 'em all
over! There's a lifetime guarantee on them.

—LES MORRISON

LES MORRISON

LES MORRISON, a charming friendly man, has created a colorful roadside attraction for his lakeside community. Les worked with his hands assembling machine parts for thirty years and found an activity for his retirement that utilized many of the same skills.

He recycles heavy plastic containers and bicycle wheels and turns them into "Wind Wheels" that come with a "lifetime warranty." A drive through his neighborhood attests to their popularity, and many have found favor gracing the yard environments of homes around the United States.

A LIFETIME GUARANTEE

My mother was German and my father was Scotch. That's what I've been told. I had an uncle told me he was part Native American. I grew up in Richmond County. My parents were from Wisconsin. I have two sisters.

When I was younger [1941–1971], I worked for Gischolt, a machine company in Madison. I was a bench assembler. I worked on anything that was in the plant that needed putting together or scraping flat surfaces and fitting them together, reassembling stuff and parts. I was there for thirty years. Before that I used to drive a truck for a furniture company, and I worked on farms when I was younger. My main job was at Gischolt. I used to take care of the neighbors' yards around here. I don't know how I ever did that with a handmower, but I did. I always worked with my hands, filing, burning, taffing, drilling, whatever it took to assemble pieces that we had to work over.

I've been making windmills for thirty years. I've made maybe a hundred or more. That's what I told the lady from the *Wisconsin State Journal*. I've got windmills scattered all over. Down in Indiana, I got one or two out in Colorado, oh lord I got 'em all over! There's a lifetime guarantee on them.

MAKING WINDMILLS

I started making windmills to give me something to do, I guess. I quit fishing. I still have boats sitting here in the shed. I hadn't caught a fish in years. I don't go hunting. I don't want to kill the squirrels. Years ago I was looking at one of those Dutch-type windmills. The one I saw had ten blades on it. It was about 1960, I saw one in a catalog or something, and that gave me an

idea. I also went and looked at one that somebody else had made. At first, I was gonna make the fins out of tin. But then I decided that kids would get their hands cut on the tin plate so I switched to plastic.

I get the bicycle wheels anywhere I can and especially at garage sales. Somebody I ran into had a few of them. Either I get them for nothing or I pay a quarter, fifty cents, something like that. I get the plastic bottles from neighbors and laundry places where people throw them away. People even bring them to me now. I also pick a few out of these recycling tanks, but I won't tell you what town. I'm not *supposed* to do that!

I cut the sides of the plastic bottles out and put 'em in a pail of water. I leave them soak overnight to get the brand off. I scrape the paper off with a good stiff brush. I have to scrub the dickens out of 'em! Then I cut 'em, whatever shape I want. Sometimes I do whatever I dream up. I also have a basic pattern I use to mark it out on the plastic. Then I take a pair of clippers and clip them off. I cut one piece on each side of the plastic bottle. I don't use any other parts of the bottle.

The bigger the bottle, usually the heavier it is. If they're too light they tend to curl over. I have a neighbor

Pre-drilling plastic blades before pop riveting them in place on a wind wheel

that gave me some Shell oil bottles. I thought they'd be nice but the darn things, they curl over. I'd like to use 'em! I suppose they'd be all right if I wanted to have a windmill with curled blades, but they tend to bend. I'm concentrating on getting just the heavy detergent soap bottles. The gallon size works the best.

I package up enough pieces of plastic for a bunch of wheels at once. The big wheels have fourteen or eighteen blades. The small pay ones run ten or twelve petals, depending on the size of the wheel. The curve of the blade is important. You can't very well see it, but it's there. I try to keep 'em all curved the same way, so they're all curving in the same direction. The curve in the blade sort of catches the air. If I get the blade at the right angle, the wind hits and spins it.

I paint and choose colors as I go along. I've been told that if I have a multiple number of colors on each one that they'll show up better, and they do.

I mix 'em, whatever color comes my way; I just put it in. People seem to like the mixed-color ones the best. I like the mixed colors. There's a dozen different colors. I don't pay any attention to which one goes where. They seem to make a better-looking wheel with lots of colors. I just figure it out for myself. If people tell me they prefer a certain color, I try to follow it. Sometimes I make the windmills all one color: red, blue, green, or whatever, white, but I kinda prefer the mixed colors.

I take the wheel, paint it up, and drill holes in it. I have to drill the holes in the wheel and space the holes every other spoke, all the way around,

Contemplating blade placement in his basement studio

depending on the size of the wheel. Some windmills work a lot better than others. I'll drill a couple holes. It takes a little while to drill a whole wheel.

I make the tails out of plastic grocery display signs. I get them from a neighbor who works at a one of the area stores. The store throws these away. Sometimes I find them in their scrap piles, and a friend who's a salesman gave me about a hundred of them that a store had thrown out. Some of the tails are made of plywood.

I used thin plywood for the tail sticks which are about twenty-eight inches long. It seems to me when I make twenty-eight-inch sticks for the tail for the average wheel, then it'll balance. In order to put the bolt in the right place, I hold the stick out and balance it. I usually take a file and let the wheel rest on it. I mark it and drill the hole. I spray paint some of them.

Some of the time I paint the tail and the fin. I got a few that I painted. I'm getting a little more sophisticated, lately. They last longer if they're painted. I don't change the windmills much. But painting 'em, makes 'em look a little nicer.

I make the brackets. I pick the metal up wherever. It can be made out of anything. I had an uncle who had bought a lot of scrap iron for his own use. When he died, they let me rummage around and take what I wanted from his farm. I took the strap iron and put most of it down in my boathouse. It was the right size. By attaching the blades to both sides of the wheel it holds the wind better.

Next page: Simon Sparrow, in his studio in Madison, c. 1995

I also oil 'em maybe once a year. Some of them I don't oil at all and they seem to run just as good as the rest of them.

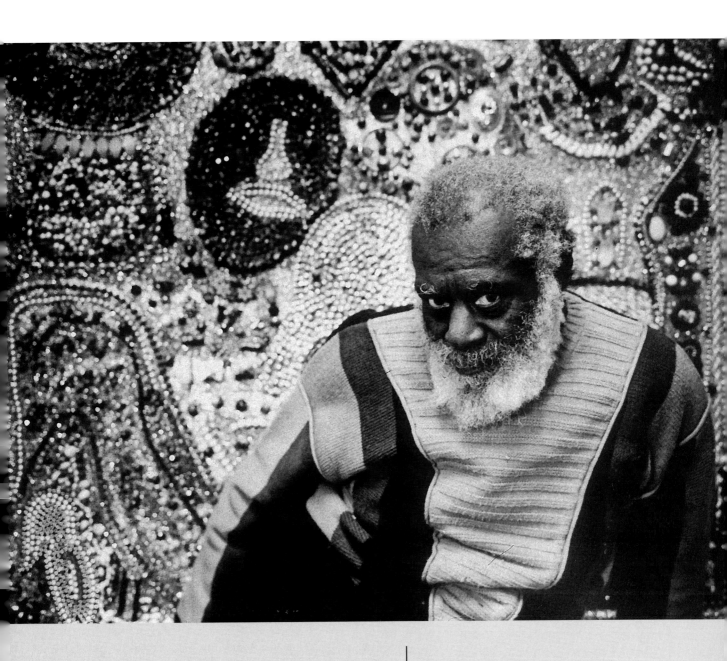

The Spirit guides me into the knowledge. It guides my hands, but not my mind, not my thoughts. The Spirit I think allows me to make the collages.

—SIMON SPARROW (1925–2000)

SIMON SPARROW

Born in Africa and raised in the Carolinas, **SIMON SPARROW** also spent years of his life's journey in Philadelphia, New York, and the Midwest. Simon was, in his time, a drill sergeant, clerk, cook, carpenter, boxing partner, wrestler, farmer, street preaching man of God, and artist. For more than thirty years, he regularly put on his robes and read the Bible on Library Mall at the University of Wisconsin–Madison preaching against sin and depravity. In the early 1980s Simon turned to art-making on a more full-time basis. The Carl Hammer Gallery in Chicago exhibited his drawings and coveted assemblages. His work found its way into several national shows of visionary art as well as the Religious Visionaries exhibition at the John Michael Kohler Art Center in 1991.

DIVERSE BEGINNINGS

My father was African. He came over to the United States and married my mother, I think around 1905 or something like that. I was born in West Africa, but my mother didn't like living there, and they moved back to North Carolina. My dad was a farmer and left home when I was five.

My mother made clothes. I used to watch her sew and she would sing. She used to make beautiful things. I had a brother who was about eighteen years older than me. He got into the bottle thing. I also had two sisters. I was the baby.

My stepdad was the sweetest man, so nice, so kind. He gave me his heart. But if you mess up, then he gave me somethin' else. He used to farm for himself. He was a sharecropper. My mom was part Cherokee and my stepdad was Cherokee. They had been schoolmates. He had been married before, too, and had four kids. His wife had passed away. He lived on the reservation that was about five miles from where we used to live.

We were from Kinston, North Carolina, near the ocean, on the eastern side. I didn't like my daddy from that day he left us. I went through where he was one time when I was a boy. I was maybe ten or twelve. Me and my sister went to see him. He was remarried. I talked to her the whole time. I don't think I said three words to him, which was about a week and a half. He wondered why I wouldn't talk to him. Every time I saw him coming, I'd move out of his path. I have always had that in my mind, because my mother was one of the sweetest women in the world. She never complained about anything. When I was only five, I used to watch those things. He jumped up and got married to somebody else. Whew! That hurt me somethin' bad.

A MYSTERY CHILD

As a child, I used to make houses, buildings, and things out of dirt and clay. I can remember those times. I used to go out and feel the clay and make animals and all kinds of little stuff. It wasn't what you'd call great, you know. Nothin' like that. But you could tell what they were. I started drawing when I was five to seven years old. The first picture I ever drew in my life, a fellow bought it from me. I used to draw on the ground. My first picture was drawn on a piece of big cardboard with pencils. I drew some different animals. A man came by and gave me $10, and I ran in the house and I told my mother. She said, "What? You got $10 for *that* thing? Ah, he's crazy." "No, Ma, he's not crazy. He knows a good drawing when he sees it." That picture built my inside for drawing things. I used to sit and draw people and animals. I'd draw anything, a*nything*, mountains, hills, and valleys.

It makes a lot of sense to me that I don't do things when I really don't want to. If I jump on everything my mind should do, I am not free. I am bound. Or I am a slave to my mind and my thoughts. Just like I can be a slave to anything else. And I never wanted to be a slave in my whole lifetime. That's one of the reasons I left home so early.

My mother had a fit when I got ready to leave home. She knew she had to give me some money to live on. I was only twelve years old. I just wanted to leave. I didn't like living in Kinston even though people treated me so nice. I couldn't even find a living soul the whole time that didn't like me. I used to go to neighbors and play with their kids, white kids, black kids, and Indian kids. I could run with any of them. Everybody loved me. But I didn't know somethin' wasn't right with me. I wanted to leave.

I hated school. I didn't attend very long. The teacher messed me up and scared me. I knew how to read before I left home. I used to read books to my mother. I just pick

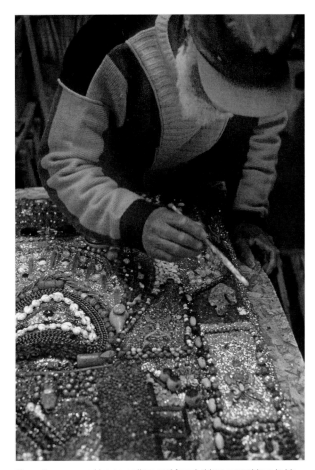

Simon Sparrow, working on a glitter and found object assemblage in his studio, c. 1995

Untitled, pencil on paper, date unknown, collection of Erik Weisenberger

one up and read it. My stepdaddy used to look at me and tell my mother, "He's a mystery child." She said, "Well, I have a feeling that he *is* a mystery child. I have a feeling that there will be special highs he can reach." My mother read me different kinds of books. When I went to school, I could read, and I liked it. But when the teacher messed me up, I hated school. I was scared to go to school again.

I learned to draw the same way I learned everything else in life, by doing it. This is how I learned how to be a carpenter, a builder of things. I helped build houses and other little things and my work was greater than those who call themselves professionals from schools, you know. I made a livin' off of building and a livin' off of farming, and off other things.

I came to Wisconsin from Nashville in 1969. A fellow give me a place out in Mount Horeb to live. Then I got a place out in Mazomanie. I raised some tobacco to buy a car. They said you couldn't raise tobacco in Wisconsin, but I raised a lot of tobacco. People said, "I don't know how he did it." I didn't either. I also raised cotton. The most beautiful bolls!

In the mid 1930s, I went to Philadelphia. I really started drawing, you know. I could look at someone and draw them in ten minutes time. They looked just like themselves. I used to sell pictures for small change in Philadelphia on buses. I'd get on the bus and if I liked someone's features I would draw them, before they'd get off the bus.

When I got to Philadelphia, I flagged down a taxicab driver. I didn't know about taxicabs. I yelled, "Hey, I need a cab." He looked at me. I really thought he was thinkin', "Who is this little boy talkin' about what he needs?" He said, "Where are you goin?" "I'm goin' to 1302 South Street," I said. He said, "Where are you from?" "North Carolina," I said. He looked at me and remarked, "North Carolina? Who is here with ya?" "*Me!*" I said. He said, "So ya know somebody on 1302 South Street?" "No, sir, that's where I want to go," I said. He said, "All right!" I got in the cab. I'm askin' him all kinds of questions. He said, "You know anybody here?" "No sir!" I said. I always would say sir, ya know. That's the way I had been raised. He said, "All right." Well, when we get almost there, "Well, how much is it?" I said. He looks at me. I still see that he is thinking to himself, *"Who does he think he is?"* So he got my suitcases out and walked me into the Ike McGill Restaurant.

As we entered, Ike McGill came over and asked, "So who is he?" The cab driver answered, "Well, he is by himself, I think." I said, "How much is it?"

Untitled, c. 1980s, pencil, 16" x 21$\frac{1}{2}$"
(photo courtesy of Erik Weisenberger)

He looked right at the meter, and I looked at the meter, and I said, "Oh! Is that how much it cost?" He remarked, "Yeah, that's how much it cost. You have that much?" "Yeah, I have that much, I have it." I said. I was getting my money out of my pocket, but he left before I could pay him.

Ike invited me in. There ain't no way in the world they were gonna let me out at that time of the night. Ike talked to his wife, and she went upstairs and

fixed up a room. He told me to go up there because I had to stay that night. I thought I was gonna leave the next mornin', but it didn't work that way. The next mornin' I came down, and Ike said, "Well this is where you are gonna stay." But one thing, if you are gonna stay here, ya gotta go to school." "*School!*" "Oh yeah, you gonna have to go to school," Ike repeated. I thought I'd get a chance to run out, but it didn't work that way. He figured earlier that he was responsible for me. The next mornin', I did go to school. I went to school and washed dishes, and every week he sent my mother money. He sent her money from me! I wrote her letters and she wrote letters to me back.

I used to do drawings in my room. In school, I wouldn't let the teachers know I could draw. But I was doing some drawing at my house. I did pictures of buildings and people and animals. Some people I made up and some people I saw, like ones that came into the restaurant. I saw those people and I said, "I can do that." Sometimes when I wouldn't be doin' anything I sat down at a table or booth and I would draw the customers. All different kinds of people. Ike's Restaurant was big. Huge! And he was one of the nicest guys I've ever seen. He was a really nice person. He treated me like I was a little king. Miss Margaret, his wife, was so nice to me, it was really beautiful.

In 1942, I went into the service. I was real young. There was a bunch of us kids, all boys, that said, "Man, why don't we go into the army?" There were eight of us that went to sign up. So there were only two of us old enough, all the rest of us were underage. I was the youngest one. I had to go. I wanted to go. All the rest of them wanted to, too. We went and signed up and they took us. They didn't ask any questions. They needed people. People were dying like flies in World War II.

When I got into the army, we were sent to Nashville. I was in about four days. I look outside, I see this corporal drillin' the soldiers. They asked a bunch of us if we could drill the soldiers. I wasn't nothin' but a buck private, but I stuck my hand up. They gave me a platoon. The next day I watched them other soldiers—how they were drillin' 'em and I drilled my platoon the same way. That turned out pretty good. I didn't end up having to go over to the war in Europe. I would have gone over, but I had a stomach ulcer. All the boys I had gone there with were shipped out.

LEAD BY THE HOLY SPIRIT

From Nashville I moved to New York City. My drawings changed when I was in New York. I came to be "spiritualized." I had a studio there in New York.

Simon's Buick "Art Car," c. 1997; now at Art Car Museum, Houston (photo courtesy of Mark Klassen)

In the studio, I had all kinds of pictures that I had drawn. I don't know, and I can't say, but I know that it was evil or Lucifer burned it down. That was in 1958. I had statues, monuments, and all kinds of things. I had the crucifixion of Jesus Christ in one. All twelve disciples were in Last Supper and Jesus was in the center. All this got burnt down. It was almost five years before I got back into drawing and by that time all my work had changed. Everything had changed.

I only work when the Holy Spirit moves me. I have a feeling, and my artwork is following in His same footsteps. I can't do anything with any of the pictures without the Spirit leading me to do it. I can't even look at it. I can't touch it! The Spirit guides me into the knowledge. It guides my hands, but not my mind, not my thoughts. The Spirit I think allows me just to make the collages.

When I moved to Madison, I started to make collages. I start my collages by building the frame. I just start, that's all you do. I screw the ends together and I glue them. Sometime I paint a frame. I also collect stuff from all around to cover the frame after it's built. I have people send me stuff and I go to garage sales. Sometimes I go and buy things. Now I am able to buy materials. I just bought ten thousand dollars worth of beads and

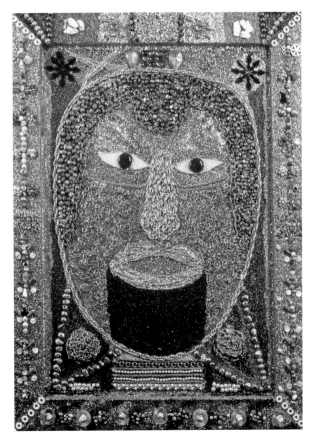

Untitled, c. 1980s, glitter/mixed media/assemblage, 28" x 34" (photo courtesy of Erik Weisenberger)

stuff from a fella that shopped in the old world. I like the glass beads, mostly the glass ones. The beads and glitter is really beautiful, and they are from all different countries. I love it. That is also why my collages are so heavy. There's a big piece of glass underneath and there are two layers of wood. I also use all the stuff that falls on the floor. I sweep it up and use it here on the collage. It can take me weeks and then it can sometime take a month to finish one of these. I glue the pieces on using a strong glue. I look for beads that will correspond with what I have glued on already. Sometimes they might match and sometimes they won't match. I never can tell till I am done. Each collage is special.

I also did a car, you know. It's a 1979 Buick. I'm making it an art piece. I'm making new wave art. It's a great piece. The art is on the back and the top, on the sides and in the front. There is a picture of Christ and dead people on the sides of the car, and on the top and the trunk is Noah's Ark. It is a fantastic piece—no joke. I believe when I finish it, it is gonna be about one of the greatest pieces I ever did. [The art car is now located at the Art Car Museum, Houston, Texas.]

I always preached, ya know. Ever since I was very young. I preached about the Holy Scriptures from the Bible. If it was not written as the Holy Words of God, I never spoke it. I spoke directly from the Holy Spirit. It was in New York that the Spirit became more powerful. At a certain time, the Holy Spirit led me to speak his words to people. I cannot cut in at this time because the Holy Spirit won't allow me to. If I'm speakin' for Christ, and of the Father and I'm speakin' at that time, I can't speak anything else because it's the Holy Spirit *doin'* the speakin' out of the body. It's like I am led. It's like I am a child and the Holy Spirit takes the child's hand and leads that child to follow others. That's the way that the Holy Spirit leads me to the Father.

Next page: John (left) and Doris Sroka (center) with Doris's daughter Marsha Parse (right), in front of their home, 1997. They are surrounded by carved wooden characters from the Crystal Forest, a series of books John wrote and Marsha illustrated in the 1990s.

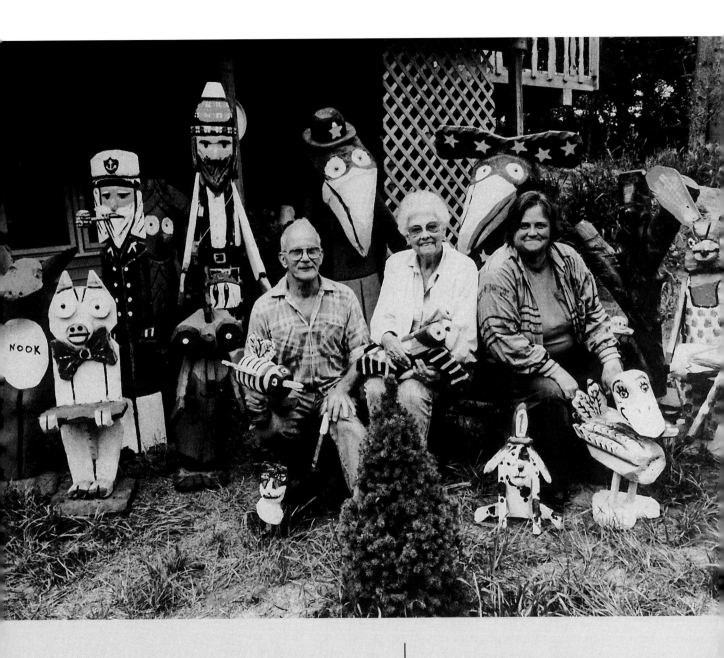

NOOK

A while back, a very strange thing happened. . . .
I was carving cedar and I felt the spirit. I thought
I was going crazy. It's scary! Is there such a thing
as spirits? I think there is!

—JOHN SROKA (1930–1998)

JOHN SROKA

JOHN SROKA was one of several hundred woodcarvers in east central Wisconsin. John's work distinguished itself in that it was based on his series of "teaching stories." Both woodcarving and book characters lived in the Crystal Forest. At one time, years ago, John envisioned carving large figures of all of these characters and creating a road-side attraction. Many signs and spiritual happenings helped him to make his way, events that were hard to explain rationally but that put him on a right course. John strongly believed that humans should treat each other with respect, dignity, and kindness and that children need to be taught to get along by their elders. John died suddenly in 1998.

A HARD LIFE

I was born in Chicago, but I grew up in Michigan. I worked on a farm. I started making things when I was about ten or twelve years old. I always wanted to carve a pumpkin and never had the chance because I came from a poor neighborhood. The lady I worked for wanted to help me. We carved that pumpkin, and they judged mine worth a prize. It gave me just a little inspiration on wanting to carve. Later, I wanted to carve wood. I knew an old man that lived in the woods. I would go and visit him. He taught me how to use a knife and whittle. We worked on a carving of an Indian squaw all winter.

I had a hard, tough life. I didn't have a life like normal people. I raised myself. When I was in the city, we were poor. When I was five or six, I used to steal food. We were hungry one time, and they had sausages hanging in the meat market. I jumped up there one day, and I grabbed a bunch of them god-darn wieners. I could see the guy in a white apron coming, and he called me a SOB and every name he couldn't think of. He came after me with that god-darn cleaver as I was going down the road! I learned the hard way about being hungry. I went to Chicago when I was sixteen years old. I used to go down to a Chicago department store and steal sardines. I liked sardines. We had to eat. They were hard times, back in '36, god-darn hard times. I slept by the railroad tracks. A hobo would teach me lessons. When the train went by, he was gone, waving good-bye.

I farmed up in Michigan. I had dairy cattle. I also had an orchard—cherries, apples, peaches, stuff like that. I started out with potatoes. Later I came to Wisconsin and farmed. I've done so many jobs. I was a master of all. I had

no education and yet I was a leader. I worked in the pickle factory. They made me top man. I was always the loner. They put me all by myself, always alone. I worked alone. I also had a gun factory for five or six years. I worked in a foundry.

There's a power out there. I have some kind of insight on it. It's not that I want to have it. I'm not a psychic, but yet I can tell all the time what's happening ahead of time. *There is somebody out there.* It is scary and creepy. I have a different kind of power, just different. I don't know what faith you believe in, but don't let 'em tell you different. I'll tell you what I went through. It's something that I don't understand. It gives me my strength.

I have a daughter. One time I went into her room, and she was dead. Boom! In the crib, dead! I got hysterical. Oh my god! I jumped in the car. I was out of my head. I had no telephone. I went to a neighbor's farm to use a telephone. I was so confused! All of a sudden, about five miles down the road I heard a voice said, "Thou should not fear. Go home. All is well." It calmed me right down. I went back and my daughter was okay. I couldn't believe it. The voice just came to me. Since then, I believed in a lot more. I don't know how to explain it.

John and *Bruno,* carved wooden character from the Crystal Forest

Another time, I was working in the pickle factory. I was happy as could be, and I felt like I came to a complete standstill. It was strange. It was like I was in a bottle. A voice came to me and said, "Thou shall become a messenger." It was as if my mind was talking to someone. The voice said, "Thou shall not fear." I said, "I'm a sinner. I can't be perfect."

Later, I was going home from work and this thing pulled me. The voice said, "Go there. Go there." I thought, "What in the heck! I'm trying to go home for lunch. I'm in a hurry. Man, I gotta get back to work!" Then, all of a sudden, a lady comes at me screaming and screaming. I said, "What's the matter, ma'am? What's the matter?" "My boy, he's crazy, he's about to kill us, he's got a big knife, he's living in the woods," she yelled. She was crying, so I said, "What's his name?" "Pepe. Pepe, he's gonna kill us!"

He was acting crazy and going berserk as hell. I looked at him and he looked at me. I said, "Pepe, I don't know what the hell it is." My hand seemed

Four in the series of twelve books by John Sroka

to open up and I walked up to him. I said "Come Pepe, Pepe," and he put the knife down. I said, "They won't hurt you, Pepe." I put my arms around him and said, "Let's go home now." I brought him through the woods. By then, the cops were all there. They grabbed and handcuffed him. I said, "He's all right, leave him alone." They took him to the hospital in the police car. About four days later, he came up to me and said, "Thank you." I said, "That's all right, Pepe. Are you all right now?" He said, "Yes." And that was the end of it. He was sixteen years old. It was weird! I have never understood these things. There are so many other examples, too.

STORIES OF THE CRYSTAL FOREST

I have twenty-eight stories I've done. My stories are about how to get along. They all started one time when I was scared to death. I don't know what the heck it is called, a reincarnation or something? I saw the beginning and the ending of the world and honest to god it was really something! I sat there and I saw the story. I wanted to write the story down. But I remembered the whole thing.

The stories are about how it happened. How the forest creatures survived. How some burned and what went into the water. What was saved, and how they reproduced themselves when the fire came. The fire came at the time where there had been dinosaurs. Everything burned, except the creatures that crawled in the caves and got away through the waters. They started learning to live in the water. But the dinosaurs couldn't make it, the big ones. Those creatures vanished.

After I had that dream, several months passed, maybe a year. All of a sudden one day I was looking at the TV and a *sign* said every god-dang thing that I had had in my mind that I had wanted to write a story on. It just came back. The same thing I was thinking of was on TV! That's how my world was. It was so scary. It's a scary thing to know something that is repeated after a while. It was like I was someplace that I've never been before.

For years, I carved and carved. I carved truckloads of stuff. I'd see things in the wood, all the time. I'd look at it and see an owl, a bird, or something.

I'd look at a piece of wood and turn it into something. I got so tired after a while, that I gave up. I didn't want to do it anymore. I was gonna quit. But then I met my wife Doris, and she believed in my work. She asked me if I'd carve my stories for her. I looked at her and something happened. She was such a wonderful person. I never had much of a family. I felt good with her. So I said, "Yeah I will carve for you." Doris and her daughter Marsha have been working with me for over twelve years. I've been doing it since I was forty. I never painted my first work. I just burned in details. They were rough. I never painted stuff until Doris and Marsha took over.

The first storybook was *The Crystal Forest*. Two little creatures came from the city looking for a place where they could always be together, away from everybody. They found a place of peace and quiet in the woods. They went in search of the Crystal Forest and found peace and contentment. Doris and Marsha have helped me write the stories, and Marsha illustrated all the characters. They were all pinecone creatures. Marsha made 'em and brought 'em to life.

There's an order to my stories. My stories are about how to get along. Here's an example for you. It's *The Island of the Speckled Birds*.

The Island of the Speckled Birds

It was early on a spring morning and the sun was rising bright and warm over the farm of Mr. Jacobs. Where the roosters crowed their wake up songs.

The cows mooed softly and shuffled their feet as they waited to be milked. They wanted to get out to pasture on the sweet grass and new spring flowers to frolic in the meadow.

In farmer Jacobs haystack a small family of mice were waking to a fresh new morning. The little white mouse lived there with his family and friends. He woke and stretched, his mom was up doing her spring cleaning.

"Good morning . . . mom" white mouse said with a yawn.

"Good morning . . . my boy." said mom as she swept the floor near the open doorway.

"Good morning Mrs. Mouse!" called Tip the little grey mouse. He got the name 'Tip' from the furry black tip on his tail, which made him different like the snowy color of his friend 'White Mouse."

"Morning Tip." Mrs. White Mouse said "Morning Tip." The white mouse said with a smile "are you coming with us to play in the old corn field?" White Mouse asked as he stood by three of their friends.

"Oh not today." said Tip "I'm going to play with Tina the little sparrow . . . We are going to see the new flowers by the 'Crystal forest."

The three mouse friends said "Why do you play with Tina, she can't fly, her feathers are shabby and missing . . . what fun could she be?"

"Yes, she doesn't look very good." said the white mouse.

Mrs. White mouse hearing this said "That's not very nice to say!" She shook her head "Beauty does not make a true friend, its honesty and loyalty."

White mouse and their three friends thought about what Mrs. Mouse said.

It made them feel bad . . . they hung their heads and said in chorous.

"We're sorry Tip, we should not make fun of others . . . because of their looks."

This made mother mouse feel good that the little mice admitted their mistake.

Tip said "Good bye" then set off through the hollow log, to go wait for Tina on an old tree stump, at the other end of the log.

In a short while, as he waited for Tina, the yellow bird of peace stopped by Tip to rest a spell.

"Hello Tip" she said "What are you up to today."

"Hi . . . Oh, I'm waiting for Tina, the sparrow, we are going to play together today, in the wild flowers." said Tip.

"Tina?" said Yellow Bird "is she that little bird with the shabby feathers?"

"Yes . . . I wish there was something I can do to help her." said Tip.

"Can she fly?" asked yellow bird.

"No." said Tip sadly "and everyone laughs at her."

"Oh, that's too bad, you should take her to the island of the speckled birds they could help her."

Said yellow bird "She would be very happy there."

"I've never heard of this island" said Tip "Is it hard to find?"

"Well . . . no . . . its in the center of the big pond in the middle of the Crystal Forest." Yellow Bird said pointing her wing down the trail.

"How can we get to the island? I can't swim and Tina can't fly?" asked Tip.

"There is a turtle by the name of Burt and his little buddy the fly, they live in a little house on the ponds bank. Ask him, I'm sure he will want to help you." said yellow bird with a smile.

"How do you know about this island?" asked Tip.

"I have flown over the island many times and I have seen the speckled birds" said yellow bird with a nod. "They are bright in color and full of spots."

"I must go now . . . good luck to Tina and you" called yellow bird as she flew away.

About this time his little friend Tina came skipping down the path.

"What was that all about?" asked Tina looking up at Tip sitting on the stump.

"Oh Tina, I have some good news . . . I'm going to take you to the island "No not too far . . . its in the big pond in the Crystal Forest." said Tip.

All the stories teach the reader something. For example, I have another story where an old man made a horse for his grandson. The grandson loved to watch the horses over the fence. So his grandfather made him a beautiful horse. He carved a wooden horse. He told little Johnny to make sure that he always loved it and would take good care of it. Johnny said, "Oh I promise, Grandpa, I will, I will! I'll always love and cherish and take care of it." Well, when Johnny got older, he forgot about his rocking horse and got a bicycle and a car. One day an antique dealer came along and asked to put it in his store window to sell. Later, Johnny had a son of his own and was Christmas shopping. His son said "Daddy, daddy, look here I want this, I want this." His dad looked in the window, and there was the horse that he had sold. He just couldn't believe his eyes. He remembered when he was a child. So he got the horse for his boy, and they went home. Later, he said, "Now, Johnny, the rocking horse has a home." It all seemed to be right and complete.

Priscilla Hippo, 1996, 37" x 24" x 12", and *Elvis Hippo*, 1996, 37" x 19" x 13", carved wood and mixed media

And this is what happened to me. This is really two stories. I had a horse and she was beautiful. She'd work with me and I used to feed her carrots. I was with the animals all the time anyway. I promised her she would be with me forever. As I got older, I got a little independent, I got an old tractor and I started working the fields. A guy came by who wanted to buy horses, and I said I could probably get rid of it. I said "okay." Then it dawned on me after I sold her that something would not be right. I wanted to buy that horse back and the buyer wouldn't sell her to me. I would've given anything to get that horse back. The owner said, "You made a deal, you gotta keep it!" You know, I can still see that horse today. It just tore my heart out. I felt so guilty, so bad. I broke my promise. I learned that you should never do that. Life when I was young went by so quickly, and sometimes I forget what I was really doing.

Some kids today don't know what they're in for. They can easily lose respect and lose themselves in loneliness and be unhappy. If they are not happy, it can destroy everything. Life doesn't always provide encouragement to go on living. Some kids try to escape by drinking and taking drugs. I believe there's no real challenge for them. They gotta learn how to work. They've got it too easy. They got too much. Kids should learn to sacrifice and do with a little less. If you give a kid a million dollars, make him or her a millionaire, there's no more excitement left in life. Kids need to learn about satisfaction. I've learned to do things all my life that really gives me satisfaction.

I just struggle through some things, and I wouldn't have it no other way. Satisfaction is peace, contentment. It's a different world. When kids get off that world, they don't know what the real world is all about. I used to sit by the wood stove and turn the radio on. I would listen to some simple music like the Grand Ole Opry. My children could never adjust to that. I wish that they could just turn the lights down low and just sit in the cool wind and just listen. It relaxes the mind. If kids could only learn to do that again and get away from that box [TV].

Every time I go somewhere, I see something. I want to turn it into something. I can make the world beautiful. Sometimes I sit and think about all these kids from the inner city. I was there. I know what it's about. If I could teach them how to paint, to use these pine cones to make them self-sufficient. I think the violence would come out of them. How good they would feel if they would use their hands and make something and sell it. Everybody's got some creativity, everybody. But it's gotta be brought out. They got to simply want to do it.

I told my grandkids, I would try to teach them to take a walk through woods and have a picnic. The woods can always provide contentment. When a person goes bananas, they should go into the woods for peace and quiet. This can't be done in the city. There's so much beauty in life. Anybody can be happy. Love is what does it. Love can do wonders. There's a certain way of lovin'. You gotta care, really care.

THE SPIRIT OF AN ARTIST

I know there's such a thing as spirits. One time I was running, and I slipped on a stair and fell on concrete. Bang, I come down and cracked the back of

my head. I lay there. As I lay there, I felt a spirit. I can tell you, there's other people in heaven 'cause I was dead. I went way up there to heaven. I lay there with my first wife and my daughter on one side. They were crying, and my spirit was starting to come out. I was in the hospital. I laid there three or four days, and they couldn't do anything with me. I waited for them to do something. I finally just got up and said I was going. "You can't go." I said, "The hell I can't." I just left. So you see there is such a thing as the spirit.

A while back, a very strange thing happened. One time I was carving cedar and I felt the spirit. I was burning the cedar and I looked up and there was this image of an Indian chief, his complete head. It stood there and just like that it just vanished. I thought I was going crazy. It's scary! Is there such a thing as spirits? I think there is!

I see things in my head all the time that I want to carve. It's going to take me, I'll bet you, fifteen or maybe twenty years before I can carve all the things I see in my head. I see it there and I want to do these things, but there are real distractions. People come along and want me to make an alligator or a crow. I feel like I just can't do the things that I see that I want to do. For example, I have some real different kind of birds and characters that I want to perfect. Carving brings me peace of mind. It isn't the money. It's the relaxation, the contentment of it. It's just something I like to do. Carving is something that I gotta do. I'm a restless person. I will work till the day I die.

Lee Boy, 1978, 62" x 34" x 28", and *Dee*, 1978, 59" x 33" x 30", with their dog *Dorrie*, 1995, 29" x 11" x 9", wood and housepaint

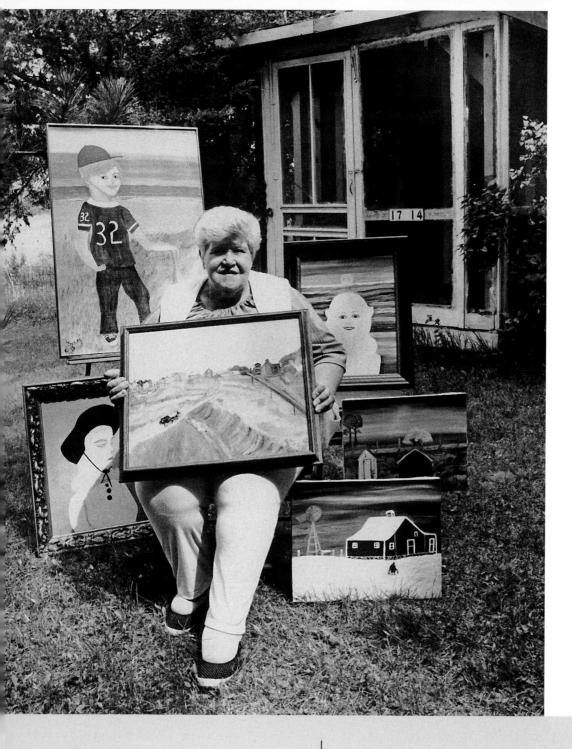

Loretta Sylke, in front of her home gallery, 1994

LORETTA SYLKE

My childhood memories, don't belong to anybody else! They're mine and nobody can say that they know better! I paint what I can associate with. They're my memories and that's why they're special to me.

—LORETTA SYLKE (1926–1999)

LORETTA SYLKE loved to paint pictures of childhood experiences. She represented the world with playful strokes from an untutored hand. Loretta lived with her husband Arthur in a small house in Princeton, Wisconsin. Adjacent to her home was a two-room gallery that her husband built so she would have a place to exhibit her art, a large collection of personal paintings executed in oil and watercolor. Loretta was a memory painter. The subject matter was mixed and reflected a time past, her personal experiences with family, friends, neighbors and loved ones.

FARM LIVING

My mother and father were farmers. My father came from Russia in 1917, when the Bolshevik Revolution was in Russia. He and his brother escaped. He had two sisters. His uncle was a doctor in Chicago, and the uncle brought him over here. My father ended up in South Dakota after World War II. He never liked to talk about it much, because he didn't like the service. They had left Russia to get away from that. After a while, he was proud of it. He hung his uniform in our house. I guess it wasn't all bad.

On our farm, we had cattle and my parents grew grain. We used to have to go out and shuck the grain. You know how they did years ago? They had a thing that would make the grain into bundles, and it would throw 'em down and we'd have to go out and stack 'em. They don't do too much of that anymore, but years ago they did. Then they had threshing. We'd have to help our mother feed all these threshers because they had to have their dinner at noon, and they had a lunch again in the afternoon. This went on for, well, depending on how much land my dad had, we did that for probably close to a week. My dad was a great sausage maker. We never went out and bought meat because we had our own livestock.

I was born in 1926, so I really knew what it was like to go through hard times. I had three brothers and one sister and lived on a farm as a child. It was during the Depression, and times were really hard, but my family never went hungry. We knew what it was like to go without a lot of things that our kids take for granted. Of course we had the radio and we used to practically crawl under the radio because we thought that was, you know, a big thing. Now we have television and all these other things. I think the younger generation is having a tough time. I always had a home and I had food and it

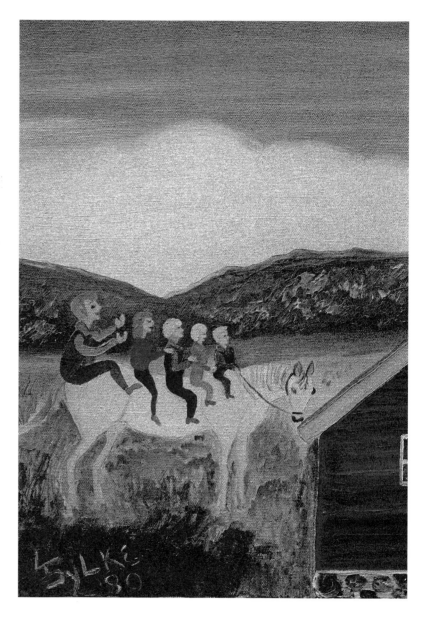

The Family Horse, 1980, oil paint, 14" x 18"

was not like my family had to go out and stand in line to eat. We never really went hungry even though the times were bad.

I remember my parents telling me my grandfather was very wealthy. He had a lot. During the crash, he kind of lost a lot of it. My mother was used to having things. I remember she had furs in boxes and that was my thing—to go and play with her furs. I used to love that, you know. I've never painted that. That would be a painting of me playing with those furs.

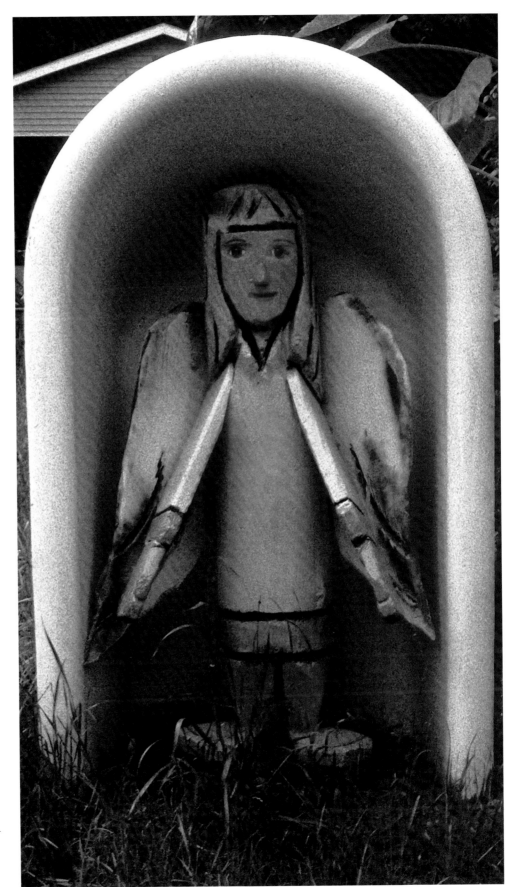

This bathtub angel, a chain-saw sculpture made by John Sroka, is reminiscent of bathtub Marys common in Wisconsin yards.

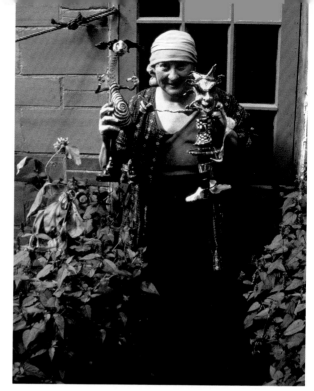

Hope Atkinson with Wanting
and Big Jack King, 1995

Untitled, by Norbert Kox

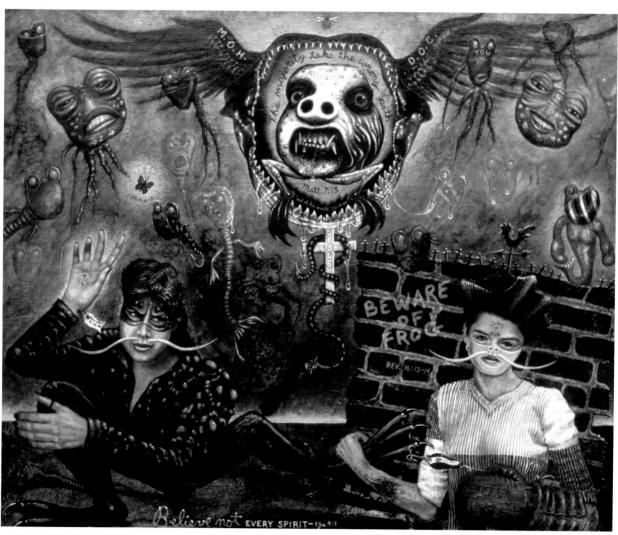

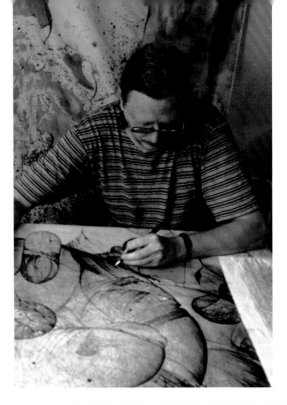

Jack Dillhunt, working on a
drawing in his kitchen, 1997

Chapter 2 Kings, 1997, by Prophet
William Blackmon, acrylic/enamel
on wood, 18$\frac{1}{2}$" x 22$\frac{1}{2}$"

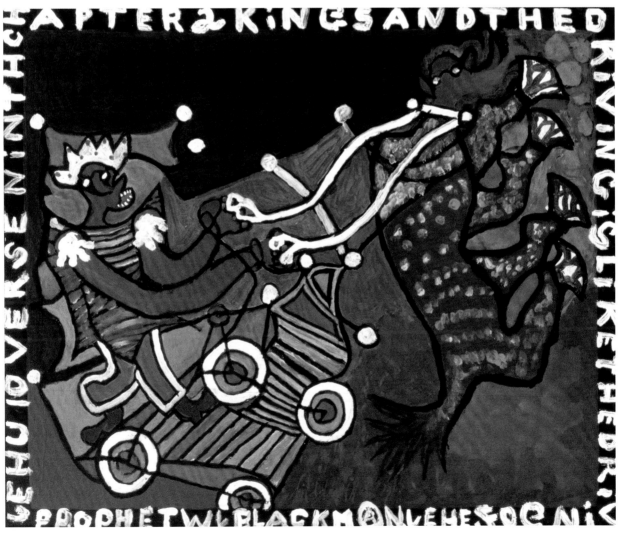

Ordained to This Condemnation, 1997, by Norbert Kox, 17" H x 18$\frac{1}{2}$" W, oil/acrylic

Snow Queen and the 7 Deadly Sirs, by Lori Reich

"RHEIROGLYPHIC CHURCH WINDOW" HAPPY 98!

Hieroglyphic Church Window, 1998, design by
Rudy Rotter, glass formation by Oakbrook-Esser
Studio, Oconomowoc, 45$\frac{1}{2}$" x 35$\frac{1}{2}$"

John Tio rigged up a system for cutting and linking aluminum pull tabs from cans. He is shown working in one of the patio rooms next to his camper. The surrounding walls were made of thousands of pull tab chains.

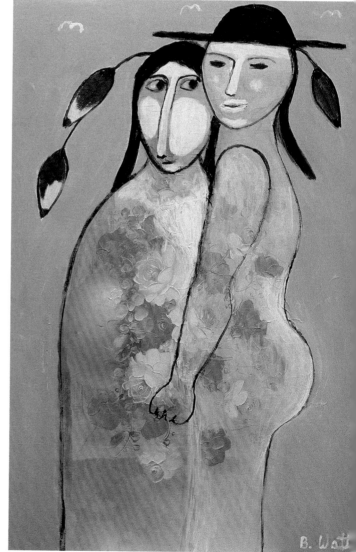

Bob Watt does Picasso, mid 1990s, 18" x 24". Bob is not shy about appropriation. Picasso and R. C. Gorman are only two of his frequent inspirations.

Fishes Bite, Alligator Yipes!, by
Della Wells, pastel, 40¹/₂" x 26"

Collage, 1998, by Mike
"Ringo" White, sled plastic
and Legos, 24" x 20"

Downstream, by Guy Church,
13⅞" x 16¹⁵⁄₁₆", colored pencil

The Fan Fair, a backyard
sculpture park by Tony Flatoff

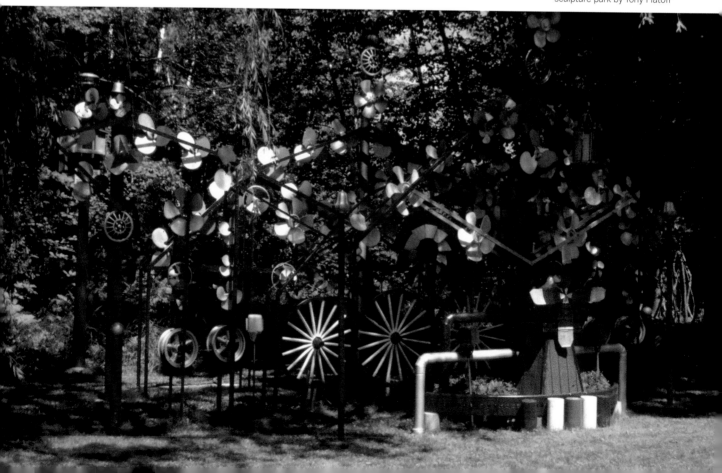

Untitled, early 1990s, by Simon Sparrow,
oil pastel, 44" x 28½" (photo courtesy
of Erik Weisenberger)

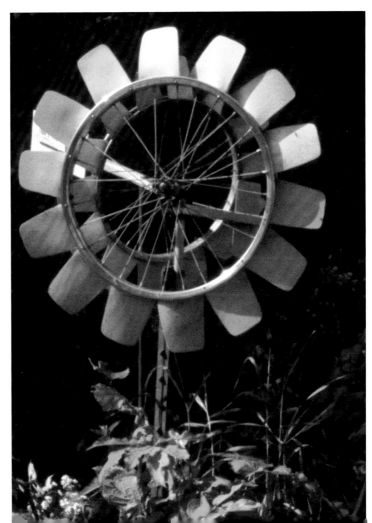

Wind Wheel, 1995, yard envi-
ronment by Les Morrison,
near Stoughton, Wisconsin

Untitled Drawing, 1994, by Carter
Todd, colored pencils and markers
and ballpoint pen, 14" x 16½"

Childhood Milking Memories,
early 1980s, by Loretta Sylke,
oil paint, 14" x 12"

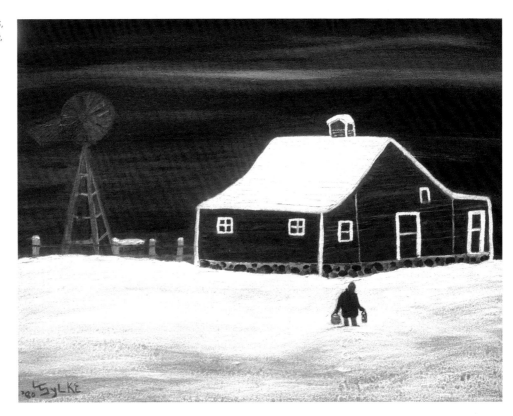

Front of Lester Fry's house

Mona Webb, in her first-floor
gallery, c. 1993

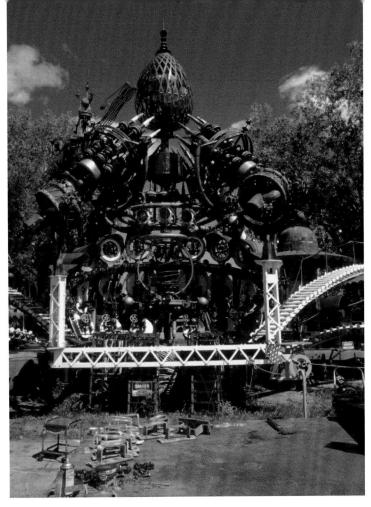

Center section of Dr. Evermor's Forevertron, an electro-magnetic, lightning force-powered space travel vehicle

Paul Hefti's front walk

Roaming dinosaur, by Wally Keller

Roadside "barrelman," c. 1995,
by Bruce Squires, 7' tall

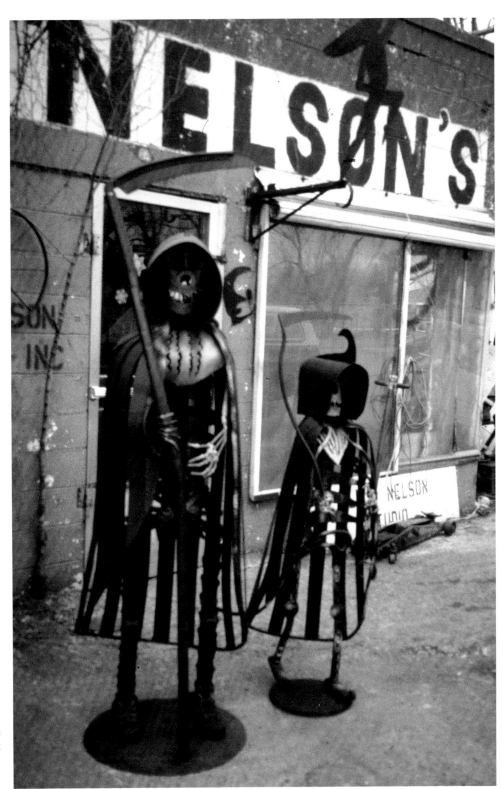

Two grim reapers, 1997, built by Ellis Nelson for the "The End Is Near" exhibition (1998) at the American Visionary Art Museum, Baltimore. They are shown in front of Ellis's workshop/garage.

Clyde's Sweetheart in Wynia's
Jurustic Park, by Clyde Wynia

Details of individual buildings
in John Ree's pebble village

I can still remember 'em. They were in a beautiful box, the big old boxes they used to have.

My mother, I remember her, she loved art. After my mother died, I went and stayed with some of my aunts for a while. All of them loved to do things like that, and I think that's where I kind of picked it up from. I think it has to be there, you want to do it. My grandmother did quilts and sewed—you wouldn't believe the beautiful quilts that she made. She taught me a lot of things about sewing because my mother died when I was thirteen. My father remarried. My grandmother made the fanciest clothes you know, all kinds of things. She was very creative. She was just a little gal. She lived to be ninety-four. She weighed probably ninety pounds. She was just a terrific gal, and she lived by herself till she was in the last year of her life. I went and stayed with her, and she showed me how to quilt.

THE RURAL REMBRANDTS AND MORE

I had been working in the supper club here for twelve years, because my children were growing up and I was a single parent for a long time. I had four girls and the two boys. My first husband was sort of a gypsy. I was married in South Dakota and sort of traveled around while he was in the military during the Second World War. He always went from one job to another. Well one day he couldn't handle it. That was the end of that! He was one of these guys that liked to take off when there was too much responsibility. Later, I married again.

We moved out here after my son was killed in 1967. It was at this time I really got myself involved in making art. I used to do little things and just give 'em away. I've given away more of my artwork I think than anything to friends and my family. My family has a lot, especially my youngest son. He and his wife are into antiques, and so they really appreciate my art. They had children and love my art. I've painted a lot of paintings of their twins.

I got involved with miniature shows. You can price your work a little cheaper, and it's a lot cheaper to send. The fees are much more reasonable, you know. There's about two or three of those that I enter all the time, one's in Colorado Springs, and one's in Billings, Montana. Those are just enough to keep it interesting, and I don't get bored. The selling isn't so great. I had been exhibiting for more than twenty years, off and on. I used to go out and do art fairs and flea markets but I can't handle that anymore. We had a com-

munal space, just a group of us area artists. We used to take turns working, like once a month, on a Saturday afternoon, or whenever it was convenient. It was exposure. That was about it. I belonged to the Rural Rembrandts for a while. But that's just an amateur group. Once you start sellin', you're not considered an amateur anymore.

A girl I went to school with, when I was younger, could draw anything. I really envied her. I always said that sometime, I'd like to be able to paint like she did and draw. Before that, I really didn't do much painting. I just kinda doodled and I did things that my family liked. I started out givin' things to my sons and my daughter. I did something really wild—a seascape. She loved that. I think my youngest son really appreciates my work more than the others do.

When I first started painting, I did wildlife like pheasants. South Dakota had lots of pheasants. That is where I was born. Pheasants are the big things out there. I always thought that they were so pretty. That's how I started painting, and I did a lot of them. I sold a lot and gave a lot away. Then I started doing the landscapes. There's a river that runs in the lake down below us here. There's so much material, you could paint forever here and never really paint everything there is.

CHILDHOOD MEMORIES

My childhood memories don't belong to anybody else! They're mine and nobody can say that they know better! I paint what I can associate with. They're my memories and that's why they're special to me. For example, my brother and I used to take our cattle out into different areas where they could graze. There was a train that would go by at 11:00. That's how we would know that it was time to go home at noon. When that train came, then we knew it was time to take the cattle back home. We used to ride horses, and we had our own horses. There were a lot of different things like the sandstorm, the wind, wind blowing that are favorite memories of that time.

When I was in school, I had this classmate named Elvella Frome that ended up being an illustrator. She went to live in Iowa. I sent her some pictures once, after I was painting, and she sent me this great letter. She thought my work was terrific. You don't know what that did to my ego to have somebody that's worked as an illustrator say that. She took the time to

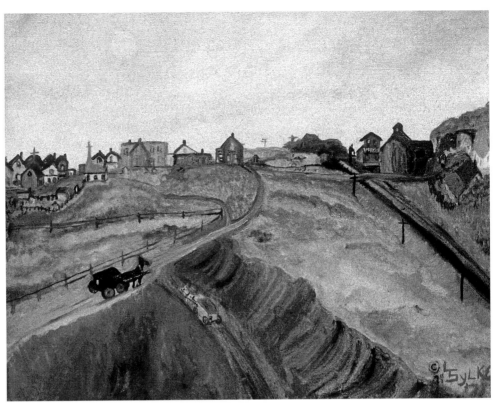

Going to School in South Dakota, c. late 1970s,
oil paint, 20" x 16"

send my pictures back and tell me how much she enjoyed them. We did art
in school, you know. Draw or color or something—I always liked to do that.

I have been married for thirty years. I lived here when I met my second
husband. All the years I was working in a supper club, I was doing it on my
own, trying to raise my kids. You know, these kids today, they don't know
how they can handle it with one or two children.

I met my second husband through a friend of mine. He'd lived here all
his life. His mother had a farm, and his uncle owned all this land around
here. I didn't paint much before I moved here. I was busy just raising all
these kids I had. That kept me busy.

We had a business downtown, me and Art. I was helping him in the serv-
ice station, and I was working at the supper club besides. I was there for
twelve years. I really felt I wanted to stay home, but after working for so
long, I wanted to occupy myself. I really started in with the art. There were
some people around here that were painting. We used to go down to a place

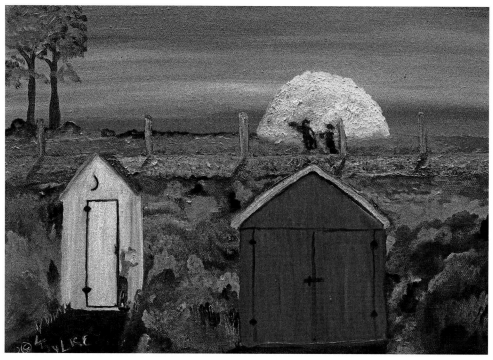

Childhood Memory, date unknown, oil paint, 14" x 12"

at the lake, and there was a friend of mine that got me into the art. We'd go there once a month. Then they would have an art show, and whatever you had done, you brought it. It was the oldest art club in Wisconsin. They're associated with the Wisconsin Rural Artists, more or less. They sponsor the traveling show that they have. It's a fairly good-sized group. They get a lot of city people, too, that retire up around here. That's how I got started, with them. We'd meet at different people's houses and socialize.

At first, I did still-lifes. I liked to paint pussywillows. That's really what I started out with. I'd get a wooden palette knife and work really heavy. Some of those paintings are still up around here. The group has got probably fifty people in it by now. They have really good shows and things. Now the Rural Rembrandts hang their stuff in the performing arts center in Oshkosh. When they had a show once a month, they had somebody from the university or somebody else come and critique the work. That was interesting, too. You found out what you were doing wrong.

After awhile, I thought, "This is getting boring. I gotta do something different." So that's when I started the memory things, just off the top of my

head. I thought, "Well, this is gonna be something different." Right around that time, someone in the group had the idea my husband was helping me with my work. That really ticked me. He thought women don't have the ability to paint or anything. They seemed to have this attitude. A man at this time who worked at the museum sort of took over the Rural Rembrandts. They'd always give you the impression, "Well, you really did this? I bet your husband helped you." This is really one of the reasons I left the group. Nobody's going to say that my husband painted my memories because he don't know what my memories are. So that's really how I got into memory painting.

There was a time during the Depression when everything was so dry. There were sandstorms, and I made a painting about that. One spring, we had a mother duck that laid some eggs, and we took the ducks and put 'em in the water tank. This was not a good thing to do, because you shouldn't disturb wildlife like that. Being young, we didn't know any better. We kinda lost the ducks. That was one of the memories that I painted.

I paint things that stand out like the sandstorms, the dust storms of the Depression. Those really stuck in my mind. I can still smell them. When we'd come home from school, the sand, the dust, you could smell it. It would blow so hard that it would blow into little drifts inside the windowpanes. It would come right into the house. Even though you had your house closed tight. It would just blow so hard that it would blow right in. We'd come home from school, and we'd walk in and see these little drifts. They looked like snowdrifts along the fences. We would have to drive in sand all the way home. There would be drifts of sand. I think things like that really etch in your mind. You could actually smell the dust. I had pneumonia real bad when I was four years old, and I think that's where it came from, and my allergy problems now, to have it so thick in the air.

We went to school in our buggy. Those memories are really etched in my memory I think. It was so cold, sometimes we would be so cold! We had five miles to go in that buggy. It would be cold in the winter and we'd have a blanket to cover up, but we would still be cold. It was five miles. Can you imagine when it was really cold? We went through the backfields. Our buggy would go through the sand and the snow. I remember one time, it snowed so bad, we couldn't go home in our buggy. Dad had to come with a sled. We almost tipped over because the snow was so bad. You don't go outside when

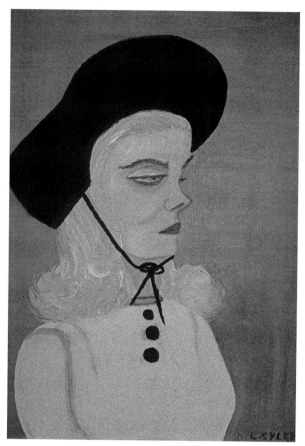

Amish Girl, c. 1973, oil paint, 18" x 14"

there's really a blizzard because you can get good and lost. Somebody told my Dad he better come and get us and not let us take a chance on getting lost. We did tip over once because we tried to go through the snow banks with our buggy.

I keep thinking about my father making all these delicious sausages. None of us kids learned. He would just roll up his sleeves and grind all this stuff. My mother would put the meat in jars, and put it in the oven to cook it. I wonder how we ever survived eating that stuff. They'd put it in the basement for all summer long. It was smoked. He made headcheese. There were things we didn't like, like the tongue. He made that sausage and we used to take it out and smoke it in the smoke house. Oh, I can smell that! I can smell my Dad's sausage. I'll probably paint forever and never paint really all of it.

Us kids used to all get on the one horse and ride one horse around the yard. Poor horse! I did a painting of that. I imagine my paintings are different than the ordinary things that are being done. To me, painting is natural. Our father, he was a Russian. We all played musical instruments, and he always had a thing about that we'd enjoy the good things in life. He had this idea and our mother did, too. They always had the music. I think this is something that was instilled in us when we were really young, to appreciate music and art, because he had lived in Odessa, Russia.

MAKING THINGS

You can get lost in making things. I think after my son was killed, I painted to forget about everything else. I think that's what we need sometimes—just to escape from reality, to forget everything, about all the hardships that you've had. I think doing painting is like therapy. I can forget everything when I'm getting into "making." I used to go out in the gallery and paint by myself and really get away out there. But now, everything's gotten so messy out there, it's kinda distracting because I have to have a certain amount of order in my life. I get a lot of satisfaction from painting, even if I don't sell

it. You know, I don't think you really paint to sell. You get so much fun and relaxation out of it—that's satisfaction enough.

If nobody ever bought any of my work, I think I'd still paint. At the time when I opened the gallery, I thought, "Well, gee, I've got major things to pay off." People would say, "Well, could we come and see your work?" You know, in fact a lotta people. We just had a front building at first, and then I filled that up in such a hurry. I really wanted a place to paint. In the back there, I have the north light comin' in and I can open all these windows and turn on the fan and really get a lot of circulation. I'm hoping I can get back out there and paint again. It's good for me to keep myself occupied.

When we moved here, my mother-in-law owned the farm, and my gallery was a barn. It was falling down, so my husband tore it down and rebuilt it. I opened the gallery about 1968. I got a lot of people at first. I still get them. In the last few years my asthma has been worse, and I have to really be careful now. The gallery gets a lot of summer people. We get a lot of summer people from Chicago that really appreciate art. I've done some commission work.

I DON'T CARE FOR "OUTSIDER"

I belong to a group called Wisconsin Women in the Arts. They're in Milwaukee. They used to be in Madison. I was in one of their shows once and I got an award. They're calling people like me "outsider artists" now. You're called an outsider artist if you don't have an education in an academy. All of a sudden this name came up in the last couple of years. Until now, I think sometimes I wasn't accepted because I'm an outsider. I haven't been to the university and I haven't been taught. So then all of a sudden they say we're outsiders. I have seen articles about outsider artists in antique magazines, antique magazines more than anywhere else. Somebody made the remark, "Outsider art—they're not being paid enough, because they didn't go to art school." I think there's a resentment there sometimes, especially if you do well as an outsider artist. If you haven't been to the academy, I think they resent you. That's why you're called an outsider. The dealers, they figured they don't have to pay you much, because you never went to school. You didn't pay your dues by going to college so you don't have a right to demand a big price for your work, or they make you feel it isn't as good as somebody that told you how to do it. That's my opinion, I don't know,

maybe I'm wrong. I think my portraits are primitive because I haven't fol-
lowed the people that teach—you gotta have shadows here and there and
all that. I paint what I see. I don't toy with all those colors that a lot of por-
trait artists do. To me, that doesn't look natural. When I look at you, I don't
see a lot of greens and blues. I paint things the way I see 'em. I paint from
memories, from things that I've seen. I think as you get older, your work
should be more expensive. Because you know, after you're dead maybe,
who knows what your stuff will go for. People call my work "primitive."
"Primitive" doesn't bother me as much as "outsider." I don't especially care
for "outsider!"

Carter Todd, in the
kitchen of his apartment
in Madison, 1994

I like having different styles, different ways to
draw and different strokes. These drawings are
all my kids. I do like to draw all the time.

—CARTER TODD (1947–2004)

CARTER TODD

CARTER TODD was a familiar sight on Madison streets and in restaurants and coffeehouses for many years. When he first started drawing, he would spend whole days working intently at student coffee shops, enjoying the company of passersby. Later Carter shared an assisted living apartment with a roommate and did much of his drawing there.

MY DRAWINGS

My mother, when she was younger, used to be an artist. I don't know what she did to tell you the truth. I'm from Indianapolis, Indiana. That's where I was raised. My brother lives in Florida, St. Petersburg. He's older than I am. I have another brother that is younger living in Bloomington, Indiana. He builds houses. He's a teacher. He takes all these young kids out and shows 'em how to build houses. He lives out in the woods. It's really nice. I was out there a couple years ago. He has two daughters.

My sister and brother-in-law moved to Madison, and I came here to visit. I've been here ever since. It's been over twenty-four years. I have two sisters, one in Indianapolis and one here. I drew a little bit when I was younger, not very much. My sister has a lot of my art all over her house and at her office,

Carter, working on a drawing, 1994

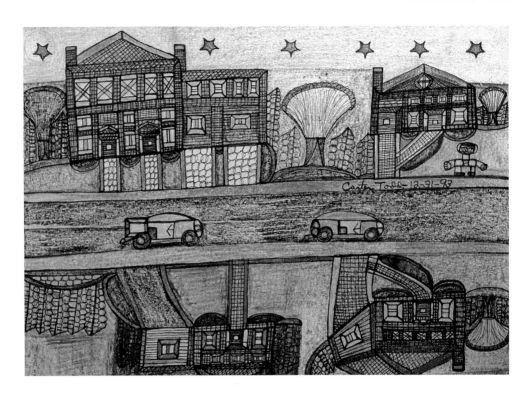

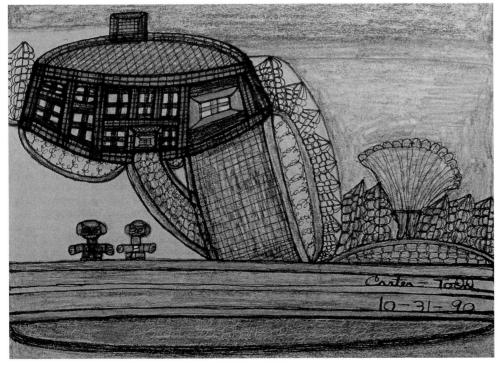

Top: Untitled drawing, 1993, colored pencil and markers and ballpoint pen, 14$^1/_4$" x 10$^1/_2$"
Bottom: Untitled drawing, 1990, colored pencils and markers and ballpoint pen, 11" x 8$^1/_2$"

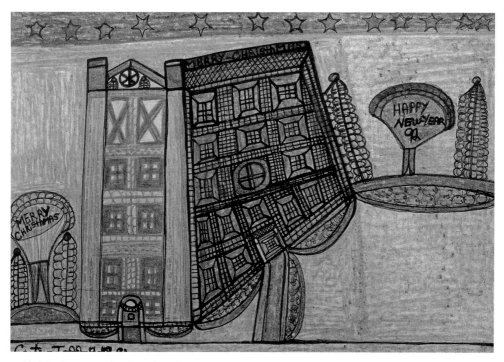

Untitled drawing, 1991, colored pencils and markers and ballpoint pen, 11$\frac{1}{2}$" x 8"

too. She works for the University of Wisconsin. She's a secretary. My draw-ings are right when you open the door in the building.

I used to work at Henry's Restaurant with Simon Sparrow right down the street. I just sat there drawing all the time. Simon also did his art there, so that's how I come to know him. He sold his art on library mall [Univer-sity of Wisconsin campus]. I was a cook at Henry's. When Henry's closed, I started going to a Chinese restaurant. I drew every day. Every once in a while I'll sing to myself. I can't sing very well and that's why my mother said she'd never give me money for singing lessons.

I also used to draw at the Union [University of Wisconsin], but people kept asking me for drugs and stuff like that. I said no. One time I was draw-ing downtown for a long time, every night from late until about six in the morning. One of the university students came by and said, "You don't mind if we videotape you, do you?" I said, "Pardon me?" So they came with all these cameras and stuff like that and made videotape.

I still draw at home most of the day, and then I go out for a little while and come back and draw some more. I like to go out and get some fresh air. I stay around here most of the time. Sometimes I stay up until about two in

the morning drawing all night. I listen to the radio when I draw. Sometimes I go to bed and sleep late. Other days, I wake up early.

I'm a recovering alcoholic. Well I'm a sober alcoholic. It'll be over twenty years. I just take one day at a time. That's what started me drawing mostly. I went to treatment for alcoholism, and when I got bored I asked one of the people on the staff if I could have a piece of paper and a pencil. They gave me it, and I started drawing. Since then, I draw all the time.

I'm epileptic and I have seizures, and sometimes I get kicked out of places for having a seizure. When I was in the hospital getting treatment, I got bored and my sister brought me pencils and papers. So I made pictures of the hospital of the floors I was on.

I'm proud of myself. I went to a stop-smoking class once and they told me to write down when I wanted to smoke. I learned that every time I want to draw, I want to smoke. I quit for seventeen days when my sister got sick. I was stressed and I went right back to smoking. Now I can't quit. I should say I probably could if I wanted to. Drinking was hard, smoking was the worst.

Nitasha Nicholson was my agent here in Madison. Then she retired and she started doing her own stuff. So now I have an agent in Milwaukee, Dean Jensen. I had a couple shows down at Dean Jensen in the last couple years [early '90s]. I have been in the newspaper. [*Wisconsin State Journal*, 21 January 1991]. The newspaper said my pictures are from a "Suburban Paradise." That sounds pretty good, wherever that means.

I do my drawings first in black and white, and then I color them in after I get done drawing. I started out with pencil. Recently I also use ballpoint pens. They do a better job. Then I color over them. I just buy my pens and stuff from the shopping center. They're not too far from here. I have millions of pencils in my box. I use colored pencils. I like colored pencils. The size doesn't matter.

I put people and cars in my drawings. I like baseball and football. I watch some of the teams from Wisconsin like the Packers and Brewers. I'm from Indianapolis, you know, and so I like Indy 500 cars. Kind of racecars. My sister saves all of my drawings.

TO TELL YOU THE TRUTH

I've got a story for every drawing I do, too. Things just spill right out of my mind. My sister thinks I draw houses because my brother-in-law buys

houses. He lives in them for a while, and then he remodels them and sells them. She thinks I probably got some of my style from looking at houses with them. I visit houses with them. That's what my brother-in-law likes to do. He's a social worker and takes all the stress out of him by doing all this other stuff. I think all the houses are from my imagination.

I have most of my stories in a sketchbook. When I had a paper route, I delivered to houses and I probably got some of these stories into my mind. I used to deliver papers in rich neighborhoods in Indianapolis. Then I got to Madison, and I had a paper route here for a while. Later, the newspaper retired me for some reason. I don't know why. It just comes out of my mind, whatever I do. I like to draw plants. I think I got the idea from my sister because she's always planting flowers and bushes and stuff.

I start my drawings all different. I never know how I'm going to start. If I was to describe a picture of some rich people's house, probably out in the country somewhere, I would say, "She wanted her own flowers and he wanted trees so they both got what they want." I might do shrubbery, and after I get done with that, gardeners might be coming to take care of the rest of the shrubs. So I'll put them in. I used to do a lot of yard work until my heart condition got bad. The doctor said I couldn't do anymore yard work because I had two heart attacks. I did gardening and trimming, stuff like that, cutting weeds or pulling weeds. And there is another house over here and more bushes. I have to wait to draw the other houses until the street people come in and pave the road and get the sidewalk finished. They usually try to get the street in first before they build a house, you know.

Now, Mrs. Jones can't figure out what color she wants the house. Mr. Jones is in Texas, and he might not like it when he gets back. It might cost him a lot. The other people in the neighborhood sold their house because it was starting to cost them too much money. Mrs. Jones, she told the painter she wants a blue house and green window wells. She used her imagination.

Mrs. Jones wanted green and all of a sudden she decided she wanted to change to purple. I'm glad she changed. Her husband's coming home tomorrow. They're gonna try to get the window wells done before he comes home. He'll be surprised. I hope he likes pink. Pinkish-purple. There might be some people in the yard, in there too. Something is going on. The workers are trying to finish before the husband gets back. I think they will. They are working pretty fast. That's terrific.

To tell you the truth, I don't know how long my drawings take to do. Everybody asks me how long it takes, maybe a day and a half. Everybody also asks me if I know what colors I'm gonna pick, and I just say no I usually just pick 'em as I draw. Someone told me I have talent for picking colors, but I don't know about that. I work until I get it all done and then sometimes I add more to it, too. Then it should be all done. That's what I always say. I noticed that when I went back to my old sketchbook that I really have changed my style over the years. I like having different styles, different ways to draw and different strokes. These drawings are all my kids. I do like to draw all the time.

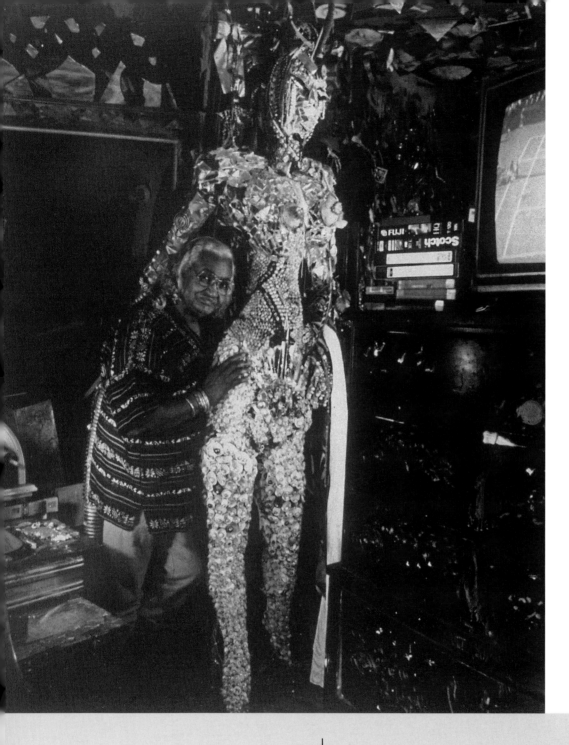

Mona Webb, in her studio/home, the Wayhouse of Light, in Madison, 1993. With her is *Aphrodite*, concrete, mirrors, jewelry, beads, shells, styrofoam, brass, and found objects, 31" x 93" x 15"

MONA WEBB

I'm like a bird. I was building my own nest. Getting up and feeling something and getting somebody in here. That's mostly what my life is all about. It's not a thinking process. . . . It's like building a nest.

—MONA WEBB (1914–1998)

MONA WEBB traveled extensively, dressed with drama, and studied with and lived around some of America's most brilliant thinkers of her day. She married twice, raised four children, and maintained her east side gallery and cultural salon for thirty years. She hosted poetry readings, dance performances, "happenings," and considerable spiritual questing in her gallery. She began to create art in earnest in the 1930s and never stopped, working in a dazzling variety of media until her death in 1998. The gallery, Mona's home environment, was a sacred space with decorated walls, ceilings, and stairways completely covered with photos, jewels, and a variety of treasured memorabilia that honored her extended family. The building that housed her environment was bought by developers after her death and turned into apartments and retail space.

ART AND LIFE

I've never had any background and training in art; however, I've always been recognized in it. I taught dance and with my first husband did drama. I published poetry and I was a writer for twenty years. I also was an editor on two or three different papers. I started painting in Mexico, back in the '30s. Mexico City was an active place in the late '40s and early '50s, after World War II. I spoke Portuguese and Spanish then, because I hadn't turned to the American thing at all.

I knew [Aldous] Huxley and that group of people down in Mexico City. The one person who really influenced me was [Jiddu] Krishnamurti. I was younger than them and the only woman. I didn't really know who they were. I knew that they were a creative group that got kicked out of Hollywood. We happened to land in the same area. They were just friends, and we lived in the same building. Hemingway lived around the corner. I was a psychic. I influenced them, and they influenced me. They were only interested in my head. I had the ability to touch something dead and see it come alive. So I had a big following. It wasn't like I was running after a group; they came after me. And that's what Huxley talks about in some of his letters. He talks about my head.

One day, I picked up my daughter's art supplies and started painting. She had brushes and stuff, and I gave them a try. She carried my work to her professor. Everybody had a fit about it. That was my first real painting. People said, "My god, look at her colors."

The University of Mexico is so beautiful. If you don't have art in your soul, it will positively bring it out, sharpen your technique. Every artist in the

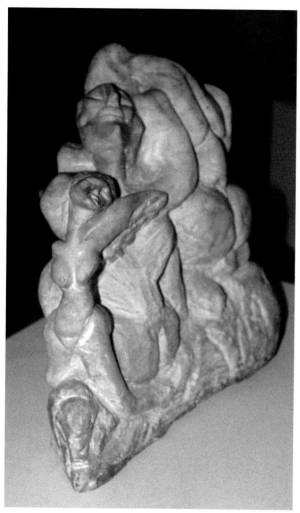

Untitled, date unknown, alabaster

world should go to the University of Mexico. It's an old university and one of the most beautiful. Rooms in the gallery look like the outside of the University of Mexico. You can see the great cultures that have lived, the great Indian cultures of time, just looking at all the motifs and stuff there. It's a very natural and dynamic site.

ART, DYNAMIC CHANGE, AND SPIRITUALITY

I have seen some beautiful sculpture that I would say is art. And oh, my gracious, that person has leapt, has touched the infinite. I've seen stuff in different countries. It's so beautiful, so satisfying to every being within you. It makes everyone happy to look at it, to become a part of it. It's a part of all of the atmosphere in which it is. And that's an accomplishment! And to reach that, to reach that place, I think that's the reason I don't use the word art, because the word art doesn't mean anything now. It just means you can paint. You can sculpt. You can do this. But what I'm after is the spirit. I'm after *something*.

I don't think I make art. I think I *make*. I don't know whether it's art yet. I'm not declaring myself an artist. I run away from titles. I've been called an artist, and I've been called everything else. But I don't accept them. With titles, it means that I'm pinned down to something. I'm not pinned down, because I haven't found what I'm looking for yet. So I make what I have to. I'm reaching it. I'm reaching after it. That's what I'm working on. I'm working at *something*. I'm looking for it. I've been looking for it on all kinds of levels. The glimpses are already in my head. I wish I could make what I perceive. I want other people to see it. But I can never reach what I perceive.

I want to bring about dynamic change in the world. I want to stop men from warring with one another. I want to stop all of the hate processes that go on. I want to stop the fighting between women, men, and children. I want to stop all of that stuff. I am a child of my father. I actually believe in love. I believe in the oneness of ideas, of everything being a part of life, with the

trees, the stones, and I positively perceive beauty. Making . . . I wouldn't call a process, it's life. That's the only way I have lived.

I like the word "creative." Creating is giving something back to humanity or becoming a part of the atmosphere in which you live. Becoming a part of the atmosphere as a tree is, or being as important to the atmosphere as water is. It's free. I think sometimes it touches us. There is a connectedness of all things. Creating is a part of God. Part of whatever you perceive of God. It is our energy. I wish I could create. I envy the growth of the tree. You blow it up or burn it down, but a tree will come back up. We're so fragile. Everything we do is so fragile. We could be easily wiped out. Look at the power of the atom. That's what's happening in this world. Creativity can be used destructively. And that is the reason that I am so into the creation of beauty, within perceiving, and trying to give something as I can.

I believe that somehow we are so involved in materialism that we miss the dynamics of the spiritual. Somebody brought a cat to me once, and it had a broken neck. I've often picked up a bird that's been hit by a car. Mankind has a spiritual thing within himself that is operating beyond the man and intelligence. Something that can reach through him, that reaches out, and can do things that ordinarily are called miracles. It's something that we often ignore. But when we find we have it, we try to make something of it, to sell or to show. The gods have been really good to me. When things like this happen to me, it happens with groups of people. If this happens to me by myself, it blows my mind. I start screaming. I'm a freak! I've known this all my life. Whatever it is it's no recommendation, and it's no decoration, either.

I have a dimension here that you haven't seen. I am working with dimensions that I perceive that man hasn't recognized yet. Dimensions that are more spiritual, that flow in and out, that are more good, that are not static, not limited by terms, words, and reasons. I want to show that man, in looking into these dimensions, can perceive through it, as an illusion where you can stick your hand through something. A mind can go through something. It is a training for the mind rather than for the material hand, as fact. I can make an allusion to go through something as an illusion, or I can try my best to communicate something that I perceive about mankind. I'm trying to communicate that mankind isn't aware of his spiritual self. He isn't aware of that depth that he has where he can do anything.

Lately, my body has been in a lot of pain. My feet and hands are numb and it's hard just touching things. As my body dies, I'm truly getting this

expression outside of myself. I don't feel pain as badly when I'm working. I can get into a piece and get so involved that there is no pain and there is no body. I can break and pick up all the glass I work with and I don't wear gloves. I don't cut myself. There's no blood. I'm working with glass, and I'm sleeping in it. I can cut this glass right in my bed. It's something in myself that goes beyond. It has to do with the spirit. It's something proving to myself that the spirit is more important than the body. The body is very important. But the spirit takes care of the body. And expressing it by working is very dangerous. Very dangerous. I don't even think about cuts, or it will cut me. It's like walking on coals. It's the same thing. I did that once, you know. It was just really beautiful. There were people all around paying money to come in and see these people walking on coals. I just tore off my tennis shoes and walked across the coals with the natives. I do things like that. When you're working with glass, you're working with nothing but sand. You're working with a reflective thing. I think reflection has something to do with the mind. There is no hurt, you're just working with the beauty. I think this is the only expression, the only happiness I really know. My happiness is in putting stuff together. I think that's where I become whole.

FAMILY AND CULTURAL HERITAGE

I don't know the outside world. I have been reared with perceiving God, perceiving love, not being a part of the world out there. This is a huge world. This is not a small world. People say, "Well, how did you meet so and so?" I don't know how I met them, but I know people come to me with all kinds of problems. And it's always been like that. I've always been in the world. My world is a totally different thing. Everything just seems to formulate around me all the time. I don't recognize rules. There are lots of people like me in the world.

For years I never really settled. I lived for a while in Mexico, New York, Madison, and Texas. My family was from Texas. I knew Malcolm X when I lived in New York because I knew Father Divine. Father Divine was in Harlem. He had all these stores and Malcolm X was one of his protégés. In those days Portuguese, Spanish, and Italians lived in Harlem. It was everything and everybody. People in the house where I lived spoke Portuguese. People there weren't into color. It was a beautiful place. I used to love to go to Harlem, because you could eat any place, hear any language.

I have never lived in any world that was separated. I talk about myself as who I am, in my own culture that I live in. I've never lived in a segregated culture. I am Portuguese. I come from all over the world. I am very proud to be Portuguese. That comes out front, just like people who are Italian or anything else. Even in Asia, there are Portuguese.

I read the *New York Times* about DNA. They said that everybody in western culture is so mixed that you can't find an ethnic group that has definite DNA that's alike. Each person's DNA is completely different. Therefore, I don't perceive Western culture as being a pure culture. By pure culture, I mean that they have their own language, their own food, their religion, make their own clothing, create everything that's all around them. It's such a mixture of people.

For example, most African Americans wouldn't be recognized in Africa. Most Africans do not recognize the American "mixed up" person in their culture as African. They may have some African blood way back there, but they have every other blood too. They're strictly American. There are different shades of brown and black Americans. I don't know anything about black culture. The word "black" to me has two meanings. One is beautiful and the other is negative. I was the darkest among all the girls in my family, and my sister next to me was blonde. She called me black gal. So that is my fighting word. That's when I would bust her in her mouth when she called me black gal.

This is who we are. Different kinds of colored, like Indian, Portuguese, Italian, American, African, and all kinds of colored. We are straight, gay, and all kinds of people. This is who my family is. This is who we are. We are between races. But my philosophy is that we are just one. We can live together. We can dance. I taught ballet. A newspaper write-up said, "Go to Mona's on Williamson Street. We were rubbing shoulders with millionaires from New York, from San Francisco, from Chicago, welfare mothers, and motorcycle riders!" You can't deny who is who when you attend something at Mona's, and that's the way my family is!

My mother was a concert pianist. My father was an educator. I'm my father's first child, and he wanted a boy. You know, that's our culture. You want boys to carry on your name. You don't want a woman. So my father taught me how to sharp shoot and all. I know how to be a boy. I grew up knowing how to be a boy. I have never perceived myself as a woman or a man.

My father was English. He was "real" European. My mother called him Prince of England. I've never heard him called by his first name. He was

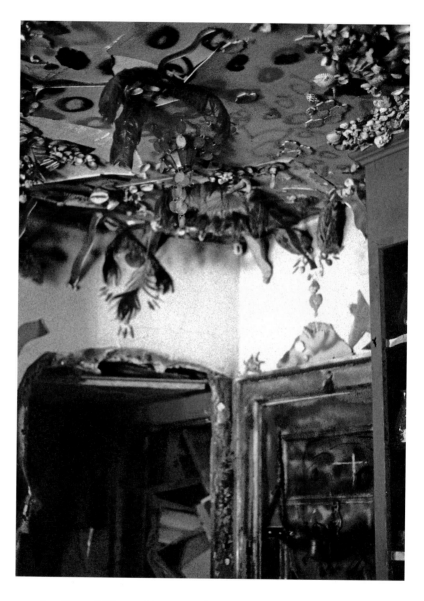

Ceiling collage, Mona's home, 1998

pure intellectual. He would never walk into a kitchen to wash the dishes, fry an egg, or anything.

My father managed stuff. He was Presbyterian and had a doctorate. He was the vice president of the Stillman Institute. He wasn't just a preacher. My father doled out millions to the poor.

When I was a child, they didn't have welfare like they have now. People would just come and you could see families, two or three people from the same family, getting gallons and gallons of milk. I would always hide

because I never wanted to see it. I feel a pang of sadness to see the separation going on for children who are being born into a world where they are going to be kept from the knowledge of their beauty of who they really are, who their families have been.

I'm very much like my father sometimes. He was beautiful, but he wasn't ordinary. He believed, he really believed. He was aware. He wasn't out there making money. He had a touch of Midas. He would go and buy some land, and save some old lady from something, and they would find oil on the land. Everything my father touched turned to gold. He gave it back to the people. That's the way he really believed. He wasn't into the American thing. He believed in humanity. That's where I get this from. People become humanity. He wasn't into, "I am a black man. I am Afrocentric. I am part this, I am part that, I am part the other." It's how you live that really matters. That you really matter. I really want to matter. I have found a way to express myself. It's perceiving things, and putting them together. The building [gallery] is my perception of things put together.

THE GALLERY

I have really lived. Most of my life, I traveled. My ethics is love. I talked with people on different islands and just about every continent. I traveled everywhere except China. I even slipped into Russia. I took a group of people with me and my kids. Some of the talk that I brought back from these places went into the building of the gallery; that was the creation of the gallery, going to these places and coming back. All of that stuff is in here now. The gallery is this whole building.

The gallery was built over Indian mounds. It must be one of the most spiritual places I've ever lived in my life. I didn't choose this place. This place chose me. It is between the two lakes and the river. It's the holiest ground that we have in Madison, that I've ever come to because I have gotten to know the tribes that lived here. They were Menomonee. I've gotten to know a girl whose great-grandfather used to walk from this one lake to the other. My whole backyard is nothing but Indian mounds. All of this part of town, from here to the state capitol, belonged to the Menomonee tribe. This is very, very sacred land. And it's a very, very spiritual place. You know, this is a very beautiful area, if you forget about the humanity and stuff and really look at the lakes and look at the river. That river is just so beautiful.

Untitled, date unknown, coins, mirrors, jewelry, mixed media

Before I lived here, this building was an old bar. I purchased it in the '60s. It was an old Polish and German neighborhood. When I first fell in love with this building, a woman who had been a hospice pal of mine was dying with leukemia. I came up to visit her, and she lived on the next block. This is the way I found Williamson Street. Every time I passed this place, it was like something out of the 1800s, when they used to have a hitch out in front for horses. I kept passing it. And then I thought, I really would like to put a gallery in that building. I would like to work in that building.

Well, in the meantime, I had just had a big write-up on my place on University avenue, a whole-page spread in the *Cap Times* (Madison newspaper.) It read something like "Grandma Moses in Madison" or "Madison's own Grandma Moses." I think that was the headlines. Every place I go, there's newspaper coverage. My place has been written about a million times. That's the way people know about me. I'm always talking. I went to Wash-

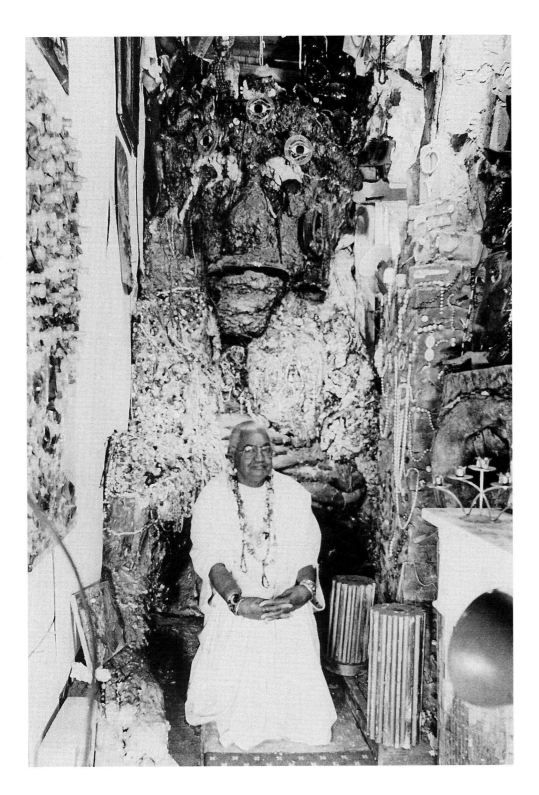

Mona, with *10 Ton Buddha*, 1993

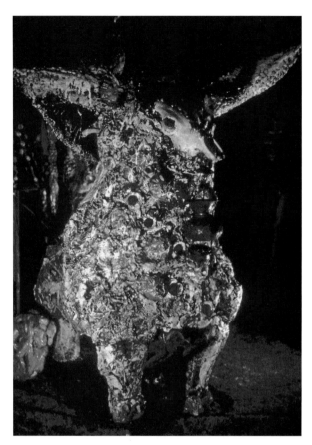

Untitled, date unknown, plaster, cowskull, paint, pebbles, roots, found objects, 78" x 68" x 59"

ington on the Poor People's March and ended up speaking to the whole state of Wisconsin. I was recognized even way back in the '50s. I think I loved Madison because it reminded me of Europe. I haven't shown my work since I have been here [east Madison]. The gallery is where I stepped away from the art world and just became Mona. The gallery brought me away from being so immaculate.

At the time, I believed in dynamic change. I took my kids to places in the world where they had never before seen blondes or blue eyes. I tried to show them the world. So they wouldn't be afraid of it. I had people coming to me from all over the world. We were painting and sculpting and making, trying to teach people how to go into other cultures and become a part of that culture. Instead of going into other cultures and bringing our culture in per se. As we traveled, I collected the dirt. I would bring it back. I would bring back some of the real stuff. I'm like a bird. I was building my own nest.

The gallery represents these people, times, and places. I can glance up and look at all kinds of people, all kinds of times, all kinds of places. When my eyes move around, there are hundreds of people. Hundreds of people, different work, different appreciations of art. Lots of people have lost their art, have burned out from different cultures, tribes, religions. Objects from my travels around the world are in this room. There's a real continuity about it being a part of my home and who I am. Now, you know, I don't think about it. It's not a thinking process. It's not like an interior decorator. I get up and feel something, and get the feeling of somebody in here, that's mostly what my life is all about.

These are sacred places here in this gallery. I have a piece down there supposedly from China. A university professor brought it who had been lecturing in China. He wanted Americans to see wood that had been carved over ten thousand years ago. He came in one day with this package and told me the history and said, "Mona, this is where it belongs, because it's sacred. There's no place in Madison where it will be respected." So it's down in the altar room.

Creating this place has been my life. I understand more. I'm complete. People come here from all over the world. Don't ask me how they find their way into here. Living here isn't relative to anything. It isn't relative that I have a bar next door. This is like a place suspended in space. It's just as much a part of space as anything I ever want. There's no consciousness in this building of the depravity that can go on all around me. All I have to do is try to keep me from feeling guilty that I get to be in here. I'm not creating this place by myself. This place drew me in. This place is helping to create me. The energy that flows through this place is helping to create me. This is one being on this earth that would really love to matter.

WESTERN WISCONSIN

Western Region

Western Wisconsin is known geographically as the "driftless area." Throughout the last ice age, four waves of glaciers pushed across all of Wisconsin except for the southwest quadrant. This process scraped and flattened many of the hills and rock formations in the northern part of the state and dumped giant chunks of granite onto the landscape as it moved to the south. The last glacier stopped its advance near present day Devil's Lake State Park at Baraboo.

Wisconsin is home to about five thousand earth mounds made by ancient peoples, many more than any other state, and many of these mounds are found in the western area. Wyalusing State Park (Prairie du Chien), Devil's Lake State Park, and Man Mound County Park (Baraboo) are excellent places to contemplate these earthworks by western Wisconsin's first settlers. Today significant Ho-Chunk (Winnebago) native populations live throughout the western area and run three casinos, as well as the Stand Rock and Ho-Chunk Ceremonials and numerous businesses.

Just outside of Prairie du Sac, in part of the area once known as the Sauk Prairie, Dr. Evermor is constructing a theme park centered around his

Taliesin, Spring Green home of architect Frank Lloyd Wright, now houses a school of architecture. It is occasionally open to the public.

extraterrestrial space travel vehicle, the Forevertron. A few miles north, over the Baraboo Bluffs, Bruce Squires constructed an eclectic assortment of figures and everyday animals out of recycled automobile parts.

Melting water from the glaciers carved the beloved pictorial limestone and sandstone rock formations found at Wisconsin Dells, along small creeks in the rural southwest, and along the Mississippi River valley. These layered cliffs inspired local son Frank Lloyd Wright to develop his organic architectural aesthetic for buildings that hugged the land like layers of sandstone. Numerous buildings by Wright and his followers near Spring Green illustrate his principles. Wright's Taliesin—Welsh for "Shining Brow"—shares the landscape with impeccably groomed farms, remnants of old log cabins, and stack and block farmhouses, a proud legacy left by German immigrants to the state.

Detail from a stack and block house, Prairie du Sac

In this agricultural area Ellis Nelson creates "prehistoric life forms" in his converted gas station/studio in Muscoda. Nearby, the residence of former farmer Lester Fry is decorated with a fanciful arrangement of electrical glass insulators and recycled farm wagon wheels.

In 1989 a portion of the Wisconsin River, from Sauk City to Prairie du Chien, became protected by law from further commercial development. This decree, controversial when enacted, has allowed a relatively unspoiled haven for hunting, fishing, canoeing, and farming. The driftless area is primarily agricultural and rural. Tiny towns supply equipment and supplies for farms perched on the rolling hilltops and valleys, along tiny winding back roads, and along creeks and rivers heading toward the Mississippi.

Western Wisconsin was settled by European immigrants from Wales, Germany, England, Ireland, Switzerland, Sweden, Poland, Norway, and Holland, and this diversity contributes to the life, food, and culture of the area. Wisconsin Dells celebrates Polish Fest with food and dancing, Monroe boasts a Swiss cheesemaking tradition, and Mineral Point serves famed pasties (meat pies) and figgyhobbin (raisin nut pastry) at Cornish Fest. Southwestern Wisconsin is home to the state's favorite small cheese factories, and the Wisconsin Candy Company, home of Cow Pies, Udderfingers, Moo Chews, and in football season Green Bay Puddles. There is a large population of Amish, and some sell crafts in small home markets in the Cashton area.

The western part of the state is also home to an amazing collection of artists actively producing traditional and idiosyncratic creations in their yards, basements, and neighboring fields. The World Peace Monument in Cataract, Herman Rusch's Prairie Moon Museum in Cochrane, and the Painted Forest in Valton are all found in this part of the state. In LaCrosse, the "land of sky blue waters," Paul Hefti's yard environment beckons visitors, whom the artist often regales with poems and puns about each part of the installation.

One of Wisconsin's best known and best documented historic yard sites is the recently restored Prairie Moon Museum in Cochrane, Wisconsin. Herman Rusch, born in 1885, retired from farming in the 1950s and bought an old dance hall, which he proceeded to fill with antiques and curiosities. Over the next twenty years he built about forty-five sculptures including mysterious spires, giant urns, dinosaurs, snakes, a bear, a concrete self-portrait, a Hindu temple, birdbaths, various towers, and beautiful red-topped concrete arches that gracefully outline the roadside of the property.

South of Rusch's fantasy, at Valton, is the Painted Forest, or Modern Woodmen of America Hall. Ernest Hupeden, an itinerant artist, painted the entire interior of this small wood-framed building from 1898 to 1899. Interior murals depict the surrounding landscape and the philosophy and rituals of the fraternal order in past, present, and future times. Hupeden's mysterious murals cover the hall's interior walls, doors, stage, and stage curtain.

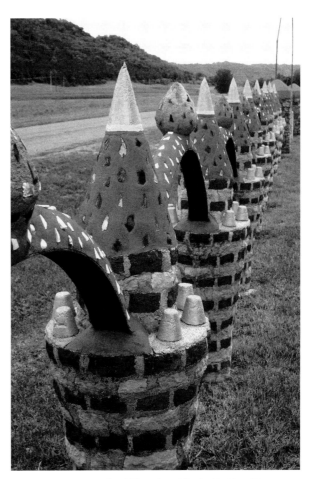

Roadside arches at the Prairie Moon Museum and Gardens, Cochrane

The Painted Forest nearly met its end in the 1950s when the building, no longer used by the MWA, went up for sale. Fortunately, in 1980 the Kohler Foundation purchased and restored the building. In 2004 care of the building was turned over to the Department of Art, Edgewood College, Madison. The building continues to be used as a public meeting facility in its small rural community.

Roadside attractions with Wisconsin flair are everywhere in the southwest. Homemade mailboxes take the shape of fish, log cabins, an Oz-like tin man, most species of animals, and of course cows.

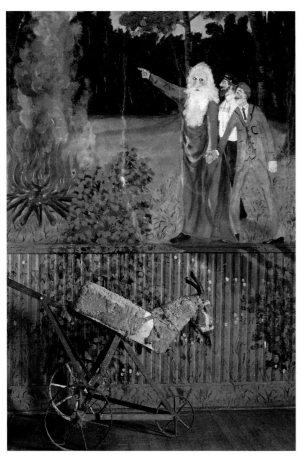

Detail from Ernest Hupeden's Painted
Forest, Valton

Netta Pohlman's terraced yard environment south of Reedsburg on Highway 23 was for many years an exceptional example of a Wisconsinite's pride and enthusiasm for making personal landscapes special. Netta's site began to take shape in the 1980s after she was given gifts of several conventional concrete yard ornaments. Pohlman began to singlehandedly landscape and transform her large sloping yard into a terraced museum of lawn art. As the yard became more formalized, hundreds of additional pieces came her way, and she arranged them carefully, eventually covering much of her front yard. Pohlman's yard became a popular tourist site in her community and one of the favorite stopping points for school buses full of inquisitive children.

The rich river-bottom fields in the west produce a variety of fruits and vegetables, and every autumn farm markets along Highway 60 treat customers to creative displays. Squash and melons are transformed into horse-drawn wagons and figures, and pumpkin pyramids lure Halloween shoppers.

Displays of another kind are found at the Fast Corporation near Sparta, which makes giant fiberglass advertising figures. Scattered across the work yard are huge molds waiting to be called into service in the production of oversized versions of Jesus Christ, the Statue of Liberty, cartoon characters, pirates, Marilyn Monroe, and an endless selection of local and exotic animals. Coloration is fanciful and bright. The figures go on to grace commercial venues, miniature golf ranges, and parks all over the country, but a huge number stay in Wisconsin.

Paul and Matilda Wegner came from Germany in 1886 and eventually settled on a farm near Sparta. In 1929 they visited the Dickeyville Grotto. Enthralled by the site, they returned to their farm and began to build outdoor concrete sculptures. Using skills learned from concrete silo construction, the Wegners built arches, fences, a patriotic shrine, a glass church (covered with a mosaic of churches on the exterior), a cement anniversary cake, and a replica of the steamship that brought them to America in 1886. The

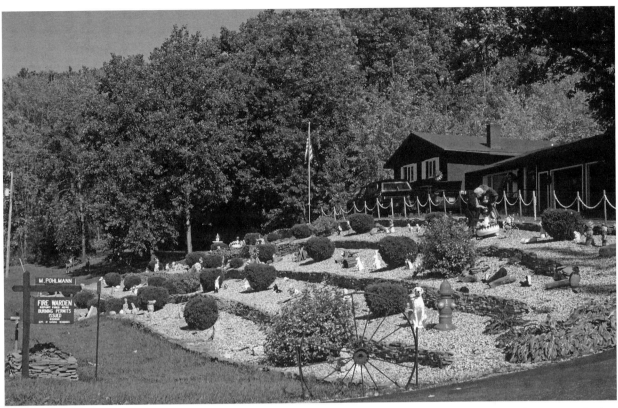

Netta Pohlman's yard environment near Reedsburg stops many passersby in their tracks.

Wegner's World Peace Monument is thought to be the first art in Wisconsin to combine both religious and secular themes.

Norwegian communities thrive in the southern section of this region. On the Business Highway 151 Trollway, Mount Horeb artist Mike Feeney has created a parade of trolls, carved into oak stumps, that lead visitors towards Blue Mound State Park. Mount Horeb is also home to the Mustard Museum and, just south of town, visitors can see the graceful large-scale dinosaurs created by Wally Keller.

This southern section of the driftless area is home to several historic environments as well as small-scale constructions. Perhaps the most famous of these is the Dickeyville Grotto, constructed by Father Mathias H. Wernerus. Wernerus was born in Germany in 1873, a year after Father Paul M. Dobberstein, and like Dobberstein, came to study at the St. Francis Seminary in Milwaukee. Although the two were not there at the same time, Wernerus was able to see, on the seminary grounds, the completed Lady of

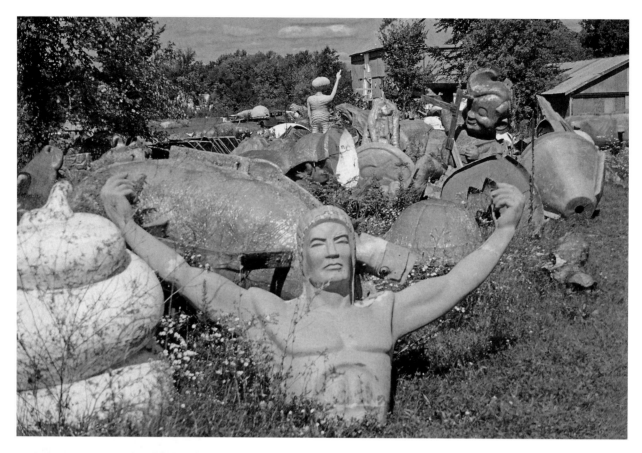

Top: Near Sparta tourists can stroll through the yard of Fast Corporation, where advertising novelties are made.

Bottom: Mailbox troll from Mike Feeney's Trollway, Mount Horeb

Lourdes Grotto designed by Dobberstein (see eastern regional tour). In 1918 Father Wernerus became the pastor of the Holy Ghost Church in Dickeyville, Wisconsin, where he soon set about making a beautiful environment for his parishioners out of concrete, found materials, and rocks procured from his excursions into caves all around the United States. As work on the Holy Ghost Park, or Dickeyville Grotto, progressed, Wernerus began to experiment with the addition of bits of colored broken glass and crockery. The church grounds came to include shrines, a cave, and devotional niches as well as numerous concrete planters, fences, and landscaped meditation areas. The spectacular scope and scale of this shrine, dedicated in 1930, along with photo postcards available to visitors at the site in its early days, quickly spread news of the grotto all over Wisconsin and the rest of the world. In the 1930s, Dickeyville attracted thousands of visitors a week, and today it continues to be a popular tourist spot. Dobberstein's and Wernerus' creations seem to have sparked a period of concrete environment building around the state.

Above: *Glass Chapel*, 1932, Paul and Matilda Wegner Grotto, Cataract

Bottom: The Dickeyville Grotto and Holy Ghost Park covers several acres with small and large shrines and areas for reflection.

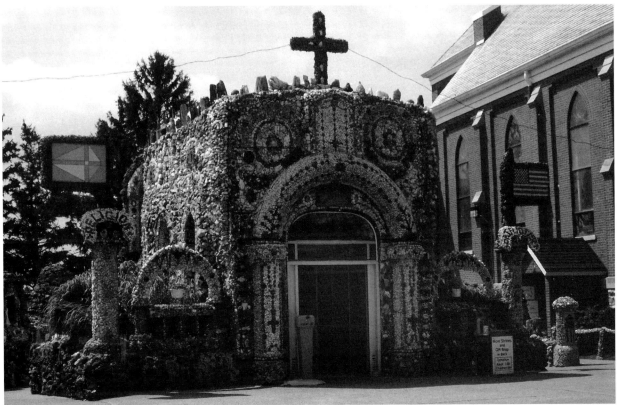

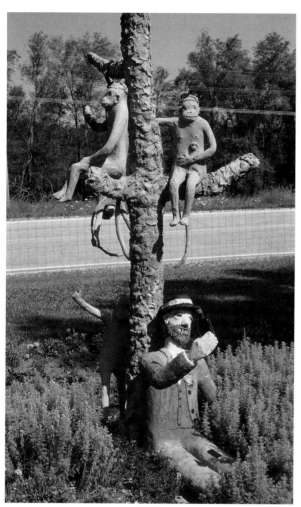

Monkey business at Nick Engelbert's Grandview
near Hollandale. Site construction began in 1937.

Nick Engelbert was born an Austro-Hungarian and in 1913 moved to Hollandale, Wisconsin, with his new bride. He farmed and raised a family about forty miles from Dickeyville. During the next twenty-plus years, Engelbert visited the Dickeyville Grotto several times and began to decorate his own yard with gardens and concrete sculptures of animals, humans, patriotic symbols, mythological characters, and historical figures. He covered the outside of his house with concrete and embedded sculptural tidbits. Nick Engelbert's approach differed from fellow environment builders in that he combined concrete figures embedded with pieces of shells, pebbles, and glass next to smoothly finished and painted figures. He built graceful arches and fences around a beautiful hillside property he called Grandview.

In the early 1950s, he stopped sculpting and began to portray farm life in detailed oil paintings, which he made until his death in 1962. Grandview was left unattended for many years. Vandals destroyed and stole several of the sculptures between 1962 and 1996. The site was recently restored and reopened with the help of the Kohler Foundation. It is now administered by the Pecatonica Educational Foundation, Inc. (PEC), a group from Blanchardville and Hollandale and surrounding rural communities.

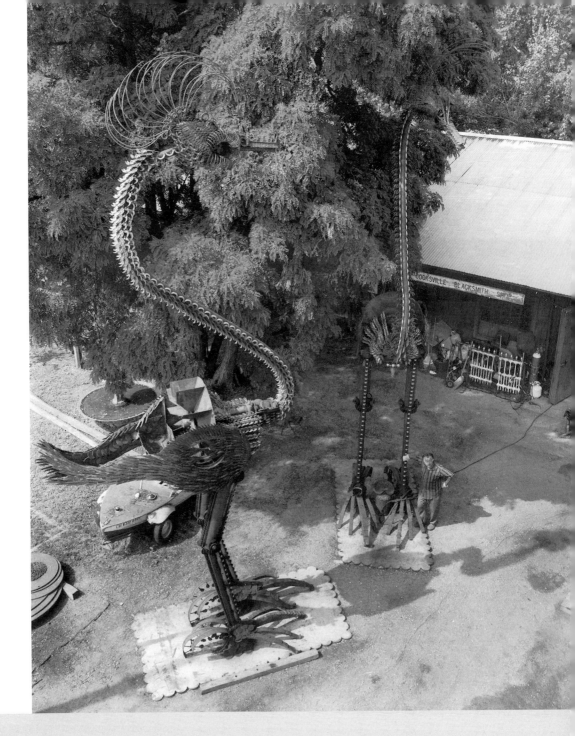

Giant (37') "dream keepers" now stand along Madison's east side railroad corridor.

What I am doing here with all kinds of little and big objects is putting together parts of history into a creative thing. . . . I try to make magic out of nothing.

—DR. EVERMOR

DR. EVERMOR (TOM EVERY)

DR. EVERMOR (BORN TOM EVERY) has been building Wisconsin's largest active sculptural environment since 1983. The Doctor's mind is constantly moving forward, inventing "timebinding" creations that support a philosophy that integrates history and artistic spark. Dr. Evermor first created a fantasy based rather loosely on the English pirates, ministers, and mischief makers from his own genealogy. Into this, he has integrated a passion for Victorian-era industrial design, several thousand tons of unusually spectacular industrial salvage, a rapid-fire imagination, and exceptional metal construction skills learned in a lifetime of deconstruction. For several years, Doc envisioned a giant earthwork, to be visible from the heavens, at the nearby Badger Army Ammunition site. This dream recently suffered a setback when he was unable to procure the land necessary for the project. He continues to build huge birds and dragons at his current site.

POWER ON

Let me tell you a kind of humorous story. Long ago, my family was from Eggington, England. In an earlier time, when I was a young boy, about eight years old, every day there was all kinds of heat lightning. One summer's day, I went to my father, a Presbyterian minister, and asked him, "Dad, where

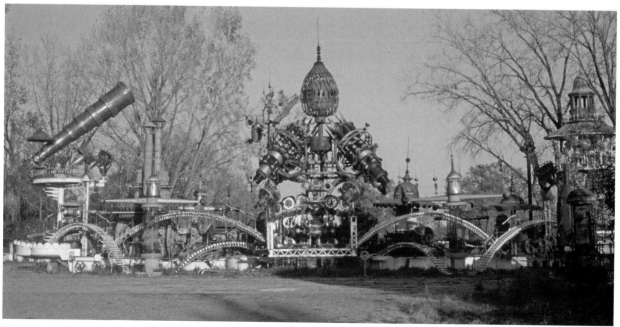

Forevertron, north of Prairie du Sac

does all that lightning come from?" Naturally, he responded, "It comes from the heavenly Father." So I was brought up with a religious background.

When I went to high school, which was around 1850 or so, there was a lot of experimenting with electrical things. I was fascinated with the push and pull of magnets. I got to thinking about that and all the lightning and I had heard about Nicholas Tesla being able to shoot giant sparks. Of course, Thomas Edison was here in America. Well, I went forward with my thinking and decided to combine the two forces—magnetic force and electrical energy. Later, in my twenties, you know, I speculated that if I could ever figure out a way to combine those two, what tremendous power I would have! So I built a device thinking that I could perpetuate myself up into the heavens on a magnetic lighting force beam inside a glass ball inside a copper egg. I became Dr. Evermor.

The Forevertron is Dr. Evermor's experimental machine. I designed it with a spiral staircase so visitors can go up and across. I will stand up on that platform and crank a crank up there and the ball would go up and signal "I'm ready to highball it to heaven," and I will go across the little bridge and get inside the glass ball inside the copper egg. The ground people will scamper around on these bridges and make sure everything is secured properly. And, in theory, at the right moment, I will be fired up into the heavens on a magnetic lighting force beam.

One day somebody from the University of Wisconsin came to this Baraboo site and said, "You know who owns this piece?" I said, "Why?" "Well, I'd like to meet the guy who owns it. I would like a job," he said. I asked, "What are your qualifications?" "Well," he said, "I'm an electrical engineer." I remarked, "Well, I know Dr. Evermor, and I'll give you his telephone number and you could talk to him. What do you want to do for Dr. Evermor?" "Well," he said, "I would like to wire this thing up!" I thought to myself, after he left, 'My god! That's wonderful! At least we fooled that guy!' There's a little bit of P. T. Barnum in what I do. Why not? You've got to be happy and laugh about a few things!

SALVAGED MEMORIES

Life is such a short period of time. So it's nice to be able to pick up on memories. I collect industrial shapes and forms. I'm interested in the rivets and all the magnificent things that somebody worked on or made with their

hands. I take things and, more or less, read and interpret them. Whether others see it as art, I don't have any idea.

I work with the imagery, shapes, and forms. I look at the form of the item, for example the teeth on a gear, and add actions, twists, and curves. When I am making, I'm looking through a different set of eyeballs. I try to make magic out of nothing. In the case of any and all these things, large or small creatures, I don't alter the shape of the materials. It takes an eye and an ability to use the things laying in front of me on the bench. I keep adjusting and disciplining myself to these things, and that is why they all come off somewhat whimsical. Is it a wing or a feather? I don't have to worry about making a feather exactly like a bird's feather. It's not going to fly, anyway. I just keep driving along. If other people view what I do as art, that's fine. I'm just challenged by one little piece at a time and try to understand some kinds of concepts. I take on projects because it's a challenge to me.

I have always been interested in how to recycle things without putting any extra energy into 'em. You have to understand that I come from the years during the Second World War. We collected toothpaste tubes and newspapers were piled up at the school grounds. We saved everything. I collected paper as a cub scout. I grew up in the little town of Brooklyn, Wisconsin, and I was known as the little "sheeny." I always collected paper, iron, and scrap. I believe there's a newspaper article about me that said I was "retiring" at seventeen years old after being in business since I was eleven. I can still remember loading my first railroad car with scrap iron when I was fifteen. I have always been interested in scrap material and what you could do with it. I think that taking a piece of scrap and then maneuvering it around so it becomes something of interest—artwise—I think that's good.

I've been involved with a lot of historic collecting of things over the years. It appears that man's mind, when they become a collector of things, they're really a lover of a certain type of art in a certain time frame. Whether it be a gun or whether it be a toy car or a truck, or even collecting antique automobiles, they are accepting that they can put a value on that and assess it into the current day value systems, that it's going to go up in value and then they trade back and forth and all this monkeying around business. I'm very thankful for people who are collectors of that type of historical things. They are saving something of history rather than letting it go down the tubes.

I think some of this stuff kind of evolves. I have been an industrial wrecker for a great period of time and I destroyed a lot of things. During

that time frame, I took it upon myself to pull out interesting shapes and forms that I thought were interesting to me, if nobody else. Then I realized that a lot of these shapes and forms are going to disappear from our landscape entirely, and whether the tank ends with interesting rivets or whether it be shapes that come from breweries or whatever, these different historic objects are too often just melted down. So I went about saving all that stuff, some of which you have witnessed down at The House on the Rock [Spring Green, Wisconsin]. I probably saved about a thousand tons of stuff. However, that project was entirely different than what I have here.

AN OLD RAILROAD PRINCIPLE

I have learned a lot about these objects by taking these things apart. Afterwards, I certainly knew how to put them back together. Early in my career, I didn't have a lot of money. Sometimes I took projects that necessitated taking things down from great heights, and I never was a good welder. When I had to have a lot of welding done, I always hired people to do the welding. In the last six or eight years the reality of things necessitated me to do the welding versus paying twenty-three dollars an hour out for welders.

So a lot of what I know about making these things probably evolved from my wrecking and salvage background. A lot of it has to do with attitude. The amount of tonnage and removal around here is minute compared with what I used to remove. In my business, we would move hundreds of tons a week. So I have really scaled down from the way I use to operate. As far as the engineering, like on the telescope, I built that on the ground. The telescope is kinda unusual. I took seven sets of agricultural wheels and put box tubing in between them and covered it with copper. I went inside and cut the hub out. I maneuvered the spokes, bending and welding on the copper surface. So it's all trussed in there. It's super strong. It's taken ninety to a hundred mile an hour winds! After it was covered with material, we raised it into place. Everything is built in a modular principle with sleeve pins. I never rely only on the welds. They are also bolted.

Some of the things weigh six to seven thousand pounds. For example, those bushlings that cantilever way out wouldn't be able to be supported with standard welding. The metal would eventually fatigue and come crashing down. I am kind of like the old railroad people. They really overbuilt a lot. I used to do old railroad work. Those old coal hoppers didn't have any

falling down. They built stuff at least five to seven times stronger than what they really needed to carry the coal. That's the way everything is built around here . . . it's all built on an old railroad principle. No computers or calculators are used on anything. It's all railroad engineering.

HAPPENINGS AND BLENDERS OF HISTORY AND ART

I think that historic objects are extremely important, as are the stories connected to each item. I like to let the piece speak for itself. The logical explanation of it is not that important. I'll never live long enough to use all this stuff. I have thousands of tons or better of oddball stuff around . . . it's kinda like coming into paradise.

I'm very saddened that I see a younger generation that doesn't have any hands-on experience doin' anything. I just had my son take an old telephone apart so he could appreciate the technology of the past in comparison to the little computer chips we have today. Technology is growing at a very fast pace. All the plumbing fittings that I have been associated with all of my life are obsolete. In another twenty-five years, we won't see anything like that around because it's all plastic. By taking these things and incorporating them into little pieces of art, they'll be around a long time. Everything's made out of plastic now and those little metal shapes and forms are gone. Who's going to know about a pipe cap end or a black pipe fitting? But if it's locked into a little hat on a little robot, at least you've got that little image that's still around, even though it's a little fantasy creature.

What I am doing here with all kinds of little and big objects is putting together parts of history into a creative thing. The little pieces are "happenings." They are not preconceived ideas. Happenings are a composite of miscellaneous preexisting shapes and forms that lost their original identity. I make them into something else again. Before I start, I don't know what they are going to look like, or I can't draw them because I am adjusting as I am going. We're trying to put the twist on this and that so they've got different kinds of messages . . . they'll become creatures that you never saw before. You can't get any of 'em anywheres else unless you have the parts, if you see what I'm sayin'. Every one ends up being different because of the combination of all these different kinds of historical parts.

I blend objects all together so that they are not lost. When I put things back together, I don't change them very much. I try to leave them the way

they are. I don't add any extra energy or try to chop things down. I try to use everything just exactly the way it was. Rather than imposing one's will on something that's already been created, I leave it alone and just add or move another piece in as a "blender." I tie the object to another form. In other words, things that were of historic significance, I leave alone. I just take these pieces, different objects, and blend them into something.

The Forevertron has a lot of blends in history and art. It is an example, probably, of the largest sculpture in the world, of blending historic things and positioning them in an artistic concept. The Forevertron is built in curved arches and circles and I used the discipline of numbers, three, five, seven, nine. I think that a person's eyes will always go to even numbers. And when I use odd numbers, it throws their perception off and they don't know what the hell it is. I use one, three, five, seven, and nine all the time, predominantly seven. It has balance.

For example, I am a fan of Thomas Edison, Henry Ford, and Samuel Clemens. A few of these people I consider to be outstanding Americans. That's why I was kind of happy to be able to purchase these Edison bipolar generators. Because they're going to be outside, and they're going to be subjected to a lot of different kinds of weather, I created the roofs that are above them. I did it using copper pots, flurrying, and these big umbrella shaped things. However, they look like, maybe, they could have been—should have been—part of the original generator. You can see examples of that all over in the Forevertron. It is loaded with blenders.

For example, the big generator on the Forevertron came from the Edgewater Power Plant in Sheboygan, Wisconsin. The big steam engine and all this other equipment is a composite of many other generators. I added heads to make it a double compound steam engine, similar to the generators in the 1850s. It is very historic and generates the magnetic force. Long ago, people used a lot of wood. I'm using four hundred wood tanks. They came from a Reedsburg, Wisconsin, brewery which I wrecked thirty-five years ago. I'm puttin' that wood to use as the warming ingredient of the

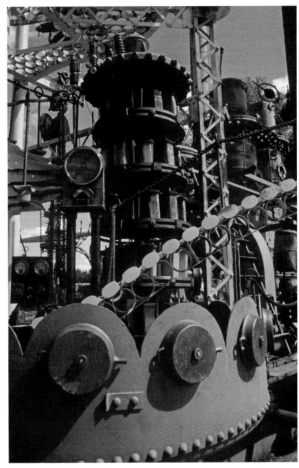

Forevertron detail, example of "blender"

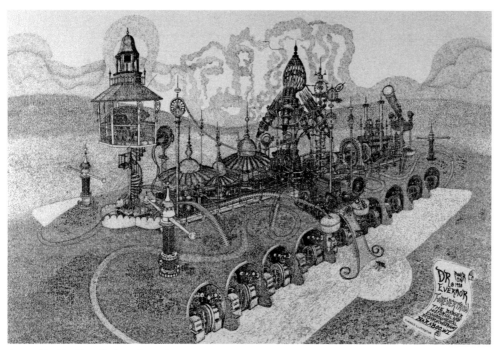

Proposal for Munitions Workers of America
Memorial Sculpture Park at Badger Ordinance,
drawing by Jakob Furnald

thing. I'm using them as the vertical lines which will make the engine look a little shorter. That's important to me. All that brass piping . . . I'm going to use it the way it came out of the brewery and add to the richness.

The giant bushlings on the Forevertron are another example of a blender. They are a composite of an art concept. They are very historical, built out of early transformer bushlings. The bipolar dynamos were designed by Thomas Edison and came from the Ford Museum. I don't know why they ever got rid of them. They were suppose to generate DC power or the lightning source. A cable leads over to a stainless steel unit that is in the front of the Forevertron. It is a 32,000-pound autoclave that was part of a decontamination operation for the astronauts that went to the moon. It just so happens that I got a hold of it before they had plasma cutters and could cut it up for scrap. Sixteen tons of stainless steel does not have a lot of value. However, I think it cost well over a million dollars to build that one unit. It would have been sad if we would've never seen it again. At least a kid can walk by and say, "Well that was the piece that went to the moon." There are two other little autoclaves that I incorporated.

There are kettles from breweries, switches for elevators that worked the state capitol elevators, switching gears from Gisholt machinery, and many

different things from around the country. In the forefront, there is a Faraday stray voltage cage. It is there to pick up the radiation from all the generating equipment, so people don't end up getting cancer from it! We have glass batteries underneath the telescope. I hope Mr. Faraday isn't rolling over in his grave with laughter! It's interesting to some people to look at how these things were designed. If somebody doesn't keep this stuff, it will be gone forever and melted down. This machine, in Dr. Evermor's estimation, would function if every thing was connected. It could function. Of course, I will have the nonbelievers sit underneath the umbrella and use the telescope to see if the good doctor made it up into the heavens or not. The teahouse is for royalty to sit and witness the happening. It's got a lace iron chair that moves with the wind. The top of the teahouse is an historic copper kettle. All the component parts that are put into the Forevertron are from fifty to one hundred years old or more, with the exception of the Apollo space mission stuff or that I created to make it blend together.

I also think it's extremely important to jump levels and dimensions, rather than put everything into a logical perspective. I leave room for people to be fascinated and inject their own interpretation into whatever is going on. I don't have anybody that ever goes away from this property that isn't smiling. If I do nothing more than that—that's nice.

FANTASY PARK

I figured on placing the Forevertron, as I call it now, in a southeast/west direction and everything that flowed out from it will be in a circular pattern. Most of the curves in the Forevertron have pathways for sculptures. I like curves.

I've been thinking about the park layout, totally from the air. So if somebody from a satellite took a picture of it, they would say, "What the hell is this place?" I call it the "Peruvian Principle." I want the Forevertron positioned so there is a west sunset silhouette for shooting pictures through the main sculpture. This is a landscaping project as much as anything else. I haven't done anything about the sound or lighting the sculptures. I will leave some things undone for other people to add to it with their talents. There are other people that are a helluva lot smarter than I am. I might as well be just working in the heavy things I can actually get done. For example, with the figure bird band, I know all those instruments can be played, but I want to get good musicians to play them.

Proposed "timebinder" sculpture park, super-imposed over aerial view of compressor area at Badger Ordinance, metal model by Jakob Furnald, Madison, 2000, computer projection by Ralph Knasinski

Currently, the Forevertron is located at Delaney's Salvage. I have it on semi trailers. I also have a maze of 1,500 blue boxes. The maze design is based strictly with a hexagon or beehive principle. I fully differ from Mr. Frank Lloyd Wright, when he said, "form follows function." From my way of looking at things, the form is first and the function is second. The form regulates whatever the function is, and in natural form that's the way things are. The design of the cell structure determines the function of the cell. When we talk about the Forevertron, the form is first and the function is second.

PUBLIC PERCEPTIONS AND EDUCATION

You better believe it's about education. Number one in my mind is trying to stimulate youth to look at what they have in their garage. For example, it is about trying to make something with an old go-cart. I'm happy if kids just do something rather than going down to the local arcade and playing those electronic games. I want them to use their hands on something. I don't care if it's a paintbrush or whatever, they need to feel good about themselves by creating something. That's what I'm interested in seeing. It is my driving force.

I try to look at everything with a positive perspective. Somebody comes back here with a little trailer load of scrap, and I get out and look at all of it. "My gosh, we sure can use that! That's absolutely wonderful. It's nice that you thought of us." Well, I might not have an idea of what to do with it, but I certainly can see the potential. I get all kinds of people hauling stuff in here. I like to make things immediately out of the stuff, so when they come back I can show 'em what I made. They feel good in their heart that they contributed with something that they were gonna throw away or haul to the dump.

I absolutely like people. Every day I think that's part of my goal in life, to try to communicate with people. People of all ages come to visit. The other day a couple drove down from Green Lake, Wisconsin. They had seen an article in the *Milwaukee Sentinel* and wanted to see this place. We got talking and he told me he made cider and had bees all his life. He said, "Well would you believe I'm ninety-two years old!" I said, "That's pretty wonderful. You look more like sixty-nine." His wife said, "Well he is too ninety-two and I'm ninety-three. What do you think?" We had very good communication and I was so happy to be part of their life.

People come from all over the world. I like all people, of course. They buy little pieces for twenty dollars and take 'em back home. The little robots are in Wales, on yachts, and every dog-gone place there is. I give them an adoption certificate and they adopt the little creatures. I make these with my son and wife. We feel part of them and they feel a part of us, which is nice, you know. The children are the ones that can make the most from using their imagination, because they don't have blinders on. Oldsters, they all have some kind of preconceived idea of what something should look like. But the children have the most joyful spirit.

Lester Fry, in his front yard, Ironton, 1991

LESTER FRY

I asked a neighbor about these other wheels, and he said, "You can have 'em." So I went and got all these metal wheels from him. He had them left from his old machinery. I thought, "Gosh, that'd be a good place to put the glass insulators!"

—LESTER FRY (1907–1996)

LESTER FRY was a hard-working, small-town family man who never let good things go to waste. Lester collected old steel and iron wheels from farm machinery and the glass electrical insulators that once were found on power poles all across America. Using ingenuity and a creative flair no one knew he had, Lester rigged a system for drilling and hanging the glass "bells," and he went on to decorate his yard. Lester took great pride in the enthusiastic response that his project generated in neighbors and visitors from all over the United States. Lester died recently, but his family still lives at his home with its sculpture-filled yard and continues the Christmas display each year.

UP ON THE FARM

I was born and raised in a barn. My parents were dairy farmers. I worked on the farm at home. My dad had a heart attack, and he was laid up for quite a while, and I done most of the farm work. My mother's folks come from Ohio and my dad's folks come from Indiana and Tennessee. Then they got married and moved up on the farm, up there. Some of my people were from England and my dad's family was from Germany. I got three brothers. I had four in all. I was the oldest brother. I had one sister older than I was. She died a long time ago. My wife and I have a big family. We had nine kids. Six boys, three girls.

When I was eighteen, I worked on the roads. Now they wouldn't let a boy work on the road at eighteen, I don't s'pose. If I had a boy, I really wouldn't want him to work on the road at that age. Too many people, they think a boy don't know nothing. They'll holler. One wants it *this* way, one wants it *that* way, and it makes it kind of hard on the kid. It gets hard on the nerves. After working in the road, I went back to farming for a while. That was back in 1925. I bought a new Ford car that summer. It cost three hundred and forty-three dollars! I remember that just as well as can be. It

Pipe and glass insulator tree

seemed like a lot of money. Money at that time was different than it is now. We had a farm north of here. Then I went and worked down at the woolen mill. The mill was just across the river on the right side, as you cross from this side in Reedsburg. The mill burned down. They got a big building there that prints paper.

JUST RIGHT

I got that insulator glass, they give it to me. I got them up toward Milwaukee. A fellow told me I could have them, and then another guy over there, he give me all that he had over there. So they was all giving me the glass insulators. I got 'em here and I thought, "Well it'd be a good idea to get them old metal wagon wheels." That's something there was a lot of around then, too. A guy told me I could have some wheels. So I took them, and I sawed them in two and put the glass on 'em.

I know a lot of people tried to drill into the glass, and they had trouble with it. My grandson tried to drill them, but he doesn't have the right kind of drill to drill 'em with.

You gotta sharpen the drill bits just right. They'll come that way, a little dull. You gotta sharpen 'em. I went to work and drilled a lot of them, but you gotta know just how to drill it and you gotta know just what kind of temperature to put on them. I use a cement drill. You gotta sharpen it on an emery wheel. You gotta get that the right temperature to drill.

GLASS INSULATOR YARD ARCHES

We get a lot of people stopping. We have a lot of people stop here and take pictures. A lot of them that we never know anything about. They drive up here, take pictures, and then beat it. A guy come here once, and he wanted to buy one of my arches I had out in the yard. He was from Colorado. He stopped and was taking pictures. One guy come along, that was from up in Minnesota someplace. He wanted to buy the stuff in the yard. I know what he wanted. He wanted me to take 'em off the lawn and take 'em up there and when I got there, he wouldn't be there at all. He said they'd send me the money. I didn't let him pull that with me.

I got some of the insulators from the farmers up there. This one farmer got a lot of them. At first, they had them out on poles. Now they're doing all

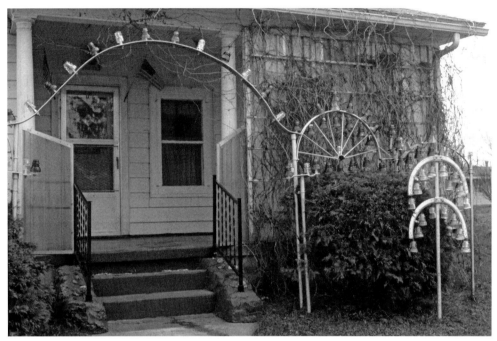

Wheel/insulator ornament #2, Fry house entrance

the wiring underground so they don't need the insulators on poles any-more. I got about four hundred of them, I guess. I got 'em and I brought 'em home, and I got to using them and I just kept going back and gettin' more of 'em. I started using them like chimes. I saw them down in Califor-nia. They had different lengths of pipe with glass in between. When the wind blows, it rings. Everybody I know wanted one at one time. I made an awful lot of them. I kept using 'em till I got 'em used up.

Things are always given to me. They didn't know what they was gonna do with them and they just give 'em to me and I used them. I always figured out something.

The chains I had, but I had to buy silver paint. The bell right in the mid-dle, that was the first part I used. It's my dinner bell from the farm. It works, but it won't ring loud or nothing. One of the wheels is off my old wagon. The kettle belonged to my folks. They used it for scalding pigs. I asked a neighbor about these other wheels, and he said, "You can have 'em." So I went and got all these metal wheels from him. He had them left from his old machinery. I thought, "Gosh, that'd be a good place to put the glass insula-tors!" When I got the wheels, I had it all planned out, what I was gonna use them for. I already had the insulators. I started cutting them out. I sawed

some of them in two. That was a big job! I didn't think much about it when I first started. These big wagon wheels I opened them up and bent them out. Bent out and drilled holes into them. Oh, I tell you, it took a lot of work to drill that. That was hard. I drilled holes in the rims. There were different kinds of wheels. That was a lot of work, especially drilling iron. I kept using the wheels and cutting 'em up.

Then I put them all out [on the lawn]. The neighbors, nobody ever bothers them or anything. My neighbors are always talking about the yard. At Christmas, I put lights all over the yard, clear around the yard. Every time you look outside, there's cars driving by looking at the lights. We get it all lit up! I get lights up on 'em about Christmastime. I think the neighbors down below there, down in the trailer courts, oh boy, they like that because it shows up down there. They're always hollerin' about that.

NO RHYME OR REASON

I don't know why I started making 'em. I couldn't tell ya. I made this like a tree that's all. I start with the windchimes and wheels, put 'em all on pipes. Then I put in small ones, some wheelbarrow wheels in between there, wheels that are cut right between the middle. Some arches are made out of a corn planter wheel. They're never welded. They're all put together with clamps and wire. I drill some holes and stuff. I got metal pieces of copper wire from the telephone line, the high lines. They used to give 'em to me and I used 'em for that. I didn't have to buy the wire. I got the metal off of the old radio tower. They were throwing them away so they give 'em to me. I didn't have to buy them, either. I sprayed them with silver paint. That reflects light, that's all. It's a light color. I used wheelbarrow wheels and left some of the spokes in it. You get lights on them, shining through that there glass, just make 'em just glow! When that's all lit up and shining through that glass, it shows, you can see it. You can go way down along the road and boy it's pretty.

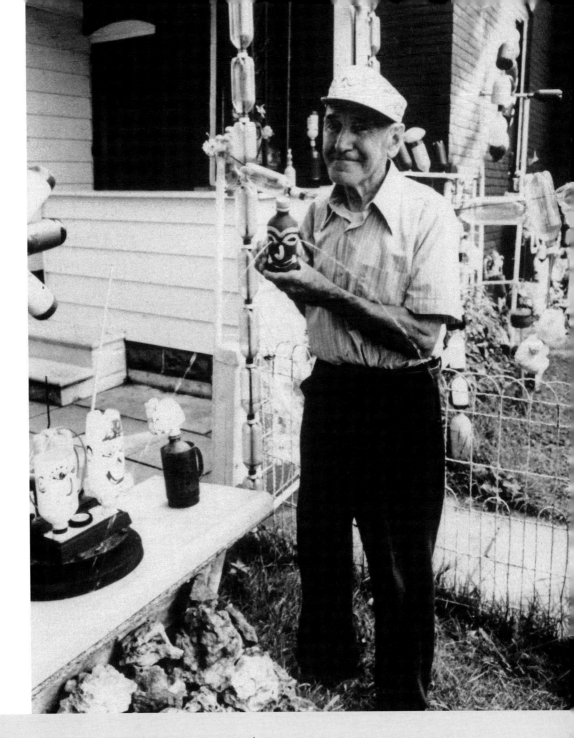

Paul Hefti, with weeping
water bottle, 1995

It's just like if I've got a dish of something to eat,
and there's some garlic in there and I don't like
garlic, it spoils the whole deal. Flowers, mud
bells, ferris wheels, merry-go-rounds. I just
cooked it up myself. This has been pretty impor-
tant to me! In fact, I'd sooner do this prett'ner
than eat.

—PAUL HEFTI

PAUL
HEFTI

PAUL HEFTI always loved puns. As we toured his yard environment, he kept us smiling with one pun after another about specific areas of his yardshow. Like Tony Flatoff, Paul Hefti set out to make something his neighbors and visitors would enjoy. Paul enjoyed his visitors, who flocked to his site, especially in the summer. Paul was a serious recycler. Sometimes he used donated items—a teddy bear, a grocery store display Ritz cracker box, or a Christmas garland—as is. But frequently, especially with plastic bottles, Paul painted and transformed his raw materials into something new that glimmered with color and humor. Paul has had a series of health problems in recent years and moved to an assisted living facility. His yard show was dismantled in 2004.

THE WHOLE BALL OF WAX

I was born right here in LaCrosse. I've lived in this house all my life. I was born in December 1912 at 4:30 in the morning on a Sunday. It seems like I was just born. I'm a kid yet. I worked at the LaCrosse Paper and Box Company for forty-five years. I was a sales manager. I attended the College of Commerce in LaCrosse. I was an usher at St. Mary's Church for thirty-five years. There's a little bit of green in my inside pocket.

My dad was Swiss. Do I look like I got any holes in me? My mom was Jewish. I really don't know when my Dad came over from Switzerland. I never asked him. I can't ask him anymore. I had three brothers: Fred, Leo, and Matt. They're all dead now. Matt was a manual training teacher. He'd show kids how to make birdhouses and stuff like that. Maybe I inherited some of this from him. He was about fifteen years older than me.

When I think of that stuff, I think, "Well, why didn't I do it?" Just like when I take a picture. I take it, and I stick it in a drawer. What I should do is put the date on there and the name, who was there, and all that jazz, because I come back in a year or two years and ask, "Who in the heck is this guy?" I don't know. Half the people are dead that I once knew. My mother took care of the house and took care of me. I'm still alive.

When I was growing up, my mother had a garden. This whole yard was all gardens, all the way up to the street, all the way in the back. She had three hot beds, one in the front and two in the back. We raised every vegetable we could think of. Peanuts, popcorn, and gourds. She had raspberries and strawberries. Anything we could think of: cucumbers, corn, peas, celery. The

whole ball of wax. My mother was good at growing celery. She'd cover them over with newspapers and, gee, they grew beautifully! When she covered them up with newspapers, they got crisp.

Shoot! We never went to the store for vegetables. She canned tomatoes, cucumbers, and sauerkraut. She used to plant cabbage. We grew so many things. We used to have grapevines. There's a grapevine out there yet. Dahlias, snapdragons, oleanders. We had practically anything you wanted. Daisies, ferns . . . I forget about a lot of that stuff.

THEY DIDN'T CALL IT ART

When I was a kid, I used to like to draw, play the accordion, and keyboard. We had a zither, a mouth organ, all that stuff. I used to sing in the choir. Now all that stuff's gone. People today don't know that stuff. I still play the keyboard and the accordion. I've still got the accordion, but I don't play it too much. On this keyboard you can play twenty different instruments, two, three at a time. It sounds like you've got a big band going or something. Play drums and all that stuff. Violin. All in one little box! Then you can have it so you can repeat what you played. I don't know how they can make those things. All I've got is a keyboard, it's only a three-quarter size. It isn't even a full size. I can take it and play anyplace. I took it to a couple of nursing homes, a couple of houses around here where people don't get out much.

When I was in school, we had maybe fifteen minutes a week where you could draw and stuff. They didn't call it art. We just drew or made something. Things have changed so much. I liked everything about school. Figures and stuff like that. We used to play a lot of horseshoes across the street. Where that pump house is over there, we used to have two horseshoe courts there. I used to volunteer to take care of it at night. We had lights. Shoot, we'd play until 10:00 or 11:00. Those horseshoes would hit that post all the time and make that noise.

This lot [across the street] has always been a park. Before the horseshoe courts, there was a roller coaster, a *high* roller coaster, you know. They condemned it. They used to make lumber down at the river and float the logs down there. They had no place to keep the lumber. So they put it in the park. They had a fire. And that's why they call it the chip yard. I talked to all the old timers and they all said it was a chip yard. I used to play ball in the

park when I was a kid. This is a nice spot to live, across from a ballpark. This is one of the best spots in the city, I think. I can see way down to South Avenue, see the cars and trucks going by. I can look over there to the two-way highway, but I've got open space here. Shoot, I wouldn't want any better place than this. My neighbors are all nice. There are a couple of dogs in the neighborhood, but I like to hear the dogs. Then I know I'm alive.

JUST FOR THE FUN OF IT

I've had this yard quite a while. I started this yard environment about in 1986. I never thought I'd do it. I put one bottle out just for the fun of it. One of those painted bottles, decorated, you know. Somebody came along and said, "Gee, that looks nice." So I put another one up, and I kept adding to it, subtracting from it, dividing. You'd be surprised who gave me some of this junk. At first I thought it would look nice to use this and to use that, you know? A lot of things I don't use, they're not bottles. I get some bottles from friends. I see stuff once in a while in the street and I pick it up. All these dolls and stuff I got from different people. They said, "Well, do you want it?" "Can you use it?" I thought, "I don't know." "Well, I will take it along, maybe some time I might make a use of it!" They said, "I don't care what you do with it." Whatever I get, it has a certain good use. Just like if I see a kid on the street that is bad. There's some good in him/her through and through. He/she isn't all bad. It's just like if I got a barrel of apples, there's always one in there that isn't up to snuff and spoils it for the other ones.

The first ones that I put up I painted them just all one color. You've got to make it attractive. If you don't get it attractive, you're dead! It was fun when someone came along and liked how it looked. To see what attitude people would take. They'd give me different suggestions and stuff. I do it more for other people, you know. My neighbors think my yard is all right. They think I should keep going on it. I thought I was going to discontinue it. Then I thought, "Shoot, it's so dog-gone much work, cutting that grass." I can't cut it all in one day. By the time I get done with one part I've got to start back on the other. If I don't keep it halfway decent, the place will look shabby, overgrown. I've got to keep it trimmed.

People give me advice. They say it's all right. Sometimes I'll take something down and they'll say, "Why did you take that down?" I say, "I can't keep everything up." Because if I keep too much up, it looks junky. Then

there are the bottles. Painting them bottles, boy that's a job! Getting the labels off is another job! If I got a bottle that isn't a good color, people don't like it. I take it out and it spoils the whole thing. It's just like if I've got a dish of something to eat, and there's some garlic in there and I don't like garlic, it spoils the whole deal.

I JUST COOKED IT UP MYSELF

Flowers, mud bells, ferris wheels, merry-go-rounds, I just cooked it up myself. From the start, I thought, "Well, gee, I can do that." Then I said, "If I am going to do a good job, okay, do it!" If I think I can't do a good job, forget it! I'd just make a mess out of it! Whenever I start anything, I like to do it and do a good job, do it complete.

I plant flowers in some spots. There's a geranium! I didn't think that geranium would grow. But it grew nice there. I made this yellow birdhouse. I fixed it with the bottles under it. I thought to myself, "I'm just going to put that on there just for show." Springtime came. The first wren that came went in there over the bottles. He liked the bottles. Of course, they were yellow, and he liked yellow, I suppose. I made a Swiss birdhouse, over

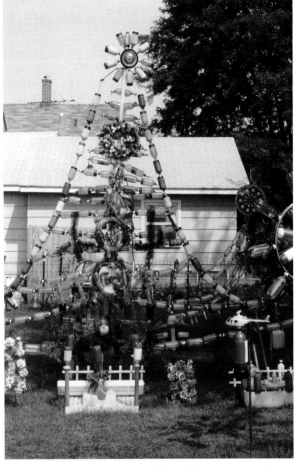

Many parts of the yard show move or turn in the wind.

Painted bottles spell out greetings and Paul Hefti's address.

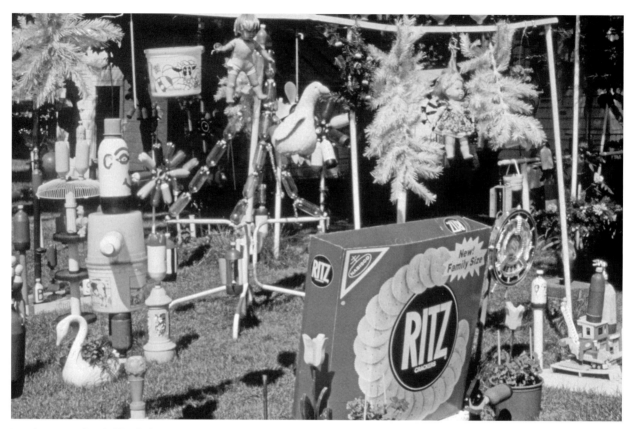

Over the years, various holiday displays have graced the property.

there, on that tree. That one always draws somebody. In the fall, the birds are gone. They don't stay too long. But, gee, they sound nice when they sing. And I get cardinals, you know. Early in the morning, about 5:30, when it starts getting light, you hear the birds. They come for the juniper berries. The birds get the plums. Squirrels, boy oh boy! I've got a run on squirrels! Any time, there's a squirrel! Over on the corner there, that's a walnut tree. The birds, the squirrels get those nuts. They bring them over here and they bury them. I think some of them worked the berries or nuts into the plants near the geraniums. Because in spring when I dig them up, there are nuts in there.

IT'S UNBELIEVABLE

I've got a lot of ideas. It just seems like I don't get time. Yesterday, I was going to do some stuff and a friend called up from next door who is ninety-

five years old. I went over there with water. He likes well water. He doesn't like city water, the chemicals and that stuff. Every once in a while he calls up, and I go over there with two-gallon jugs of well water. I ride a bicycle there. I never had a car. Things here are close and I don't have to worry about parking.

Why do I do this? It's the joy of seeing everybody happy and giving me a lot of different suggestions. "Where did you get this?" and "How did you do that?" It's fun. When you don't *have* to do it, it's fun. When you've *got* to do it, it's work. I always enjoy it. Except when the mosquitoes are biting. Then I'd have to fight them off. When the days are getting shorter, I spend less time outside. Then it gets cold! People ask, "Gee, do you change it every day?" I change it. It all depends. If it's raining, I'll do things in the morning. If it's nice in the evening, I'll change it before I go to bed, see.

This has been pretty important to me! In fact, I'd sooner do this prett'ner than eat. Sometimes I get out here and I keep working and working and shoot, it's way past dinnertime. Sometimes I figure, well, I'll finish it because if I've got to come out and start over again, I'm liable to say, "Well, where did I finish off?" I use a lot of screws. Every time you get a screw loose and you want to screw it in, you've got to get a Phillips screwdriver. Or I've got to get a regular one. Nine times out of ten I don't have the right one. I've always got to get the right one. I got the screwdrivers and everything, but the right one, I've got to have the right one to fit. It keeps me pretty busy. I'm always doing . . . If I come out here there's always something I'll think that needs fixing.

It's great for the kids. They like to horse around during the tourist season. I've got one little gal who comes around. I asked her what she thought. She said, "Gee, I wished I lived here." I just like a lot of people that come here. They stop across the street and take pictures, you know. I come out, "Want a tour?" "Sure." I take them on a tour. These kids come and I see them coming. I come out and ask them if they want to take a little tour, show them something, and they're happy. If I'd say, "Oh, get away from here, I don't want you to touch that," then they'd be raisin' Cain. But this way they're happy. "Looks cool." It was so hot, and they say it's so cool. "Gee, it was so hot I had to put up extra fans."

These all sit still early in the morning, when I get up. It's so quiet sometimes, you could hear a pin drop. It's unbelievable. Well, you know, when I get a lot of people in here, they look at this stuff. They really got their eyes

on one item, which is their favorite item that they like. I get so many people that come in. I like to show it to them. I like it best when there's three or four visitors. If there's more, I can't keep an eye on them. They go look at this and that. Sometimes they get those bottles and they twist them in the wrong spot. Then they come loose. Geez—you know! I've got to drill holes again to get it . . . I do all this drilling by hand. I like to do it by hand. There's always something moving. I had so much out here that I took down. When they're all done looking, I talk to them about it.

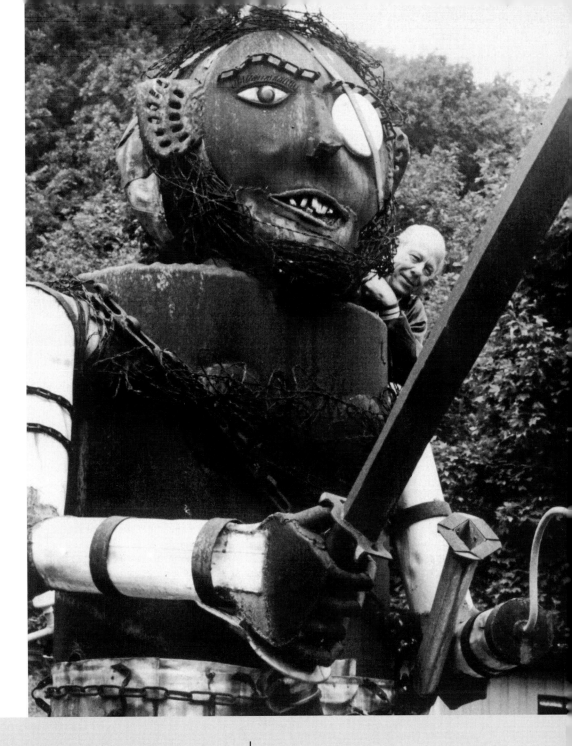

Wally Keller, with *Peg Leg the Pirate*, in his front yard near Mount Horeb

I use a lot of old farm machinery parts plus commercial and automotive parts . . . valve, horse corn planter, horse harness, machine gears, sprockets, roller chain, milling machine, buckets, lots of flat wrenches for birds' feet. I like parts with grace and form. The tricky part is taking the pieces and arranging them so they resemble something. I like making things that are one of a kind.

—WALLY KELLER

WALLY KELLER

Wally Keller in his workshop

The many jobs that **WALLY KELLER** held in his working life have come together in his retirement: farmer, machinist, welder, salesman, custom ironworker, and antique dealer, a résumé that has led to a tin man mailbox and a giant pirate that dares visitors to cross the bridge to his workshop and home. Wally is a recycler of agricultural machinery, a commodity readily available in America's Dairyland. The precise and elegant works created in his immaculate workshop are carefully painted, finished, and sold as popular items at art fairs and small galleries in southern Wisconsin.

GETTING STARTED

I grew up on the farm. My dad was a dairy farmer. We were pretty poor. My dad lost his farm in the Depression. The machinery we had was cobbled together. We never had any decent machinery, so I had to learn to fix a lot of that stuff. When I joined the Navy, I went to machinist school right out of boot camp and ended up in an engine room on a destroyer. That was in the Korean War. After a few years, they put me in the navy machine shop. Of course, I learned more about machining and stuff like that. Later, I bought my own welding shop; well, then I had to learn how to fabricate and repair. I guess that's really how I learned how to do all of this work with my hands.

I got started doing this because I couldn't work, and I had time to work on it. I kind of got forced into it you might say because I had to quit my real estate job. My doctor said I needed bypass surgery, so I had it. I was home from the surgery one day, and then I had a heart attack. I hadn't had heart problems before, but they kind of felt blocked. The bypasses were plugged and they couldn't open 'em. They eventually opened two of 'em with angioplasty. So I went back to work in real estate and wasn't doing very well. I worked for about six months, and I had another heart attack. They did angioplasty—again! So then, I quit working. I quit real estate—I had to. I just can't do hard physical labor. I just run out of breath. If I tried to actually run over to the shop, I doubt if I'd make it. But as long as I don't work

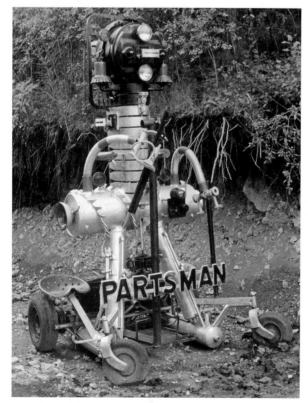

When his grandchildren were young, Wally Keller rode with them in local parades on *Partsman*.

too hard, it's okay. These health problems got me out of work. Gave me an excuse to retire at sixty-two.

My wife and I designed this house in 1970 and had it built. I have seven grandkids. I let them rummage around in my workshop. Of course, I have to explain how things gotta be compatible with each other. For example, I helped my granddaughter understand that a part she had for a bird's head was far too big for the body she wanted to put it on. For a while, one of my granddaughters, when she was twelve or thirteen, was interested in learning about this, but I don't know if she is still.

When I started, I was just doing it for my own satisfaction. I'm working on making something nearly every day. I've been working with iron all my life. I started out having a welding shop in '57. I had that six years and then I went on to a few other things. But that's when I really got interested in making things out of metal, such as mailboxes, ornamental iron railings that I sold through the shop and installed. I really didn't do this type of sculpture until 1992, when I retired from selling real estate because of my poor health.

TIME FOR ANOTHER CHANGE

I started out on the farm, then four years in the navy, and then worked as a machinist for a year at the old Gisholt Machine Company in Madison. I ran a large radial drill and did jig boring primarily with manual controls that you actually used to make lathe parts and machine rough castings. I put the castings in to observe and then machine tools came in and cut the holes to make the pieces. So it was production work in a sense. Afterwards, I bought a welding shop and had that six years.

Again, I wanted to try something different. I thought sales people always seemed to be happy, so I sold the welding shop to an employee and started selling bulk milk coolers. At that time, the majority of farms around here were still using cans for their milk and bulk coolers. These big tanks were just being developed. I picked the wrong time to start because there was a drought that summer and sales were just nothing. So I thought, "Well, I'll

Wally Keller frequently uses parts from old farm machines to create his creatures.

try another sales job." I always liked trucks, so I went into Madison and sold trucks for Thorstad Chevrolet. I was in the sales department. Afterwards, I went to work for a trucking company in Mount Horeb, hauling livestock long distance.

Then a friend of mine actually was working for a new company that started out in Madison, Polk Diesel. I always liked engines, too, and especially diesels. So I went to work for Polk Diesel and Machine, which is now one of the major players in that field in Wisconsin. But after two and a half years there, why it was time for another change.

A local bar and restaurant came for sale in Mount Horeb, so my wife and I bought it. What an eye opener! We had twenty-three employees and named the place Keller's Restaurant. In 1970, we sold it to a bartender working in Madison who offered to buy it. Then I drove a Redimix truck for a year working construction. Then it was time for yet another change.

My mother was always collecting antiques when I was younger, and she got me interested in that. So in 1971, I started dealing in antiques. We named our new store Keller's Trading Co. It was the first fulltime shop in town. I stayed at that for fourteen years. It was located in the Old Strand Theater building, which we bought in 1975 and gutted, and put all the stuff into the shop. I was buying most of the furniture from an importer in Milwaukee. We handled a lot of European, American, and many different types of furniture. I also bought from small shops and bought privately and at auction sales.

But after seven days a week for fourteen years, that was getting old, even with part-time help, I was there practically all the time. So I worked for a couple years doing custom ironwork, doing a little light manufacturing, and then I tired of that again. Finally, somewhere in the past, real estate had interested me. I revived that interest and sold my business in 1985. I got a real estate license and started to sell real estate in '87 and up till '92. That is when I had major heart problems, so I had to retire.

PARTS WITH GRACE AND FORM

To occupy my time, I started playing with this stuff for something to do. Pretty soon I had a pile of small stuff I made and couldn't give it all away. People were telling me to try to sell. It surprised the heck out of me when it started selling very well. I think this all started when my wife asked me to make a different mailbox stand. I started building a pirate and all of a sud-

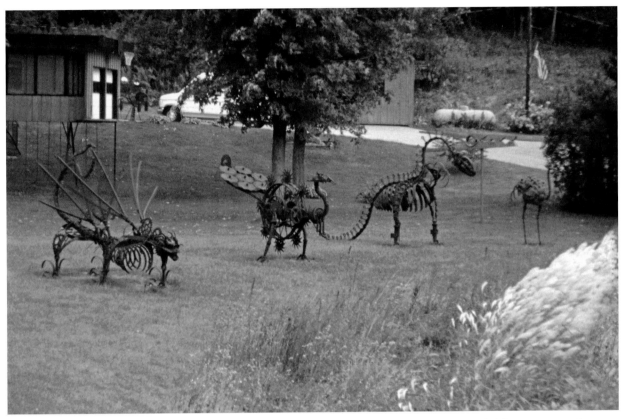

A growing herd of dinosaurs graze on the Keller's front lawn.

den I realized this thing is getting way out of proportion. I can't put this over by the highway. So I completed it and I thought, "What am I gonna do with it?" "Well," I thought, "A pirate relates to water." So I made a platform and set it above the small creek that runs through our yard. From that, the rest sort of evolved. I got a little more interested in making stuff. I made the turtle, the tinman mailbox, and some other smaller pieces. I have pictures in a scrapbook at home of all these things made out of parts. Usually, most of my work is made out of found pieces, not much sheet metal, and some iron and pipe. I look to use something already formed rather than cut it out of sheet steel. I use a lot of old farm machinery parts, plus commercial and automotive parts. Some parts are from farm machinery, semi-tractors or cars, such as a car valve, horse corn planter, horse harness, machine gears, spockets, roller chain, milling machine, buckets, lots of flat wrenches for birds' feet. The backbone of one of the dinosaurs is an unloader chain from a Harvester silo. Most silos around the country unload from the bottom.

The chains are very heavy metal with teeth on them. The eyelids on the dinosaur are pieces from the barn cleaner chain. One hooks into the other to form a continuous chain. That's what lays in the gutters and goes around; it drags out the manure into the yard.

When I started, I had a lot of this stuff. My shop in the garage always looked like a junkyard. In the wintertime, it doesn't look very good around here. I had a lot of this stuff, but when I really started making things, I had to start buying tools and materials. So I bought tons of stuff. I use drinking cups from barns, a fair amount of automotive parts, too. I get stuff from repair shops and farm machinery, and anywhere that parts are broken or worn and they throw 'em out. I pretty much know the history of what I use. There's hardly a part I use that I don't know what it was for, its former function. I like parts with grace and form.

In my crown bug, I used a roof ventilator. A roof ventilator circulates air through spaces in ceilings. The eyes are power line insulators. I used ten and call it a ten-eyed crown bug. Some parts came from a field cultivator. The antennae are from a hay grapple fork.

I used car springs, hot water tanks, a water softening tank, parts out of a farm disk, car springs. I've got thousands of pieces around here. I pretty well know what I'm gonna use 'em for. I have an idea what they relate to in what I make. I like milker buckets. You hardly find them anymore now because milk runs through a pipeline now. These used to hang under the cows, they would put a strap around the cow's body and hang the milker on, up to the teats. From there, I start welding pieces together.

I have my stuff sort categorized in my shop. As I got into this more and more, I started organizing the materials. Instead of just throwing it on a pile, I sort things. For the heads that go on these birds I might have a little pile of those, which I'm buying all the time.

When I work on those roadrunners, I take off the paint and grease. The pieces go right in here, in the furnace. That stuff gets hot in there, and of course, all that paint flakes, debris, and dirt then comes right off. The small parts go through the fire first. After the furnace, to take off the rough edges, I put them in the cement mixer and let them tumble against each other. Just beats the edges right off.

A lot of what I use is outdated machinery. For example, pieces might come off a horse-powered mower. They are no longer used except by the Amish, so there's quite a bit of that kind of stuff around now. Some pieces

are worn out, too. They come off of combines or hay bins. Sometimes things are thrown away because they are broken. What I do then is just cut good pieces off from bigger pieces and save the pieces I want. I weld some nuts on it, schmaltz it up, put some things on it. There you have it! It looks messy in my shop, but I know where the stuff is at pretty well.

The welding is simply done; welding is pretty basic in that respect. The tricky part is taking the pieces and arranging them so they resemble something. I try to make my stuff resemble something that existed at one time, and then it's gonna stretch the imagination a little that's for sure. As far as simple welding processes there's nothing difficult about that. I might make legs welded on here, which are drill bits. I get the bits from electricians. They use them for drilling, residential drilling. They wear out, so they throw them away. They sharpen them once or twice, then throw them away. Sometimes, someone will want to give me a bunch of pieces and not want any money for them, so I'll make him a small sculpture.

For a small bird, I'll start by welding on a base plate. The next step, I weld wrenches on for feet. I'll bend each leg slightly. Before the legs are welded, the heat pulls the metal a little bit, so I put a slight curve in 'em. When I weld there, it's gonna pull it back again. I want my pieces to be straight up and down. I don't want them to tip over. I work toward the right position I want. The next problem is to get it relatively square on the wrenches.

I've got a couple different welders. I have a wire feed; it's called a MIG welder. MIG stands for Metallic Inert Gas. The way it works, there's wire coming out and as you weld it, it consumes this wire. I have another "toy," an electronic weld hood. I can start welding immediately, darkens automatically. I use an electronic hood that's pretty classy. Between that and that wire feed welder of course, it's nicer than doing stick [iron rod] welds. The stick welders are much more common. As you weld, it just consumes the stick but it probably takes twice as long, and then you end up with residue. It's just melting metal together. That's all welding is. The wire feed is a lot nicer. It's costlier, too. You gotta buy the argon gas and that's twenty-six bucks a tank. It's expensive. But the wire feed is real nice.

I use a cut-off wheel for cutting pipe or cutting iron. I cut a lot and that thing is fast. It makes a nice clean cut. It's a pretty cheap tool to use. It'll make hundreds and hundreds of cuts for five bucks, that blade. That's relatively inexpensive to use. My hydraulic press here, is a home built job. My brother built it. I've bent heavier shapes with that. I've got an overhead

crane here, a bridge crane that I built, so I can pick up heavy stuff with it, like when I make dinosaurs and stuff like that. I've done a fair amount of that kind of fabricating, designing.

Usually I get two or three buckets full of wrenches at a farm auction. A truck salesman brings me some and I buy the wrenches from various other small scrap yards and privately.

VISUALIZE AND BUILD IT

There are a lot of ideas I want to put together. Rather than making one piece completely from scratch, it's much quicker to make ten pieces at a time. Even a simple bird has got around twenty different pieces in it. If I do ten at a time, I suppose there's a couple hours in each one. If I go individually, I spend half a day just doing one. I don't want to really get into production work. I know of a guy in Illinois who has probably a thousand pieces already fabricated out of new steel. He's real successful, but I don't want to get into making multiple objects. For me, it takes the fun out of it. I've done that kind of work in my welding shop. I have made parts for machinery, ten at a time. It's okay, other than that it gets boring. There's hardly anything ever alike or identical that I make. I usually can't get that many pieces that are the same. I like making things that are one of a kind.

When I begin, I have a pretty good idea of what I want to accomplish. I don't draw it out first. I just visualize and build it. If it doesn't look right, I pull off the piece and start over. For example, a couple years ago we took a tour of Europe and sat around a hotel in Hungary. They had a sculpture similar to this in a hotel lobby and it showed a bunch of birds flying into a hole, and I thought about a Venus flytrap flower. I came up with this "bird in flower." The birds are hay mower guards welded together, and I used a regular dinner bell for the mouthpart.

The first big piece I made was a large pirate. I was going to hang a mail-box off the sword. I made an arm and threw it away. The fingers also looked bad. So I made a second arm. When I started this time, I really didn't have a preconceived notion as to how I wanted the thing to end up. I usually don't know how it's supposed to look exactly. I just sort of started welding stuff together and I react and change things. The pirate body is a fuel oil tank, and the head was a similar tank. The eye sockets I made out of sheet

metal. To model the lips and the teeth, I snarled at myself in a mirror to get a face ugly enough. I just copied myself.

I came up with the idea that he's been in a battle and that's where he lost the left eye, the left hand, and the left leg. The story all sort of started flowing together. His eye is a telephone wire insulator. My daughter had the idea of using barbed wire for the hair. The sword is probably a little too long. I think pirates used a shorter sword, but that's the way it ended up. I've learned a lot by putting this pirate together.

Now I try to get things more in proportion. Sometimes I don't like what I make. In my mind it's not in perspective. The bird's tail might look too long. The bug's head is too high. I sometimes lose track of what I had in mind. It's sort of funny. I've had one thing in the shop that I felt needed to be changed, and someone came along and said, "What about this one?" I responded, "I was gonna cut it up. I don't like it." "Oh, I like it," she said. "But I don't like the tail on it." So I ended up putting the tail on the base she liked, and I sold it to her. If I don't like the body, I can cut stuff away and put it on a bigger or a different type of base. Maybe I will tilt the body differently, or I just might start over. I don't throw parts away because they are too expensive and hard to find. I save the good pieces.

At the very end, I get around to painting the pieces. The paint is an enamel-based paint that protects the metal from rusting outdoors.

IN-LAWS AND OUT-LAWS

I like doing this for a couple of reasons. One is I like the work process. Secondly, people like to look at it and they smile. Kids especially like this stuff. I am just amazed at an art fair, people will come up and touch it, rub it, and look at it. I like making people happy or making them smile. Like with our Tinman mailbox, there's so much attention paid to it. Not all that many people actually stop and get out of their cars because of the dogs barking. I think people are intimidated, but a small amount do stop and look. Sometimes they will buy a little piece.

I like to have this stuff on my lawn. I don't sell the large pieces. I'm a little screwy, I guess. I was thinking about a drill in church when the priest was going on one day in his sermon. "How am I gonna hold this big drill." I thought, "I can use a tree stump in the yard and take the chainsaw and cut

a hole out. Set the bit in the hole upright." My mind seems to constantly shift to making this stuff.

I use stuff I can replace pretty easily. I'm buying all the time. One guy comes by that I've been dealing with and bring me stuff. I end up paying about ten to fifteen cents a pound. There's some cost in making these things. Two years ago, I spent eight hundred dollars for another welder. A hundred dollars here and another fifteen hundred dollars there, it all adds up. I'm pretty tight, and I always have to talk myself into spending the money.

I get all kinds of hay mower guards and wrenches. I might buy fifty wrenches at a time. But all this stuff is running into more and more money. They're asking a buck apiece for those wrenches. A buck isn't much but when you buy fifty of them, all of a sudden you spend fifty bucks. Now, that stuff is being collected. Before, they just dumped it all. It's getting harder to buy these kinds of things from salvage yards and garage sales. Still, I buy a few new parts. Auto parts prices are going up. By the time I go to build this stuff, buy the material, build it, and go to the shows and pay for spaces, I figure I have about 25 percent cost. But even so it's a nice profit for a hobby.

I never really thought about actually selling my work until a few years ago. I had a bunch of stuff in the shed and my kids said, "You should try to sell it." My wife said the same thing and I thought, "Well, I wouldn't know how to price it." What I did was to ask the five kids and in-laws and "out-laws," to write down what they thought each piece should sell for and then I averaged the work. I did that for the first art fair in Mount Horeb in 1995 and sold about twenty pieces. Now the Ornate Box Turtle in Spring Green and Main Street Antiques in Mount Horeb sell my work.

The nicest part of going to an art fair is just watching the people look at my stuff and smiling. That's sort of satisfying. I think that it's a nice feeling when other people enjoy it too. There should be some value to it. I'm always surprised how people accept my work. I'm pleased, of course!

Ellis Nelson, in his studio, sitting in front of a sawdust-burning furnace that he invented and built, Muscoda, 1996. His brass bat belt-buckle was inspiration for the bats he often makes.

I really enjoy this. In fact, if somebody told me, "Let's go on a vacation," I'd say, "You go on a vacation. I'll have more fun in my shop than you will have on your vacation." And this is a true story. Really!

—ELLIS NELSON

ELLIS NELSON

ELLIS NELSON creates prehistoric life forms and anything else that strikes his fancy in a converted gas station/studio. Part of Ellis's charm is his ability to work with mechanical devices, such as his sawdust-burning furnace that keeps the studio cozy on even the coldest winter days of Wisconsin. Ellis's early work was his largest and most complicated, but within a few years of immense popularity, small gallery commissions occupied most of his time. Ellis entertains guests from all over the world, and visitors often travel from Chicago to just look and listen to the stories he tells about his wonderful work.

FAMILY TALENT

My dad came from Logan, Kansas. It was pretty wild country at that time. My dad's family raised horses more than cattle. His father came from Denmark. My mother, she was born and raised right in this area and her grandfolks came from Germany. My father's name was Marion and my mother's name was Elenora.

People back in 1910 came to this country with their traditional ways. They farmed. It was kinda a small farm, and they raised watermelons, and for many years we used to raise a good many acres of sorghum cane. My mother used to make things. She done some sewing. But she was not talented. I also have two sisters and one brother. Now my one sister, Verna, used to do some drawings. She would win first prize in every contest she ever entered her pictures in. Oh, she would draw farm scenes, buildings, and machinery. The stuff she'd like was the scenery on a farm. She was talented in that way. I don't know why but as the years went by, she gave it up.

In 1960 I got married, and of course, my little shop wouldn't support a family. My wife, Rita, she came from Spring Green. They had a real nice farm there.

LABORS OF LOVE

My first job was working with my dad in a veneer plant where they used to take logs and put 'em on a great big lathe, and there'd be a knife that would shear off the veneer. I worked there for a while, not too long. Then I worked for a man that had a filling station garage right in Muscoda. I also worked with people who done electrical work. I worked with a plumber for about a

year in my younger days, a year, maybe two years—I don't know. I worked with a man that was a professional automotive mechanic. He taught me a lot of things. I worked with him for quite a long time. I also worked for a man who had a machine shop out of town. He was a very precise machinist who taught me how to be a gunsmith. He was a professional type. Yes, it's very delicate work.

I think in order to be a gunsmith you've gotta be a real top machinist. I built stocks and parts to firearms, and it is a very precise thing to be a machinist. So I had my own machine shop, later years. In 1953 to about '60 I had a lathe and all these milling machines and a lot of different things. I remember I built a milling machine. It worked very well. And then about in 1960 I got married, and I rented a Standard Oil station. It was a garage and a station together. So I repaired cars there for four years, until I moved to this garage to repair cars and tractors, too. All types of engines regardless of what it was, you know.

BEING WITH THE PROBLEM

I was not interested in school. School was not my thing at all. I was only interested in mechanical and electrical things. The rest of it did not hold my interest at all. If it

Ellis, in his studio constructing a bat

didn't hold my interest, I was all done. So therefore, I only have an eighth-grade education. I always would say that I was probably the dumbest kid in school, but I was the only one there that could take my pocket watch apart and put it back together and make it run again, and actually, yes, that's true.

I was always interested in mechanical things. When I was quite young, probably, oh, I was probably six or seven years old, I used to like to work with my dad. He had a little place out in the country for fixing his farm equipment. But it was nothing more or less than a household tool shop. I mean just a hammer and maybe a hacksaw with a dull blade in it and maybe a few bolts and maybe we were lucky enough to find a screwdriver that would work.

So I can remember one of my first things I ever built. I took a two-wheel scooter, and a guy gave me a regular washing machine, gasoline engine.

They were just little devils in those days, sold by Maytag. So I put that on that little scooter. I didn't have any pulleys or anything, so what I did was take the rubber tire off of the scooter, and put a V-belt from the tire right directly to the little engine. I started the engine, and I had a way to tighten the belt so that when I wanted to make it go it would take off and run for me. It worked very well. I used to run it up and down the road and everywhere. It would probably move along at the rate of fifteen miles an hour, I suppose, top speed. I don't know. But anyway, that belt lasted a long time. It was amazing how long that belt ran on that road.

Another time, I had an old car battery, and I bought an old generator off'n a car or something, and I put a propeller on for the wind, and it would charge this battery up for me. So then I ran the wires inside the house to my bedroom, and I took flashlight batteries and had them on the wall of my room. I had light in my bedroom! At that time there wasn't any rural electricity out to the country. I was probably about eight years old.

In those days, I could actually go to places where they'd throw out all this stuff from the village. I could pick out almost anything I wanted. I can also remember building stuff for my shop. I started building a shop quite young, probably at the age of thirteen or fourteen years old. I started gathering up

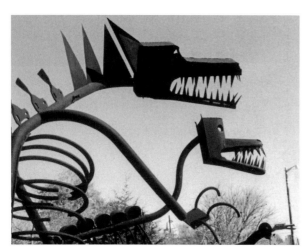
Early dinosaurs, c. 1985

tools that I could use. There is also a muffler-producing factory in town called Universal Silencer. They build big mufflers and silencers for big trucks and stationary engines. I seen some mufflers go outta there that are probably ten to twelve feet in diameter and probably thirty feet long. There's just one to a semi load. They have 'em that huge. They weigh tons. They have a lotta loose scrap metal.

There wasn't any electricity through this area, until 1938. There were very few farmers that could afford to hook on anyway. I suppose I was about fifteen years old when I built a small power plant that would produce electricity for the things that I was building at that time. I also built a homemade drill press and maybe a forge. There was a machinist that lived out probably two or three miles, I imagine. So I took parts over and he would drill it out. So that's how I started building tools. I started building a few things on my own. I built practically my own shop like that—really! I also liked motors and there was a lotta wash-

ing machines that had motors and stuff that you could get for practically nothin'. Electricity, it was very easy for me. I experimented with electricity. I soon caught on how it worked.

I also built this furnace many years ago. It's a sawdust-burning furnace. It's an unusual machine. The furnace is made out of many different parts. About the only thing I used from a furnace, actually, were these doors. The frame I made up entirely, I had to build the parts in the way I wanted them. The entire machine is completely automatic. It feeds its own sawdust in there, from the roof, regulates its own temperature for whatever you set the thermostat for. It maintains the room temperature.

This furnace was entirely experimental when I first started. I didn't even know that sawdust could be burned without smoking. I started experimenting with sawdust and found that if the air and everything was not right, it just smoldered and smoked. But I found that if it had the proper amount of air, and if the sawdust was fed in at a very regulated amount, that it would burn as clear as fuel oil, with no smoke whatsoever. And that's the way this furnace goes. There is no smoke on the stake of it whatsoever. I've eliminated it, entirely. So I had to figure out ways of overcoming a lot of problems with it, to be able to get the sawdust to feed down from the bin into the auger. It took me a bit of figuring to be able to do that. I eventually used a vibrator that turns the sawdust into a fluid-like material, so it'll actually runs in like water with a certain frequency. This regulated exactly where the sawdust is supposed to be for a certain pile. It has to be an exact pile height and maintain that height to stop it from smoking. So when the sawdust comes in against that paddle in the inside, it moves that paddle a little bit. The micro-switch turns the auger off. It's simple. I think I can explain it so most anyone can understand it. So that is the way that it regulates the fuel, exactly. I was able to figure this out by being with the problem. I could very easy solve the problem that way, really.

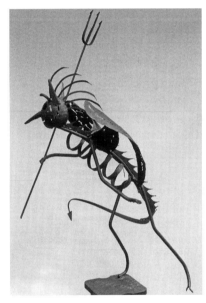

Neptune, c. early 1990s, height 45", collection of Colleen and Dennis Bindley

HERE IN THIS PLACE

Of course, in China and Japan the bat is a symbol of good luck and good fortune. Most people are scared of bats, but most bats are very harmless creatures to a person and they're also very useful. My bat buckle, I had it many years. I bought it one time when I was at a gun show at LaCrosse. I noticed this buckle there among one guy's stuff. I asked him what he wanted

for it. "Well," he says, "you know it isn't brass." He said, "I'll take two and half for it." Well, it sure turned me off when it wasn't brass, but I did give him two and half for it. Later, I was showin' it to somebody afterwards, and we turned the belt buckle over, looked at it, and it *was* solid brass. Well, a bat is a very mystifying creature, very mystifying. They do a lot of good. They eat a lot of mosquitoes and things like that, so actually they do a lot of good, and I enjoy making them.

This grim reaper is movable with the shroud on it. The wind does move it. It's got really a pretty horrifying face. It's supposed to, that's part of the grim reaper. The grim reaper is my favorite. The head has to be just right to be able to make a good grim reaper, and it has to have large eyes that are ghostlike or like a skull. The cloak pieces came from the salvage yard. There must of been a thousand in a bundle or more so. I loaded 'em on the truck and I've used 'em ever since. They're this nice heavy type of metal band, and they were really great for the grim reaper. And the cape I also made of scraps of pipe.

I was fifty-seven years old before I realized I had any talent at being an artist—in February of 1985. Well, I didn't know nothing about artwork before. Okay, absolutely *nothing*. I was not interested in artwork. And I didn't even know the meaning of artwork really. I wasn't busy on a Saturday, doing much. So I told my son, I said, "Say, I'd like to build a sign in my shop in the shape of a Sinclair dinosaur, I think. Why don't you help me carry that piece of metal in. Let's! I wanna see if I can," I said. I can still remember what my son said. He said, "Dad, don't even attempt it! You don't know anything about something like that. Don't even try it." So I don't know if I coaxed him into helping me carry the metal in or not, that I can't remember. But I did get the thing in here. It's a great big sheet of metal. And I had fun drawing out a Sinclair dinosaur on it. It was that huge of a piece of metal. And I hand drawed it.

Oh, it was probably six feet high and eight to ten feet long with the tail and all. Sure it was all one piece of metal, it was I know. But anyway, I marked it out. I marked the body out and how I ever got the idea of makin' the legs afterwards I don't know, but I've never seen that done either. But, anyway, I cut the body out and hung it on the chain hoist and it was just hanging there, the body. So then, I drew out some legs, and I added the legs to it. And it was three dimensional on the sides, and when I got all done with

it, why I figured, "Gosh, I don't think I should really be putting my name on the side of that thing, it looks too good, I mean!"

So what I did was I painted it. I painted it a blue color. It was all blue color right, and dark. I figured now you know that should have different colors on it. So what I did was I put a screen sort of a thing over the surface and I sprayed through that a primer gray. And say, that blue and gray really done it. And then when I got that done, I figured, what I really should do to this thing now—it looked so good—I said, "I think what I should do to it is take my torch," and I had a bunch of these plastic Easter eggs, you know the plastic kind that pops apart. They come in two halves and they're pressed together in pretty colors. I found one of them from the Easter before, and my son might have had some for the following Easter. I don't know. Anyway, he was one short. I took the torch and I cut it out. It was a blue Easter egg I used. I put it right in there for an eye. And I said, "Say that really looked sharp." I thought, "That's really great!"

At that time of year, there was probably a foot of snow on the ground or something like that. It was a cold winter, too! So I got it all done. It took me one day. I started Saturday noon and finished up Sunday by two o'clock. When I got started on it, I just wouldn't quit. I was so interested in it. And it really looked pretty sharp. So I took and opened the door and pulled the thing out in the snow, and it was sittin' out there against that white background. And I thought, "Say, that looked pretty sharp."

It wasn't out there, I don't think, a whole day when a family went by here from the next town in their car, a man with his kids. The kids said, "I seen a dinosaur. We gotta go back." They said, "I wanna say hello to it." So they wouldn't let up on him, so he turned around in the road and came back and showed the kids the dinosaur. And they were all excited over the dinosaur.

Well, pretty soon, why probably the following day, or so, the Muscoda newspaper editor came down and said, "You know that dinosaur looks so good I want to put a picture of it in the Muscoda paper." So, I said, "Go ahead." So I was standing having my picture taken with it, and everybody in town got to see it. Then the *Telegraph Herald* out of Dubuque, Iowa, sent one of their photographers or news writers through here one day, and the man made an appointment to come out and see the dinosaur. Then other papers started to come out. By the time they came, I had three other sculptures made. I had a real nice tin man made from *The Wizard of Oz*. It was a

really nice tin man. So I started building a few more sculptures and have finally gotten to the age where I am retired and I get my social security. So now I don't fix cars anymore, I haven't for several years. I went into fixing cars many years ago, here in this place.

THAT IS A TRUE STORY

I guess the fun is being able to create something different. I have a lot of people stop here over the weekends from the cities Chicago, Milwaukee, Minneapolis, and, of course, Madison. I have a lot of people that come to see me. It seems this artwork does not appeal to people in a small town. It's nothing to a small town at all. It's great that way. They don't bother me at all. But I like to be able to create something new. That is what I like to do. You know I never get tired of doing this. I'd also rather spend a half hour extra and make it look good than to turn it out when I know it isn't right. It only take a little bit longer to make it well. It don't take much longer to do it right. I learned about quality by trial and error. By lookin' at it, you can tell it's right. It's either good or not. But I'm really enthused to keep goin' building this stuff. It's always something different. I don't use any copy or anything. I figure what the head should look like. I just play it by ear as I go along. It's quite interesting.

I try to get out here by five o'clock in the morning. Mostly, I use an acetylene torch, oxygen. But if I wasn't building these sculptures I'd be tryin' to figure out how to improve that furnace or building somethin' in that line. I really enjoy this. In fact, if somebody told me, "Let's go on a vacation," I'd say, "Well you go on a vacation. I'll have more fun in my shop than you will have on your vacation." And this is a true story. Really!

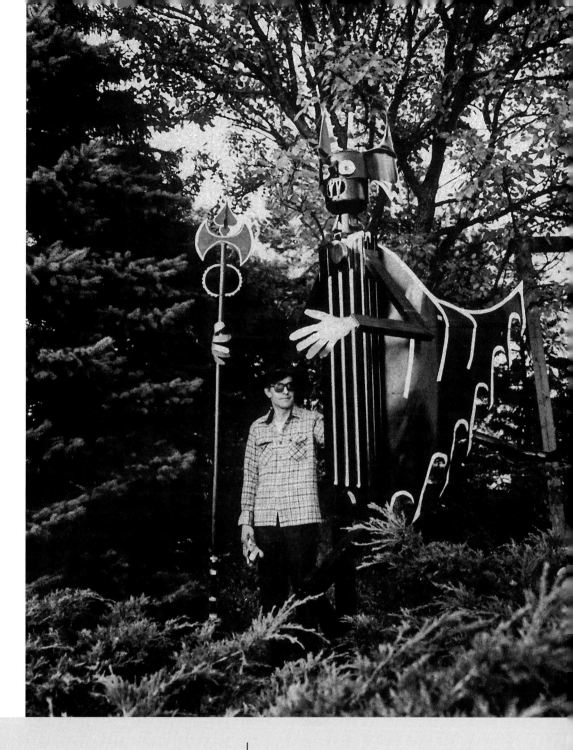

Bruce Squires, in his yard with winged warrior figure, c. 1996, 9½' tall

I learn as I go. I can't always go by what I see. It's what's in the back of the mind that I see. It's kind of an imagination type thing. It's what I see.

—BRUCE SQUIRES

BRUCE SQUIRES

BRUCE SQUIRES is a materials recycler. He primarily uses automotive parts, and he sees his work as something very different than that created by other recyclers. Bruce has looked at the work of famous artists in books and museums and is compelled by the concept of masterpieces. Although aware of the work of other artistically unschooled artists in his area of Wisconsin, he feels strongly that his path is well chosen. Bruce has found sculpture-making to be a welcome activity that relieves the stress of a nine-to-five day job and one that allows him to see in new ways.

A REGULAR JOB

I did art when I was in high school, but afterwards, I went out and found myself a job. After I was out doing a regular job, I got tired of it. When I'm using my own talent, I feel I have done something. It's a lot more interesting than working for a living. It's not only that, but it's a lot of fun. It makes me use my mind in creating things. I can see images of the idea I am going to make. I have to use my imagination when I look at my art. It's like I *see* it.

I COLLECT JUNK

I find that making stuff is a lot more pleasant than working in a factory under a lot of pressure and stress. It's a relaxing situation. As I collect junk, I hang onto it. I probably shouldn't say *junk*, but that's what it is. It's junk! I search out the pieces and collect 'em from different places. I haul the iron scraps, like transmissions, home and break everything down. I take all the gears out of all the cars. I might find a radiator piece that would make a good body, so I don't throw it out.

When I tear transmissions apart, I end up with a lot of pieces. The first time I took one apart, I had one sitting out back and I figured, "Well I'll tear it apart and I'll find out what's in there." I came out with all these pieces and I thought, "Boy what nice-looking wheels they are!" I had all kinds of ideas for them.

When I'm looking at all these junk pieces, it just falls together. Some of my ideas come when I haul scrap. For instance, a guy had an old snowmobile. I hung onto the ski pieces because—who knows? It might come in handy for something. I just put 'em all on the pile back behind the garage, where everything is all piled up. Eventually, there it is! I've got my stuff where I can see it.

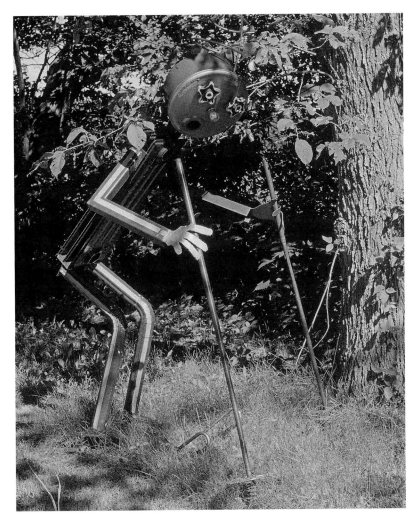

The Skier, c. 1996, 6$\frac{1}{2}$' tall

When I see these things, it's almost like they're saying, "Well, here I am! I'm the bicycle wheel. I'm the horse body. I'm the horse head." They *talk* when I'm looking at them and after I have already seen the image in the back of my mind. It's a weird situation. I try to find pieces that are going to set it off, the feature of the figure or thing I'm working on. I might have a radiator around for quite some time. I just set it off to the side and figure, "Well, I'll use it sooner or later for something." But I don't know what it will be, until I see it. After I had done a railroad spike skier, I said, "Now wait a minute! How 'bout if I enlarge that" I have to wait to see an image before I can create. I can't create something that I can't see. But, I have these visions all the time.

But I've also had challenges. You have to understand that when someone comes up to me and says, "I would like to have a bear," or "I would like to

have a squirrel," all I can say is, "All right, but you're gonna have to wait until I see it because I can't do it until then." A guy drew me a picture of an armadillo. "Can you make one of these? I'll pay you anything if you make this armadillo." I said, "I'm sorry man, if I ain't got the parts and if I can't see it, I can't do it!" It's what's in the back of my mind in my imagination that I see. There's so many different ways that I can use pieces, such as for eyes, noses, bodies or necks. I can use any of these things for any project. I learn as I go. I see all pieces as universal. They can be used for just about anything. It is up to me to use it to the best advantage. If it makes a nose look good, I use it. If it does something for a guy lifting weights, I use it. When I do this kind of stuff, I have to be able to look at any piece and say, "Where is the best spot for that piece so it would make the feature stick out?" It's up to me to use my better judgment when I'm placing things together. It's quite a deal!

Sometimes I put an iron piece together that isn't in the right proportions. Proportions are very important, because people like to see something in the right proportion even though it may be either smaller than life or much bigger than life. Some people like to see a lot of detail. If I get into detail, it sets it off. For example, in the squirrel, the whiskers, nose, and eyes are small details that people enjoy. People like things that are in detail.

People really like my bigger stuff, too. I've had people come and say, "Gee I like this one, and I like that devil, or boy, where'd you get that?" A UPS worker came to my home and said, "Boy, I like this one better than all the rest of the other ones." Certain things will draw a certain person's interest.

What makes this unique is that nine out of ten times, I *can* see it. As I look at the junk pieces, the idea will be there. A lot of good comes out of that. I look at the sketch; I look at all these iron pieces sitting in front of me. I have to make the animal or thing in a way where people can recognize it and be able to relate to it. I like to do things so that a normal "Joe Schmoe" can come over and see a skier and say, "That's a skier. I can relate to it, I recognize it." I do it so that anybody can recognize what I make.

MEETING THE CHALLENGES

When I use an idea, that's it. Once it's been done, it's gone. If it's not a challenge anymore, it's done. I'll do one piece at a time. It might look great at first, but I always think, "I can do much better." The next pieces that I see

will be something that I have not done before. Nobody knows anything about it. Nobody has seen it. When I get it done, then somebody will see it, and there it is, it's done. Eventually, after I get done, it's already taken out of the back of my mind and it's already been used. It's no longer back there. I don't need to see the vision in my head anymore; it is in the artwork. It's a hard thing to explain.

Doing this is a challenge, but that's what it's all about. I try to make the best art that I can and try to do better each time, to keep bringing out new ideas. That's called meeting the challenges. This is just part of what I can do. I don't rush anything. I don't "sell no wine before it's time." It's better if it's done in a very unrushed way. I get better results. The hardest thing about making art is the waiting, and waiting, and waiting, and waiting. This is just the beginning of what I'm capable of doing. Just give me a chance!

If I go to museums, I see all these clumps of iron, a "masterpiece." Most normal people cannot relate to that, to some forms of abstract art. When they go to museums, some people get very frustrated with what they see. Sometimes I think I could have done better myself if I would have gone down to Sam's junkyard and picked up scraps. I look at that stuff, and I don't even know where those artists got their ideas! An artist has got this iron piece sitting there, with an off-the-wall title, and the public's supposed to be able to figure it out and see things. I've had some people come up to me and tell me that my artwork is better than what you would see in the museums down in Madison. But everybody has their own taste. I think the artwork that I do is simpler. People can come and look at it and say, "I can relate totally to that, I know what it is." They'll get a laugh out of it. "Look at this! Look what he did with the bicycle sockets." I would say that the artwork I do can be the stepping stone for some people to be able to get the idea of what's going on with art. It's a mixture of a lot of things.

Take the *Mona Lisa*. A talented artist could look at that and sit there, and they could paint it. It'll look just exactly like the original. A masterpiece in my mind is something that cannot be redone, no matter how hard you try. You can't counterfeit the work. That's what I think. Master artists don't look at somebody else's stuff. They dream things up in their own mind. They see it. They actually do it. Those are the kind of people who eventually, when they have an opportunity, do a masterpiece.

NORTHERN WISCONSIN

Northern Region

When Wisconsin tourism promoters coined the phrase "Escape to Wisconsin" in the 1980s, the place many visitors visualized was Northern Wisconsin. The north woods is a fabled land of waterfalls, lakes, and streams, of deer, ducks, and bears, of rustic saloons, Friday night fish fries, and mile upon mile of forest. Northern Wisconsin offers fishing, water sports, hiking trails, and campsites in the summer. In the autumn visitors come to marvel at the spectacular fall colors of the deciduous forests, and then they return to ski, snowmobile, snowshoe, and ice fish in the nearly endless winter months.

The history of the northern part of the state developed around the use and sometimes misuse of its plentiful natural resources. Native American groups were the first to occupy northern Wisconsin. Recent research suggests that indigenous peoples were manufacturing, using, and trading copper objects five thousand years ago. Based in northern Wisconsin and traveling the country's waterways, these people likely traded as far south as the lower Mississippi Valley.

Gullickson's Glen near Black River Falls is home to many early etched petroglyphs (350 A.C.E.) from the ancestors of the Ho-Chunk and the Ioway peoples in that area. The Wisconsin Gottschall Site is the most dra-

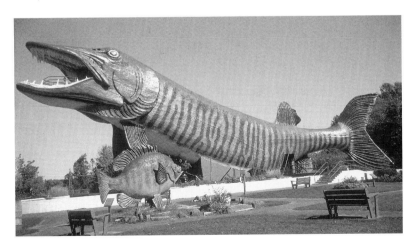

Giant fiberglass walk-through muskie at the Freshwater Fishing Hall of Fame at Hayward. Photo courtesy of Trudi Mullen.

matic example of visual culture in the upper Midwest and is now managed by the State Historical Society. The discovery of this site by a local farm boy in 1974 eventually lead to the uncovering of over forty prehistoric and historic petroglyphs.

The Menominee people are believed to have inhabited areas of northern Wisconsin continuously for upwards of five thousand years. Ho-Chunk (Winnebago) peoples have moved over the years into different areas of Wisconsin and the upper Midwest. Today sizeable Ho-Chunk communities live in Wisconsin Dells, Tomah, and in the Black River Falls area in the northwest. There are several Ojibwa (Chippewa) settlements in Wisconsin from far in the north along the shores of Lake Superior through the north central areas at Lac du Flambeau, Mole Lake, and Shell Lake. WOJB, serving the Lac Courte Oreilles area, is the only Native American radio station in Wisconsin. It provides news of pow-wows, dances, and local events, as well as stellar blues, country western, folk, and contemporary music programming. The Potawatomi, who once lived all over the upper Midwest, still have populations in Forest County at Wabeno and Stone Lake. There is a tiny reservation for the Oneida people at Oneida, and communities are developing nearby in Green Bay. The Stockbridge-Munsee people are now centered on a reservation just to the southwest of the Menominee Reservation.

Native American groups in northern Wisconsin lived, and continue to live, relatively peaceably with the land. Plentiful fish, wildlife, wild rice, and building materials were used successfully without significantly changing the environment, a pattern that changed drastically with the arrival of Europeans.

Early immigrants from Finland, Sweden, Norway, Germany, and Poland swarmed into northern Wisconsin from 1820 to 1900 in search of logging opportunities, furs, mining riches, and eventually cheap farm land from the cut remains of the forests. Within that brief time frame, almost all of the forests in northern Wisconsin were cut down and towns that had sprung up to support the logging industry fell onto hard times. From the 1880s through the Prohibition era, far northwestern Wisconsin was a wild place. Along the northern Wisconsin/Upper Michigan border, towns such as Hurley developed reputations for hard drinking, prostitution, murder, and mayhem as miners and lumberjacks exploded into town after grueling weeks in the mines and forests. Liquor flowed freely into Hurley throughout Prohibition and gangsters from Chicago used the far north for hideaways and vacation spots during those years.

In the early 1900s many cut over areas were laboriously turned into wheat and dairy farms, some of which were successful. In general, farming in much of northern Wisconsin was a tough business because the land was covered with rocks and pebbles left by receding glaciers. Intensive iron and copper mining in the far northwest, followed by boom periods in shipbuilding and the shipping of ores, caused rises and falls in the fortunes of northern Wisconsinites. Almost everyone who chooses to live in northern Wisconsin has been directly impacted by the still bountiful, natural world of logging, mining, recreation, hunting, and fishing.

Norman Pettingill was a north woods cartoonist who published his work as postcards in the 1950s. *Buck Shots*, 1940, Pen and ink on paper, 27" x 20". From the Permanent Collection of the John Michael Kohler Arts Center.

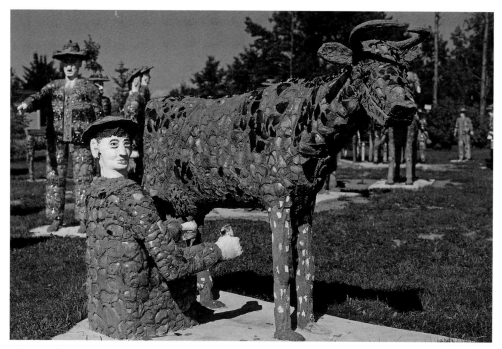

A farmer milks his cow at Fred Smith's Wisconsin Concrete Park.

Postcard of American Birkebeiner, Hayward-Cable, Wisconsin. Photo courtesy of Zane Williams.

Winters in northern Wisconsin can be long and brutal and the hardy souls who stay there have devised ways to enjoy themselves despite the intensity of the climate.

John Ree, an elderly "recycler" who lived in Mellen, used pebbles he collected with his grandchildren in nearby Lake Superior to build tiny houses that he displayed like an elfin colony in his front yard. John filled long winters puttering in his workshop, which was heated by a big wood stove. His creations served a double purpose of helping him pass long winter days and providing him with visitors who came to admire his work when the weather improved each spring.

Hope Atkinson was at one time one of the highest ranking female mariners on the huge ore boats coming out of Superior. Hard times in the industry and a boating accident forced her maritime retirement and eventually resulted in her current career creating sculpture and drawings.

Norm Pettengill was a draftsman and humorist who poked fun at traditional north woods pastimes and people. In the 1950s and 1960s, Pettingill published many of his cartoons as postcards. His highly patterned and intricately drawn vignettes featured hunters, fishermen, lumberjacks, tourists,

and bathing beauties behaving and misbehaving in highly entertaining ways against a backdrop of pine-covered forests and lakes.

South of Phillips in north central Wisconsin is the Wisconsin Concrete Park, a creation of Fred Smith. Smith was a farmer, lumberjack, bar owner/operator, and fiddle player extraordinaire. He retired from work in the logging camps in 1949 and proceeded to populate a wooded area on his farm with about two hundred decorated concrete life-size figures. Many of the figures were arranged into tableaux celebrating north woods life. Hunters, fishermen, loggers, beer wagon operators, tourists, and farmers mingle with deer and other animals. Smith constructed angels, a Statue of Liberty, a scene from the movie *Ben Hur*, a Lincoln-Todd Monument, Iwo Jima Plaque, a giant eight-foot muskie hauled out of its lair by a team of horses, and various characters from news, history, and myth that caught his fancy. Fred Smith worked tirelessly on the site through 1964. The concrete park was seriously damaged twice by storms in the 1970s but was successfully restored with the help of the Kohler Foundation. It is now maintained by the Price County Highway Department.

Another concrete and found objects environment, no longer in existence, was Mollie Jenson's Art Exhibit constructed in the 1930s near River Falls, Wisconsin. Jenson reportedly visited the Dickeyville Grotto as a young woman. A farm wife, her impulses for making things special started with quilt-making, drawing, painting, and wood carving. In her forties, she began to build a family zoo and yard environment complemented by a very large windmill. The site grew to include a shrine to patriotism, a large outdoor fireplace, and a room covered with mosaic designs. Only the windmill remains today.

Wilmot Swanson used the omnipresent rock-strewn fields and cut over terrain around Lakewood to build a collection of cabins and farm buildings that eventually became a small European-style village on his property. The site, complete with

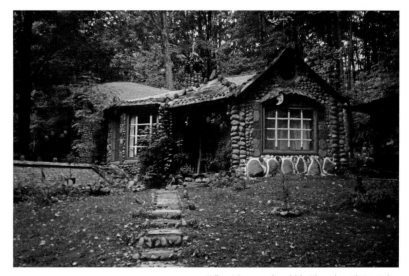

Wilmot Swanson's pebble Gingerbread House is one of several decorative and whimsical buildings he created near Lakewood.

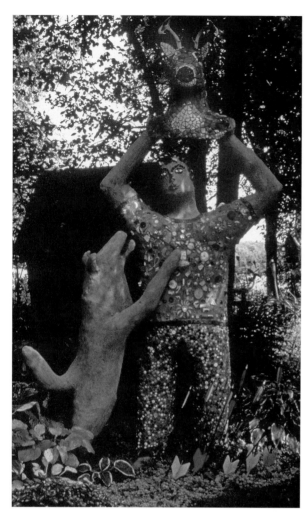

Riana de Raad, *Bow Hunter and His Dog,* north-western Wisconsin. Deer torso is a yard light. (photo courtesy of Riana de Raad)

woodland paths, gates, and columns, was all constructed of available natural materials such as stacked pebbles, branches, and driftwood. Swanson created the picture frames, stairways, window trim, and furniture in his little houses from unmilled wood and used bright paints and fanciful details to embellish his handiwork. Now operated by Swanson's daughter Esther Larson and her husband John, the Camp Lake Resort is a fabulous example of a magical environment created with locally available materials.

In the early 1960s in Menomonie, Wisconsin, Frank Oebser filled his barn with mechanically animated figures that he made using mixed media. Oebser enjoyed making mechanical toys as a child, and when he retired in his seventies from dairy farming, he began building large-scale toys with a passion. His Little Program environment differed from earlier sites in that it was manually and electrically powered. Many sculptural actions were accompanied by entertaining movements and noises. After Oebser's death in 1990, the Kohler Foundation helped put his work into storage with plans to reassemble the site at a future date. Several pieces from this collection are regularly displayed at the John Michael Kohler Art Center.

In far northwest Wisconsin, Riana de Raad has transformed an old farmstead into a two-acre sculpture park and garden. The gardens, most beautiful in the full bloom of summer, combine the color, lushness, and textures of Indonesia where de Raad grew up. De Raad creates charming concrete and found object sculptures that give a nod to Wisconsin's concrete and assemblage makers such as Fred Smith. Originally schooled as a fiber artist, de Raad now builds and sells her sculpture on commission.

Chainsaw art is a logical art form in an area known for forests, lumberjacks, and chainsaw prowess. Several towns in northern Wisconsin host lumberjack championships with log rolling, tree felling, and tree climbing competitions. Wood is the medium of choice for many hand-crafters, and

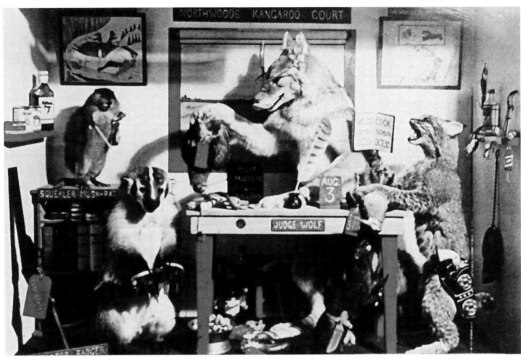

Northwoods Kangaroo Court, taxidermy by Karl Kahmann, Noah's Arc Taxidermy, Hayward (photo by permission of the Moccasin Bar, Hayward)

back roads throughout Wisconsin are dotted with wooden mushrooms, windmills, and painted cutout plywood figures doing just about any human activity imaginable.

Fish and fishing motifs are everywhere you look, from hand-painted bait shop signs and billboards to the gargantuan muskie at the Hayward Freshwater Fishing Hall of Fame, a museum where visitors can pose "hooking" giant fiberglass panfish. A local doctor spent his career removing wandering fish hooks from area fisher-people, and when he retired he donated a hook display to the museum chronicling dates, names, and hooked body parts of each victim. The museum also has a large collection of antique fishing lures and hand-tied flies and an unusual display of outboard boat motors.

Hayward has yet another colorful claim to fame: the Moccasin Bar. This downtown gathering spot features entertaining tableaux, engineered by a local taxidermist, of local wildlife dressed in human garb. The posed creatures participate in human-style mischief in case after case scattered around the bar. The Moccasin Bar also claims the world's largest stuffed muskellunge (a prized game fish), a boast disputed by other bars in this part of the

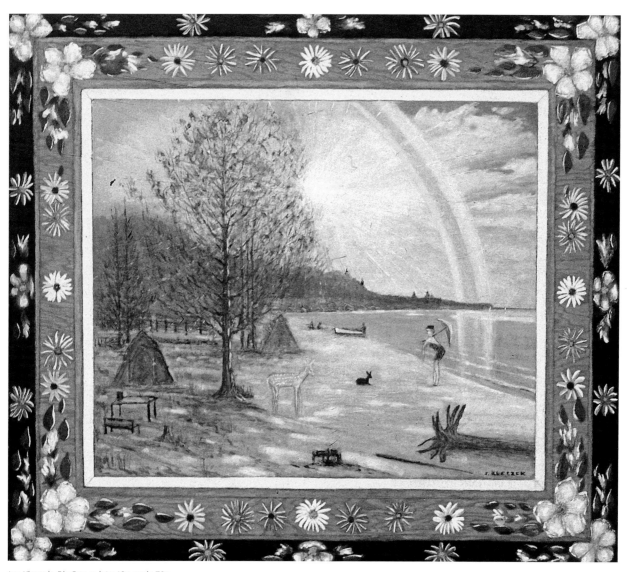

Joe Kleczek, *Big Bay*, c. late 60s–early 70s,
collection of Susan Souchery

state. Taxidermy is huge in northern Wisconsin. Hayward is also home to Schoenerwald, the estate of the late pinup artist George Petty.

The Bayfield area is one of the most picturesque areas in all of Wisconsin. This tiny fishing village offers wonderful views of Lake Superior from its hilltops, access to nearby Native American attractions and several state parks with sizeable waterfalls, charming accommodations, excellent food options, and water transportation to the Apostle Islands.

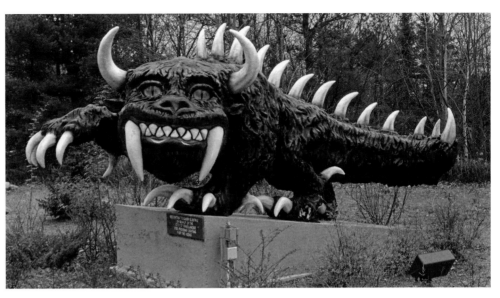

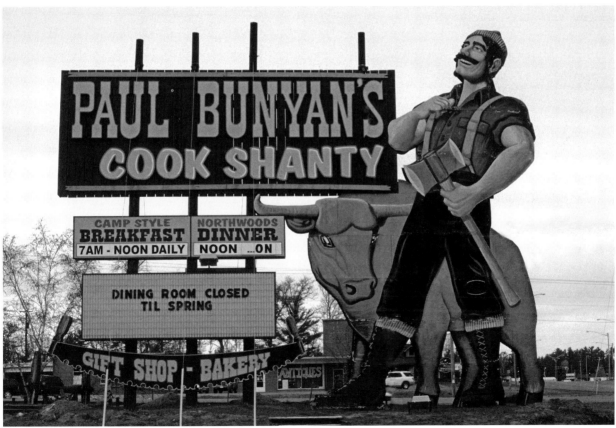

Top: A very large Hodag lurks at the Rhinelander Chamber of Commerce (photo courtesy of Jim Mankoph)

Bottom: Paul Bunyan's Cook Shanty, Minocqua (photo courtesy of Jim Mankoph)

The town of LaPointe on Madeline Island is a bustling arts community listed as one of the best places in the United States to live if one is in the arts. In the 1960s and '70s, Joe Kleczek moved here from the Chicago area and began to paint rather mystical landscapes filled with mysterious light and atmosphere. Kleczek's considerable output vanished when family members cleared out his house at the time of his death in 1975, and only a few of his paintings are known to still exist in the art collections of his local supporters. A small exhibition of his work was organized by the Madeline Island Art Guild in 1992.

Wausau is the largest city in the northern half of Wisconsin. Located on the Wisconsin River, Wausau's history, as well as that of neighboring communities, developed around the paper and logging industries. Today its diversified industrial base attracts workers from many cultures that mingle with the Poles and Germans who originally settled the area. Wausau is now home to thousands of H'mong peoples from Southeast Asia who migrated to the area after the end of the Vietnam War. Laotian handicrafts are available in many Wausau area venues and the H'mong community offers plays, music, and dance to share its ethnic culture with neighbors.

Northern Wisconsin is a land of myths, fish stories, tall tales, and larger than life constructions. In myths, logger Paul Bunyan and his blue ox Babe stomped the north woods through Minnesota, Michigan, and Wisconsin creating lakes with each giant footstep. In Rhinelander, early settlers claimed the existence of the Hodag, a fearsome beast with long sharp teeth and claws. These storied characters show up in statues, restaurant motifs, children's books, and advertising gimmicks throughout the north woods.

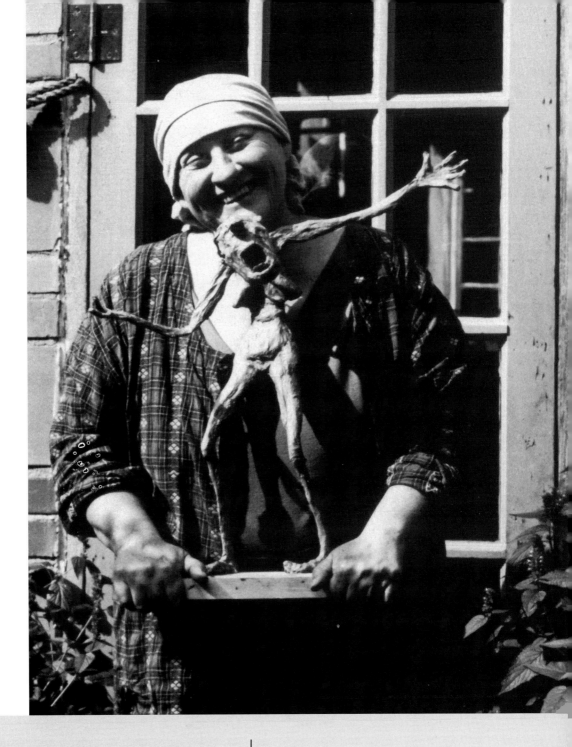

Hope Atkinson, with
Menopause, 1995

Being self-taught, I really tried to teach myself,
you know. But then at some point I started won-
dering what I was trying to teach myself. I feel
like God has something planned for my life. The
more I give myself to God the more I'm able to
do, you know. . . . Sometimes I think we're catch-
ing glimpses of God everywhere.

—HOPE ATKINSON

HOPE
ATKINSON

Through extraordinary personal courage and determination **HOPE ATKINSON** has survived many hard challenges to come to a place and time where she can create art full time. Her work consistently expresses her empathy with the people of the world who feel the pain of discrimination, poverty, and abuse. These messages come to us through satire, humor, and a wonderful playfulness. It is Hope's wish that these accessible approaches lead to proactive ends. Hope is a teacher, both through her art and through classes she offers to neighborhood children and to communities that she has lived in. Although a private person, Hope has been generous with her life.

FAMILY MEMORIES

When my mom got pregnant for the sixth time she kept saying, "I hope this one's a girl." She'd already had my half-brother and sister, and my three older brothers. She called me Hope Joyce. My dad worked at the steel mill in Duluth, Minnesota. We lived in Oliver, Wisconsin, a little town outside of Superior, Wisconsin, on the Minnesota/Wisconsin border.

We lived in a little four-room house and all us kids slept in one big bed. There was no running water or indoor plumbing. It must have been a very hard life for my mother. When I was four years old, she left with her first two kids. My dad kept my three brothers, and I was sent to a foster home. The foster home was very different from anything I knew. I had to be very quiet. They cut off my hair because of head lice, I guess, and tried to put me in a big foaming tub that looked like a huge pot of boiling potatoes. I thought they were going to cook me and eat me! I was so traumatized and I screamed so hard that I lost my ability to talk for a long time. They would coax me to speak by holding a cookie out in front of me, "Say cookie, say cookie." They called me "Cookie" all the years I lived there.

I'd get to go see my dad and brothers once in awhile, but soon my dad remarried and started another family. Soon I had a younger half-brother and three sisters. When I was in third grade my dad took me back for a trial visit, but I lost my ability to talk again and was sent back to the foster home. I wouldn't spend time with family much again until I was an adult. It's terrible being raised in a place where there's nobody who loves you or wants you.

As a child, I carved scottie dogs out of bars of soap and made things with twigs and stuff. I had to really stay out of the way of people at the foster home. I spent a lot of time alone. I still like solitude. My preference is not to

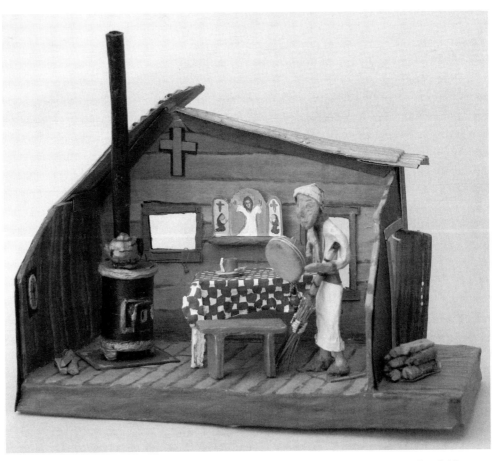

Grandma's House, c. 2000, papier-mâché, cardboard, wood, and found objects, 9³/₄" x 13³/₄" x 7", courtesy of Marcia Weber Art Objects, Inc., Montgomery, Alabama

have people around. I don't have a husband or a family or anything. It's just myself. I know other people think that it's really strange, but I like it. In my mind, I have a rich life.

In high school I loved to read but was not a very good student. I couldn't spell and math was a mystery to me. I was a good worker though and had part-time jobs all through high school. I graduated at seventeen in 1964. Immediately, I took a bus to Minneapolis. I only had a little bit of money, so I stayed at the bus depot, until I could find a job and a place to stay. The bus depot had an attendant, a very nice black woman who let me wash there. She was very kind. Later, she told me about a woman's motel that was in Minneapolis. Life was pretty ugly. I guess I felt pretty alone. I got into some bad situations that overpowered me. It was a very bad life, but soon I got a job as a proof operator at a bank.

Over those next years I made a lot of bad choices but also good ones, too. I discovered libraries and the University of Minnesota; what wonderful places! I read furiously and took classes, or sat in on classes, at the university whenever I could. I was feminized and politicized during that time, which led eventually to my volunteering to work for the McGovern campaign—they had lots of volunteers in Minneapolis but needed more in other areas. Superior, Wisconsin, was one of them, so I went "home" again.

My dad's new family had separated, and the little kids were now becoming teens. My dad had had a well put in and indoor plumbing, a tin shower stall, a hot water heater, and a flush toilet. The one big bedroom had been divided in half. Dad said I could stay with him until I found a place. My dad was a Nixon man, a major gulf that led to endless political arguments. Dad always thought I was getting above myself, "uppity." I think of that now with great regret. It's foolish to argue with someone you love, especially about politics.

When I found a place of my own, Dad asked if I would take in my kid sister, April [who was fourteen at the time], to live with me, as she was having a hard time. Then something absolutely wonderful happened! Some people working for McGovern, from Grand Rapids, Minnesota, gave me a gift of tuition for my freshman year at UW–Superior. I was in heaven. I wanted to study literature to read everything and write great books (even if I couldn't spell). I was twenty-four years old then and very happy.

I especially wanted to study the authors who wrote of the lower classes, the peasants and the poor, with some respect and dignity. I felt, and continue to feel, that there is very little voice from our class that is not denigrating. Over the years I'd developed a very strong class-consciousness, for good or ill, that is easy to see in my work.

WO"MEN'S" WORK

Those next four years went by quickly. April and I both graduated. For me it was time to pay off a mountain of school loans. It was a very good time to do that because the affirmative action laws had just passed and for the first time women could get into those high-paying "men only" jobs. Living in the port cities I saw the ships coming and going and said, "That's for me!" I was one of the first women to challenge that system, and soon I was a passenger porter for the summer on a 750-foot ore boat in the Great Lakes. It was wonderful . . .

beautiful beyond anything I'd ever seen. The work wasn't hard, and the money was wonderful. I was hooked. That was the beginning of the next five years.

With all that money I was making I bought myself a little house down on the waterfront in Superior. Mostly it was a place to store my stuff while I was out on the boats, or a place to spend shore time. It was reputed to have once been an old whorehouse, and I got it real cheap on land contract. I also looked into buying a boat, a small tug of some kind that I could convert to a houseboat. Oh, I had dreams, dreams of adventure!

During the first two years out on the boats, I moved into several different jobs: passenger porter, relief porter, and relief second cook. One day just as I was to be laid off, a guy from the engine room didn't show up for his job and it became open. So I did engine room work for the next three years. The system of advancement in the engine room was via written tests—I was good at book learning and advanced quickly. That didn't hold well for me when the industry cut back and the layoffs began.

Suddenly, women on the ships were seen as threats to "men's jobs." The union meetings were a snarling match. The passing of the written tests gave you seniority over men who had more years or even more knowledge. It was their system. It was real tense times.

MY CABIN ON THE WAVES

In my shore life, I was more determined to get my own little boat. I finally found an old wooden fish tug in Duluth, thirty-five feet long—gray marine gas engine. It was a beauty. I wanted to find a place to moor it where I could work on it and live on it. That's what first brought me to Cornucopia, a beautiful little fishing village on the south shore of Lake Superior. I motored the little tug across from Duluth, named her *Suzanne*, and lived and worked on her whenever I was off the ore boats.

When I came to Cornucopia, I didn't know a whole lot about how to run a fishing tug. I had to make friends with people that knew that sort of thing. There was an old fisherman here in town that showed me. It was a big old clunky boat. I just mostly lived on it, my "cabin on the waves."

Things were getting ever rougher and tenser on the boats, as more and more layoffs came. I finally felt too threatened and opted to take winter ship-keeping work rather than active duty. That gave me summers off, more

time for working on *Suzanne* and living in Cornucopia. The fishermen in Cornucopia were wonderful. They taught me a lot about my boat and were infinitely patient with my ignorance. I'd go out fishing with them, which was a great privilege. One old retired fisherman they called "Cachunk" was especially interested in my project and spent many hours with me teaching me how to run the boat, how to dock, how to care for the engine.

I had the boat for three summers. On one particularly beautiful summer day, the old fisherman said the engine was clinking or clanging or something. He said, "Let's go out and we'll see if it's missing or something." So we took the boat out a couple miles on the lake, and I had the floorboards up so we could hear the engine. We were quite a ways out when I leaned over the engine with my really long hair. My hair got wrapped around the shaft and it pulled my scalp off from the eyebrows to the back of my head. I didn't lose consciousness. I guess I couldn't quite figure what had happened. I was probably in shock. I stood up and the old fisherman said, "You don't have any hair." I didn't understand what he said, and I looked in a mirror that was below on board the boat. When I looked at myself in the mirror, I had a vision. It was like I saw right through the mirror into a whole different dimension. I experienced an incredible calming peace that said, "You can handle this." The fisherman got a towel, put it in the lake and wrapped it around my head. He untangled my scalp from the shaft, and I sang songs coming in. This absolutely changed my life. From then on, everything was different. Everything prior to that, it's like talking about someone else that I don't know. Some of this is very hard to remember.

My life has never been the same. It is a whole different me. The person that I was, prior to that, was just gone. I was in the hospital for a long time. Later I bought an old barn right down by the waterfront. I'd mostly bought it to keep stuff in while I was out on the ore boats. I went and I lived there. I really locked myself in.

A MASK OF SHAME

Two important things happened within that time. While I was in the hospital, April's best friend Lynn sent me a gift of a little papier-mâché puppet on a stick. It had a deformed little baldhead and only one ear, a crooked smile and eyes of absolute peace and acceptance. They were the eyes of peace that I saw

in my vision. It was the most beautiful piece of artwork I'd ever seen. It became a talisman to me and still is. It's a reminder to me of knowing infinite peace. When I got out of the hospital, Lynn showed me how to make papier-mâché.

The other incredible thing that happened was an outpouring of love from the community of Cornucopia. They prayed for me, visited me, held my hand, and loved me. The community held a benefit/celebration for me, and it was their generosity that allowed me to survive over that long winter, recover, and heal.

I went back to my house in Superior. I was still in bandages and had to change them every day. My nightmares were horrendous, and my days were filled with shame, anger, and rage. The peace of God I so longed for was nowhere for me. I was nowhere for myself. I didn't know myself anymore. Something had changed in me way beyond appearances.

Using papier-mâché I began to make masks; deformed creatures, scary, violent images of my nightmare horrors. Facing these monsters was impor-tant, I'd look at them reminding myself they were just paper and bad dreams—I'd paint them with shoe polish and house paint. When they were no longer scary to me, I'd burn them up in the wood stove.

Yellow Cow, (canned animal), papier-mâché and found object, 12½" x 15½" x 7", courtesy of Marcia Weber Art Objects, Inc., Montgomery, Alabama

Somewhere in the making of the masks, I began to like the soothing process of laying paper and forming it with my hands. As I found satisfaction in the process, the pieces themselves became softer and gentler. I was finding an inroad to peace again. I began to keep some of the masks and went to the library to read about masks. In one book I found a "mask of shame."

I still keep this mask hanging on my wall. It is still very relevant to my life and my thoughts . . . that heavy burden of shame. When it's not shame, it's blame. I once heard it said that shame and blame is the two-headed monster that blocks the path to forgiveness. I believe this is true and much of my "mind time" is involved with getting past this mon-ster. You'll see much of shame and blame and the seeking of forgiveness in my work.

When spring arrived and the last of the bandages were gone, I returned to Cornucopia. I knew I had to sell *Suzanne*, but it gave me a place to live till

then. I picked up odd jobs in Cornucopia and in my free time I made large scary masks for the fishermen, which they used like scarecrows to hang on the pond net poles to scare the cormorant birds from their catch.

These masks are my favorites to remember even though the winds and water eventually destroyed them. I like to think of them out there in the lake that I loved so much.

SKILLS OF SURVIVAL

Suzanne sold and I took a part-time job at Langhammer Fruit and Vegetable Farm in Bayfield, Wisconsin. There was a little shack next to the gardens that I rented and made home. I also worked fourteen hours a week as the Bayfield librarian. I was thrilled and scared.

Bayfield was not quite the tourist town it is now. It was more of a fishing village. Few people used the library except children. When school was out and during the summers, the children would fill the library. I used my papier-mâché skills to make the characters from different books to encourage reading. I made many of the characters from *Alice in Wonderland*, and masks of the wild things in *Where the Wild Things Are.* The kids would do skits, parades, and puppet shows with the props we would make. The kids taught me so much about joy. A dimension I hadn't often had.

As time passed I was invited to other libraries and schools to teach toy-making workshops and to do storytelling or a puppet show. People began to seek me out to make toys for them or their children. What began as my gift for the children was beginning to become a way to make a living. After four years in Bayfield I thought I'd test my newfound direction in a big city, and I moved to Duluth.

In Duluth I rented some warehouse space where I could live and work. I got a part-time job at the Duluth Art Institute teaching toy-making classes to children. As in Bayfield, I was again invited out to schools, churches, and libraries. I even gave a workshop for area Head Start teachers. All my toys are made from junk and waste—cardboard boxes, pieces of wire and cloth, sticks. I make something from nothing. You must be creative.

About this time I was reading a book by Matthew Fox in which he said, "The issue for the poor is survival and creativity: how to survive with what minimal gifts one has been left, and how to make something with the sim-

plest of materials, out of the nothingness of one's existence. Here lies new birth and new creation."

I was very struck by his writings, and I decided to teach my skills of survival to other poor people. With the help of the Duluth Art Institute, I got a grant to set up a toy-making studio next to the soup kitchen. When families came in to eat, they could come next door to make toys and play together. This was a great success. Many families took part and made wonderful toys. Some of the mothers were more excited than the children. At the end of each workshop, the participants were given paint and brushes so this art-making direction could be continued.

I did these workshops for three summers, and it was very good, but I missed Cornucopia, and I wanted to be back to that beautiful place where I was loved and cared about.

I would visit Cornucopia whenever I had the chance, always looking for a place to live that I could afford. A barn called the twine shed, where the fishermen would make and store their nets, had been abandoned for a long time . . . since the advent of nylon nets. The windows were broken out, the chinking between the tiles was badly eroded, there were huge cracks, and the cement floor had heaved up and broken. Yet, it was beautiful, and I knew I could make something of it.

Playing with Toys, c. 2000, house paint on board, 24" x 16", courtesy of Marcia Weber Art Objects, Inc., Montgomery, Alabama

The twine shed had electricity but no water or sewer hook up. At first this wasn't a problem, as the village had outdoor toilets at the beach as well as a community well. But eventually, I had to hook up to the town sewer system. The cost of that was twice what I paid for the barn! No wonder my dad went without indoor plumbing for so long.

TEENSY TOYS

I wanted to pay off that debt as quickly as possible so I began to seriously sell my toys and characters. I showed my work at a cooperative gallery in Bayfield. It went well when I was showing mostly children's toys, but as I

moved into showing my adult work I started to get in trouble with some of the other artists. They thought my work was offending the tourists. When I was not there, they would put pieces of my work in the back room or cover offending parts with bits of paper.

What really made them angry and anxious was a series of piggy banks. I had taken all the references to swine I could find in the New Testament and made a series of piggy banks, then made the characters that were involved with the swine. It was basically three stories: the prodigal son feeding the swine; Christ casting demons into the swine; and casting your pearls before the swine. I made the prodigal son as a raggedy boy with a menu in one hand, feeding dollars to the gold-headed swine with the other. You may remember from the story that the prodigal son was jealous of the food he fed the swine.

For Christ casting the demons into the swine I made several piggy banks with demons riding all over them. One little demon had his penis caught in the money slot and his partner who was riding along was bare breasted. The woman that I made casting her pearls before the swine was naked and tragic. Her swine was turning to her to warn her, "Do not cast your pearls before the swine less they turn and rend unto you."

When I realized that my work was being seen as something dirty and offensive, I quit. In Cornucopia I took a job at one of the restaurants, doing cleaning and a little cooking. It was enough to get by. I spent time working on the barn, and I made my artwork for myself. People began to seek me out to see my work and to buy it. A wonderful break came for me when Marcia Weber, a gallery dealer from Montgomery, Alabama, came to me offering to handle my work on a big scale.

She shows it in big cities—even New York. Another miracle, a dream come true! Marcia's been handling my work for the last five years and my sewer system debt will be paid off this year. I don't work at the restaurant anymore. I still do occasional toy-making workshops. As for my artwork, I've been working for years now on a "carnival of sins." It has cardboard sideshows and roaming sideshow freaks. It has carnival rides, bizarre jack-in-the-boxes, angels, devils, pony rides, bake sales, and hoochie koochie dancers.

I've been working on it so long I can't make my way through it. It has to do with shame and blame, fear, anger, and all the different guises fear can wear. Fear of what? Of God, of course! It's also taking me so long working on this because I keep selling off pieces. Fortunately, the pieces are with col-

lectors who respect my work and take good care of the pieces. One day I hope to see the carnival all together. Maybe then I'll understand what I've been trying to teach myself by making it.

Sometimes when I look at my most simple pieces—brown paper faces that carry humility, anonymity, simplicity—I see that is the direction I need to go. When I think of this barn and dreams of making a sanctuary, I see more and more that it is my heart that needs opening as well as the building. I'm still given to anger and fear, but when I catch the glimpses of God leading me home, I'm so grateful, ever, ever so grateful.

CATCHING GLIMPSES OF GOD

I moved from Duluth, and I've been here five years now. Sometimes I think that making my artwork and this building were a gift from God. God just kind of gave them to me, a gift or compensation for losing my hair. To think that something so horrible could happen and something so good could come out of it! Sometimes I'm just stricken that that would happen and I'm so grateful that it happened.

I'm so grateful that God changed my heart, changed my mind, gave me the skill, and gave me the vision. I feel like I'm supposed to be making a sanctuary here with this building. The artwork has something to do with that—teaching. Not teaching art, but teaching survival. You can survive, and people are going to need a place, a sanctuary.

You know when they put the well in, they drilled down eighty-five feet, and they hit an artesian well and the water just flows constantly. That's pretty amazing. I feel that my vision pulled this all together here. I didn't know who was supposed to come here, but people come here from all over. They like to get my artwork. I don't have a telephone. I seldom write letters and people come.

It's kind of a silly thing, like that baseball movie [*Field of Dreams*]. There's something more to it than meets the eye. I can't believe how sometimes I need something, like flooring, plumbing, or lights, and somebody will come within a couple days and bring it. It's happened so many times it's almost eerie. Maybe I shouldn't talk about it. For example, when I bought this building, I had to hook up to the city sewer, which cost six thousand dollars. The biggest expense of my life was plumbing. It is so bizarre. Society's just gone mad. That has a lot to do with the artwork I'm making, these

little jacks jumping around, waving dollar bills. Is society possessed with some kind of greed and craziness? Anyway, suddenly somebody comes along and they purchase my art for exactly the amount of money I need to pay for my bills or something. I think that since the accident there's been some grace, some love, kindness to myself. I think that something came to abide in me which was not there before. I feel that there's something happened there that touched me.

My relationship to God, Jesus, and prayer connects me with other artists. I don't know how to explain it. Something really struck me about making some kind of sanity within the confusion and madness of our society. I feel that in some ways I do that. I can see it in people, when they come here, to get away. They like what I have here.

Being self-taught, I really tried to teach myself. But then at some point I started wondering what I was trying to teach myself. I feel like God has something planned for my life. The more I give myself to God the more I'm able to do, you know . . . Sometimes I think we're catching glimpses of God everywhere.

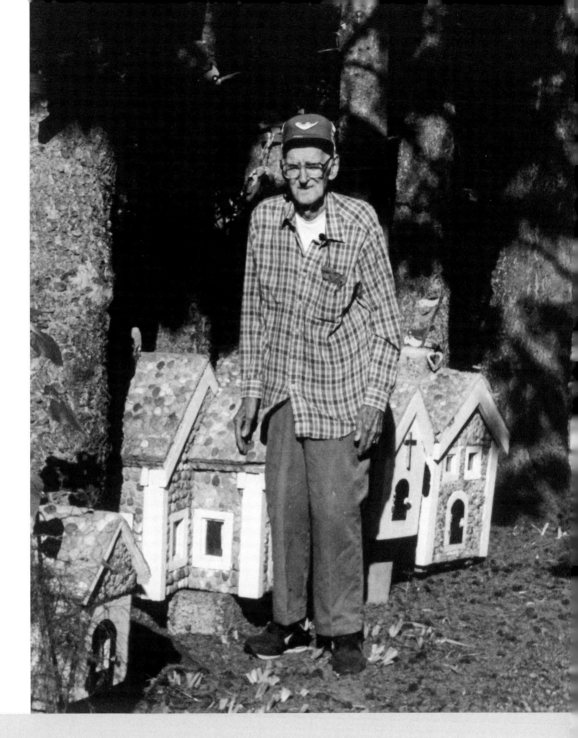

John Ree, in front
of his pebble village,
Mellen, 1996

I just started picking these rocks up, and I said,
"Oh well, maybe some day I'll use them for
something!"

—JOHN REE (1907–1999)

JOHN
REE

JOHN AND MARY REE were married for over fifty years before John's death in 1999. For much of their lives, they worked together in farming and mink ranching. Building their retirement environment engaged them both as well. Wisconsin homebuilders have long used pebbles and rocky debris—free raw materials left behind by glaciers—for construction. John, Mary, and their family made beach pebble collecting an enjoyable family activity at nearby Lake Superior. John transformed the pebbles into a charming roadside pebble village, a quiet personal project that gave him enjoyment and brought hundreds of interested visitors.

NO APRIL FOOL

My parents came from Italy, and Mary's were from Czechoslovakia. I don't know how old my father was when he came to the United States. They bought a farm up the road. My dad was a butcher, and we lived on a farm. He'd whittle. He could fix a harness. He was pretty good with his hands. My dad used to make decoupage. People around here thought it was great. Lots of people stopped. Different people called and whatever, you know. I was born on April Fool's Day, April 1, 1907. I followed in his tracks.

I met Mary when I was doing some farm work or something up at her parents' house. I think it was butchering. Her folks had a couple cows then. She comes from a big family of ten. Mary worked in a defense plant during the war, in Eau Claire, for a couple years. Then she worked in Madison for Madison Kip Corporation, then in Eau Claire where they made ammunition. I showed up at her place to kind of help out. I kind of took a shine to her and that's all they wrote about it. We have been married for over fifty years.

We used to have a farm here. When we bought this place, it was all brush, across the road there, woods, woods, and great big elm trees. We started from scratch. We had nothing. We'd do the roof on posts. When we had the money, we laid the foundation. Later, we had mink for about twenty years. It's a lot of work. We must have had, oh probably, a thousand mink. We made a living out of them in those days. The mink is worth nothing now. It was time to retire anyway. They're really kind of mean animals. They had choppers. The kids got bit a couple times. Once our daughter stuck her hand in the pen and a mink grabbed hold of her finger, and wouldn't let go. I came along with a cigarette and burned the mink's nose, and it let go in a

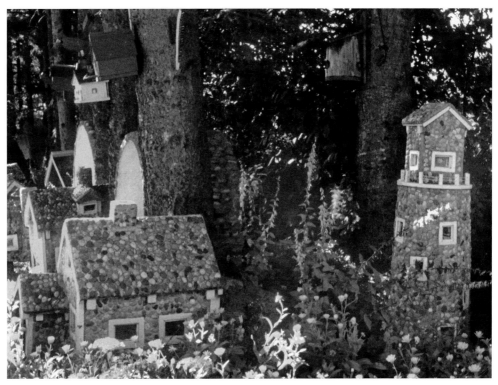

Details, pebble village

hurry! You can't shake them off. They put their teeth on top of something, and they don't let go. They bite to kill. They're mean.

When our kids were small, they each had a pet mink. They played with them all the time. When the mink got older, then they started turning mean. One time we went downtown and the kids each had their minks. They had 'em on leashes. "Cripes, it was just like the Fourth of July!" I thought. Everybody was looking at us! Walking around with a mink on a leash!

I was also a farmer until I was forty years old. That's how twenty years passed. There were three of us brothers. I moved down here when I married Mary. My one brother, he had asthma so bad. He was single. He used to come over here quite a bit. He liked our kids. In the summertime the three of us brothers went hunting.

CABINS OF STONE

I've been making the little houses since 1992. They're hard to handle. We skid 'em over on a toboggan in the winter behind a tractor. The ground is frozen.

Lake Superior pebbles in John Ree's workshop

The big cabins we've been making from 1986. When our daughter comes up from Texas with her two little girls, they enjoy going down to the beach. They help us pick pebbles. We used to haul them ourselves. But since they've been coming, our daughter and the girls, they've been hauling them up for us because they're getting pretty heavy. They're getting heavier every year.

When our daughter comes with her girls they'll say, "Grandpa, let's go someplace." I always say, "No, I'll stay home." They say, "Grandpa, let's go to the lake." So I'll say, "Oh yeah, I'll go there, but anyplace else, I'll stay home!" The kids, they're eager because they want to collect the rocks. We all like to collect the rocks. In the winter it's really cold out here in the workshop. It's awfully cold because it isn't insulated, and it's just a brick building.

I made one of the wood cabins first, and then I got an idea to make one with all the stones. It was my own idea. I didn't see them any place first, it just come to me. The kids always wanted to go down to the beach to Lake Superior. When we had a little time off, which wasn't too often when we had the minks, we'd go down there with the kids. The kids just liked to go there. I just started picking these rocks up and I said, "Oh well, maybe some day I'll use them for something!"

Time goes fast. I just keep working. When I start a cabin of stone, I just make a little box. I think about where the rocks fit in, wherever it needs to be filled in. I think about how high I want it to be. I create my own shapes. I've got one like a church with a cross on it, for example. Then, I put mesh wire over the wood box. If you stick the pebbles to the board, they fall off. So it's best to use the mesh. Once that cement dries, it's really strong.

I ALWAYS WORKED WITH MY HANDS

All my life, I worked with my hands. After I retired from the mink farming, I worked for the Department of Natural Resources (DNR), conservation. I worked at the ranger station, and on the tower I watched for fires.

When I first got started with constructing houses, I made a log cabin. I did it just for something to do. I had the material so I thought, well, I'd start

something. I always worked with my hands, all my life, all the time. It makes me feel good. It's something to do. It's a pastime. It keeps my hands going. It makes me feel great when people stop by. We never advertise. People just stop. I like watching people do stuff. When I retired, I couldn't sit still. I had to do something.

This is a hobby. It's something to do because I'm a nervous type of person and I've gotta be doing something. I don't sit in the house all that much.

In the beginning, when I was first making those wooden flowers and tulips, Mary and I had a big wooden pot and we filled it with sand. I would say, "Well, why don't we just fill that up and stick those tulips in there." Then people'd stop. When we had those little wooden houses, why I just had them in the workshop, and Mary said, "People don't know you've got those houses. You don't advertise. Set one or two out on the lawn out there and put a for-sale sign on them." Mary set it on top of the wheelbarrow because I didn't want to leave them out overnight. People could drive by and walk away with

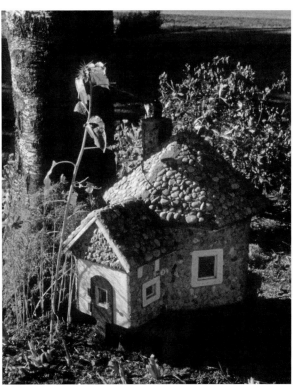

Detail, individual building

them. We'd wheel them out in the morning, add a for-sale sign. Here's this little house sitting on the wheelbarrow. Customers wanted to come in. We started at twenty dollars for the little wooden houses. Then we raised it to twenty-five dollars, and now they are up to thirty dollars.

Mary's brother came by one day and said, "John, you're giving them away!" Down where he lives people make little houses like that, and they're smaller and they're thirty-five to forty-five dollars apiece. He said, "John, you shouldn't give them away like that. You work too hard at that." Mary said, "Let me set the price." I said, "Quote a price. You can always come down but after you once quoted a price you can't go up." You tell them so much. You can always come down if they hesitate. I sell about twenty-five to thirty little houses a year. People like having stuff to put in their yard. And they're inexpensive.

We always get lots of company that keeps coming to visit after they've got stuff. We've met people that we never knew before that have come off the road and stopped. They keep on coming and visiting us. People, when they come, get whatever is out front in the yard. If it's there, it's there, and if it's not, it's gone!

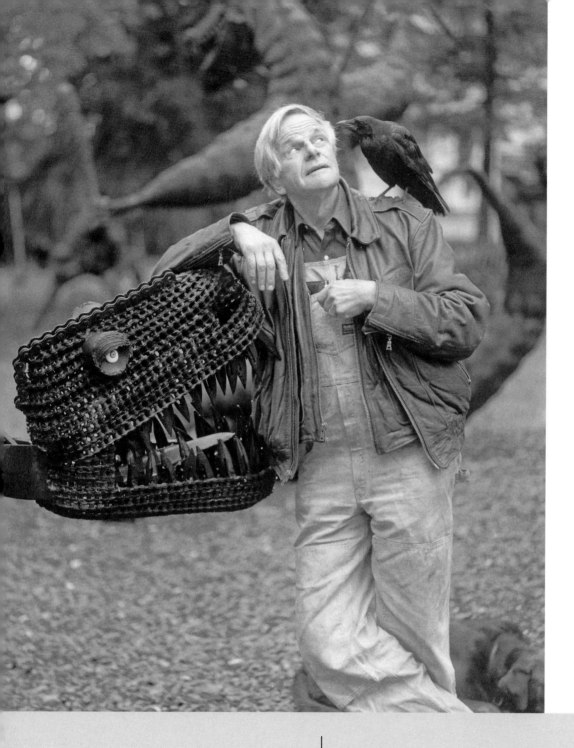

Clyde Wynia, with
Marsh Dragon and
Jerry the Crow

CLYDE WYNIA

I never had any art classes. As I recall, there

was never any art classes in high school,

Of course, that was a hundred years ago.

I never did anything like this before I moved

to Marshfield. I just had no interest.

—CLYDE WYNIA

Five and half years ago **CLYDE WYNIA** retired and decided to dedicate his life to the art of paleontology. Since then, he and his wife get around 15,000 visitors each year stopping to view his creations. Clyde estimates that he has creatures roaming about in thirty-six different states and ten countries.

LIVING A HEALTHY LIFE

Well, I was born between Holcomb and Cornell, Wisconsin, back in 1934. I then lived in Iowa during my grade school years and moved back up to Holcomb/Cornell area through my high school years. In 1961 I graduated from law school, came to work in Marshfield, and spent the next thirty-eight years as a lawyer in Marshfield.

I bought a welder back in 1962, soon after I came to town, and spent a lot of time making tools, trailers, etc. I like to weld, but I never got into sculpture until about ten years ago.

When we were in Iowa, my dad worked in a coal mine. When we moved back to Wisconsin, we had a small farm. Prior to this I did a lot of stained glass work and made a lot of pottery. I made my own potter's wheel, kiln, etc. I like to play with machines, yeah. I used to sell a lot of pottery. Then I did three-dimensional lamps, etc. I also did a lot of photography and had my own dark room, so I guess you can say I have been a visual person.

Ten years ago, just as a lark, I built a large metal bird, which weighs a couple hundred pounds and has a nine-foot wing span. It hangs in a tree, and when you pull on the cord it flies and if you snap it, it sings. I never intended to make any more, except that one of the neighbors came by and said, "Where did you ever get something like that?" Well, the first thing that came to my mind: "I dug it out of the big McMillan Marsh out here, and it inhabited the marsh during the Iron Age, but they're all extinct now." Well, you can't stop with one, so I've been out there digging out these creatures ever since.

Of course, my career as a lawyer overlapped with this for about five and a half years, but I loved the practice of law. It was a great life. I had wonderful clients, wonderful people working for me, and loved it. But there's no pressure out here, and it has become an ego trip and it's a lot of fun. I can spend at least six months of the year, from 10:00 to 5:00, helping people laugh and enjoy things. It's been a ball.

Nowadays, I never sell anything because I don't want to part with them. What I do is lease them out for a hundred-year period so eventually I get them back, which, of course, is an incentive to live a healthy life.

CREATURES OF MCMILLAN MARSH

This is a Marsh Mouse and it taught me a lot about the creatures of McMillan Marsh. See, I never could figure out how the food chain worked because the teeth are actually too soft to chew each other up. Then we found this one and solved the problem. See that, that's a cutting torch. So what they could do is just cut each other up. It caused a lot of fires and a big flatulence problem, but it solved the crisis.

Here is a Marsh Cow. See those fins that look a lot like shovels. Well, actually they are for cooling purposes. When it gets hot in the marsh, she just turns herself over on her back and digs herself right into the muck.

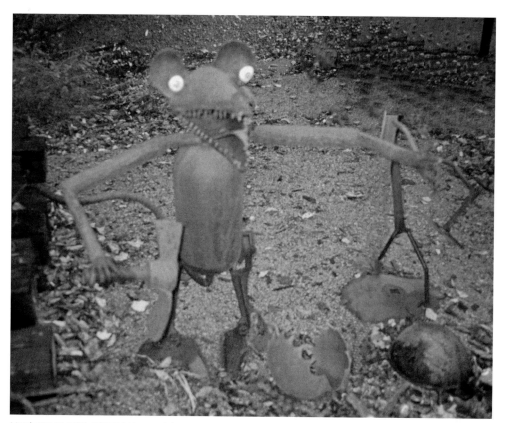

Marsh Mouse, 2003, salvaged scrap metal

This one is my sweetheart. She's not only good-lookin' and talented, she sings. We are going to put her in a choir because when you hit that skirt with a mallet, she rings forever. She also swings, because when you push that bell the skirt moves. A lot of the critters depend either on sound and/or motion in order to appreciate them.

There are a lot of frogs in the marsh. Of course these are only semi-amphibious, because if they go in the water they sink. They can't go through a normal tadpole process, so we bring them in with this frog stork over here. By the way, this one clears the marsh of riff-raff, that is Riff-Raff up on his four-prong trident.

Over there is Oxide, my watchdog. I put him in charge of security around here. Now if Oxide catches anybody doing anything wrong, he doesn't bite; he just sits on them until they repent. He also snacks on cats and lunches on pit bulls.

This is my Twin Feather Prop Whirlysaurus. He is electric as you can see. Of course we had to remove the solar panel so he can't fly away. This big dragon with the helicopter blades is the largest piece we have here. It weighs about two tons and is about forty-five feet long. I've been negotiating with the hospital now, and it looks

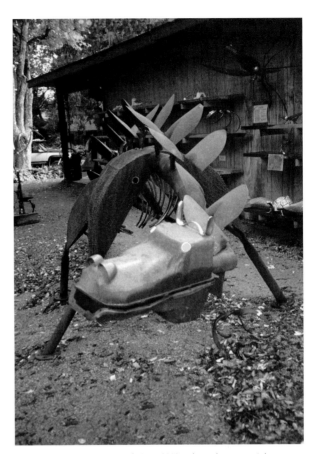

Marsh Cow, 2002, salvaged scrap metal

like we are going to be able to use it as a back-up for the ambulance helicopter. Seriously, with four claws and a mouth, he could take five patients. Of course, if we get the contract, we'll take that bomb off from underneath and put an oxygen cylinder on there, and we'll have a good all-weather rescue system.

LIFE IS TOO PRECIOUS

This big dragon was down in the botanical domes in Milwaukee a couple of years ago for the Merlin show. It was kind of fun going down highway I-94 with him on the trailer, a lot of thumbs up and honks. We just made it under the viaducts. I did run into a real problem once I got down there. See the domes always tries to promote its next show, so when I got there they had two TV stations waiting, and they had the *Sentinel* reporter and cameraman

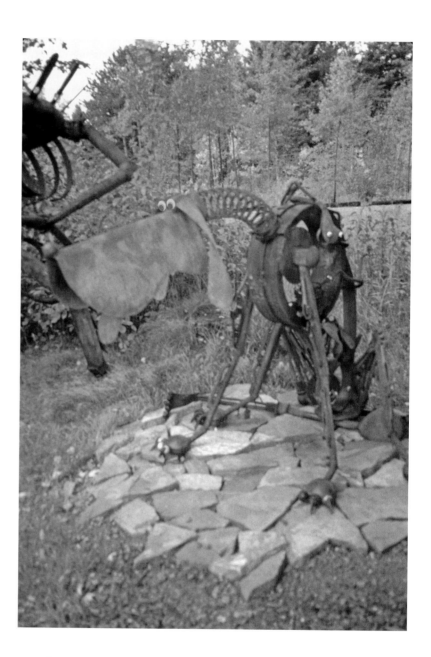

Oxide, 2002, salvaged scrap metal

and all these people there. Well, by the time I was to put on my welding helmet, it wouldn't fit anymore. Of course, my wife fixed that—not the helmet.

A couple of years ago my wife found out that she had a pension from the county where she was a nurse for awhile. She didn't know how to take it out, and whether to take it over a period of time or whether to take out for the rest of her life. So I went on the internet in search of some life expectancy table,

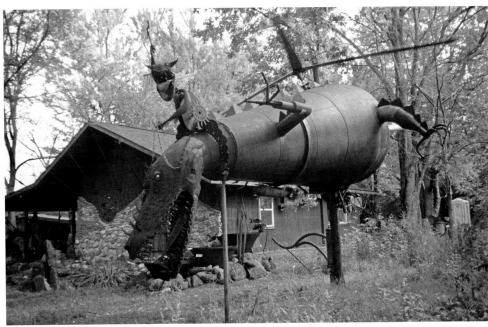

Whirlysaurus with Hobbit House in background, 2002, salvaged scrap metal

but instead of the life expectancy tables I found a couple of insurance sites, which asked several pages of questions regarding your genes you inherited, what you ate, how you exercised, all your habits in life. I took the test myself, and it came out that I would live until I'm 102. I was a little suspicious, so I told my wife to take the test, and she came out to 103. Well, one of the questions on the test was are you still working. And both of us answered, "yes," since we spend more than full time at our art projects and renting our little Jurustic Park and talking to people. Well, then she went back and changed her answer to "no," that she wasn't working, and she lost four years. I went out and bought a bigger welder, and I told my kids you can forget the inheritance.

We get a lot of school buses, or rather tour buses, out here. Many times, they are usually older people and they have the time to ride on these tour buses. So many times some of the older gentlemen will walk up to me and say, "Hey, this is great, we really like this. You're so lucky you have something to kill time with." In fact, I had one fellow standing in my shop, a cynical type of guy, and he says something to the effect that "Ah, yes, you use this stuff to kill time with." You know, that gets my feathers up. Well, I said, "I never kill time. Life is too precious. Time is too precious. I use every minute to enjoy myself, to help others, to do something, and to accomplish something." I have found out there's a lot of fun in life.

THE LIFE OF IDEAS

THE FORMATION OF OUTSIDER ART IN WISCONSIN

If the life of ideas is shaped through moments of time and by the interplay of people's economic and political interests, then outsider art is a part of a vortex of social forces and historical power relations. In the state of Wisconsin perceptions of this visual culture are inextricably linked to evolving contextual conditions and events in the region.

CHICAGO CONNECTIONS

The Chicago Expressionists, many of whom were affiliated with the School of the Art Institute of Chicago (SAIC), were some of the first schooled artists in the Midwest to take notice of things made by people with no academic education in the arts. From 1945 to 1975, three generations of figurative Expressionists looked to outside sources for inspiration. The Monster Roster (late '40s to early '50s), the Middle Generation (late '50s to early '60s), and the Chicago Imagists (late '60s to early '70s) were united by a common interest in the human figure, an innovative manipulation of visual form, and a direct desire for unmediated self-expression.

The first generation, christened the Monster Roster, leaned toward a painterly approach to the human figure. One of the most celebrated of the group was Leon Golub. Golub was a student at the SAIC from 1946 to 1950. His reputation in the art world started to solidify in the early '50s, after he produced several works based on archaic themes including frontal figures rendered as seers, kings, shamans, and priests. Russell Bowman (1992), former director of the Milwaukee Art Museum, pointed out that Golub was "seeking, not unlike the older abstract Expressionist generation in New York . . . a true

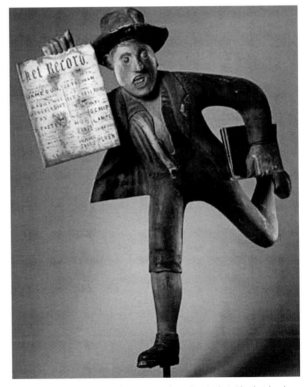

Unknown American, Pawtucket, Rhode Island, *The Newsboy*, c. 1888. Carved, assembled, and painted wood with folded tin. Milwaukee Art Museum, the Michael and Julie Hall Collection of American Folk Art, M1989.125.

authenticity of expression" (p. 152). Golub combined and balanced his artistic practices between the acceptable art world standards of the time and non-mainstream, raw self-expression. Bowman wrote, "Based on his understanding of the Northern European Expressionist tradition, tribal art, and the art of the insane, as well as of the classical and Renaissance Humanist tradition, Golub helped to establish in Chicago a tradition of looking to outsider art as a source of inspiration" (p. 153).

The second generation Chicago Expressionists also embraced some of the special things made by folks unschooled in the arts. Exploring provocative juxtapositions of images and literary devices, they were not unlike the Dadaists and Surrealists of European vintage (see chapter 7). Their fascination was partially established through the provocative art of H. C. Westerman. His interests in the visual culture of artistically unschooled and indigenous people and his firm refusal to accept established art conventions and established canons led him to a self-expressive form of art making based on his own criteria. Westerman's idiosyncratic tendencies mimicked to a certain degree the practices of unschooled artists, while his sense of self-expression followed his own personal experiences and aesthetic sensibilities. Westerman helped to break away from established art traditions for the next generation of aspiring artists. His interests prompted Walter Hopps to remark that "Westerman was an outsider" (in Bowman, 1992, p. 155), and his distance served as an opportunity for the third generation of Chicago Expressionists. However, it would be through the artwork of the third generation of artists, the Chicago Imagists, that outsider art would come to be acknowledged more fully in the many different art worlds.

Ray Yoshida taught at the SAIC, and over the 1960s established a close working relationship with art historians Katherine Blackshear and Whitney Halstead, who shared his interests in tribal, folk, and outsider art (Nutt and Nilsson, 1993). Yoshida, Blackshear, and Halstead each introduced their students to the work of unschooled artists and the work of Jean Dubuffet and *art brut*. The study of new art forms was not limited to the lecture hall. Yoshida and his students rummaged Chicago's Maxwell Street flea markets for what Yoshida called "trash treasures." The group's inquisitiveness with visual culture led them to the work of Chicago-area artists who worked outside the mainstream. For example, in 1967, students Gladys Nilsson, Jim Nutt, and Carl Wirsum noticed the work of Joseph Yoakum at a small coffeehouse on Chicago's east side. Yoakum's work was on exhibit after an asso-

ciate at the coffeehouse had spotted his drawings hanging on a clothesline in a store window with a sign, "4 Sale 25¢" (Carlson, 1988).

The third generation of Expressionists, the Chicago Imagists, first exhibited at Hyde Park Art Center and included three groups: the False Images (Roger Brown, Christina Ramberg, Phil Hanson, and Eleanor Dube), the Non-Plussed Some (Don Baum, Ed Paschke, and others), and the Hairy Who. Each of these three groups had established connections with Chicago, Wisconsin, and Midwest area unschooled artists. "The Chicago Imagists," Russell Bowman (1992) has noted, "had no ideological program; they, in fact, refused to theorize or to develop a program (a stance common to the two preceding generations of Chicago artists). They sought to reach beyond conventions of style (or even of good taste) and beyond ideologies to a personal expression based in part on their understanding of outsider propensities" (p. 160).

The artists of the third generation welcomed subject matter from commercial media such as comics, cheap advertisements, and kitsch. In their work, they transformed everyday images through exaggerated visual effects of line, color, and a miscellaneous use of puns, misspelled words, and metaphors.

We interviewed Gladys Nilsson and Jim Nutt (Chicago artists and collectors) about their experiences at the School of the Chicago Art Institute to find out more about the allure of aesthetic inspiration associated with outsider art and unschooled artists. Their group name, Hairy Who, was selected by the group members: Nilsson, Nutt, Wirsum, Art Green, Suellen Rocca, and James Falconer for the Hyde Park exhibition.

GLADYS NILSSON: I'm a native Chicagoan, [and] started going to the Art Institute in the latter part of grade school. I knew that by the time I graduated from high school which was January of '58 that the Art Institute was the only place that I was going to go.

JIM NUTT: As a young person living in Washington, D.C., I was interested in architecture and started out in college in liberal arts. When I moved to Chicago, I'm guessing the summer of 1960, the show that opened at the Art Institute was the Cahill Collection of American Folk Art. It was a stunner. There were some of the most peculiar paintings there I have ever seen, very strange kinds of things. I asked, "How do they fit into twentieth-century paintings?" In many cases, we start to read certain things as Modernist, and

they don't seem that peculiar. Ray Yoshida probably came to the Institute somewhere in either the late '40s or about 1950. Ray was very excited about Roger Brown, Chris Ramberg and Phil Hanson, who were students of his and Whitney's. They had been working in a number of Ray's classes. Somewhere around '66 or '67, they started to go to Maxwell Street a lot. Maxwell Street is the old flea market where you can buy zoot-suit type clothes and stuff, you know. It's got quite a history. It's all sorts of things. In any case, they were going there and this phrase "trash-treasures," that Ray coined, had developed. They would go every Saturday morning and spend four or five hours pawing through this stuff, and they might come back with a rug-beater or a flyswatter, or God knows what really interesting visual they would pick up. They would take these things home and put them up to look at them. We began to realize that there were these different characteristics to the way people displayed their things, different ways that gave them different meanings, or suggested different things. So it was pretty exciting, all these ideas coming together.

GLADYS NILSSON: The main structure of the whole school for an enormous period of time was studio arts. I mean there were other factions, but the main thing was the studio art.

Whitney Halstead was an art historian and a member of the faculty in the 1960s. He had taken Blackshear's position after her retirement. Halstead's interests in non-mainstream traditions ranged from African, Oceanic, and Native American art to American folk art. He conducted his art history classes many times at the Field Museum of Natural History. Nutt served as Halstead's projectionist, and Nilsson took classes from him in Surrealism and Dada in the summer of 1961. Both remembered Halstead showing slides of work by Henry Rousseau, Scottie Wilson, Ferdinand Cheval (European), and Simon Rodia (United States). Whitney Halstead also knew Joseph Yoakum and later went on to document the story of his life and work in an unpublished manuscript.

We asked Nilsson and Nutt about their participation in the Parallel Visions exhibit (see chapter 6). The show was conceived of as a way to juxtapose and compare the art of established artists in the different art worlds with the work of their unschooled contemporaries. Nilsson and Nutt exhibited work in this show and both artists attended the show's opening.

GLADYS NILSSON: Since we were lenders to the exhibit and it was a big museum show, it was important to be there.

JIM NUTT: Actually, we had already done that [exhibited work with artistically unschooled artists] in part, because in Don Baum Says Chicago Meets Famous Artists, a show that was done at the Museum of Contemporary Art in '69, Yoakum's work was included along with Mrs. Simon, Aldo Piacenza, and almost all of the Imagist artists. Things that people had started to collect—we wanted to show that these people were artists too. These were artists that we admired and we wanted to exhibit with them. We wanted to treat them as artists from the very beginning and wanted to see our work exhibited with them. I think it would vary from one person to another, but that was the way the Hairy Who was formed. It was because we thought the work would look interesting on the wall in combination, and I think the same thing would hold true with an outsider's work. I don't necessarily think my work would look interesting next to all outsiders' work, but next to some of it. I think it would be interesting in the same way that it's interesting perhaps to have it hung next to Gladys's and/or Carl Wirsum's.

GLADYS NILSSON: Well, sort of the way we all would hang our house, it was all interspersed; nothing was segregated.

JIM NUTT: Yeah. As opposed to having our outsider room and our "this or that room." It was usually interrelated in very different ways; sometimes just because it's the only thing that fit on that wall, and then there are other times because it was just made peculiar. The way Yoshida placed his rug-beaters on the wall. They're visual forms, and somehow I think that this form sort of relates to that form in some way, makes a nice kind of connection.

GLADYS NILSSON: One of the Ramirez pieces that they selected [for the Parallel Visions show] was a large Madonna standing on a globe that came from us. There was a particular watercolor that I had done which was called *Gladalupay*. It has this big self-portrait of a woman standing on a globe. I thought if they were taking the Madonna, that maybe they should look at this watercolor of mine, because that was a definite instance where I did an homage to that particular image. So they decided that they would use this.

JIM NUTT: They were curious about where there were things that had a direct relationship.

GLADYS NILSSON: In my instance, Russell [Bowman] wrote, comparing some of the earliest pieces of mine, which were in the show . . . where the space

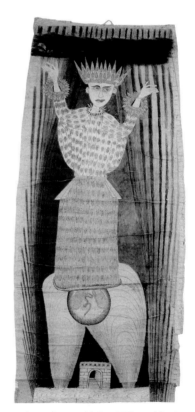

Martin Ramirez, Untitled, c. 1950, graphite, tempera, crayon, and collage on paper, 110" x 31", collection of Jim Nutt and Gladys Nilsson

Gladys Nilsson, *Gladalupay*, 1977,
watercolor on paper, 102.2 x 65.5 cm.,
collection of Claude Nutt

was very condensed and the forms were very big and so on—I think Russell made mention of Aloïse, whose work I was familiar with through art history classes. I certainly don't dislike the work, but she has never been someone that I would really gravitate towards. So I was kind of surprised, when Aloïse was the one person that he made reference to, although after the fact I could see why he did that. I wasn't [influenced by Aloïse]. I liked looking at Schröeder-Sonnenstern as a student, or Scottie Wilson.

JIM NUTT: I think it's very difficult talking about sources. Because on the one hand, you're very familiar with

Aloïse Corbaz, *Dans le Manteau de Luther*, c. 1950, colored crayons on paper 47$^1/_4$" x 25$^1/_8$", collection de l'Art Brut, Lausanne

something, but it isn't what sort of kicks into place—what you're aware of, generating the thought of doing something. What I'm getting at, it is like her analogy of Wilson. When you think of Wilson's work relative to those drawings, you can see where the relationship could exist. Even though she was familiar with Wilson's drawing, that's not what really generated them. It was really her interest in the aboriginal bark painting that had the more direct connection. In other words, those are the things that are making her think, "Oh, you know, I'd like to do something with some aspect of this work, and I think I can do it this way," which turns out to also relate to this guy, Wilson. On the other hand, she's been aware of Wilson for a long time. So who knows if, subconsciously, there's something going on helping to form where the work goes.

GLADYS NILSSON: [This connection] just never occurred to me, and it was twenty-five or thirty years after the fact. Still I wondered, "Oh, was this guy Wilson somewhere in there?"

Gladys Nilsson, *Looky-Looky*, 1994, etching, 33.6 x 55.9 cm., collection of the artist

The Parallel Visions catalog connected the curtain in Nutt's *I'd Rather Stay* and Martin Ramirez's Untitled (1950). We asked him if he saw any relationship.

JIM NUTT: Yeah, I think that's more direct. I certainly was aware of Paul McCarron, who is an artist who did a painting of a movie theater and curtains. In one of Roger Brown's little stage sets, curtains were used as another framing device, as opposed to a proscenium. So it was an interesting thing to have in a picture. There are aspects of the Ramirez that I think were an influence in that feeling of some of those drawings. Even though the way I did it was different. I deliberately tried not to use some of the materials that Ramirez would use, and then try and take it into something. But I think it was an influence, definitely. Just as I think some aspect of the kind of rhythm influenced me with respect to the line in Yoakum's work. I would more consciously try to make use of that at one point, not long after seeing them.

Jim Nutt, *I'd Rather Stay (on the Other Hand)*, 1975, acrylic on canvas in wood frame, 124.5 x 109.2 cm, private collection

Joseph Yoakum, *Mt Cloubelle of West India*, 1969, ballpoint pen, colored pencil, and ink on paper, 12" x 9¹/₂", collection of Gladys Nilsson and Jim Nutt

We were curious about how the search for inspiration in the art of other people satisfied these artists' needs for the unconventional. Nilsson and Nutt articulated a desire to tap their own creative subject from within, during our conversation.

JIM NUTT: I see outsider art as people doing something because it means something to them. As a young person, I wanted to be an architect because I knew my parents and their friends were always saying, "What are you going to be when you grow up?" It didn't mean that I wanted to be an architect. But with these people, for whatever reason, what was particularly nice

is that they're getting something out of it. They're doing it for their own something or other.

GLADYS NILSSON: Personal inner need.

JIM NUTT: You'd have to stop to rethink that or to utilize that phrase of "personal inner need" to get this thing out. That is what we're all about. Take the work of Mr. Yoakum for example. It wasn't like this was an old man who had done this work when he was a younger person or something, and then it stopped at that time. This is somebody who started this work. It's not like he had built on anything previous. I mean, it just came from—within!

GLADYS NILSSON: A lot of times things can look generic. You can take some things that somebody does in Washington State, and that can look like the same kind of thing that somebody can do in Texas. But nowhere, ever, was there anybody that drew two mountains talking to one another like Mr. Yoakum.

JIM NUTT: Well, he represented the kind of linear life in the work that was so unusual; how these funny wave-forms could function as mountains. But then there were these second images, where the mountains suddenly became heads rather than mountains. It was really kind of amazing. In Chicago, here he was, in the middle of an enormous city, with all of this stuff around him, and he had produced this work that was strictly his own. That meant there could be lots of other people doing the same thing. Most of the mainstream artists that are closely identified with outsider work are people who went through a fairly rigorous education in a major art school and who are intimately involved with a large museum. So these are people who were looking at traditional art and had to deal with what it meant to them, one way or the other, and for all of us. It means a great deal to us. It helped us turn our back on the academic tradition when we found this other stuff. There's really nothing there for us, you know. There's this other world that's much more meaningful. I think that we all sort of go through, whatever is in front of us and cherry-pick the things that are interesting to us.

GLADYS NILSSON: The strong visual statement that just reaches up and grabs you, regardless of what discipline or non-discipline that it comes from.

According to Nilsson and Nutt, visual form and the organization of objects in various combinations was critical to their need to create art. Their strong emphasis on form organization and the use of visual devices was under-

standable, considering their art instruction was based on a conventional aesthetic orientation. Halstead introduced them to the work of artistically unschooled artists and interpretive criticism using "all aspects of its visual make-up." Nutt stated, "Basically, the art history classes would dominate heavily on studying the visual characteristics of a piece of art. Not the iconography or the meaning of the piece." Golub, Yoshida, Brown and others were instrumental in introducing students at the SAIC to trash treasures. They readily embraced the special things of a "different" group of folks involved in creative self-expression.

In our interview, Nilsson and Nutt expressed a caring interest for people making art outside the mainstream art worlds. Each of them had a deep concern both for Joseph Yoakum's personal life and for his art. People who made significant things and who were not educated as artists provided a rich source of inspiration for many of the Hairy Who, Chicago Imagists, and Chicago Expressionists as a whole.

The art produced in Chicago from 1945 to 1975 is generally recognized by the larger art worlds as part of a regional art movement, with strong connections to an Expressionist aesthetic (see chapter 7). Chicago artists, perhaps due to their isolation from New York City, had a strong interest in art produced both inside and outside of academic institutions. Still their fascination for exploring a wide range of visual culture can also be connected to a larger Modernist tradition that placed a great deal of emphasis on aesthetic individualism.

In the sixties, the Chicago Expressionists started collecting the work of unschooled artists and were instrumental in introducing this work into the mainstream of the Midwest art worlds. They studied images, talked with people, and exhibited these "things made special" by unschooled artists alongside their own art in exhibitions. Since then, mainstream and non-mainstream artwork have been exhibited together in numerous locations.

WISCONSIN EVENTS

Since the 1970s, hundreds of contemporary folk art events have been staged around the world. Some of these events and related publications have added to the growing recognition of outsider art in educational institutions and the different art worlds. In the 1990s, Wisconsin hosted several exhibits, courses, and symposia that contributed to the allure of outsider art mys-

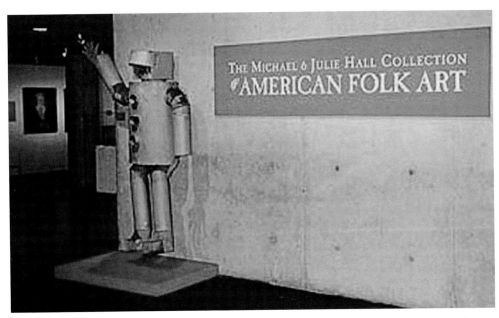

Bruno Podlinsek, *The Greeter*, c. 1982, galvanized steel parts, 67 x 33 x 18 in., the Milwaukee Art Museum, the Michael and Julie Hall Collection of American Folk Art, M1989.129.

tique in the state. Three events, in particular, were seminal because they helped shape public perceptions about the work of artistically unschooled folks in Wisconsin through extensive media coverage.

COMMON GROUND UNCOMMON CONTROVERSY

In the spring of 1993, the Milwaukee Art Museum held the Common Ground Uncommon Controversy Symposium, a major contemporary folk art event that brought together distinguished panelists to address aesthetic and cultural issues. Art museum director Russell Bowman organized the two-day symposium in conjunction with the museum's purchase of the Michael and Julie Hall Collection of American Folk Art.

On display for the symposium were 270 objects, encompassing both traditional (folk) and idiosyncratic (outsider) expressions of artistically unschooled makers. Weathervanes, decoys, and paintings were placed alongside contemporary expressions, such as Bessie Harvey's figures, made of tree roots, wood putty, beads, glue, hair, and polychrome. The Milwaukee Art Museum published a 330-page catalogue. Financial support for the exhibition came from the Lila Wallace–Readers Digest Fund, with additional funding coming from the National Endowment for the Arts, individual contributions, gifts from local support, and community foundations.

The panelists, respected members from the art community and academe, engaged in sometimes heated debates on the aesthetic and sociocultural values of artistic expression from artistically unschooled folks. On the last day of the symposium, Hilton Kramer, editor and art critic for the *New Criterion*, and Kenneth Ames, chief of historical and anthropological surveys at the New York State Historical Society, appeared on a panel to address issues of aesthetic values and contextual conditions.

Kramer's comments were sharp and specific. He argued that "the subject of folk art, like the subject of art in general, and the art museum in particular . . . has now become captive to the jargon of the social sciences; the social sciences that are continually mute, silent, or as we used to say, dumb, about all matters pertaining to art and aesthetics." From Kramer's point of view, the concept of art should not be replaced with the notion of material culture. A sociocultural approach attempts to put "the greatest works of art from the most advanced stages of civilization on the same level with the most mundane debris of social usage." The merging of art as a product of culture denies the distinction that art objects have aesthetic qualities. According to Kramer, material culture is an inferior social thing because it lacks those qualities. He closed by noting that the artistically unschooled maker's contribution to the art world is significant only if academically educated artists use the artist's sense of spirit to inspire their own creative endeavors.

Ames's rebuttal was brief and critical of Kramer's remarks. "The admiration for beauty in our life is not to be denied," confirmed Ames. But, he added, "The question becomes whether the quest and interest by people for beautiful things costs anybody else anything. Does it hurt anybody else?" Ames contended that the social sciences should not be criticized for questioning how people are dehumanized within selected social systems of different societies. Rather, art patrons and members of the different art worlds should be held critically responsible for how they conduct their personal and professional business. We all need to be accountable. Art businesses and art institutional systems need to change and function more equitably. Ames concluded that the world is full of wonderful things, as most people would agree, but at what cost do we pursue our interests to possess "aesthetic objects"? What things signify is fluid in society. It is not possible to control how meanings will be valued and used by different groups of people at different times.

In an early morning interview the next day, Roger Cardinal commented, "It seems to me, that . . . the debate we had, had a certain temperature. It was really not one that needs to be face down, between the two extremes. When two people are saying, what art is—that it is part of culture and that it hinges upon art—both are defining those terms—the art-making activity or the art-looking activity—from a perspective that sees culture in the sense of ordinary life." In providing a forum for debate of these important ideas from multiple perspectives, the symposium advanced the dialogue about schooled and unschooled artists.

WISCONSIN TALES

In April 1993 the John Michael Kohler Arts Center debuted the center's permanent collection of artistically unschooled folks with the official opening of the Wisconsin Tales exhibition. This exhibit provided a telling glimpse into the vast array of work by four folks from Wisconsin: Eugene Von Bruenchenheim, Nick Engelbert, Frank Oebser, and C. M. Powell.

The visual culture collection featured in Wisconsin Tales was initiated through the preservation of the artwork of Eugene Von Bruenchenhein (d. 1983). Dan Nycz, a West Allis police officer who had befriended Von Bruenchenhein, approached Barbara Brown Lee, curator of education at Milwaukee Art Museum, who directed Nycz to talk with Russell Bowman. Nycz was interested in preserving the estate and establishing financial support for Marie, Von Bruenchenhein's widow (Bowman, 1993c). Upon seeing the artwork, Bowman immediately recognized the significance of the estate and contacted the John Michael Kohler Arts Center to help with this challenge. Director Ruth Kohler (1993b) described her first encounter with Von Bruenchenhein's home:

Russell Bowman took me to Eugene Von Bruenchenhein's home. It was one of the most moving experiences I have ever had in my life. Although Eugene had died two weeks before, the small home was alive with the intensity of his creations. Hundreds of paintings, thousands of photographs, bone towers [chicken bones], bone crowns, ceramic vessels, musical instruments, poetry books etc. were stacked everywhere. Even the walls and furniture were painted as was the outside of his home. It was painted and decorated with huge concrete heads.

The preservation efforts were supported by a grant from the National Endowment for the Arts, by the Wisconsin Arts Board, and by the Kohler Foundation. After the objects were conserved, the estate was put up for auction. Because the John Michael Kohler Arts Center was not a collecting institution at the time, the collection was eventually purchased by a group of business associates from Chicago, spearheaded by art dealer Carl Hammer. A few years later, the JMKAC acquired from the Hammer Group some 250 pieces representing a broad overview of the artist's aesthetic vision.

By the time of the 1993 exhibition, the Art Center had amassed a collection of more that 400 pieces of work by artistically unschooled folks. In the introduction to the Wisconsin Tales brochure, Ruth Kohler (1993b) stated:

During the past decade, scholarly and public interest has increased dramatically. Most of this attention has involved seeing these artists as "outsiders," as symbols of tortured genius who live and work in isolation. These ideas in turn have affected the way we perceive these artists. However many unschooled artists do not cultivate isolation. In fact, their work is often inspired by a desire for communication, for discourse. (p. 1)

By the end of the 1990s, the Art Center's permanent collection would grow to over 900 pieces and include nationally known folks Frank Oebser, Nick Englebert, Clarence M. Powell, Norman Pettingill, and Reverend Mary Le Ravin (CA), and internationally known artists Eugene Von Bruenchenhein and Fred Smith (WI); Nek Chand, (Chandigarh, India); Loy Bowlin, the Original Rhinestone Cowboy, (MS), and Lee Godie, (IL).

NEGOTIATING BOUNDARIES SYMPOSIUM

Issues of aesthetics and culture are complex in relationship to interpreting art. These socially constructed systems are arbitrary and always subject to interpretation and negotiation. Some of the issues are interwoven through academic and curatorial approaches used to study and present the art of these "different" artists. They can limit and enhance the preservation, conservation, and stewardship of site work and objects of artistically unschooled people. Aesthetic and cultural values also affect how decision-makers view the relationship and interplay of this "different" art when engaging in collaborative ventures. This was the focus of the 2000 symposium, Negotiating

Boundaries: Issues in the Study, Preservation, and Exhibition of the Works of Self-Taught Artists.

The symposium, sponsored by the John Michael Kohler Arts Center and Kohler Foundation, Inc., attracted a broad audience of curators, community advocates for preservation, conservators, educators, graduate students, stewards of collections and environments, art historians, historians, and scholars in related fields. Presenters, moderators, and panelists represented a wide cross-section of interested art-based groups. Conference sessions covered academic and curatorial approaches; preservation, conservation, and stewardship; and "crossover" studies related to the latter topics.

The five-day symposium offered participants an opportunity to visit selected sites. Two different weekend site visits were planned. Excursion #1 toured the Dickeyville Grotto, Dr. Evermor's Foreverton, and Nick Engelbert's Grandview. Excursion #2 visited artist Mary Nohl's home and sculpture garden and the Michael and Julie Hall Collection of American Folk Art at the Milwaukee Art Museum. A special half-day trip offered symposium goers a brief visit to Mary Nohl's site and the Anthony Petullo Collection of Self-Taught and Outsider Art.

Participants in the symposium were also able to view the JMKAC exhibitions, which included Our Wisconsin Home, H'mong Art: Selections from the Collection, and Arts/Industry: 25 Years of Collaboration. Special exhibitions on view during the symposium were Nek Chand: Healing Properties, Loy Bowlin: The Original Rhinestone Cowboy, and Fixations: The Obsessional in Contemporary Art. The Nek Chand exhibit displayed 150 concrete and fabric sculptures created by Chand for his world-famous Rock Garden of Chandigarh in India. The following year these immortal beings, holy men, maidens, and animals, many of which had suffered damage as a result of weather and age, were earmarked for restoration and conservation. The Loy Bowlin show featured the ornately decorated living room of an artistically unschooled artist who called himself "The Original Rhinestone Cowboy." After the restoration of these two exhibits, the work became part of the JMKAC's permanent collection. In

Dr. Evermor listens to messages from the universe received on his *Celestial Ear*.

conjunction with these two shows, the JMKAC juxtaposed the work of contemporary artistically schooled folks who expressed obsessive tendencies through their working practice in the Fixations exhibition. The purpose, curators wrote, was "to broaden discussion of the obsessional to encompass a wider field of contemporary art production."

The JMKAC symposium challenged many arbitrary boundaries that are socially defined within category systems (i.e., ability, age, ethnicity, gender, race, sexuality, socioeconomic status). Fischer (1986) cautioned that, when creating autobiographical forms of art, boundaries are "inadequately comprehended through discussions of group solidarity, traditional values, family mobility, political mobilization, or similar sociological categories" (p. 195). By reconceptualizing traditionally accepted meanings and values ascribed to certain terms, art world members were invited to negotiate the boundaries of folk art, self-taught art, and fine art.

GALLERIES, MUSEUMS, AND INSTITUTIONS

CHICAGO

The mission statement of the Carl Hammer Gallery (Chicago) declares, "Renowned throughout the world for its unique focus, the Carl Hammer Gallery has pioneered much of the accumulated knowledge about this 'emerging' genre, and, for the last twenty years, has led the incorporation of outsider art into the contemporary art mainstream." The gallery specializes in the art of self-taught and outsider artists along with historical and contemporary twentieth-century American art. Since as early as the 1980s, the art of several Wisconsin folks, including Norbert Kox, Simon Sparrow, and Eugene Von Bruenchenhein, have been marketed by the Carl Hammer Gallery.

In 1967, the Phyllis Kind Gallery began exhibiting master prints and drawings in Chicago. By 1970, Kind had altered her focus to include a young group of Chicago artists known as the Hairy Who. Some of these artists later were known as the Chicago Imagists. She also sustained her Midwest gallery with consigned shows of artists of national reputation from galleries on both the East and West coasts. Kind developed an interest in artistically unschooled folks early in her career and was the first gallery owner to pro-

mote such work within the context of contemporary high, or serious, fine art. In 1993, her New York gallery provided space for "Cameo Talks" during the first Outsider Art Fair (OAF). For more than thirty years, Phyllis Kind has represented artists whose work is unique, transformational, and well-crafted. Advocating artists, schooled or unschooled, with a "personally consistent vocabulary of form that is both complex and wide-ranging" (Phyllis Kind Gallery 2002), she has contributed enormously to the recognition of outsider art in national and international art markets.

Other notable Chicago art galleries include Ann Nathan Gallery, Aaron Packer Gallery, Cortland-Leyten Gallery, Eastern Gallery, FolkWorks Gallery, Gallery 1756, Gimcracks, Judy A. Saslow Gallery, Oh Boy!, Plum Line Gallery, and the Vale Craft Gallery. Russell Bowman has also opened an art advisory service out of the Chicago area after departing the Milwaukee Art Museum in 2002.

One of the most active art organizations in the United States, In'tuit: The Center for Intuitive and Outsider Art is a nonprofit group in Chicago that recognizes the work of artistically unschooled folks who seem motivated by a unique and personal vision. The organization was formed in 1991 in response to a small group of artists, collectors, art dealers, and business people, who had been directly influenced by Chicago Expressionists. In'tuit organizers speculated that interest in these different artists grew in the Chicago area, "due in part to their sense of being 'outsiders' in relation to the New York art community. These early artists and collectors demonstrated an awareness and appreciation of the work of unschooled folks, many of whom were rural African Americans, eccentrics, isolates, compulsive visionaries, or the mentally ill" (Intuit: Center for Intuitive and Outsider Art 2001).

Over the years, In'tuit has sponsored on-site visitations, symposia, exhibitions, and tours. Members have toured local individual collections of outsider art in Milwaukee and Chicago and have held exhibitions featuring artistically unschooled folks newly identified by its membership.

WISCONSIN

In Milwaukee, the Dean Jensen Gallery has sold outsider art since before it was fashionable. It carries the work of local, national, and international artistically unschooled folks from outside the mainstream art worlds. Several

"alternative" art galleries have come and gone in Milwaukee over the years; the most prominent are the Metropolitan and Instinct Gallery. Currently, KM Art features artists working in contemporary, self-taught, "funk," and photography. Milwaukee is also home to several other galleries, which have featured the work of these artistically unschooled folks in the past.

The Haggerty Museum of Art at Marquette University has held two significant exhibitions of artistically unschooled folks: Contemporary Folk Art from the Balsley Collection (1992) and Signs of Inspiration: The Art of Prophet William J. Blackmon (1999). The Balsley Collection represents the longtime passion of John Balsley, a sculpture professor in the Department of Visual Art at the University of Wisconsin–Milwaukee, and Diane Balsley, a painter. It consists of contemporary folk art from artists in Wisconsin and throughout the United States. Most of Blackmon's art in the Signs of Inspiration exhibition were from the Paul Phelps collection. Phelps, an Oconomowoc collector and promoter of artistically unschooled people, hopes to someday create a Wisconsin Visionary Museum. He has purchased a large number of works from several Wisconsin folks, including Mona Webb, Della Wells, Prophet Blackmon, and many more.

Edgar Tolson, *Original Sin*, 1970, from the Fall of Man Series, 1970, poplar wood with paint, varnish, pencil, glue, marker, and pen, 14$\frac{1}{2}$" x 10$\frac{1}{8}$" x 13$\frac{1}{2}$", the Milwaukee Art Museum, the Michael and Julie Hall Collection of American Folk Art, M1989.315.3

The Milwaukee Art Museum is an outgrowth of two institutions, the Layton Art Gallery (1888) and the Milwaukee Art Institute (early 1900s), who joined forces in 1957 to form this private, nonprofit organization. The Museum collection comprises art from ancient Egyptian and fifteenth- to twentieth-century European and American painting, sculpture, prints, drawings, photographs, decorative arts, the Flagg Collection of Haitian Art, and folk and outsider art. In 1993 the Milwaukee Art Museum organized an exhibit with their purchase of the Julie and Michael Hall Collection of American Folk Art. The collection encompassed what Julie and Michael Hall called a stereoscopic vision of both traditional and idiosyncratic ways of making art.

Milwaukee is also home to the Anthony Petullo Gallery, a study center housing the owner's spectacular private collection. The gallery is open by appointment.

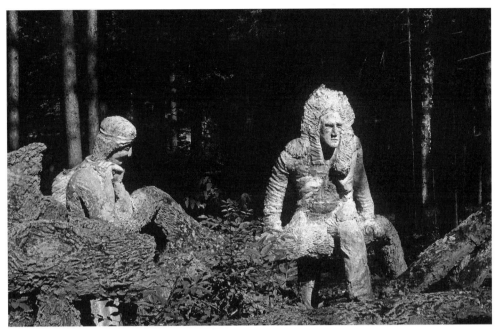

Concrete sculptures, James Tellen, Sheboygan

In Sheboygan, the John Michael Kohler Arts Center has been a leader in restoring and preserving whole collections of idiosyncratic artists' work and environments. Its mission has been "to encourage and support innovative explorations in the arts, to nurture artists, and genres that have received little exposure, and to foster an exchange between a natural community of artists and a broad public that will help realize the power of art to inspire and transform our world" (Kohler, 1993b, p. 6).

Since its inception in 1967, the center has become nationally known for its support of the work of Wisconsin artists. As early as 1978–1979 it housed the Grassroots Arts Wisconsin exhibit, which included the concrete sculpture of Fred Smith (Phillips, Wisconsin) and James Tellen (Sheboygan, Wisconsin) and the wooden animal head sculpture of Frank Wolfert (Sheboygan, Wisconsin).

In introductory remarks at the opening of the 1993 Wisconsin Tales exhibition, Ruth Kohler stated that the operation of the art center "is very much a collaboration. The collaboration between, [and] among a small private foundation, the art center, the artists, and the people of Wisconsin." Ruth Kohler realized early that collaboration was necessary to protect and maintain the work of Wisconsin's artists. She has worked closely with the Kohler Foundation, Inc. to preserve unconventional architecture as well as environ-

ments and objects created by artistically unschooled folks. These efforts began when KFI joined with the Wisconsin Arts Board and the National Endowment for the Arts to save Fred Smith's Wisconsin Concrete Park in Phillips, Wisconsin. Since then, KFI has conserved and then gifted several major sites to local governments and not-for-profit organizations in Wisconsin and other states.

Some of the incredible Wisconsin sites the Kohler Foundation and the John Michael Kohler Art Center have helped conserve include Herman Rusch's Prairie Moon Museum and Park, the Paul and Matilda Wegner Grotto, Frank Oebser's constructions, Ernest Hupeden's Painted Forest, the Mecikalski Stovewood Building, James Tellen's Concrete Sculpture, and more recently Nick Englebert's Grandview.

Black bear, Herman Rusch's Prairie Moon Museum, near Cochrane

In 1999 the John Michael Kohler Art Center moved into an impressive 100,000-square-foot facility that hosts art and music events and educational conferences. In May of that year the center established the Community Collections Gallery for their permanent collection and opened the ongoing exhibition Our Wisconsin Home. The Art Center's collection continues to grow with the objective "to encourage and support innovative explorations in the arts and to foster an exchange between a national community of artists and a broad public that will help realize the power of the arts to inspire and transform our world" (website).

The JMKAC staff, under the direction of Ruth Kohler, has challenged categorical distinctions that exploit and dehumanize particular artistically unschooled folks, and they have publicly questioned the use of terminology like "outsider." Language is an arbitrary system of meaning based on social differences, and frequently these social differences are sensationalized to market the artwork made by these so-called "different" artists. In the process, this sensationalized language can be used to overgeneralize about the lifestyle of folks without formal art instruction. Sensationalized language can be used as a communication practice that divides and objectifies individuals. In the art world, "folk," "outsider," "self-taught," "unschooled," "primitive," "naïve," and "different" artists are objectified when they are discussed as outside the mainstream of culture and society.

Detail, Ernest Hupeden, *Painted Forest*

Occasionally, the art world is taken with the allure of a different form of art. Like a vortex of moving forces that surround the eye of a storm, multidimensional and unpredictable conditions change over time with the negotiation of certain artistic practices. In a sense the Midwest was the eye of the storm for what was to come in the 1990s, a cyclone-like, heightened enthusiasm for a different kind of art. But this increased attention on outsider art was not all that new for many Midwest art advocates. For more than five decades, professional and institutionally schooled artists have been awhirl actively seeking local people who make things.

MIRACLES OF THE SPIRIT OF ART

REPRESENTING AN ARTIST'S SENSE OF PLACE

The narratives told in the artist profile section of this book are but a small glimpse of a more complex collage of the artists' art and ways of life. Nevertheless, as we traversed the state our conversations with people about their sense of place in the world were especially helpful to understanding their art and artistic practices. Many folks we talked with emphasized how their entire fabric of life was deeply connected with the special things they made. We came to understand their making of significant things, not as some sort of mystical or universal condition. Rather a person's visual cultural practices are intimately connected with the formation of multiple identities simultaneously (e.g., Rudy Rotter was a father, dentist, high school and university athelete, sculptor, etc.) as people negotiate how to makes sense of their place in the world (Krug 1992/93). Perhaps human language cannot express the complexity of these interconnected ideas, feelings, and other intangible aspects of human experiences and cultural identity. Perhaps some meanings about the art and life of artists are better left unsaid or should be kept private.

Language is always open to interpretation. Therefore, the art and life stories of people can be made to mean just about anything because language is arbitrary. We believe this is the heart of the issue associated with representing people as "different," "folk," "self-taught," "unschooled," or "outsider" artists. Our daily lives and communications are influenced by language systems such as the sophisticated strategies of commercial media marketing. These communication practices are useful and efficient, but they can also be employed to disadvantage some groups of people by those who wield these strategies to further their particular interests.

In the commercial marketing systems of the many different art worlds, artists are sometimes provided a means of earning an income by exhibiting their artwork and telling stories about their own life and art. However, these same communication practices can also be used to discriminate against some artists, while benefitting wealthy collectors, dealers, critics, scholars, and others associated with art world institutions. One way this occurs is

Rotter's high school football days (photograph courtesy of Rudy Rotter)

through the telling of sensationalized stories through art literature, art symposia, educational venues, and exhibits that represent "folk" artists as the "other," "self-taught," "different," or as the "modern muse" in society.

A couple of newspaper articles, one written *with* and the other *about* Mona Webb, illustrated this point.

In a 1992 *Wisconsin State Journal* article, "Her Eyes Are Watching the Gods," Elizabeth Brixey writes, "The home on Williamson Street may be wonderland, but Alice doesn't live there. Instead, Mona B. Webb is more like Lewis Carroll's caterpillar who sat upon his mushroom, offering Alice obscure advice. Mona's mushroom is her strange old house, where she doles out comments to most anyone who seeks them. But she remains sovereign shrouded in mystery and spirituality" (p. 3). Brixey's article integrates many sources of information to represent Mona's sense of place. Most importantly, her characterization of Mona as a Carrolleon caterpillar was crafted with Mona's guidance and supports Mona's own view of her place within the Madison community.

In 1985 Dean Jensen, a former art critic for the *Milwaukee Sentinel*, wrote an article about Mona portraying a very different point of view. He said, "Her eccentric, if visionary creation is distinct from any of the strains of painting or sculpture that are currently in the mainstream of contemporary American art. She is an example of what art scholars have recently taken to calling 'outsider artists' or 'isolates artists'" (p. 14). In this article, Jensen referred to Mona as "a lone rider in the art world." He discussed her sense of place as the "other," making use of a language system that could potentially subject her to exploitive marketing practices.

From our visits, we learned that Mona was not isolated from society but chose to live a life away from social affairs. She kept abreast of political issues and events through periodicals, friends, acquaintances, and family members. Mona said, "I am still working to do art, and I will work until that moment I die to perceive art."

Whereas Jensen used sensationalized language to represent Mona as an outsider artist, Brixey provided a medium through which Mona was allowed to speak about her own sense of place on Williamson Street.

Our goal in writing this book reflects some of these philosophical differences between Jensen and Brixey, between sensationalized "art-speak" about artists and creating a place for artists to speak for themselves. Interest in what is often called "outsider art" has grown steadily in recent years, and

artists and patrons of such art are gaining recognition. Still, there continues to be a debate over what to include in this category and what to name it. Morris (1993) stated that this art has "little or no contextualization into the art world at large; and worst of all it has become a secret hiding place for the last bastions of cultural elitism, imperialism, and out-and-out racism. . . . We seem to need to believe that the 'noble savage' still exists. We need to believe it so badly that we will even cut off part of our everyday world and exoticize it to create an 'other' we can collect, embellish with theory, and still seek to control" (in Lippard, 1997, p. 60).

Because art critics and journalists have been slow to challenge the ways that language is used and misused in the art worlds, contemporary art communities continue to represent certain artists as "different" and "folk." In the Winter 2000/2001 issue of *Folk Art Magazine*, Jenifer Borum called for the field to look critically at its "own history of self-marginalization, especially through the act of self-naming—the choice of value-laden, often pejorative labels like 'outsider' and exhibition titles such as 'Baking in the Sun'—[which] have created for the self-taught artist the persona of cultural other" (p. 54). Unfortunately, the cultural richness of the artists' lives and their connections with communities have typically been denied, ignored, or made invisible in the marketing of these people in contemporary art worlds.

Below we broadly provide a theoretical interpretation of how ideas of "difference" and "folks" have been represented through three national exhibitions: Parallel Visions: Modern Artists and Outsider Art (1993), The Outsider Art Fair (1993), and Self-Taught Artists of the 20th Century: An American Anthology (1998). We conclude with a few examples of how a life-of-ideas has affected some of the artists we interviewed from Wisconsin.

PARALLEL VISIONS

Parallel Visions: Modern Artists and Outsider Art was organized by the Los Angeles County Museum of Art (LACMA). The exhibition, which traveled to Germany and Japan, was the first international exhibition of the twentieth century to publicly highlight the art of artistically unschooled folks in the warm embrace of a larger art community. The Parallel Visions exhibition focused on a comparison of the innovative and creative endeavors of contemporary artistically unschooled and academically educated artists. Ironically, what was critically absent from Parallel Visions: Modern Artists

and Outsider Art was the mention of these artistically unschooled folks in the exhibit's title. Modern artists were specifically included, but for the "outsiders" the art object was substituted in place of the artist.

The purpose for the exhibition was stated in a lavishly printed catalog of 336 pages. Maurice Tuchman (1992), the senior curator of twentieth-century art at LACMA, wrote in the introduction:

The focus of Parallel Visions . . . is on the modern artists drawn to, and influenced by, the art of "outsiders," or, as we refer to them, compulsive visionaries. These outsiders have usually been self-taught individuals, sometimes mentally disturbed, who have created their work while isolated generally from mainstream culture and particularly from the complex infrastructure of the art world, that is, from the galleries, museums, and universities with which mainstream artists are regularly associated. (p. 9)

Alfonso Ossorio: Feast and Famine, 1966, plastic and mixed mediums on wood, 56 inches in diameter, Los Angeles County Museum of Art

Significant Others

Header from Ken Johnson's article in *Art in America*. Alfonso Ossorio, *Feast and Famine*, 1966, plastic and mixed media (horns, paint, skull, bones, shell of S.A. River Turtle) on wood, diameter 56 in. (courtesy Michael Rosenfeld Galley, LLC, New York, NY), Los Angeles County Museum of Art, Gift of Frederic E. and Siena H. Ossorio, M.91.222 (photo 2003 courtesy of Museum Associates/LACMA)

Parallel Visions was mounted as a sequel exhibition to LACMA's 1986 show, The Spiritual in Art: Abstract Painting 1890–1985. This earlier exhibit explored the aesthetic relationships in the lives of academically educated artists that attracted them to "other modes of perception" (Tuchman, 1992). In the Parallel Visions show, "other modes of perception" referred specifically to the unadulterated and unmediated expression of contemporary visionaries.

The Parallel Visions exhibition received national and international attention. In *Art in America*, Ken Johnson (1993) wrote a review of the show called "Significant Others." Johnson asserted that curators attempted to "blur the differences between insiders and outsiders" (p. 88) in the show in order to avoid the same kind of prejudicial, hierarchical relationship the Museum of Modern Art was accused of promulgating in their Primitivism exhibition.

Johnson took issue with many of the underlying ideas of the Parallel Visions exhibit, some of which were stated in the show's catalogue by associate curators' Carol Eliel and Barbara Freeman (1992), who wrote:

We have already seen that the distinctions between the categories of insiders and outsiders are disappearing, just as differences between American, German, French, Italian, and even Japanese art have narrowed since the early years of the century. The so-called global village has expanded to include outsiders; as outsiders are absorbed into mainstream culture or, more precisely, as mainstream culture expands to include them—the term outsider is likely to become obsolete. (p. 227)

In his critique, Johnson maintained that in order for outsider art to remain mysterious and mythologized, the artwork of these people must be distanced from the everyday lives of members of society.

In effect, the curators have tried to advance their mainstreaming of outsider art, which is unfortunate because it denies what is arguably the one fundamental quality that has made outsider art so fascinating and influential: *its otherness*. After all, outsider art is not interesting because it is like mainstream art but because *it's so strangely different*. It's the feeling you get when looking at outsider art that you're in the presence of a mind that's *wired in a fundamentally different way* that accounts for its magical allure. (p. 89) [Emphasis added]

A gallery dealer wears white gloves while showing drawings at the Outsider Art Fair at the Puck Building, New York.

OUTSIDER ART FAIR

Since 1993, the Outsider Art Fair has been held annually in New York City. The three-day event brings together dealers, collectors, museum directors, and curators along with interested art educators, patrons, and a curious public from around the world.

At the first fair and in subsequent shows, artwork was mounted using a museum format of wall and pedestal display, with minimal information provided for the viewer about the work or the artist. The art was re-contextualized in this mock gallery setting. Some dealers even wore white gloves while handling the artwork adding to the perception of preciousness and aesthetic mystique of the objects.

On the second day of the first Outsider Art Fair, a symposium was held at the Phyllis Kind Gallery. Approximately two hundred people came to hear influential experts speaking on a variety of topics. Herbert Waide Hemphill Jr. reflected on his lifelong collecting of folk art memorabilia. Milwaukee Art Museum Director Russell Bowman discussed the art and life of Eugene Von Bruenchenhein, an artistically unschooled artist from Milwaukee. Gallery owner Phyllis Kind spoke of three artists she represented and the formal qualities of their work. John Maizels, editor of *Raw Vision*, discussed visionary environments outside the United States. Artist biographies and art were addressed in sessions by Lee Kogan, American Folk Art Institute assistant director; Didi Barett, past editor of the *Clarion*; and Glen Smith, private collector. In conclusion, Dana Mensi, director of La Tinais, showed various art forms from patients at her mental health facility in Florence, Italy.

The language used in these cameo talks suggested that these "outsider" artists were unlike most people in society. Frequently they were referred to as someone waiting to be discovered. Some presentations promoted owning art objects over knowing more about the community and cultural contexts of the artists' lives. Several of these folks were represented as having no identity that they themselves brought to the work, as if they were located outside the mainstream of society and not just outside the mainstream of art communities. It was strongly suggested that their work had to be rescued by collectors and dealers and assessed by critics before it could be accepted into larger art communities.

Later, we met a few artists who attended the first OAF on their own accord with aspirations of being "discovered." One artist was marketing himself, but eventually left disappointed. No dealer wanted to handle his artwork because he was too aware of his own artistic interests. Some artists have attended the OAF by request of their dealers and their participation has been both positively and negatively received. In the late 1990s a few dealerships stopped exhibiting altogether in protest of the "zoo-like" conditions and practices of "displaying the artists" during the exhibition.

One purpose of the Outsider Art Fair was to establish and elevate reputations of idiosyncratic artists who did not have a formal education in art. One way that the process of validation works is to have collectors and dealers legitimize the artists' work. At the 1993 Outsider Art Fair, the program alluded to this objective:

Hand and face carved into moose antler, small interconnected figures fashioned from clay. Sculpture by Rudy Rotter.

It is only recently that outsider art has begun to be recognized by scholars and critics as important contemporary art. . . . Taken as a whole, these works are an important chapter in our history of art, but one that up until now has remained largely unwritten. Countless works and environments have been lost because we never thought to look for genius down the block, or just across the tracks. . . . The acceptance of outsider art as part of the contemporary canon, while long overdue, has been remarkably rapid. Publications like *Raw Vision*, organizations such as In'tuit, and scholarship of many individuals and institutions have all helped immeasurably in bringing these works to our attention. However, no one would dispute that the principal credit must be given to the hundreds of collectors and dealers for whom the discovery and often the rescue of outsider works became a passion. (Morrison, Smith, Kerrigan, 1993, pp. 4-7)

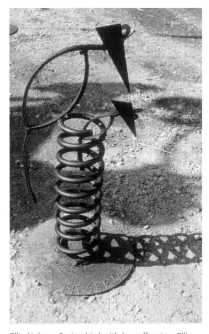

Ellis Nelson, Spring bird with her offspring. Ellis said he got the idea for the sculpture watching the Heckel and Jeckel cartoon on television with his son.

Marketing strategies that touted the "discovery" and "rescue" of these works depend upon the construct of "outsider," linking the "genius down the block" to popular stereotypes of the autonomous, Bohemian artist (e.g., Van Gogh), living a solitary life outside of social interactions. Undoubtedly, some artists do prefer to work in the privacy of their own home or institution. For example, Guy Church and Jack Dillhunt each reported that they rarely draw in public places, preferring a more controlled environment like their home or studio. However, for most of the people that we talked with, this notion of living an isolated life is an oversimplification.

The great majority of people interviewed for this book practiced their artistic endeavors while enjoying the social activities offered in their own community. Ellis Nelson, for example, used materials he bartered from friends, relatives, and local business people. He obtained many of the things he used from the local salvage yard and from a nearby muffler factory. Rudy Rotter had access to a wide array of products and goods through his church affiliation and practice as a dentist. Personal and professional contacts in his local community provided a wealth of materials—bowling balls, mahogany models, aluminum purge, and copper gaskets—and important social relationships. Early in her life, Mona Webb obtained many of the materials she used to create things while traveling to the Fiji Islands, Germany, Portugal, Mexico City, Florence, and London. Returning to Madison, she used her collected objects to build the gallery so that she could share her adventures with visitors.

Outsider Art Fair, booth display, Puck Building, New York

Organizers of the Outsider Art Fair proposed that for outsider art to be socially and economically valued, it needed to be linked to acceptable art world aesthetic criteria. Once criteria were formed and endorsed by art experts, new standards could be circulated for meeting the art community's demand for the work. According to Phyllis Kind, one duty that members of the art community must perform was to "highlight twentieth-century self-taught artists, who have developed distinct vocabularies of form" (Kind, 1993). These aesthetic criteria need to be defined within the existing language of the art world. Art world members had the task of linking this "different" creativity with the artistic endeavors of contemporary academically educated artists.

Organizers were also interested in distancing the work of these artistically unschooled artists from those objects created by "just plain folks" making things. Immediately after the first Outsider Art Fair, Sandy Smith, the show's coordinator, questioned whether dealers had exhibited valid art. He wanted to establish a policy of display for next year's show and do some "weeding out." He encouraged "dealers to show only valid art works that hold up to art criticism, and not just the work of people who have interesting life stories that might dub them as 'outsider artists'" (Gabriel, 1993, p. 61). Smith's statement illustrates how art institution policy might be used to legitimize some artists' work as art, while excluding the "things" of other "folks" as less significant. His statement also reflects that because language is arbitrary, it is open to being used to defer and/or circulate meanings and values about people and the things they make through business policies and marketing practices.

Early in his career, Dean Jensen had written for most major art periodicals including, *ARTNews*, *Art in America*, and *Arts Magazine*, before opening a Milwaukee art gallery. In a 1993 conversation, he explained to us how policy and representation issues surrounding outsider art are connected with art criticism and journalism practices in the larger art communities.

The work began to get more and more attention in the popular press. I find people collect work, a lot of times, because they kind of like the mythology that develops

around the artists. The mythologies around the artists sometimes are more interesting to the collector than the work itself. So, they tend to view these people as somehow 'exotic' because they are 'isolated' or their work is 'peculiar' or their personalities are 'distinct.'

As a writer for the mass media, I couldn't get a story into the paper if I talked solely about the aesthetic issues. . . . The newspaper and the popular press tend to focus on the stories about the unusual qualities of the people. "So your brother and you are Siamese Twins and you make art." Well, it is a hell of a lot easier for me to write a story about that. I suppose I was a party to that whole thing. . . . in some small way I helped to elevate it and legitimize it through writing about it.

At a kind of superficial level, outsider art is an easy art for a lot of people. A collector brings these things into their home and they have guests over. Someone says, "Wow, what an interesting piece. Look Marge, look at that face." The collector can start to talk about Simon Sparrow, about this illiterate preacher up in Madison with the white beard and the black robe and all of these stories you read about. The collector really doesn't have to deal with the issue of that work, the aesthetics of it. . . .

We aesthetize the work by placing it in the gallery. The gallery becomes part of its life. It is all part of the presentation that helps to legitimize it. It's all part of the work's credibility. Just by bringing the work in here, that gives it some additional cachet, some additional validation. It's not just me. It is any dealer. It all helps to legitimize the art.

Some journalists, art critics, and dealers exaggerate the life stories of "folk" artists as marketing strategies to help sell an artist's artwork, but these sensationalized stories eventually find their way into conversations, symposia presentations, exhibition literature, and the popular periodical press, where the artists are locked into labels like "other" and "different."

In "Art from the Outsiders," Jensen (1985) cast Simon Sparrow and Mona Webb as "other": "What drives such outsiders as Webb, [and] Sparrow . . . to work so obsessively at giving concrete expression to their private visions? Because the artists express themselves in intensely personal, distinctly original ways, we can probably conclude that each is commanded by a different muse" (p. 17). While Mona and Simon would probably agree that there was a spiritual force that guided them to create, both would probably disagree that they were commanded to make things or that they were obsessive about

Dean Jensen at the OAF in New York proudly displays the work of Norbert Kox. Jensen has been one of the strongest advocates for artistically unschooled artists in Wisconsin.

Simon Sparrow in front of the University of Wisconsin–Madison library (photo courtesy of Erik Weisenberger)

what it is that they did. The terms "obsessive" and "commanded" do not acknowledge the artists' own socially interested agency. This sensationalized language supports misconceptions that the things that folks create need to be strangely different in order for them to be appreciated.

Furthermore, Jensen (1985) called Sparrow the "Black Moses of Madison" and dubbed Mona "a self-described mystic who is given to wearing satiny saris that give her the appearance of a priestess" (p. 14). This exaggerated tone was aimed at promoting economic market interests at the expense of the social and cultural differences of the artists.

SELF-TAUGHT ARTISTS OF THE 20TH CENTURY: AN AMERICAN ANTHOLOGY

Self-Taught Artists of the 20th Century: An American Anthology was a national traveling exhibition in the United States that began in the spring of 1998, showcasing the work of "self-taught," "outsider," or "visionary" artists. The exhibition was organized by the American Folk Art Museum (AFAM), New York. Founded in 1961 as the Museum of Early American Folk Arts, the name was changed in 1966 to the Museum of American Folk Art. Its present name was adopted in 2001 with the opening of its new $35 million building. AFAM has been committed since the mid-sixties to the study and exhibition of contemporary unschooled artists as well as eighteenth- and nineteenth-century folk sculpture and painting.

The exhibition highlighted the historic and creative spirit of artists without formal artistic education. It circulated widely the achievements of artists who transformed ideas, memories, and dreams into tangible forms of reality. The show included the work of such well-known artists as Grandma Moses (1860–1961), Horace Pippin (1888–1946), Howard Finster (b. 1916), Martin Ramirez (1895–1963), and Henry Darger (1892–1973); and many equally accomplished but less well known artists such as Purvis Young (b. 1943) and Ken Grimes (b. 1947). It spanned more than a century of art, from Henry Church (1836–1908) to Lonnie Holley (b. 1950). Elsa Longhauser (1998), a guest co-curator for the exhibition, described the exhibition as "neither [the] greatest hits nor [a] comprehensive survey. Rather, it is a cross-section of powerful work selected from each decade of the twentieth century."

The show included paintings, drawings, constructions, and installations made from traditional artistic media (oil, photography, and stone) and a

wide variety of found objects (chicken and turkey bones, glass eyes, glitter, hair, corrugated cardboard, roots, wire, tin, fur, acorns). Subject matter was equally far reaching, from humor and riddles, extraterrestrial and apocalyptic themes, and religious visions and erotic voyeurism, to portraits of Marie, the wife of Eugene Von Bruechenhein (1910–1983), photographic prints which reflected the artist's deeply cherished love and affection. This exhibition displayed over 250 objects from thirty-two American artists. These artists were selected because their vision, creativity, and unique perspective had had a tremendous influence on twentieth-century art.

A concern for representing art within narrowly defined distinctions was addressed by American Folk Art Museum emertius director Gerard Wertkin (1998):

Increasingly, distinctions are being drawn between folk art, on the one hand, and such categories as outsider art, visionary art, or intuitive art, on the other. Rather than clarifying matters, however, the distinctions too often are drawn at the expense of the older term: "folk art" is defined according to more specific, more limiting European criteria, but it is also stigmatized as static, shallow, and derivative. . . . Facile and narrow labels that reduce the creative spirit to a single dimension are of little significance in the long run, especially when they obscure the multiplicity of intentions, ideas, meanings, influences, connections, and references inherent to every work of art. (p. 9)

Wertkin's statement is a positive step toward changing the prejudice and discrimination that occurs when "folks" are metaphorically distanced to a place of difference in society. The "weeding out" of artists based on rigid formal art criteria is a discriminatory practice that has the potential of excluding some works of art because they do not fit within the prescribed "narrow labels." Roger Manley (1991) has suggested, "Perhaps the best thing . . . would be to drop altogether the terminology that takes a scattered, unrelated number of people and creates a group called 'outsider,' 'unique,' 'isolate,' etc. It sets up an imaginary we/they dichotomy that has made it possible to separate and exploit many people who have always been, and seek to remain full participants in their communities and contribute to the culture in which we share" (p. 28).

Our visits with twenty-six artists in Wisconsin indicated that these artists are not a homogenous group. They have different sets of interests, priorities,

The chalkboard in Ellis' office offers changing tidbits of philosophical advice.

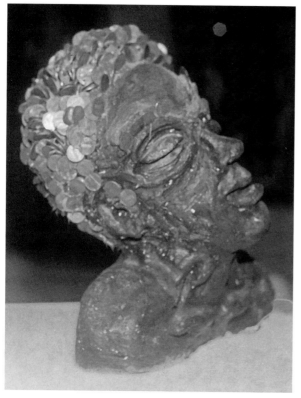

Untitled, date unknown, pennies, plaster, paint, 13" x 14" x 12". Mona joked that she put pennies on the head of this bust of her first husband because he "always had money on his mind."

and criteria for living their life and making art. Ellis Nelson was a service mechanic, electrician, machinist, and gunsmith before he became a maker of art. Hope Atkinson was a maritime crewmember. Wally Keller sold insurance. Rudy Rotter was a dentist. John Tio was a security guard; and Mona Webb was a dance and guidance teacher. Still they each derived a certain degree of satisfaction and value from making things special. Mona redesigned her entire three-story building to fit her particular lifestyle. Rudy filled three floors of an enormous warehouse with artwork he had made over forty-plus years. Paul Hefti's art flowed out of his place of residence and covered the grounds of his yard.

Why things are produced and where they end up are many times unimportant to these folks. It is the process that brought them tremendous satisfaction and value. Ellis offered, "I really enjoy this. In fact, if somebody told me, 'Let's go on a vacation,' I'd say, 'You go on a vacation. I'll have more fun in my shop than you will have on your vacation.'"

Making art is, at times, informed by the person's sense of social status in the community. Some of the artists we interviewed were also aware of their reputation in the art world market place. Hope Atkinson and Norbert Kox have both attended the Outsider Art Fair in New York. They understand the financial importance of having their work shown in national and international venues. On the other hand, Mona claimed that she was not interested in selling her artwork. She said, "I have a fear of money . . . and I have a fear of losing my art. It's the only thing I have that I really love. It's the only thing that really satisfies me" (in Brixey, 1992). Mona thought of art as visual culture, as a process to be lived and not as a product to be sold.

On several occasions during our interviews with Mona, she asked us to turn off the tape recorder. She said, "I am interested in talking to your head and not to

your book." During our conversations we found that she tried to balance her understanding of the art world's meanings with the values that circulated about her. Mona arduously ignored reporters and critics who sensationalized her art and ways of living. She espoused her own sense of place, saying, "When I'm doing my art, I am in my spirit. I'm not broke, I'm not old, I'm not Black, I'm not White—I AM, and it's beautiful" (in Brixey 1992). Mona's statement exemplified how her art and life were a miracle of the spirit. Her stories, home, and gallery represented Mona's sense of place in the world.

While signs of change are beginning to slowly appear in larger art communities, the possible consequences of this change seem exceptionally far off in the future, if at all. Currently, many of us are caught in an economic conflict between using sensationalized language to market a book, sell artwork, or promote an exhibition and trying to represent the artists in the best possible light to reflect the contextual complexity of their art and lifestyle. Art world members and patrons are placed in a precarious position, caught between the exploitive practices of an elaborate market economy and our own moral and ethical responsibility to acknowledge and respect the diversity and differences of an artist's cultural lifestyle. We hope our story will contribute positively to the discussion about these important economic and political issues in contemporary art worlds.

ARTISTIC INDIVIDUALISM IN THE UNITED STATES AND EUROPE

UNITED STATES

In the United States, a break from past artistic traditions occurred in the early part of the twentieth century. Modern artists defined themselves as the avant-garde and looked for new sources of inspiration from sources other than European Impressionism and late nineteenth-century academic art. According to Walter Kuhn, an organizer of the Armory Show held in New York City in 1913, the show marked "the starting point of the new spirit in art, at least as far as America is [was] concerned" (Brown, 1963, p. 56).

The Armory Show stirred the aspirations of many fledgling artists on the American scene. Their search for a new modern muse was grounded in conceptions of formalistic and theoretical perspectives made popular at the time by art critic Roger Fry and art historian Clive Bell (Fry, 1924). Art was associated with progress, individualism, and an isolated Bohemian lifestyle. Moderns looked to break from the cultural constraints that they saw as binding the innovations of their European contemporaries. They looked for

1913 Armory Show, Main Gallery view, photographer unknown

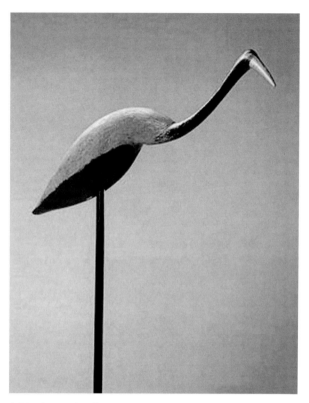

Artist unknown, American, New Jersey *Great Blue Heron*, c. 1900, carved and painted wood, metal, 50" x 5¹/₂" x 36¹/₂", the Milwaukee Art Museum, the Michael and Julie Hall Collection of American Folk Art, M1989.297

a new type of art that captured a different sense of reality about abstracted ideas, in simplified forms.

Immediately following the Armory Show in 1913, Hamilton Easter Field invited artists to spend the summer at Ogonquit Colony. Field had purchased a small area of land along the coastline of Maine and with his friend Robert Laurent, an accomplished artist in his own right, conceived of a hamlet where artists could gather. They called it the Ogonquit School of Painters and Sculptors. Regional artists used the retreat for their own artistic pursuits, and by the 1920s, many prominent artists had participated using makeshift studios, which were nothing more than renovated fish shanties. These studios were decorated with simple furnishings, i.e., homemade rugs, weathervanes, decoys, portraits, and other items that Field had collected on his fishing and hunting expeditions to various parts of New England. Antique collectors referred to these types of objects back then, as many still do today, as American primitives and traditional folk art.

The artists' daily routines brought them in direct contact with these objects, many of which piqued their curiosity. Rumford (1980) wrote,

Each artist was struggling to develop a visual language expressive of emotion. . . . They recognized in the neglected carvings and portraits many of the same abstract qualities that were the essence of their own art and came to appreciate what America's unschooled eighteenth- and nineteenth-century craftsman and amateurs, unshackled by aesthetic theories, had achieved. (p. 15)

The "modern muse," in the United States, had been discovered in the art of the common folk. A source of inspiration was found in the objects of unschooled artists making things outside the mainstream art community. It was the antithesis of their European contemporaries, who found inspiration in non-European people, children, and that of isolated psychotics. For a small group of artists, the search for inspiration and innovation was momentarily satisfied in early American art.

Early American folk art soon became defined as art that was passionate, personal, expressive, obsessive, and visionary. Folk art was art made by somebody else and needed to be discovered. In a sense, folk art was uniquely the art of the folk. It was the art of "the other," people who were artistically unschooled and not like you and me. Simone de Beauvoir (1952) stated,

The category of the other is as primordial as consciousness itself. In . . . most . . . societies, . . . one finds the expansion of a duality—that of the Self and the Other. . . . No groups ever set up as the One, without at once setting up the Other, over and against itself. (p. xix)

People in prominent social circles were soon collecting these unusual and unique objects once relegated to attics and knick-knack shelves. The identification of plain and simple objects, made by common and ordinary folk in their everyday life was becoming economically and socially valuable.

In February 1924, a show titled Early American Art at the Whitney Studio Club was one of the first to publicly display the work of artistically unschooled common folk. The show had a profound impact on the subsequent collecting practices of many prominent individuals (e.g., Elie Nadelman and Abby Aldrich Rockefeller). After the exhibition, under the watchful eye of folk art enthusiasts Edith Halbert and Holger Cahill, major collections were formed by conspicuous members of the upper class. Prominent members of society started to exhibit their collections through major art galleries and museums all around the country.

The selection of the objects for these collections underwent careful scrutiny. Soon, not all objects made by common folks could be called folk art (Cahill, 1932). Folk art's value needed to be assessed by people with a discerning eye. Halbert and Cahill proposed assessment criteria based on formal aesthetic standards of taste. Cahill stated that an art object has to have art quality in order to be classified as folk art.

The term art quality is not easy to define, though it is not hard to understand. It is the 'something' beyond simple craftsmanship, a skill in drawing which transforms the merely competent outline of the craftsman into the contour drawing of the artist, a native feeling for arrangement and color combinations, a sense of unity which makes for good composition and clarity of statement, the craftsman's feel-

ing for 'good joinery' carried over into the making of paintings and sculptures, and a dozen other qualities through which the 'pedestrian work' becomes the 'work of art.' . . . In any event, the number of objects which have art quality in the welter of artisan-craftsman-amateur work is low. (Cahill, 1935, letter to Helen Bullock; in Rumford, 1980, p. 40)

Cahill's description of the quality of folk art objects embraced formalist aesthetic criteria of the time (Fry, 1928).

For example, the art form's significance (quality) was judged by evaluating the artist's skill in composing formal elements and principles of design, i.e., color, line, and unity. Because "art quality" could not be easily defined by just anyone, Halbert and Cahill were the self-appointed experts, insiders to the larger art community, who would name the aesthetic qualities of "folk art." They succeeded in convincing their clientele-at-large that objects needed to be recognized for their formal aesthetic significance in order for them to carry economic and social value in the art community.

For many, the collection of these objects became a passion (Hartigan, 1990). At one point Abby Aldrich Rockefeller collected so many pieces, with the assistance of Edith Halbert, that she was unable to store all of them at her New York residence. More recently Herbert Waide Hemphill Jr.'s attraction for possessing the objects of the common folk became a "lightning rod for a new generation's perceptions and activities." Hartigan (1990) wrote, "Today, it is evident that Hemphill's efforts as a collector, curator and author have quietly, yet irrevocably, altered not only the interpretation of folk art but that of American art as well" (pp. 1–2). The monetary and social value of folk art gradually increased with the formation of major collections and the growth of its popularity.

In the past eighty years, there have been many outsider and/or outsider/Modern artist exhibitions in the United States and Europe, most notably the Prinzhorn Collection in Heidelberg, Germany (1922); Fantastic, Art, Dada and Surrealism Exhibition, Museum of Modern Art, New York (1936); International Surrealist Exhibition, New York (1936); Art Brut Exhibition (Dubuffet Collection), Musee des Arts Decoratifs, Paris (1967); Outsider Art at the Hayward Gallery, London (1979); and Open Minds (1989) at the Museum van Hedendaagse Kunst, Ghent. There are also several permanent outsider art collections, Dubuffet Collection de l'Art Brut, Lausanne, Switzerland; Museum im Lagerhaus, St. Gallen, Switzerland; Museum of

Naïve Art, Netherlands; Outsider Collection and Archives, London; the Permanent Collection of the American Visionary Art Museum, Baltimore, Maryland; the Anthony Petullo Collection, Milwaukee; and Wisconsin Tales, John Michael Kohler Art Center, Sheboygan, Wisconsin.

United States outsider art developed, for the most part, independently from European influence. Nevertheless, the search for aesthetic inspiration as the modern muse in Europe was not all that different from its American counterpart.

EUROPEAN INFLUENCES

Since the early 1900s, unschooled artists have been openly embraced and labeled by many art world community members as psychotic, isolated, mentally ill, compulsive, obsessive, visionary, innovative, authentic, genuine, expressive, primitive, naïve, amateur, grass roots, country, popular, backyard, folk, self-taught, unschooled, spontaneous, unsophisticated, innocent, provincial, anonymous, homemade, vernacular, ethnic—outsider. Hall (1991) stated, "Modern culture isolates its outsider and mythologized[izes] the purity of their artistic otherness, to suit their own purpose" (p. 16).

Artists in Europe sought inspiration from outside sources. These "Modern" artists were affected and influenced by the wealth and diversity of the world and their immediate environments. In Europe, Cubist artists drew from tribal African cultures. The Fauves found excitement in the arts of Oceania and other non-European communities (Rumford, 1980; Cahill, 1932). Gauguin lived among peasant workers in Brittany and with the indigenous peoples of the Marqueses Islands in his search for aesthetic inspiration. German Expressionists of Der Blaue Reiter and Die Brücke were fascinated with the art of agrarian farmers. Paul Klee and Wassail Kandinsky enjoyed the artwork of children. Dada artists such as Max Ernst delighted in the art of Northwest Coast peoples and André Breton based his innovative Surrealist writings on the unschooled art of the mentally ill. Similarly, outsider art was closely connected to the interests of Jean Dubuffet's obsession with idiosyncratic and "raw" artistic practices of psychotic people (Becker, 1963).

Dubuffet was engrossed with the inner need of institutionalized patients. He visited unschooled artists who were incarcerated and distanced from

society. He speculated that their work was pure, raw, and uncultured. Dubuffet (1976) believed that the art of psychotic individuals was produced outside of a cultural context. He did not conceive of institutional settings for the mentally ill as cultural microenvironments within a larger social context.

Dubuffet was not alone in his search for an alternative art form (Cardinal, 1972, 1992). In Europe between 1905 and 1930, three distinct art movements came into prominence: Dada, Surrealism, and Expressionism. The artists of these art movements were interested in something other than civilization, something other than technology, and something other than their own concepts of culture (Hughes, 1980). Dada looked at chance, Surrealism looked into dreams, and Expressionism looked into the need of children and indigenous people to make things.

In the early 1900s, the different art worlds of Europe were alive and animated. In Zurich, Switzerland, conscientious observers from Germany, Romania, and France gathered at the cabaret Voltaire to form open literary and artistic groups. One group adopted the name Dada, by chance, as they were looking in a German-French dictionary for the name Madame le Roy (Chipp, 1975, p. 377). Dada was selected as the name because of its brevity and suggestiveness, emphasizing its position as anti-tradition, anti-logic, anti-institution, in short, anti-everything.

Dada artists celebrated the art of the mad as the key to liberation (Breton, 1965). They obsessed over the art of compulsive visionaries as they searched for aesthetic inspiration. Max Ernst (1891–1976), a close friend of Surrealist author André Breton, had studied psychology and psychiatry at Bonn University. Although he never practiced as a therapist, he "sought to understand these flashes of genius and to inquire into the vague and perilous tendencies on the borders of insanity" (Ernst, 1970, p. 255). Ernst's interests in the art of the "isolated" prompted him to look for inspiration outside the academic walls that housed the Modern canons of Western rationalism.

Ernst was one of many advocates of the Dada movement. In 1919, he collaborated with other Dada artists to mount a show in Cologne that was staged as a provocative alternative to contemporary art. In this exhibition, Dada works of art were exhibited side-by-side with African carvings, amateur paintings, children's drawings, found objects, and works by psychotic patients. Dada artists were interested in the art-making practices of people outside the mainstream, especially the art of naïves, mediums, isolates, and

mentally ill individuals. They delighted in the creative interplay or provocative juxtaposition and parallel visions of modern artists and outsider art.

Surrealist artists also held collective exhibitions that involved unschooled artists. But their interests in the relationship of culture, art, and aesthetics were driven by a need to understand the *creative subject* as artist. Cardinal (1992) wrote,

. . . such enthusiasms were fueled by the Surrealists' need to construct and have validated a model of what I shall call the creative subject, that is, the individual self seen as the initiator and mentor of its own artistic impulses. Ranging from the naive-awkward through the mediumistic-fluent to the schizophrenic-obsessional, the inventory of eccentric artworks esteemed by Surrealism was regulated by the overriding postulate that true aesthetic quality and expressive authenticity derive from those fertile, subliminal levels of the psyche that are unmarked by establishment standards and indeed lie beyond the scope of rational surveillance. It was this 'psychic elsewhere' that Surrealism identified as the locale of genuine invention, and it was an ideology of the intrinsic positive value of radically altered mental states that formed the enthusiasms and affinities I am concerned to evoke. (pp. 94–95)

Guided by André Breton, this search for the *creative subject* led Surrealists to investigate pure psychic automatism. Breton wrote his Manifesto in 1924, which was the cornerstone of the Surrealist theory of creativity. This document helped to spur twin practices of automatic writing and automatic drawing. Surrealists considered automatic drawing and writing the foundation of artistic expression. Members believed these actions presupposed a deliberate refusal of reason and directed the artist on a journey into an unmapped psychic interior to authentic creativity.

Surrealists experimented with hypnosis and trances in their exploration to discover the "inner voice" of the uncivilized creative subject. But their experiments were "modified to produce something one could adopt deliberately and safely" (Cardinal, 1992, p. 97). The Surrealists' search for a "modern muse" embraced notions of "the other" to more fully explore their own creativeness as artists. Surrealism also accentuated ideas of distance, in the exploration of psychic elsewhere. Psychic elsewhere, metaphorically, separated the person's mind and body, allowing the artist to freely associate images, thoughts, and texts from the unconscious.

Expressionists were also fully absorbed in the search for aesthetic inspiration. They turned their attention to the creative output and practices of Africa and Oceania, and the art of the insane. The art of children was seen as containing unharnessed aesthetic forces. Paul Klee (1911) stated in a catalog entry for an exhibition,

Children too are able to make such art, and this is in no way detrimental to the newest artistic efforts, but rather the situation is a source of positive wisdom. The more untutored these children are, the more instructive is the art they give us, since even here corruption quickly enters: when children begin to absorb developed artworks or even imitate them. Parallel phenomena are the drawings of the mentally ill, and therefore the word 'insane' must also be rejected as an appropriately derogatory characterization [of the new art]. (Klee in MacGregor, 1989, p. 231)

Klee proposed a new and distinct vocabulary of form that would survey the uncivilized world of tribal ethnography, children's gestural drawings, and the art of the mentally ill. Uncorrupted and untutored artists provided a source of inspiration.

In this area of art making, Franz Marc was studying tribal ethnography, as was Wassail Kandinsky, who was also smitten with the art of children. Kandinsky became acquainted with Gabrielle Münter, a German artist who collected the art of children. Several pieces in Münter's collection appeared in Der Blaue Reiter almanac of 1912. The significance of child art in Germany was not, however, first discovered by the German Expressionists. Since the 1890s, children's art had been widely revered and accepted in the German school system. This artwork was recognized for its "unique manner of comprehending the world as seen in drawings done from memory" (Heller, 1992, p. 82). The art of children was also appropriated into the art world's aesthetic marketplace.

Alfred Kubin (1877–1959), was a Der Blaue Reiter artist who was interested in the art of unschooled artists. His interests in the art of the mentally ill took him to see the Prinzhorn collection in 1922, in Heidelberg, Germany. Kubin sought to validate creative characteristics of the mentally ill by identifying universal artistic principles. He stated,

The works themselves . . . affected me as well as my art-loving friend extremely intensely by means of their hidden adherence to artistic laws. We stood before

miracles of the spirit of art that emerge dawn-like from depths far beyond thought and consideration. Work and admiration must benefit from them. Herein resides the value that points to universality. And that too is why I absorbed these impressions into myself with an emotion of greatest joy . . . and now these things refuse to leave me alone any longer. (Kubin, 1977, pp. 13–17)

Kubin, as well as other Expressionists, saw the work of uncivilized makers as untainted artistic expression produced from a universal creative drive. Heller (1992) wrote, "Kubin clearly recognized parallels between the visions of the patients and his own bizarre, dark renditions of ominous dreams and foreboding fantasies" (p. 88). His vision from 1920 to the 1930s was premised on a search for a modern muse as an expressionistic aesthetic. Such interests resulted in the rejection of these innovative German Expressionist artists in the late 1930s by Hitler, as he mounted a conservative campaign against what he considered a degenerate form of art.

Exploration of the art of the "other" was also going on in the fields of psychology and psychoanalysis. In German-speaking countries that had suffered most in World War I, there was a huge interest in human pathology and what made people deviant and/or abnormal. Studies conducted by Freud, Jung, and Rorschach are best remembered.

Earlier, in 1882, Lombroso conducted a study of the relationship between psychic disorders and artistic creativity. Lombroso was interested in the notion of genius, as it was equated with madness, or the psychopathological aspects of creative expression. The results of his work contributed to many basic assumptions about patients' artistic behaviors in institutions. A basic contradiction formed as patients who were considered mad were also honored for their creative output and considered to be artistic geniuses. Since that time, the notion has been more than adequately proven to be inaccurate (Wolff, 1981, 1983; Cardinal, 1972). The mental health profession now acknowledges that the categorization of patients as deviant and mad during this time period was a gross oversimplification based on medical conventions and cultural prejudices (Foucault, 1965, 1982).

Hans Prinzhorn and Walter Morgenthaler, two German psychiatrists, studied the cognitive functions of people's consciousness and unconscious. Dr. Walter Morgenthaler was one of the first to actually call institutionalized patients "artists." He published his research citing that a person "who composed such astonishingly harmonious works merits unreserved recognition

as a genuine artist" (Morgenthaler in Cardinal, 1972, p. 17). Morgenthaler recognized that institutionalized "subjects" were more than objects of study. Artistic creativity and self-therapy was a means, he believed, for patients to attain a psychic stability.

In 1919, at the Psychiatric Clinic of the University of Heidelberg, Hans Prinzhorn began to collect and study the objects made by institutionalized patients. The institution collected over 6,000 works from 450 individuals over the years, including drawings, paintings, collages, textiles, books, note-books, and sculptures. The work was accumulated between 1890 and 1933, and the majority—some 5,000 pieces—were collected after the young assis-tant Prinzhorn arrived at the institution.

Prinzhorn was influenced by the work of Klages and his administrator, Professor Karl Wilmanns. He believed "that a mental patient who is lost to life can create works of undeniable artistic quality whose effect on the viewer corresponds by and large to the effects of a real work of art" (Prinzhorn, 1922, p. 1). Prinzhorn mounted a major exhibition in 1922 and that same year, published *Artistry of the Mentally Ill*. Prinzhorn's book and the Heidelberg collection were a major source of aesthetic influence for Dada, Surrealist, and Expressionist artists.

The French artist, Jean Dubuffet, was aware of Morgenthaler's and Prinzhorn's work and was equally impressed with the art of the institution-alized. He believed the drawings and other visual representations made by isolated people had nothing to do with civilization or social progress. The art of culture, he proposed, was cooked (Levi-Strauss, 1969), according to "fastidious recipes drawn up by the chefs of culture" (Cardinal, 1972, p. 26). On the other hand, the art of the institutionalized, and notably the schizo-phrenic patients, had a puréte bruté quality (raw purity). Hence, Dubuffet called the work, "l'art brut" or "raw art."

In a series of publications Dubuffet (1967) highlighted the work of artists who were distanced from society and culture. According to Dubuffet, a "basic confusion springs from the word culture itself. It has two meanings: 1) knowledge of and deference to works from the past (or at least those works whose survival has been engineered by the historians of Art); 2) the active development of individual thinking. What has happened is that the first meaning has come to asphyxiate the second" (Dubuffet in Cardinal, 1972, pp. 26–27). In this sense, culture was an object of appreciation and not the nego-tiation of particular sets of meanings and values among groups of people.

Dubuffet believed that one way to overcome this serious condition of cultural asphyxiation, or the moral, placid, stability of Western art, was through mobility, or an ever-shifting type of caprice (Cardinal, 1972). Artistic practices needed to keep changing in order to be innovative and progressive.

Dubuffet stressed that people overemphasized the negative side of madness. He considered madness to be a positive attribute and not a negative condition. He said, "It contributes to human life, [which is] not unhealthy, but regenerative" (Dubuffet, 1967, p. 27). Dubuffet understood, in the cultures of everyday life, that social and cultural forces flow, bubbling over with vitality and human energy (Bakhtin, 1984). Therefore, mentally ill outsiders required a designated place of difference. These "othered" artists have to be separated from society to control their inner life forces that are different or "deviant from the norm." (de Certeau, 1984, 1986). Psychiatric institutions were constructed as a place for the mad, the abnormal, and the other.

Mentally ill outsiders, while accepted as artistic geniuses, were isolated as a threat to the greater good of society. The myths of genius and other have been socially constructed over time as a means to control the deviant behaviors and actions of someone who was not understood to be "like us." The institutionalization of the "mad," in the words of Foucault (1965), took place because "there is [was] no common language between the sane and the mad." Cardinal (1972) wrote, "Exchange [had] broken down and the language of psychiatry which [was] a monologue of reason about madness, [had] been established only as the basis of such a silence" (p. 23).

Cardinal's book, *Outsider Art*, linked art to values and associated these values with the meanings of cognitive processes within social relations. He powerfully addressed issues of social diversity and the homogenizing forces of surveillance and institutionalization. He warned, "When we are confronted with artistic production which is so different from what we know, the danger lies in falling back on the superficial similarities we think we can spot, and in imagining this is all the description we need to characterize the new" (p. 49).

BIBLIOGRAPHY

Adrian, D. (1984). *The Artistic Presence of Jean Dubuffet: Forty Years of His Art.* Exhibition catalogue. Chicago: David & Alfred Smart Gallery.

Appadurai, A. (1986). *The Social Life of Things: Commodities in Cultural Perspective.* Cambridge: Cambridge University Press.

Apple, M. & Beyer, L. (1988). "Social Evaluation of Curriculum." In M. Apple & L. Beyer (eds.), *The Curriculum: Problems, Politics, and Possibilities.* Albany: State University of New York Press.

Bakhtin, M. (1984). *Rabelais and His World.* (H. Iswolsky, trans.). Bloomington: Indiana Press.

Barthes, M. (1972). *Mythologies.* Johnathan Cape: London. Trans. A. Laves. Republished in 1973 (and later editions) by Paladin Books, London.

Becker, H. (1963). *Outsiders: Studies in the Sociology of Deviance.* New York: Free Press.

Becker, H. (1982). *Art Worlds.* Berkeley: University of California Press.

Berger, J. (1972). *Ways of Seeing.* London: British Broadcasting Corporation.

Borum, J. (2000/2001, Winter). "Artists's Artists: The Instructive Relationship between Self-Taught and Academically Trained Artists." *Folk Art* 25 (4), pp. 54–63.

Bowman, R. (1992). "Looking to the Outside: Art in Chicago, 1945–75." In M. Tuchman & C. Eliel (eds.), *Parallel Visions: Modern Artists and Outsider Art* (pp. 150–173). Los Angeles: Los Angeles County Museum of Art.

———. (1993a). Interview (Cassette Recording No. 302). Milwaukee, WI: Krug, D., Doctoral research.

———. (1993b). "Eugene Von Bruenchenheim" (Cassette Recording No. 0113a). Manhattan, NY: Krug, D., Doctoral Research.

———. (1993c). "Uncommon Artists: Outsider Art Fair Symposium" (Cassette Recording No. 1030). Manhattan, NY: Krug, D., Doctoral research.

Breton, A. (1965). "Joseph Crepin." In J. Dubuffet (ed.), *L'Art brut* (pp. 44–63). Paris: Compagniede L'Art Brut.

Brixey, E. (1992, January 12). "Her Eyes Are Watching the Gods." *Wisconsin State Journal,* pp. 1, 3.

Broudy, H. (1972). *Enlightened Cherishing: An Essay on Aesthetic Education.* Urbana: University of Illinois Press.

Brown, M. (1963). *The Story of the Armory Show.* Greenwich: New York Graphic Society.

Cahill, H. (1932). *American Folk Art: The Art of the Common Man in America, 1750–1900.* New York: Museum of Modern Art.

Cardinal, R. (1989). "The Art of Enchantment." *Raw Vision,* 2, 21–31.

———. (1992). "Surrealism and the Paradigm of the Creative Subject." In M. Tuchman and C. Eliel (eds.), *Parallel: Visions: Modern Artists and Outsider Art* (pp. 94–114). Los Angeles: Los Angeles County Museum of Art.

————. (1993a). Interview (Cassette Recording No. 0031). Milwaukee, WI: Krug, D., Doctoral research.

————. (1972). *Outsider Art*. New York: Praeger Publishers.

————. (1993b). "Folk Art and Identity" (Cassette Recording No. 0012c). Milwaukee, WI: A Symposium: Common Ground/Uncommon Controversy.

Carlson, C. (1988). *Joseph E. Yoakum: a Survey of Drawings*. Davis, CA: University of California.

Chipp, H. (1975). *Theories of Modern Art: a Source Book by Artists and Critics*. Berkeley: University of California Press.

Clifford, J. (1988). *The Predicament of Culture: Twentieth Century Ethnography Literature, and Art*. Cambridge: Harvard University Press.

de Beauvoir, S. (1952). *The Second Sex*. New York: Random House.

de Certeau, M. (1984). *The Practice of Everyday Life*. Berkeley: University of California Press.

————. (1986). *Hetergologies: Discourse on the Other*. (Written in collaboration with Dominique Julia and Jacque Revel). Paris: U.G.E.

Dissanayake, E. (1988). *What Is Art For?* Seattle: University of Washington Press.

————. (1992). *Homo Aestheticus: Where Art Comes from and Why*. New York: The Free Press.

Dubuffet, J. (1967). *L'art Brut: Catalogue of the Exhibition in the Musee Des Arts Decoratifs*, Paris.

————. (1976). *L' Art Brut: Introduction to the Collection*, Lausanne.

Eco, U. (1986). *Art and Beauty in the Middle Ages*. New Haven: Yale University Press.

Eliel, C., & Freeman, B. (1992). "Contemporary Artists and Outsider Art." In M. Tuchman (ed.), *Parallel Visions: Modern Artists and Outsider Art* (pp. 198–229). Los Angeles: Los Angeles County Museum of Art.

Ernst, M. (1970). *Ecritures*. Paris: Gallimard.

Fischer, M. (1986). "Ethnicity and the post-Modern Arts of Memory." in J. Clifford and G. Marcus (eds.), *Writing Culture: The Poetics and Politics of Ethnography*. (pp. 194–233). Berkeley: University of California Press.

Fiske, J. (1989). *Understanding Popular Culture*. Boston: Unwin Hyman.

————. (1991). "Cultural Studies and the Culture of Everyday Life." In L. Grossberg, C. Nelson, & D. Treichler (eds.), *Cultural Studies: Now and in the Future*. New York: Routledge.

Foucault, M. (1977). *Discipline and Punishment: the Birth of the Prison*. London: Allen Lane.

————. (1965). *Madmen and Civilization: a History of Insanity in the Age of Reason*. New York: Pantheon.

————. (1982). "The Subject and Power: Critical Inquiry." In H. L. Dreyfuss & P. Rabinow (eds.), *Michel Foucault: Beyond Structuralism and Hermeneutics* (pp. 777–95). Chicago: University of Chicago Press.

Fry, R. (1924). *The Artist and Psycho-analysis*. London: Leonard and Virginia Woolf.

————. (1928). *Vision and Design*. London: Chatto and Windus.

Gablik, S. (1991). *The Reenchantment of Art*. New York: Thames and Hudson.

Gabriel, R. (1993, Summer). "Outsider Art Fair: Unqualified Success." *Folk Art*, pp. 60–61.

Gee, J. P. (1991). "The Narratization of Experience in the Oral Style." In C. Mitchell & K. Weiler (eds.) *Rewriting Literacy: Culture and the Discourse of the Other.* New York: Bergin & Garvey.

Georges, R. (1969). "Toward an Understanding of Storytelling Events." *Journal of American Folklore,* pp. 316–28.

Grotto and Shrines, Dickeyville, Wisconsin. (Booklet available at gift shop at shrine, publishing information not available)

Hall, M. (1991). "The Mythic Outsider: Handmaiden to the Modern Muse." *New Art Examiner,* 9, 16–21.

Hartigan, L. (1990). *Made with Passion: The Hemphill Folk Art Collection.* Washington and London: Smithsonian Institution.

Heller, R. (1992). "Expressionism's Ancients." In M. Tuchman and C. Eliel (eds.), *Parallel Visions: Modern Artists and Outsider Art* (pp. 78–91). Los Angeles: Los Angeles County Museum of Art.

hooks, b. (1990). *Yearning: Race, Gender, and Cultural Politics.* Boston, MA: South End Press.

Hughes, R. (1980). *The Shock of the New.* New York: Alfred Knopf.

Hutcheon, L. (1989). *The Politics of Postmodernism.* New York: Routledge.

Intuit: Center for Intuitive and Outsider Art. (2001). Retrieved January 4, 2001 from http://outsider.art.org/Pages/About.htm.

Jensen, D. (1985, July). "Art from the Outsiders." *Air Waves,* pp. 14–17.

———. (1993). Interview (Cassette Recording No. 303). Milwaukee, WI: Krug, D., Doctoral research.

Johnson, K. (1993, June). "Significant Others." *Art in America,* pp. 84–91.

Jones. M. (1975). *The Hand Made Object and Its Maker.* Berkeley: University of California Press.

Kind, P. (1993). "The Art of Martin Ramirez" (Cassette Recording No. 003). New York, NY: Uncommon Artists: A Series of Cameo Talks.

Kohler Arts Center. (1988). *Eugene Von Bruenchenheim: Obsessive Visionary.* Sheboygan, Wisconsin: John Michael Kohler Arts Center.

Kohler Arts Center. Retrieved 2005 from .

Kohler, R. (1993a). [John Michael Kohler Art Center debuts collection of self taught artists.] Unpublished raw data.

———. (1993b). [Wisconsin tales: The premier of a permanent collection.] Unpublished raw data.

Krug, D. (1992/93). "The Expressive Cultural Practices of a Non-Academically Educated Artist, Ellis Nelson, in the Macro and Micro Environment," *The Journal of Multicultural and Cross Cultural Research in Art Education,* USSEA, Madison: University of Wisconsin Press. 10/11 (01), pp. 20–48.

———. (1993). *An Interpretation of the Expressive Cultural Practices of Nonacademically Art Educated Makers of Art in Wisconsin,* (Doctoral dissertation, University of Wisconsin–Madison). Dissertation Abstracts International, 93 - 30823.

———. (1998). *The Study of Cultural Identity and Art Education.* Proceedings from the Taiwan International Congress. National Changhuall University of Education Changhua, Taiwan.

Krug, D. & Parker, A. (1998). "Power On!: The Fantastic Environments of Dr. Evermor," *Raw Vision: International Journal of Intuitive and Visionary Art.*

Kubin, A. (1977). *Werkstatt-Berichte.* Salzburg: Residenz.

Levi-Strauss, C. (1969). *The Raw and the Cooked.* London: Cape.

Lippard, L. (1997). *The Lure of the Local: Senses of Place in a Multicentered Society.* New York: The New Press.

Longhauser, E. (1998). Introduction. *Self-taught Artists of the 20th Century: An American Anthology.* San Francisco: Chronicle Books.

MacGregor, J. (1989). *The Discovery of the Art of the Insane.* Princeton: Princeton University Press.

Maclagan, D. (1991). "Outsiders or Insiders?" In S. Hiller (ed.), *the Myth of Primitivism: Perspectives on Art* (pp. 32–47). London: Routledge.

Manley, R. (1989*). Signs and Wonders: Outsider Art Inside North Carolina.* North Carolina: University of North Carolina Press.

————. (1991). "Separating the Folk from Their Art." *New Art Examiner,* 9, 25–28.

Morawski, S. (1974). *Inquiries into the Fundamentals of Aesthetics: What Is a Work of Art?* Cambridge, MA: MIT Press.

Morrison, R., Smith, C., and Kerrigan, C. (1993). *Outsider Art Fair Catalogue.* New York: Stafford L. Smith and Associates, Ltd.

Novitz, D. (1992). *The Boundaries of Art.* Philadelphia: Temple University Press.

Nutt, J. & Nilsson, G. (1993). Interview (Cassette Recording No. 306). Willmette, IL: Krug, D., Doctoral research.

Phyllis Kind Gallery. (2002). Retrieved May 15, 2002, from http://www .phylliskindgallery.com/gallery/index.html.

Prinzhorn Collection, The. (1984). Urbana, Champaign, IL: University of Illinois Press.

Prinzhorn, H. (1922). *Artistry of the Mentally Ill.* (Eric von Brockdorf, trans.) New York: Springer-Verlag.

Rumford, B. (1980). "Uncommon Art of the Common People: A Review of the Trends in the Collecting and Exhibiting of American Folk Art." In I. Quimby and S. Swanks (eds.), *Perspectives on Folk Art* (pp. 13–53). New York and London: Routledge.

Sherzer, J. (1983). *Kuna Ways of Speaking: An Ethnographic Perspective.* Austin: University of Texas Press.

Stone, L. & Zanzi, J. (1991). *The Art of Fred Smith,* Park Falls, WI: Weber & Sons, Inc.

Stone, L. & Zanzi, J. (1993). *Sacred Spaces & Other Places: A Guide to Grottos and Sculptural Environments in the Upper Midwest,* Chicago: School of the Art Institute of Chicago Press

Stuhr, P., Krug, D., Scott, A. (1995). "Partial Tales of Three Translators: An Essay," *Studies in Art Education: A Journal of Issues and Research in Art Education* 37, (1).

Tannen, D. (1984). *Coherence in Spoken and Written Discourse.* Norwood, NJ: Ablex.

Teske, R. (1987). *Wisconsin Folk Art: Continuing a Cultural Heritage, from Hardanger to Harleys: A Survey of Wisconsin Folk Art.* Sheboygan: Sheboygan Arts Foundation.

Teske, R. (ed.). (1998). *Wisconsin Folk Art Celebration.* Cedarburg, Wisconsin: Cedarburg Cultural Arts Center.

Tuchman, M. (1992). Introduction. *Parallel Visions: Modern Artists and Outsider Art*, pp. 9–13. Los Angeles, Los Angeles County Museum of Art.

Vlach, J. (1991). *By the Work of Their Hands: Studies in Afro-american Folk Life.* Charlottesville: University Press Virginia.

Weitz, M. (1958). "The Role of Theory in Aesthetics." In G. Hardiman & T. Zernich (eds.), *Discerning Art: Concepts and Issues,* Champaign, IL: Stipes, (Original work published 1956), 25–35.

Wertkins, G. (1993). Foreword. *Self-taught Artists of the 20th Century: An American Anthology.* San Francisco: Chronicle Books.

Williams, R. (1977). *Marxism and Literature.* Oxford: Oxford University Press.

———. (1981). *Culture.* Glasgow: Fontana and Collins.

Willis, P. (1990). *Common Culture; Symbolic Work at Play in the Everyday Cultures of the Young.* Boulder: Westview Press.

Wolff, J. (1981). *The Social Production of Art.* Hong Kong: New York University Press.

———. (1983). *Aesthetics and the Sociology of Art.* London: George Allen & Unwin.

Zurmuehlen, M. (1986). "Reflecting on the Ordinary: Interpretation as Transformation of Experience." *Art Education,* 39 (6), 33–36.

———. (1987). "Context in Art: Meaning Recovered and Discovered." *Journal of Multicultural and Cross-cultural Research in Art Education,* 5 (1), 131–43.

INDEX